BOTTICELLI'S
⚜ SECRET ⚜

BOTTICELLI'S SECRET

THE LOST DRAWINGS
AND THE REDISCOVERY
OF THE RENAISSANCE

JOSEPH LUZZI

W. W. NORTON & COMPANY
Independent Publishers Since 1923

For information about permission to reproduce selections from
this book, write to Permissions, W. W. Norton & Company, Inc.,
500 Fifth Avenue, New York, NY 10110

For information about special discounts for bulk purchases, please
contact W. W. Norton Special Sales at
specialsales@wwnorton.com or 800-233-4830

Manufacturing by Lake Book Manufacturing
Book design by Brooke Koven
Production manager: Julia Druskin

Library of Congress Cataloging-in-Publication Data

Names: Luzzi, Joseph, author.
Title: Botticelli's secret : the lost drawings and the rediscovery of
the Renaissance / Joseph Luzzi.
Description: First edition. | New York, NY : W. W. Norton &
Company, [2022] | Includes bibliographical references and index.
Identifiers: LCCN 2022036535 | ISBN 9781324004011 (hardcover) |
ISBN 9781324004028 (epub)
Subjects: LCSH: Botticelli, Sandro, 1444 or 1445–1510—Themes,
motives. | Dante Alighieri, 1265–1321. Divina commedia—
Illustrations. | Renaissance—Italy. | Art and society.
Classification: LCC NC257.B68 L89 2022 | DDC 759.5—dc23/
eng/20220805
LC record available at https://lccn.loc.gov/2022036535

W. W. Norton & Company, Inc.
500 Fifth Avenue, New York, N.Y. 10110
www.wwnorton.com

W. W. Norton & Company Ltd.
15 Carlisle Street
London W1D 3BS

1 2 3 4 5 6 7 8 9 0

To my son,
James Baillie Luzzi
legato con amore in un volume

What mystery here is read
Of homage or of hope? But how command
Dead Springs to answer?

<div align="right">—Dante Gabriel Rossetti,
"For *Spring* by Sandro Botticelli"</div>

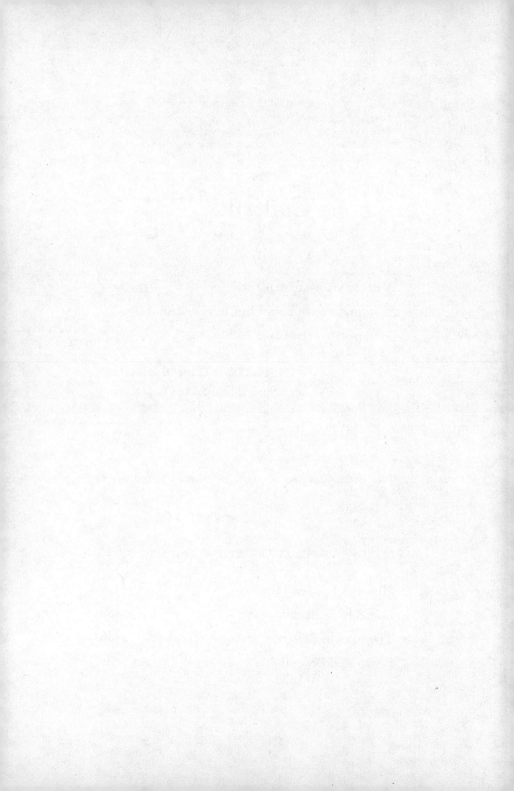

Contents

Prologue

Renaissance, noun (from the French, *re-*, "back, again"
+ *naissance*, "birth"):
 1. The advent of a new kind of art and the free play
 of the imagination.
 2. A period when Satan ruled as the absolute
 master of the world.
 3. A flood of folly and hypocrisy.

On June 9, 1882, a tall, fashionably dressed man with a trim gray mustache ambled into Ellis and White booksellers on London's New Bond Street, a posh enclave studded with the city's deluxe art dealers and antique shops. Heading a select group of cultural emissaries, the distinguished visitor had come to view an artwork that had much of Europe buzzing.[1] Director of the print collection at the newly formed Royal Museum of Berlin, Friedrich Lippmann often traveled to the great European capitals looking for treasure. This time, he had his aim set on one special target.

Lippmann, whose Prague accent revealed his Austro-Hungarian origins, had already made a name for himself as one of Europe's finest art historians and shrewdest arbiters of aesthetic value, in both the spiritual and financial sense.[2] He was married to an English woman, and his zealous charm coupled with his vast erudition had won him many admirers in London. Though he was on foreign turf, he felt very much at home. Lippmann's bluff and easy manner hid a serious poetic side, especially when he stood before a work of brilliance. He belonged to a new breed of artistic impresario called the "connoisseur," a cultured and commercially savvy sect whose encyclopedic knowledge of art helped wealthy collectors and ambitious museums build their collections. Some of these connoisseurs—like the once impoverished Lithuanian immigrant Bernhard Valvrojenski, who rebranded himself as the lofty Florentine expat Bernard Berenson—would become rich, like the magnates and moguls who employed them. But the scholarly, civic-minded Lippmann was more interested in adding to the glory of his new German nation, unified only recently in 1871, than in padding his bank account. Besides, as the scion of a wealthy industrialist, he could afford to work for love instead of profit. Lippmann's tastes ranged omnivorously, from Chinese porcelains and Italian woodcuts to Dutch etchings and Flemish oil paintings, and he had an eye for works that could outlast changing fashion and fickle taste. But even an eye as discerning as his could not have prepared itself for what the bookseller was about to reveal in an auction bloc antiseptically labeled Manuscript (MS) Hamilton 201, which contained a group of unfinished drawings that would shape the way we understand the monumental term *Renaissance*.

The word *Renaissance* is by now so familiar that its actual meaning can become lost. It might invoke traveling bards

singing of courtly love and damsels trailing ribbons from conical hats. Or it might suggest a dry subject debated over by
academics who live more comfortably with the settled truths
of the past than the uncertainties of the present.³ Whatever
the word evokes, it tends to be located in what the Italians
call the *passato remoto*—literally the "remote past": something
over and done with, a matter of history and a wager with time
that has been resolved. From this perspective, the Renaissance
becomes merely part of what one of its most acid detractors,
the great Victorian critic John Ruskin, used as the title for his
autobiography: *Praeterita*, Latin for past tense.

But to think of the Renaissance as belonging to some lost
kingdom buried in the recesses of memory is a mistake. For
in truth, it was only around Lippmann's time, about a hundred and fifty years ago, that the term began to make any
sense. Crucially, the word was not coined in the place and
time with which it has become synonymous: fourteenth- to
sixteenth-century Italy in general and Florence in particular,
the epoch of artistic colossi like Leonardo and the site of such
groundbreaking works as Brunelleschi's Duomo and Michelangelo's *David*. Those geniuses had no terminology on hand
to label the tectonic shift in cultural life that they were setting in motion. The term *Renaissance*, in its current sense as
the era of world-changing Italian art, did not actually appear
in print until 1855, when the French historian Jules Michelet
wrote:

> The pleasant word "Renaissance" recalls to lovers of beauty
> only the advent of a new art and the free play of the imag
> ination. For scholars, it is the renewal of classical studies,
> while for jurists, daylight begins to dawn over the confused
> chaos of our ancient customs.⁴

Not all of Michelet's contemporaries were as happy about such a break with the past. One skeptic claimed that the Renaissance marked the devil's return to earth to rule over humankind. Another argued that the coming of the secular Renaissance signaled the disappearance of the more spiritual Middle Ages, thereby ushering in all manner of lies and foolishness. Ruskin was harshest of all: he believed the Renaissance was on balance an "evil" time.[5]

Despite the differing opinions, one thing is clear: the notion of the Renaissance as a light-filled, rational era that signaled a clean separation from what Edward Gibbon called the "barbarism and religion" of the Middle Ages was a powerful fiction. This seductive put-down did contain an element of truth. But the view of the Middle Ages as a "dark age" of antirationalism and unquestioning faith was largely a willful creation of Gibbon's Enlightenment, intended to draw a bright line between religion and the "rebirth" of scientific reason in the Renaissance. In reality, some of the elements now associated with the Renaissance already existed in the medieval period, many of whose thinkers were committed lovers of ancient Greco-Roman culture who devoted their lives to learning in flourishing intellectual centers like the recently founded universities at Bologna, Cambridge, Heidelberg, Oxford, and the Sorbonne.[6] Simple chronology reveals how foolish it would be to see these two eras in binary terms: a writer deemed eminently medieval, Dante, died in 1321, while a notional founder of the Renaissance, Petrarch, was born in 1304. Similarly, Christian Europe's renewed interest in pagan authors like Virgil predated the Renaissance, not only in Dante but also in many other medieval scholars.[7] In Dante's own words, artists and writers of the Middle Ages were just as concerned with *l'uso moderno*, modern usage, as the forward-thinking minds that succeeded them.[8]

Its roots in the Middle Ages notwithstanding, the birth of the Renaissance did arguably initiate a new outlook on human life that emphasized to an unprecedented degree the value of the ancient world and the power of rational inquiry in the arts and sciences. Late fourteenth- and early fifteenth-century Florence in particular began to attract a critical mass of artists and intellectuals who became synonymous with this epoch of cultural rebirth—an insight that we owe in large part to Giorgio Vasari's seductive pages in *Lives of the Artists*. The cultural glories that resulted from the new ferment are well known. But many critics believed it came with a dark side. When Ruskin called the Renaissance evil, he was lamenting what a much later writer would call "the disenchantment of the world."⁹ To Ruskin's Gothic tastes, the mysticism and religious fervor of the Middle Ages had created more powerful and awe-inspiring art than what followed this period. Versions of Ruskin's antirationalist bias have continued to resurface throughout history in reaction to reason-based movements like the Renaissance, including in our own times. Whether it was Hitler's Nazi Party rejecting modernist art in the name of medieval myths celebrating a "Germanic" spirit, or today's alt-right propagandists advocating a "traditionalist" return to faith-based communities, a strand of modern thinking blames the Renaissance for the dwindling of belief in God, the loss of inherited cultural values, and the ascent of a soulless technocracy controlled by a bureaucratic elite.¹⁰

Despite such resistance, a core of historians in Lippmann's time believed that the Renaissance, true to its etymology, represented a return to something that had been lost, especially the pagan culture of ancient times and the celebration of earthly life, due to the intense religiosity of the medieval world. For that generation of scholars, connoisseurs, and collectors, the word *Renaissance* depended on its prefix *re-*: it was an age of

rebirth, rediscovery, and reinvention. It produced much that was new—opera, the telescope, the widespread application of one-point perspective in painting, to name only a few. But just as important, it revealed how to reuse, reconsider, and recreate ideas and practices that had slipped into oblivion. No rediscovery, no rehabilitation, would be more dramatic than the one about to transpire before Lippmann's wire-rimmed glasses.

Dr. Friedrich Lippmann was a bit like the character Kurtz in Joseph Conrad's *Heart of Darkness*: all of Europe had contributed to his making. He was born in 1838 in the German-speaking Prague of Franz Kafka and the Hapsburg Empire, traveled frequently to Italy as a child, spent swaths of his gilded youth in Paris and London, attended university in Vienna, and finally settled in Berlin in his late thirties, when he became director of the Kupferstichkabinett, a fledgling museum that he was transforming into one of the world's preeminent print and drawing collections.[11] From childhood onward, Lippmann's was a life of privilege. His father regularly took the family on visits to the great European museums, while making sure that young Friedrich had a well-rounded education that left time for musical and athletic pursuits. A committed cosmopolitan who mastered several European languages, Lippmann studied law, history, politics, and science in addition to art. Blessed with unusual vigor and energy, he once built a boat by hand and sailed it from Prague to Dresden, a three-hundred-mile journey along the Elbe River. Sportsman, scholar, and savant: Friedrich Lippmann was the proverbial Renaissance man.

If all of Europe had contributed to the making of Lippmann, then centuries of inbreeding and sloth had conspired to produce the man who stood between him and the coveted drawings in MS Hamilton 201. Its owner, William Alexander, 12th

Duke of Hamilton, was one of those figures that only privilege and peerage can produce. Born to an ancient Scottish family—and a line of distinguished collectors who had made the family seat, Hamilton Palace, one of Europe's premier private libraries and artistic repositories—young William Alexander was about as fond of books as a dog is of getting beaten with a stick. Whist and whisky, not Titian and Turner, were his sort of thing. He drank and boxed his way through Oxford, hunted five days a week, and accumulated such staggering gambling debts (two million pounds' worth in today's currency) that he was compelled to auction off a catalogue of breathtaking art, painstakingly collected over centuries but only to be squandered over some bad turns at the gaming table.[12]

That the Scottish noble family should have come to this point defied logic. Just generations earlier, William's grandfather Alexander, 10th Duke of Hamilton, had amassed works once owned by Roman emperors, Russian tsars, various popes and cardinals, Queen Marie-Antoinette, and the Emperor Napoleon. Alexander was a brilliant collector—but he was also a lavish spender whose ambitious purchases depleted the family's capital.[13] Because of his profligate grandson, the coffers of Hamilton Palace were about to hemorrhage priceless art as well as cash.[14]

The young duke's fate, along with that of his clan, hung in the balance over a single set of drawings that had inexplicably faded into oblivion for centuries. A simple line in the catalogue listing MS Hamilton 201, a privately printed document that circulated only within the small circle of potential buyers, had drawn Lippmann from Berlin to London: "88 exquisitely beautiful Designs by SANDRO BOTTICELLI." A version of these magical words (which should have included the word *lost*) had first appeared eighty years earlier, on April 27,

1803, in the beautiful cursive script of the Parisian bookseller Giovanni Claudio Molini, who sold the drawings to the Duke of Hamilton that same year.[15] It is not known how the volume had ended up in Molini's possession. Its cover read that the drawings were "by Botirelli [sic] or another artist of the Florentine school," an equivocation echoed by Molini, who wrote that they were "either in the hand of Sandro Botticelli, or some other draughtsman in that optimum period of drawing."[16] The blunt misspelling of the artist's name in the earlier notice suggests the limbo into which the once renowned Botticelli had fallen. One of Lippmann's predecessors, the art historian Gustav Friedrich Waagen, viewed these same illustrations at Hamilton Palace around 1850,[17] and later wrote that *perhaps* they were attributable to Botticelli, but ultimately "various hands, of various artistic skill, are discernible."[18] The French bibliographer Paul Colomb de Batines also gushed over the drawings, a few years later in 1856—but he too failed to express a definitive opinion on their authorship.[19] Botched sightings like Waagen's and missed identifications like Batines's helped keep the drawings under the radar of many skeptical art collectors. But not Lippmann's.

The official inventory of the Hamilton family collection mentioned a "fine MS." of Dante's *Divine Comedy*, "written about the year 1450 [and] ornamented with eighty-eight original designs supposed to be executed by the hand of Sandro Botticelli, or some other eminent Florence artist."[20] The astute Lippmann would have seized on that inconclusive adjective *supposed* and wavering conjunction *or*. He had come to London to put to rest once and for all the rumors that had been swirling for decades about this legendary, enigmatic, and contested edition. It was either one of the most valuable and beautiful books ever produced, a sublime testament to Botticelli's skilled

hand, or it was a hodgepodge of different artists' work, with Botticelli's in the mix, all of them struggling to measure up to Dante's soaring genius. Only Lippmann would be able to say.

When Sandro Botticelli died in 1510, his name had long been synonymous with the artistic splendors of Florence's Medici dynasty, which had been involved directly and indirectly in the creation of such masterpieces as *Primavera* (or *Spring*) and *The Birth of Venus*, two of the Western world's most recognizable and beloved works of art—even though scholars and collectors continue to debate their meanings and the circumstances of their commissions. But there was one project of Botticelli's that drew much less attention, even though it was equal in ambition to his most remarkable achievements. From sometime around 1480 until about 1495, the artist worked on a commission that functioned as a kind of diary, something akin to Leonardo's notebooks and Michelangelo's poetry: a mirror of his artistic thinking and creative vision, perhaps even a visual record of his intimate thoughts or a repository for his doubts. Botticelli's "secret project"—in the sense that it was barely commented upon during his life, worked on sporadically and in the midst of more celebrated works, then forgotten for centuries—was his illustration of nearly all one hundred cantos of Dante's *Divine Comedy*, an epic poem on the state of the soul after death that had been completed around 1321, the year of Dante's death. Somehow this grand set of illustrations disappeared after Botticelli's own death—just as, even more surprisingly, the artist's reputation fell into oblivion. The founder of modern art history, Vasari, was largely responsible. His *Lives of the Artists*, first published in 1550 and revised in 1568, spoke of artists as creators of special talent and superhuman skill. But it expressed lukewarm appreciation for Botticelli and ridicule for his Dante cycle.[21] According to Vasari, Botticelli had taken on

this mighty challenge out of vanity and insecurity, wasting his time on it "to prove he was a sophisticated person" (*"per essere persona sofistica"*).[22] Crucially, the word *sofistica* here differs from our own more positive understanding of *sophisticated*: the savvy wordsmith Vasari deftly played on the term's ancient Greek root in *sophistry*, with all its implications of deceptively appealing surfaces. In Vasari's view, Botticelli's Dante project was a pretense aimed at gaining the supposedly unlearned artist intellectual legitimacy.

Before Vasari, an unknown author known as the Anonymous Magliabechiano—whose identity remains controversial to this day[23]—had referred to Botticelli's drawings briefly and enthusiastically in his own *Lives of the Artists* from 1540, a collection of notes for a planned book that never appeared: "Botticelli painted and illustrated a Dante in sheepskin for Lorenzo di Pierfrancesco de' Medici, and it was considered a marvelous thing."[24] Magliabechiano's words are generic and impersonal (he uses the passive *fu tenuta*, "it was considered"), leaving us to wonder who was praising this largely overlooked masterpiece. Despite its sparseness, the notice was extremely important: it remains our lone source for identifying the patron who commissioned Botticelli's project. Meanwhile, the idea of an encounter between two figures as luminous as Dante and Botticelli has elicited an enormous amount of scholarly attention ever since these initial mentions of it during the Renaissance. But its true nature remains a mystery. We cannot seem to escape the distortions, even flat-out lies, emanating from Vasari, who never actually saw the complete illustrations, but with typical boldness claimed that they caused the painter "infinite disorder."[25]

Botticelli's decade and a half spent illustrating Dante for his Medici patron was certainly common knowledge in the artist's thriving workshop, as his assistants were involved in the

preliminary work for the drawings: they prepared the paper, inks, and pigments that Botticelli would then transform into the swirling figures of Dante's afterworld. And it is likely that, within Florence's tightly knit circle of artists, craftsmen, and patrons, news of—and gossip about—the project would have spread quickly. Contemporary eyewitnesses attested to Botticelli's *"carattere allegro e burlone,"* his carefree and roguish character.[26] His extroverted personality, combined with his wide network of friends and business associates, made it probable that this intensely social artist would have shared word of his project freely and blithely. Yet the work remained Botticelli's secret in the ancient sense of the word's root, *secretum*: something set apart from everyday life and his more public work, perhaps even a private confessional. Petrarch's *secretum* was to write a book distilling his religious doubts into a tortured discussion with an imaginary St. Augustine in a masterpiece he titled *My Secret Book*, a work whose complex and sustained self-analysis reached neurotic heights that would have floored Freud. Botticelli's *secretum* was to toil, in the margins of his career and while working on higher-profile commissions, on an ambitious plan to illustrate a Christian poem whose scholarly rigor challenged him aesthetically, intellectually, and morally.

The Dante project wasn't Botticelli's only secret. We know precious little about the painter's personal life. He left no writing in his hand, not even a will. After his well-documented youth and early decades of artistic success, which we can piece together through the records of his plum commissions and the abundant commentary of eyewitnesses, his final years are a blur. The onetime superstar Botticelli fell off Florence's artistic map and, in a seeming flash, took all his glory to the grave with him. Once quite well-off, he managed to die penniless. He never married,

had no children, and likely preferred men to women—or, at the very least, the bachelor's life to that of a married man. If he was in fact gay, as the evidence suggests, he left nothing that would confirm his sexuality one way or another. And later in his life his once straightforwardly loving and affectionate relations with Florence's political titans, the Medici, became complicated by both external political pressures and internal fissures within the family—though again, we can't be certain exactly how his feelings about his most important benefactors may have changed. Similarly, we can't know his ultimate position on the man who, more than any other, signaled the bloody end of the Medici rule that had brought Botticelli accolades and riches: Girolamo Savonarola, the so-called Mad Monk. Despite his outward gaiety and easygoing manner, Botticelli was in the end a complicated man of many *segreti*.

So are his Dante drawings. After Vasari's withering dismissal, they disappeared from the written record for more than a hundred years. Then, when Queen Christina of Sweden died in Rome in 1689 and her library was bought by Pope Alexander VIII, the Vatican archivist noted that eight of the drawings, including seven canto illustrations and the most magnificent of all Botticelli's renderings from Dante, the full-color *Map of Hell*, were in this coveted acquisition. So, the nearly complete set of illustrations—one for almost all of the poem's one hundred cantos plus *The Map of Hell*—had been broken up and dispersed to different places and patrons, though nobody knows how or why, and no further mention would be made of them until the Hamilton family purchased the bulk of the illustrations from Molini in 1803. Ten of the illustrations have gone missing and remain unaccounted for to this day.[27] Given the drawings' imperiled afterlife, which would include last-dash storage in a Nazi-controlled salt mine

and Cold War-induced dispersion into East and West Berlin in the era of the Berlin Wall, it's a miracle that so many of them managed to survive.

The case of Botticelli and his lost drawings shows how malleable and changeable artistic fortune can be, even for those who we assume have always occupied fame's loftiest perch. The painter's work had become so unfashionable that, as late as 1867, the Pre-Raphaelite poet and painter Dante Gabriel Rossetti was able to purchase Botticelli's now-priceless *Portrait of a Lady Known as Smeralda Bandinelli* for a piddling £20, or $3,000 in today's money—less than the cost of a low-end Rolex. But by the time of Lippmann's visit to Ellis and White in 1882, just fifteen years after Rossetti's purchase, the vexed question of Botticelli's authorship suddenly mattered, thanks in large part to a strange, brilliant essay written in 1870 by an obscure Oxford academic with a foot fetish.[28] Walter Pater helped revitalize interest in Botticelli by musing on what he called the painter's "middle world," his gift of blending the divine and the secular into one joyous artistic vision.[29] Another Oxford don, the equally gifted (and equally eccentric) John Ruskin, also contributed to the growing British cult of Botticelli with a series of influential lectures in the 1870s that praised the revolutionary qualities of his style.[30]

Pater, Ruskin, and Rossetti's Pre-Raphaelite Brotherhood were all linked in reclaiming Botticelli, and with him his Dante project, after centuries of neglect. They were continuing a process of rediscovering fifteenth-century Italian art that had begun, conceptually, in the debates about the term *Renaissance* initiated in the 1850s by Michelet and culminating in the Swiss historian Jacob Burckhardt's epochal 1860 book, *The Civilization of the Renaissance in Italy*. The episodic fate of Botticelli and his Dante illustrations shows that there

was never one monolithic "Renaissance," but rather a series of mini-renaissances, which when taken together tell a story of why that period was felt to be so vital for later cultures. To equate the Renaissance with "modernity" writ large became a way for thinkers and artists to say "our history as a culture that believes in science and reason, and celebrates beauty as an end in itself, starts *here*."

Despite Botticelli's rebirth in the nineteenth century and into our own times, he still raised doubts. Though Ruskin did much to enhance Botticelli's reputation, he also believed that his art, at its worst, signaled a spiritually bankrupt and overly rational Renaissance. And Botticelli's champion Pater compared him negatively to Michelangelo and Leonardo, concluding that Botticelli was ultimately "secondary."[31] Similarly, the most consequential Botticelli proponent of all, Lippmann, would one day write that the painter "does not, indeed, dazzle and entrance by the force and splendor of his genius, the power and majesty of his conceptions, as do Leonardo, Michael Angelo, and Raphael. His charm lies rather in the sweet and delicate play of fancy, the depths of quaint yet sympathetic emotion that make up his artistic personality."[32] Even among his biggest fans, Botticelli was (and is) sometimes seen as too "pretty" a painter to be taken seriously.

Yet the savvy connoisseur in Lippmann sensed that Botticelli's star would continue to rise, even if it would never ascend to the heights occupied by the Big Three: Leonardo, Michelangelo, and Raphael, the lone Renaissance artists whom museums of the time dared collect. Renaissance art still had limited appeal as late as 1903, when the influential critic and painter Roger Fry lamented that New York's Metropolitan Museum of Art lacked works by Botticelli, Leonardo, and Michelangelo, not to mention the host of other Renaissance artists, from

Piero della Francesca and Andrea del Sarto to Titian and Bronzino and many more, who are now staples of private and public collections worldwide.[33] Lippmann would help transform this neglect into enthusiasm.

When MS Hamilton 201 finally arrived after what must have seemed like an eternity to the German art historian as he waited in Ellis and White, the first thing Lippmann might have noticed was the sheer size of the drawings: each sheepskin parchment measured eighteen and a half inches by twelve and a half inches, roughly the size of a traditional portrait or still life. Each page was filled, on one side, with a canto of Dante's *Divine Comedy*, elegantly recorded in the hand of the Tuscan scribe Niccolò Mangona, whose script had enchanted wealthy Renaissance families like the Medici and their rivals the Pazzi as well as the King of Portugal.[34] On the flip side of the pages was Botticelli's flowing silverpoint line, in different colored inks and of melting finesse and grace, illustrating Dante's words on the Christian afterlife from the depths of hell through the mountain of purgatory and into the stars of heaven. With one glance, Lippmann knew. Each line was unmistakably, inextricably connected to the next, from the minute details of the suffering sinners—pelted by rains of fire, mired in their own filth, devoured by a cannibalistic Satan—to the sparsely rendered flow of angels basking in divine love. His predecessor Waagen and, before him, Clarke and Molini, were dead wrong: these were not "various hands, of various artistic skill."

Instead, the illustrations coalesced into one supremely rendered vision, no less unified and transcendent than the poem that inspired it. Here was Botticelli's true secret: Dante's austere Christian vision could somehow be translated into a new worldly key, a vision that celebrated earthly life rather than

looking past or through it. The dance of the angels could take on human form, and Dante's spiritual beauties could assume a mortal, sensual coil.[35] If ever there were a visual mapping of the human spirit's transition from medieval to Renaissance times, here it was. Adrenaline likely coursed through the naturally exuberant Lippmann as he pondered the works that for months he had plotted and daydreamed about. Only afterward, in a Wordsworthian moment of emotion recollected in tranquility, could the spike of exhilaration finally release from him, perhaps as he penned a letter to his employer back in Berlin, in words that made it all the way to the new German emperor, Kaiser Wilhelm I:

> Imagine a parchment manuscript of large folio size, every folio having the text on one page, and on the other the whole page throughout covered with pen and silverpoint drawings by Botticelli.[36]

With those breathlessly underlined words *whole page* and *covered*—in the stately German, *ganze Seite bedeckend*—Friedrich Lippmann asserted that any lingering doubt about a four-hundred-year-old mystery, one of the greatest in all of art history, was at a close.

~

Each year, about four million visitors fill the twin corridors of Florence's Uffizi Gallery, Vasari's greatest architectural work and the world's preeminent collection of Renaissance art. For some, the encounter with sublime painting by the likes of Giotto, Michelangelo, and Leonardo is so overwhelming that it causes rapid heartbeat, dizziness, even fainting, as they experience Stendhal's Syndrome, the debilitating effect of profound

beauty first described by the great French novelist (and Florentine tourist) after whom the condition is named.[37] Perhaps nowhere is the aesthetic concentration more disorienting than in galleries 10 to 14, the Botticelli Rooms. The shutters whirl and the selfie sticks fly as viewers gape at *Primavera* and *The Birth of Venus*, enormous paintings whose frolicking gods and goddesses are now reproduced on everything from priceless jewelry to cheap key chains and dorm room posters—even Lady Gaga's ribcage. The pop icon wore a Dolce & Gabbana dress festooned with *The Birth of Venus* to promote her single "Venus" in 2013, making her one of many women, real or imagined like the character Odette in Proust's *In Search of Lost Time*, to evoke the term "Botticellian."[38] Other reinventions have been less fashion-forward: in a dramatic instance of Botticelli's influence on modern art, in 1939 Salvador Dalí transmuted his Venus into a surrealist key, replacing her head with that of a fish.[39]

It's hard to believe that just six years later, in 1945, the eminent art historian Ernst Gombrich could observe, "The history of Botticelli's fame has yet to be written."[40] Or that, until the nineteenth century, *The Birth of Venus* had been out of public view, privately housed in a lush Medici villa for the first three hundred years of its life.[41] Once forgotten, Botticelli is now ubiquitous. As his recent curators put it, he is "one of a handful of artists whose works are instantly recognizable to a very wide and increasingly global public."[42]

In the surge of bodies surrounding *Primavera* and *The Birth of Venus* in the Uffizi, it can be easy to overlook the nearby *Cestello Annunciation* (Plate 1*), which Botticelli painted in 1489 for a Florentine monastery. The Annunciation theme is one of the

* *All plates are located in the color insert.*

most hallowed in the Renaissance, an inspiration to Leonardo, Raphael, Fra Angelico, and many others who immortalized the ineffable moment when the archangel Gabriel announced (hence the term *annunciation*) to the Virgin Mary that she was to give birth to Jesus. As marvelous as these other paintings are, none conveys the peculiar mystery of Botticelli's Virgin, who seems to be dancing—or at least swaying, her energy concentrated inward, her body in thrall to the divine message that has just been transmitted from Gabriel's fingertips to her own. If she were not fixed forever by Botticelli's brush, the Madonna would seemingly sashay out of the frame.

Mary's gracefulness has little of the spiritual about it. It is earthy and earthly, a hum of pleasure that we feel in the flesh, rather than contemplate in the mind. The angel has come to announce the coming of God. Botticelli has come to proclaim a different arrival. If ever an entire historical epoch could be conveyed in a single, simple gesture, here it was: Botticelli's annunciation of the Renaissance.

By painting his *Cestello Annunciation* in so sensual a key, Botticelli was depicting how the gods have come to earth, as he boldly (even heretically) suggested that secular life was an end in itself, not merely a preparation for Christian eternity. If anyone understood this, it was Lippmann. When he gazed at the Dante illustrations, he likely realized that Botticelli's drawings have little of the "medieval" about them, even though they interpret the world's most influential poem from the Middle Ages. Like the *Cestello Annunciation*, they exude secular joy while depicting a Christian poem that emphasizes the concerns of heaven and hell and the purgation of sin. In Botticelli's hands, Dante's muse Beatrice is nothing like the doctrinaire saint that *The Divine Comedy* makes her out to be. She is instead more like the pagan goddesses in *Primavera* and

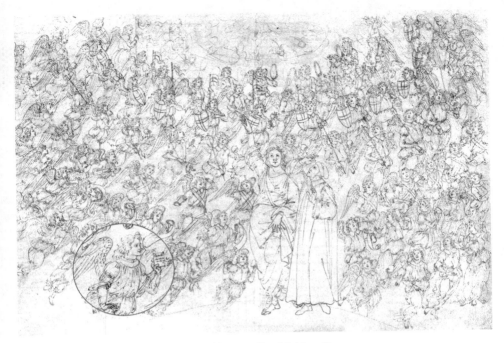

Botticelli, *Paradiso* 28 (detail).
bpk Bildagentur/Art Resource, NY

The Birth of Venus, or the dancing Madonna in the *Cestello Annunciation.* Dante's Beatrice came to save a soul; Botticelli's Beatrice was there to spread bliss. To behold the drawings was to witness the transition to a new historical era.

Lippmann was among the first to grasp how intimately bound up these Dante illustrations were with Botticelli's artistic vision. Not long after his visit to Ellis and White, he wrote of the drawings, "a careful study of their details confirms the belief that they were entirely executed by [Botticelli]. We recognize throughout the specific character of his art ... the peculiar sense of movement, the type of head, the somewhat melancholy expression of the features, the full lips, the

slight inward curve of the nose, and the rich folds of the floating draperies."[43] As if this internal evidence wasn't enough, on Botticelli's illustration of *Paradiso* 28, on a tiny tablet held by one of the throngs of angels, Lippmann observed that there "is inscribed in minute but perfectly legible characters: Sandro di Mariano."[44] For the first time, Botticelli, born Sandro di Mariano, had signed a work in his name and in his hand.

PART I

Infinite Disorder

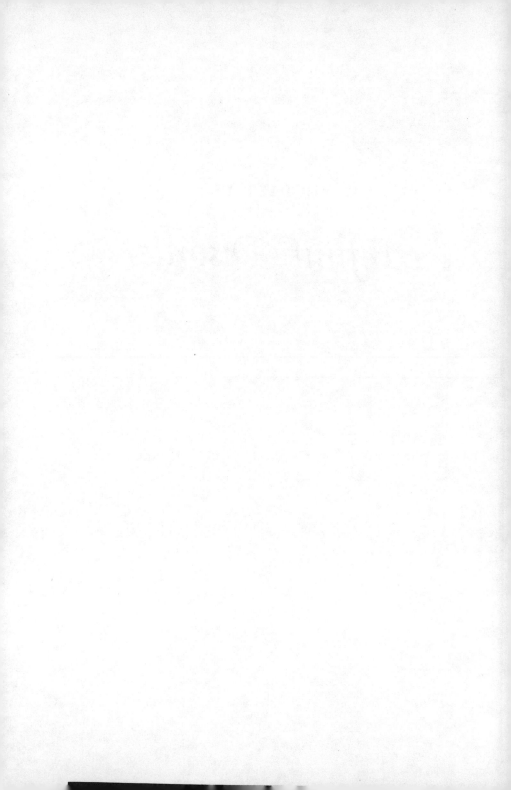

ONE /

The Pop Star

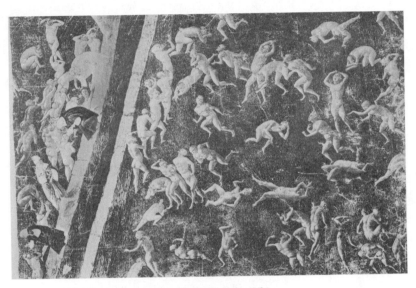

Botticelli, *Inferno* 15.
bpk Bildagentur/Art Resource, NY

Even the donkey-men sang the verses of Dante.
—JACOB BURCKHARDT

On May 1, 1274, supposedly, a young boy with dark curly hair and large thoughtful eyes joined his parents at a gathering of Florence's leading families to celebrate the arrival of *primavera*, spring.[1] The holiday was one of many that affirmed the city's growing—and increasingly combative—civic pride and sense of destiny. Created by Julius Caesar, the one-time remote military camp Florentia had now become Firenze, "blooming flower," a fitting name for one of the largest cities in Europe, with a population of nearly one hundred thousand, which had chosen the three-pronged lily as its cherished symbol.[2] Florence was also one of the world's wealthiest urban centers, as was clear from the grand setting where the boy and his fellow celebrants gathered. Folco Portinari's home stood in the heart of the original Roman city, close to the Cathedral of Santa Reparata on Florence's sacred axis, a consecrated block of Christian worship where one day its looming Duomo would rise. The house was paid for by Portinari's profits in banking, the nascent industry that, along with the wool and silk trades, would transform Florence into an economic juggernaut.[3]

The narrow cobblestone streets surrounding the Portinari estate would have been unusually quiet that day. Normally, they hummed with the clatter of looms weaving wool and silk into sumptuous garments and the rumbling of vendors' carts conveying goods to the city's open-air markets, while ringing

with the echoes of songs from servants and housewives washing clothes along the banks of the river Arno. But holidays meant rest for all in this socially stratified city, whether or not they were lucky enough to receive an invitation to the Portinari feast. Beckoned by such prestigious events, aristocratic women, often with their hair pulled back high upon their foreheads in the severe-looking style of the day, would emerge from the courtyards of their family towers and walk with heads raised and profiles turned, making eye contact with no one, accompanied by retinues of bodyguards who would shield them from the mud flung by wagons and the searching arms of beggars. Their homes seemed as unapproachable and impregnable as the women themselves: sandstone *palazzi* fronted by imposing gates and huge wooden doors, radiating the tension between openness and closure, cosmopolitanism and close-mindedness, that defined the city.[4] The writers and craftsmen of Florence would soon gain renown throughout Europe, but its collective gaze was always turned inward, especially when it came to rivalries among leading families like the Portinari. Disagreements and disputes could quickly escalate into bloody combat in the streets. The most prominent clans had turned their homes into private military bases, replete with their own militia and munitions, giving the city the look of a miniature Manhattan from a distance, as its fortified towers dominated the Tuscan skyline.

The dreamy boy's family lived near the Portinari in a much more modest setting. His *maggiori*, ancestors, descended from ancient Roman stock and included a warrior in the First Crusade. But if Folco Portinari was a distinguished *banchiere*, banker, the boy's father, Alighiero di Bellincione, plied a far less exalted, even scurrilous trade: moneylender. Even in Florence, this most mercantile and fiscally minded of cities and

the birthplace of modern banking, lending money at interest was against the law. Astute bankers like Portinari, and after him the Medici, found ways around the Christian ban on *usuria*, usury, by disguising their services with financial sleights of hand. Above all, bankers protected themselves by making generous civic donations, such as the Hospital of Santa Maria Nuova that Folco Portinari gave to the city, which remains its most important medical center. Minor moneylenders like Alighiero di Bellincione had no such public relations machine. After his death, he was allegedly buried *"tra le fosse,"* among the pits—a mass grave on unconsecrated ground reserved for heretics, moneylenders, and those too poor to afford an individual tomb.[5] But on a celebration like *Calendimaggio*, May Day, Alighiero's ancient stock and political allegiances—he and Portinari belonged to the same ruling party—would have guaranteed him and his son entry into the gilded circle.

The boy locked eyes with a beautiful girl. At the time, it was not uncommon for children of that age—they were both about nine—to fall in love and create a lifelong match out of a seemingly innocent early infatuation.[6] The girl's name cast an incantatory spell: "she who blesses." She was dressed in crimson and, like the other well-born girls at the party, her manner emanated restraint and decorum. One day she too would walk through the city like a female fortress, patrician and unassailable. If the girl felt something for the boy, she would never show it. The boy had no such sangfroid. The vision awoke something inside him, the sensation moving quickly from inchoate to overwhelming. His heart began to tremble violently, and he heard an inner voice announce, in the Latin of his school exercises, "Here is a god stronger than me, who comes to dominate me."[7] The ambient drinking, singing, and dancing must have receded into a blur. The boy's internal

drama culminated in an ominous phrase that felt as if it was being written on his heart, again in Latin: "Oh miserable me, what endless hindrance awaits!"[8]

For years after the party, the boy carried this enigma inside him, until one day, exactly nine years after the Portinari celebration, the girl of the blessings reappeared. He spotted her walking through the streets of Florence, accompanied by two other noble ladies; she had blossomed into a lovely teenager and was dressed in white. With the grace and tact appropriate to her social class, she turned in the direction of her admirer and signaled "hello" and "be well," which in Italian are the same word: *saluto*. The young man fled home to the privacy of his room and fell to weeping.[9] Later that night, she returned to him in his dreams. She was naked save for a crimson cloth draped over her body, and she was being carried in the arms of a formidable figure, a cross between a deity and a monster who ominously called himself Love. This prodigy held something burning in his hand: the young man's heart. The monster–god took the flaming organ and fed it to the limp, languid woman. She ate it slowly.

Thus did Dante Alighieri, son of the moneylender Alighiero di Bellincione, fall in love with Beatrice "the thrice-blessed" Portinari, youngest daughter of the banker Folco Portinari.

~

The birth of that love as narrated above comes mostly from Dante himself—and, as with most of the story of his relation to Beatrice, it is a mix of fact and fiction, dipped in mythmaking and hagiography, the writing of a saint's life. Yes: Dante and Beatrice were members of Florence's high society and could very well have interacted at a party like that fateful

May Day celebration. Yes again: class distinctions in a city of burgeoning wealth like medieval Florence were pronounced, and the physical layout of the city was more a network of elevated military fortresses, stacked side by side like massive dominos, than the expansive sundrenched piazzas filled with art that we see today. But that particular May Day event was an invention of Giovanni Boccaccio, who in his gushing *Brief Treatise in Praise of Dante* created a dramatic meeting of the two young lovers at a holiday that was in fact first celebrated sixteen years later, in 1290.[10] Dante himself established improbably precise patterns for these encounters with his beloved Beatrice: their paths would cross, like clockwork, every nine years, per the breathless plot of the *Vita Nuova*, or *New Life,* Dante's memoir of his youthful love for this aristocratic maiden. All told, Dante's story of Beatrice combined legend and reality to a dizzying degree that would have made Vasari proud.

But the liberties and even distortions in Dante and Boccaccio do not obscure the reality of what actually transpired between these two young Florentines: Dante did in fact meet his future muse while they were still children, he did fall under her spell for what would be his entire career, and their meetings did inspire the most impactful poetry in the history of Italy. We can think of the imaginary May Day encounter in Aristotle's terms: history, he claims in his *Poetics,* tells us what happened, gives us the specific and contingent. But poetry tells us what could have or should have happened, through imaginative universals that reveal a more general "truth" than a mere report of events.[11] Some elements of Dante's first meeting with Beatrice and the birth of their love may have been "made up," but they resonate nonetheless with genuine feeling and consequence. In Dante's own words, the scene is an exam-

ple of a *non falso errore*—an error that was invented but not false. Ultimately, it is a testament to the literary imagination's capacity to go beyond rational cognition in discovering hidden realities.[12]

The love between Dante and Beatrice, real or imagined, was unrequited in our modern sense of the word. In the Middle Ages, a sign of true love was that you did *not* have sex or physical contact with the object of your affection. In a book dear to Dante and his circle, *The Art of Courtly Love* by Andreas Capellanus from around 1190, marriage is described as a strictly contractual arrangement between husband and wife that centers on practical concerns: producing heirs, obtaining a dowry, elevating social standing. Love for the unattainable woman taught virtue and lifted the soul. Turning love into sex was the equivalent of reducing the most sublime emotion to the tyranny of the body and its unslakable desires. Better to have loved and never touched than to have physical consummation. The cobblestone alleys of medieval Europe were no place for the proverbial "walk of shame." And it was difficult for even the age's most sensitive spouses to conjure romantic thoughts when wedding contracts enumerated passion-crushing items like socks and buttons.[13]

In keeping with her high standing, Beatrice married the banker Simone Bardi in 1287, bringing a substantial dowry to their union. That same year, Dante's wife, Gemma, to whom he had been engaged since age twelve, may have given birth to their first child, a son, Giovanni, whose identity remains a mystery.[14] Gemma would go on to bear three more of Dante's children and stand devotedly by him for the twenty years of his exile. Yet she never appeared in a single line of his work. Meanwhile, Beatrice, or Bice as she was known by her more familiar and less exalted nickname, died tragically young in

1290, at the age of twenty-four. Though she and Dante never touched, and laid eyes on each other only a few times, she helped inspire the 14,233 lines that many consider to be the greatest literary work ever written: *The Divine Comedy.*

~

Just a few years before his death at age fifty-six in 1321, the one-time boy with the dark curls and large thoughtful eyes wrote these words:

> If it should happen . . . If this sacred poem—
> this work so shared by heaven and by earth
> that it has made me lean through these long years—
> can ever overcome the cruelty
> that bars me from the fair fold where I slept,
> a lamb opposed to wolves that war on it,
> by then with other voice, with other fleece,
> I shall return as poet and put on,
> at my baptismal fount, the laurel crown.[15]

This passage from *Paradiso* 25 calls for listening as much as reading. To hear its words in Tuscan is to experience Dante's voice at its most intimate and revealing. He calls the city where he met Beatrice, Florence, the *bello ovile*, the "fair sheepfold" where he slept as a lamb, in hummingly soft *l* and *v* sounds that evoke the tenderness of his feelings and the vulnerability of a man who will never return to the place he loves most. He describes how the labor of writing his poem has cost him his health, each word marking a painful distance between him and his homeland that not even his faith can heal. Dante wrote the passage while languishing in political exile in Ravenna, some hundred miles from Florence. In *Paradiso* 25, the nor-

mally reticent, tough-minded poet let down his guard to describe the lacerations of exile, releasing in one exhale his pent-up nostalgia for Florence, even though he spent much of his life skewering its corruptions and injustices.

The words are a history in miniature of what transpired between Dante's legendary meeting with Beatrice in 1274 and his writing of the masterpiece she inspired. *The Divine Comedy* begins with Dante's rescue from the *selva oscura*, the "dark wood" of earthly sin, by the ghost of Beatrice, who collaborates with no less a benefactor than the Virgin Mary to intercede on his behalf. Beatrice may be Dante's spiritual guide, but the poet's most visceral connection is to his lost city. By the time he wrote *Paradiso*, Dante knew that he had achieved something extraordinary. Others did as well. Portions of *The Divine Comedy* had begun to circulate in manuscript form while Dante was still alive. In 1319, the scholar Giovanni del Virgilio invited Dante to come as honored *poeta* to Bologna, home to Europe's first university in 1088 and a major intellectual center. In short, it was quite the honor for an aging author enduring the ignominy of exile. But Dante politely declined: as *Paradiso* 25 shows, only in Florence would Dante *prende 'l cappello*, assume the laurel or poet's crown, in the shadow of the Baptistery where he had been christened in 1266.[16] By calling his work a *poema sacro*, sacred poem, Dante anticipated the glory that would come his way. He was correct: a few centuries after he completed what he called simply his *Comedìa*, a Venetian printer insisted that the word *Divina* be added to the title page.[17]

The tag stuck but the divinity was hard-won. Like his father and Beatrice's father, Dante was a Guelph, one of the two leading parties in Florence. After their mortal enemies, the Ghibellines, nearly wiped out the Guelphs at Montaperti in 1260, the Guelphs rallied to rout the Ghibellines in 1289 at Campaldino—a decisive battle in which the twenty-four-year-

old Dante took part as a cavalryman, experiencing the horror of hand-to-hand combat and perhaps even killing an enemy—thus giving them control of the city's affairs.[18] Afterward, Dante rose within the ranks of the Guelphs, becoming in 1300 one of the city's six priors, the highest elected office in republican Florence. He had published the *Vita Nuova* in 1295 and dedicated the work to his mentor, Guido Cavalcanti, a brilliant, dashing nobleman whom Dante called his *primo amico*, best friend. But Dante's time at his city's literary and politic apex would be short-lived, and he would later claim that his ascension to the position of prior marked the beginning of his personal calamities.[19]

While Dante was prior, the Guelphs splintered into rival factions. Though the party was traditionally pro-pope, Dante's White Guelphs opposed papal influence in Italian affairs. Meanwhile, the Black Guelphs continued to support the papacy, while adopting a more agressively militant stance than the Whites against their common Ghibelline adversaries. Dante's opposition to the papacy made him the worst possible enemy: the mighty Pope Boniface VIII. While Dante was on a diplomatic mission to the Vatican in 1301, the Black Guelphs outmaneuvered the Whites to gain power. Sensing an opening, the ruthless Boniface had Dante detained in Rome while his opponents in Florence plotted revenge. The edict that would forever change Dante's life—and the course of literary history—was issued on March 10, 1302:

> Alighieri, Dante is convicted for public corruption, fraud, falsehood, malice, unfair extortion practices, illegal proceeds, pederasty, and is sentenced to a fine of 5,000 florins, perpetual disqualification from public office, permanent exile (in absentia), and if detained [in Florence], condemned

to death at the stake, so he will die.[20]

The hyperbole and trumped-up charges reflect the bloody tenor of the age's politics: the proud, short-tempered Dante had his faults, but he was also known for his honesty and probity, and there is certainly no record of him ever being a pederast. Exile would make him, in his own word, *macro*, lean from hunger and want, as he ranged throughout the Italian peninsula looking for a home and a way to earn his bread—literally and figuratively.[21] The first years of his exile were passed close to Florence, in hopes that he would be able to return to his beloved city. Dante met with former enemies and plotted ways to regain his lofty political status and restore his good name. This period, from around 1302 to 1305, was the lowest of his life. His ideals compromised, his energies sapped by the chaos surrounding him, he was unable to write lasting poetry. He may even have contemplated suicide—though he somehow managed to produce major philosophical and scholarly works in this dark period.[22]

Early in his exile, Dante could not conceive of a life outside Florence. The city was not just his home; it was his identity. Only when he let go of his fair sheepfold, accepting once and for all that his exile was definitive, could he begin to write his magnum opus. After 1305, Dante's wandering intensified: Pratovecchio Stia, Forlì, Verona, and Ravenna were just a few of the many stops in the decade and a half, and hundreds of miles of wandering, it took him to complete the *Commedia*, which he likely began around 1306.

The fallout from exile permeates the poem. In *Inferno* 10, Dante meets the Florentine patriarchs who burn in hell because of their heretical Epicurean belief that *l'anima col corpo morta fanno,* the soul dies with the body.[23] Among the

sinners is the father of his *primo amico*, Guido Cavalcanti, who asks chillingly, *"mio figlio ov'è?"* ("where is my son?").[24] As prior in 1300, the White Guelph Dante had actually signed an edict banishing Guido, a Black Guelph, for his radical politics. Guido contracted malaria during his exile, dying shortly thereafter. When Dante uses a past tense verb to describe Guido, his devastated father assumes the worst and thinks his son is dead. After Dante inexplicably hesitates to convince him otherwise, Guido's father falls back into his burning tomb, "showing his face no more."[25] Later, in *Paradiso* 17, Dante will meet his ancestor Cacciaguida, a medieval Florentine of ancient Roman descent who predicts Dante's exile, saying that he will learn "how salty is the taste of another man's bread"—which sounds like a gorgeous metaphor, but is in truth a bald statement of fact: Dante and his fellow Florentines were accustomed to the taste of unsalted bread, probably because their rival Pisa had long charged them prohibitively for salt.[26] The diet of exile would indeed be bitter for this lost son of Florence.

Before Dante encounters the ghost of his best friend Guido's father in *Inferno*, he meets another Florentine leader, the formidable Farinata, a decorated general who stands so proudly that "he seemed to hold all of hell in scorn."[27] A Ghibelline, Farinata sneers to Dante, "[The Guelphs] were ferocious enemies / of mine and of my parents and my party, / so that I had to scatter them twice over."[27] Dante doesn't skip a beat in returning the insult: "If my kind were driven out . . . / they still returned, both times, from every quarter; / but your people were never quick to learn that art."[28] The infernal trash talk reveals a trait familiar to anyone who has spent time among the Florentines: their knack for the verbal takedown, especially when it comes to a local rivalry or turf war that can

go back centuries—and especially when it involves their most famous native son, Dante. In 2008, Florence finally rescinded the ban that exiled Dante with a city council vote of 19 for and 5 against.[29] Even in this act of delayed reparation and clemency, the vote was not unanimous. Little wonder that the notoriously *polemici*, polemical, Florentines are renowned for their capacity to nurse a grudge. All told, it took Florence 706 years to welcome Dante back home. But in truth he never left.

*T*he *Divine Comedy* became a staple of cultural life from the moment Dante died in 1321 in Ravenna, where to this day his corpse remains interred—much to the chagrin of Florence.[30] The scholarship on the *Commedia* began, in typically nepotistic Italian fashion, with Dante's son Jacopo going into the "family business," producing a commentary on the *Inferno* that is still a gold mine for researchers.[31] Dante's work soon became part of the school curriculum in Florence, and there was such heavy demand for manuscripts of the *Commedia* that they began to be mass produced.[32] One particularly industrious copyist, Francesco di ser Nardo da Barberino, was rumored—we now know falsely[33]—to have padded his daugh-ters' dowries by undertaking a herculean *gruppo del Cento,* no fewer than one hundred manuscripts of the *Commedia* in his own hand.[34] Dante was as much talked about as read, his epic so popular that it no longer even went by its original name. Most Florentines simply began calling it "the Dante."

The majority of the poem's early readership comprised the professional class: lawyers, bankers, merchants, scribes, and other bibliophiles who had the resources and education to collect manuscripts and commit Dante's lines to memory.

Another important early group of readers were notaries, who often took time out from their official duties to annotate their documents with marginal comments on *The Divine Comedy*.[35] The rise in Dante's popularity coincided with an outpouring of scholarly activity in Florence, as the city became the center of European humanism—the cultural movement that veered away from medieval religious thought and championed the previously oft-reviled pagan cultures of ancient Greece and Rome.[36] The city became, in the words of Jacob Burckhardt, "completely swamped with humanists. There was then, we are told, nobody in Florence who could not read; even the donkey-men sang the verses of Dante."[37] The Swiss scholar was embellishing: not all could afford the luxury of books and schooling even in prosperous and cultivated Firenze.[38] But from lowbrow to highbrow, from the streets to the libraries and from the donkey-man to the nobleman, Dante had become an icon. And not just in Florence. Before the first printed edition of the *Commedia* appeared in the late fifteenth century, a whopping number of eight hundred manuscripts circulated throughout Italy.[39]

Dante mania peaked in the summer of 1373, when a group of Florentine citizens drafted a petition calling for the establishment of a lecture series meant to instruct audiences in the world and work of their *Sommo Poeta*, Supreme Poet.[40] The initiative was almost unanimously supported—except by self-proclaimed enemies of poetry and, understandably, those whose families Dante had assigned to hell in his *Inferno*. The wording of the commission suggests the scope of Dante's prestige:

On behalf of the several citizens of Florence who wish, as much for themselves as for other virtue-seeking

Florentines and for their posterity and descendants, to be instructed in the book of Dante (from which even the unlearned may receive instruction on the avoidance of vices and the acquisition of virtues), it is respectfully proposed that you, the honourable Guild Priors and Gonfalonier of Justice of the People and Commune of Florence . . . provide and . . . arrange for a worthy and learned man . . . to offer lectures . . . on the book commonly called "the Dante" [the *Commedia*] to all who may wish to hear them.[41]

The man chosen to deliver the inaugural lectures was nearly as famous as his subject: Giovanni Boccaccio, author of the *Decameron* in 1353, a collection of one hundred short stories narrated during the Black Death of 1346–53 and often described as Italy's "Human Comedy," the secular complement to Dante's divine epic. The public lecture series was the first time that anyone would be paid to speak on Dante—and paid handsomely, to the tune of 100 gold florins, a sum that would cover the expenses of a bourgeois household for a full year.[42]

But Boccaccio had his reservations. Not everyone in his learned—and often snobby—circle was thrilled with the idea of his speaking about a subject as fine as epic poetry to what some dismissively called the "rabble." Then there were the more pious, who took issue with the idiosyncratic, even heretical religious views of *The Divine Comedy*, which had the chutzpah to self-nominate a regular Florentine citizen (Dante himself) for the upper reaches of Christian heaven. Boccaccio, who came to be known as a scandalous author and bon vivant,[43] was actually a distinguished scholar and a devout man of God by the time of the lecture series. He regretted the more sensuous literary sensibilities of his youthful, intensely

bawdy *Decameron*, a work filled with licentious nuns, randy priests, and nonstop fornication—including the tale of a monk who convinces a pious beauty to have sex with him by telling her that he is only trying to "put the devil back into hell" each time he enters her.[44] By 1373, Boccaccio had come to believe that poetry was a "stable and fixed science, founded and anchored on eternal principles," and not something to be shared, as his most esteemed mentor had ominously warned him in a letter, "*inter ydiotas in tabernis et in foro*," among idiots in the tavern and the marketplace.[45] But the aged and unhealthy scholar, now suffering from morbid obesity and a slew of other ailments, needed the money. So he accepted the invitation, grudgingly.

Despite Boccaccio's misgivings, it's hard to imagine anyone better suited for the task. A fellow Tuscan born in 1313, just a decade before Dante's death, Boccaccio was related to Dante's muse Beatrice Portinari through his father's second wife, and his education and travels brought him into regular contact with people who had known the living Dante.[46] His *Brief Treatise in Praise of Dante* from 1351–55 transformed the elements of the poet's life into legend and proposed that his poetry was divinely ordained. Boccaccio wrote that when Dante's mother was pregnant with him, she dreamt that she was beneath a "lofty laurel tree" (the symbol of poetry), where she delivered a son "who in shortest space, feeding only on the berries which fell from the laurel tree," morphed into a shepherd and then a peacock.[47] In Boccaccio's words, God Himself granted to the Florentines a man like Dante, "who was first to open the way for the return of the Muses, banished from Italy."[48]

And so, on October 23, 1373, just a half century after Dante's death, the portly Boccaccio took to the podium for the first in his series of lectures on *The Divine Comedy*. The setting was the

chapel of Santo Stefano, next door to the abbey where Dante had grown up listening to monks singing in Latin Gregorian chant. The audience included merchants, tradesmen, artists, and artisans as well as scholars and fellow authors, all gathered to hear Boccaccio give, in his own words, "the exposition of an artist text, of multitudes of stories, and of sublime meanings hidden beneath the poetic veil of Dante's *Comedy* . . . [to] men of keen understanding and admirable perspicacity."[49] The schedule was punishing, especially for someone in Boccaccio's unhealthy state. He was to speak almost daily and cover all of Dante's one hundred cantos in a few short months.

But after giving an already exhausting number of sixty lectures, yet making it only as far as *Inferno* 17, Boccaccio fell ill. In January 1374, just a few months after the series began, it was suspended.[50] By that spring, Florence was gripped by a successive wave of pandemic, set off by the Black Death of 1346–53, which claimed thousands of lives and canceled out any possibility of resuming the lectures once Boccaccio recovered.[51] He never did. In 1375, Boccaccio died, abruptly ending the most promising early chapter in Dante's Florentine afterlife.

It was more than bad luck and ill health that spelled the end of this first live presentation of Dante's work. Even though he accepted the invitation, Boccaccio's misgivings never dissipated. He had grown increasingly susceptible to criticism from fellow humanists averse to the supposedly vulgar idea of a public event that dared to teach the sublimities of Dante's verse to the uninitiated—and, in the eyes of many of Florence's literary lions, unwashed. There were also attacks on Dante by theologians like Guido Vernani, who called Dante an emissary of the devil. Criticisms of Dante were so fierce that Boccaccio felt relieved when the series was halted. He came to see his sick-

ness as divine punishment for having taken on the lectures in the first place.[52]

The aborted series signaled a turning point in Dante's reputation. He continued to enjoy celebrity status, especially in Florence, and Boccaccio's talks set off a flurry of similar initiatives throughout Italy. Public readings of *The Divine Comedy* were established in Bologna, Ferrara, Venice, Pisa, and Siena, among other cities, between 1375 and 1400.[53] The series was even reestablished in Florence in 1391, with the honor going to the scholar Filippo Villani, the son of Florence's most acclaimed early historian, Giovanni Villani. But many, especially among the learned, remained less than hospitable to Dante's ghost. Ironically enough, the greatest challenge to Dante's popularity and prestige (a rare combination in the high-minded world of Florentine culture) would come from one of Boccaccio's closest friends—a fellow humanist who figuratively hovered over Boccaccio's lectures in Santo Stefano like a scolding spirit.

At that time, the most celebrated writer in Italy, indeed in all of Europe, was Francesco Petrarca, or Francis Petrarch in anglicized form. Petrarch was born to a Tuscan family that, like Dante's, would be forced into political exile. Dante was actually friendly with Petrarch's father and likely met the young Francesco when he was a boy. More than a few scholars have conjured the image of a wizened Dante bouncing the young Francesco, his literary heir apparent, on his knee. Like Dante, Petrarch spent most of his adult life in exile. But the link between the two emphatically ends there, mostly because of Petrarch's willful desire to cut any tie that might link him to the man whose massive cenotaph in Florence's Piazza Santa Croce now reads—presumably to Petrarch's post-mortem chagrin—*onoratissimo poeta*, most honored poet. Whereas Dante's exile was bitter and fretful, a story of constant move-

ment and struggle, Petrarch's was cushy. He lived in the French Provençal village of Vaucluse, a gorgeous area carpeted with fields of lavender, and traveled extensively both at his leisure and at the behest of one enticing invitation after another. His skills as a diplomat, courtier, and scholar were coveted by the most powerful patrons and politicians in Europe. His life was similar to that of a distinguished (and tenured) professor of the humanities who is often invited to prestigious international postings, rather than the Dantesque lot of the scrambling political exile fighting for his life and livelihood, condemned to salty bread far from Florence. If Petrarch was decorated and emeritus, Dante was itinerant and adjunct.

Petrarch took religious orders early in his career and enjoyed a steady income as a prelate, along with plenty of time to pursue his literary interests. Like Dante, he wrote in the Tuscan vernacular, even while living in France. But their poetry was as different as their personalities: Dante's surging language reflected the urgency of his religious and moral vision as well as the raw emotions of a man who had lost everything. Petrarch's refined, elegant verse affirmed his scholarly detachment from human affairs and rang with the steady hum of pleasure, dipped in intellectual melancholy, of a life devoted to solitude and learning. When Dante died in 1321, Petrarch was still a teenager and had yet to rise to literary heights, so Dante never wrote a word about the man who would become his principal posthumous rival. But comparing the two men became a literary ritual for later writers like the Italian poet–patriot Ugo Foscolo, who saw in them competing models of human nature: the spiritual striving of the pre-modern Dante versus the worldly complexities of the all-too-modern Petrarch.[54]

When Petrarch was forty-six and already a celebrity, he received among his fan mail a Latin epistle set in poetic meter

and bursting with fulsome praise from an aspiring writer only nine years his junior, named ... Boccaccio. Always susceptible to flattery—and good Latin—Petrarch answered in kind, and the two agreed to meet that fall, when Petrarch was on his way to the Jubilee of 1350 in Rome. Boccaccio anticipated the encounter breathlessly, having worshiped Petrarch from afar for fifteen years, describing him as a *"vir illustris,"* illustrious man, in his laudatory Latin biography, *De vita et moribus domini Francisci Petracchi de Florentia* (On the Life and Habits of Master Francis Petrarch of Florence, 1341–42).[55] The two hit it off. Petrarch stayed on as Boccaccio's guest in Florence for a few days, enough time to meet other Florentine admirers. When he left, Boccaccio presented him with a parting gift: a ring.

The shiny object symbolizes their decades-long relationship: Boccaccio was the courtier and Petrarch the courted. Theirs would be a friendship of genuine affection and reciprocal warmth. But it would not be without its tensions, especially when it came to Dante. As renowned as Boccaccio would become after that first meeting in 1350 (his *Decameron* was published just a few years later), he would always play a supporting role to Petrarch, who accepted him into Italy's first literary triumvirate but assigned him a distant third place—after Dante and, of course, Petrarch himself.[56]

In 1359, fourteen years before his Dante lectures, Boccaccio sent Petrarch an edition of the *Commedia* that he had copied by hand. The magnificent manuscript was one of the three that Boccaccio produced in his lifetime, and he also illustrated an edition of *The Divine Comedy.* Along with the handwritten volume, Boccaccio included a collection of fifteen sonnets by Dante, the first edition of his *Brief Treatise in Praise of Dante*, and a Latin poem praising Petrarch as the savior of "Our Italy." When it came to gifts, Petrarch would have preferred that Boccaccio stick with rings. "If my many concerns

were not so pressing," he wrote back snarkily in a letter, "I might even strive to the best of my powers to rescue [Dante]."[57] As ever, his intent was to make Dante old news. He categorized him as a mere "dialect" love poet, linking him with such nonentities as the now-forgotten Guittone d'Arezzo. The irony is profound. Petrarch was trying to position himself as the great Italian epic poet, author of the long-winded Latin poem *Africa*, on the Second Punic War and the Roman general Scipio Africanus, the work that would supposedly make him Virgil's heir.[58] But this pedantic epic was a flop, and the text that did make Petrarch famous, his verses to Laura, was precisely that same love poetry in the Tuscan dialect that he derided in Dante.

Petrarch's constant belittling of Dante began to work its dark magic. In Boccaccio's second edition of his *Brief Treatise in Praise of Dante* from the 1360s, he was far less enthusiastic than in his first version from the decade previous. He omitted his claim that Dante had restored the muses to Italy, and Dante was no longer the Florentine Homer and Virgil. Instead, following Petrarch's cue, Boccaccio demoted him to the status of poet laureate in the humble dialect, someone who essentially wrote for lowly readers disdained by Petrarch as "woolworkers and innkeepers."[59] Many working-class Florentines knew the verses of *The Divine Comedy* the way that teenagers today know the lyrics of pop songs. But for Petrarch, Dante's cult status was a sign of his literary uncouthness: Petrarch was indeed that "esteemed mentor" who had asked Boccaccio how "idiots in the tavern" could appreciate poetry, an implicit slight of popular writers like Dante. Petrarch thought that literary language should be for the educated few, not for mass consumption. He was not alone. A fellow devotee of his cult of Latin antiquity, the humanist Niccolò Niccoli, contemptuously remarked that

Dante was the poet for "shoemakers and bakers," his work best suited for "grocers to wrap up salted fish."[60]

Dante believed the opposite: his point that poets writing in the "illustrious vernacular" preserve what is lasting in everyday speech is one of the most innovative in his groundbreaking study of the Romance languages, *On Eloquence in the Vernacular*.[61] Boccaccio wavered somewhere in the middle, caught in the titanic struggle between Petrarch's ego and Dante's legacy. He understood that the new Italian literary tradition had to be as robust, energetic, and experimental as Dante's and as refined, musical, and erudite as Petrarch's. But Boccaccio's fragile ego—and youthful devotion to Dante—was no match for the man whom he worshipfully called in Latin *dominus Franciscus Petraccus*, Master Francis Petrarch.

For Boccaccio, as for many others, the choice between Petrarch and Dante wasn't just about books. It was a struggle for the soul. For Dante, poetry was tied to revelation and intimately bound to theology. In his view, Beatrice was indeed what her name suggested: the giver of blessings. Not so for Petrarch. Though an actual person, the muse of the love poetry that brought him fame, Laura, was more artifice, a poetic code that could be assembled, disassembled, and reassembled as the occasion called for. In one poem, her name assumes a dizzying range of meanings, from "laudible" and "regal" to "praise" and "reverence," all of whose Italian roots can be derived from the word *Laura*.[62] For Dante, God was no less than the Supreme Poet: *The Divine Comedy* ends with a vision of the universe as "*un volume legato con amore*," a book bound together by love.[63] For Petrarch, poets may be godlike in their creative powers, but in the end they are eminently human, with all the flaws and limitations that this distinction implies. As for his faith, Petrarch professed to be a devout Christian and dedicated

his poems about Laura to the Virgin Mary. But beyond these official declarations, he was also a man constantly plagued by spiritual doubts—the central theme of *My Secret Book*, his mix of self-involved neurosis and stunning emotional insight.

By the time of Petrarch's death in 1374, the year of Boccaccio's last Dante lecture, the tide of public opinion had begun to turn against Dante. He was still adored by the broader literary public, but many of the more educated hankered after the literary elegance and sustained reanimation of ancient Roman and Greek culture in Petrarch.[64] Boccaccio himself had steadily and inexorably drifted away from the vigorous Tuscan dialect of his *Decameron*, a work deeply influenced by Dante, into a literary career devoted exclusively to learned Latin works.

In 1436, a Petrarchan protégé, the Florentine humanist Leonardo Bruni, authored a *Life of Dante* that rejected the Dantesque mythmaking of Boccaccio's first edition of his *Brief Treatise in Praise of Dante*. In reaction to the "loves and sighs and burning tears" in Boccaccio's biography, Bruni emphasized Dante's studiousness, civic-mindedness, and public life. He concluded with a comparison between Dante and his successor as Italy's supreme author, Petrarch:

> Petrarch was wiser and more prudent [than Dante] in choosing the quiet and leisurely life than in working in the Republic and amid its disputes and civic factions. For these often lead to one's being driven out by the wickedness of men and ingratitude of the people, as happened to Dante.[65]

Biographies of Dante continued to proliferate, but the verdict was in. The more rarefied verse of Petrarch became the literary gold standard and the term *Petrarchism* was born. Dante

certainly retained a high position, especially in Florence. But the momentum was shifting in Petrarch's direction and would remain with him throughout the Renaissance.

A lot more was at stake in the rivalry between Dante and Petrarch—or more accurately, Petrarch's ongoing antagonism with Dante's ghost—than cultural prestige. Underlying this quest for literary supremacy was the relation between artistic creation and religious faith. For Dante, from the moment he set eyes on Beatrice in 1274 until his death in 1321, the two, art and religion, were inseparable: to write poetry and to love God were mutually reinforcing. For Petrarch, literature was instead a refuge in a world of uncertainties, from the secular to the spiritual. By the time of Petrarch's heyday, the animating principle of Dante's poetry, its belief in the world as God's poem, was being called into question.[66] With Petrarch, a modern idea of art was born just as an older version of God—and with it, Dante's legacy—started to recede.[67]

~

Though Dante's spirit began to struggle for a home among Italy's scholars and intellectuals, its poets and artists continued to welcome him with open arms. In the Florentine author Franco Sacchetti's *Il trecentonovelle*, a collection of "three hundred short stories" that appeared in 1399, soon after Boccaccio's lectures, one tale finds Dante winding his way through the streets of Florence on his way to attend to a legal matter, when he happens upon a blacksmith who "sang from Dante's poem as one sings a song, and he so jumbled his verses, clipping here and adding there, so that he seemed to Dante to be doing him a very great injury."[68] The image of a lowly workman chanting Dante's epic poem from memory in

the streets confirmed Petrarch's prophecy: Dante had indeed become the cultural go-to for the tavern drunkard and his social equivalents. Meanwhile, the literary persona of Dante himself had fully emerged with characteristics that we recognize to this day. In Sacchetti's story, Dante was reputed to be a cool, cutting customer, so he said nothing to the smith. Rather, he calmly walked over to his forge, grabbed his tools, and threw his hammer into the street. The bewildered blacksmith asked, "What the devil are you doing? Are you mad?" Dante answered, "If you don't want me to spoil your things, don't spoil mine."[69]

The story distills the ferocious *ingegno*, quick wit, associated with Dante, while revealing how his poem permeated the public spaces of Florence. Sacchetti narrates a similar story that finds Dante, once again, walking through Florence and encountering a donkey-man, basically a garbageman collecting loads of waste. The donkey-man was "singing out of the book of Dante," and "when he had sung a piece he struck his animal, and cried, '*Arri!*'"[70] Dante was none too pleased when he heard the garbageman say "Heel!" (*Arri!*) to his beast, as though this grating sound was part of *The Divine Comedy,* so he walked over and gave him a sharp blow, saying, "I did not put that 'arri' in my book."[71] The donkey-man did not recognize Dante and drove on, then turned and stuck out his tongue mockingly, saying to Dante, "Take that!" Dante registered the insult and, once again thinking quickly, sneered to the man, "I would not give one verse of mine for a hundred of yours."[72]

Sacchetti's most telling story involves the poet Maestro Antonio da Ferraro. A gambler and sinner, he embodied the Italian trait of *furbizia*, cunning or street smarts. After a day of gambling losses, Antonio found himself in a church

in Ravenna and noticed that there was a cluster of candles before a crucifix just a few paces away from Dante's tomb. From either reverence or mischief—probably a combination of both—Antonio did something heretical, transferring all the candles from the crucifix to Dante's tomb. Brought to account for this sin by the people of Ravenna, he explained his seemingly impious action thus:

> Look at the writings of one [the Bible] and the other [Dante]. You will conclude that those of Dante are a wonder of nature and the human intellect, and that [in contrast] the gospels are stupid. And indeed, if those gospels contain anything high and wonderful, it's not surprising, since He who sees everything and has everything [God] should express Himself in that manner. But what's more remarkable is that Dante, a mere man . . . has nevertheless seen all and written all. . . . So from now on I'm going to devote myself to him [instead of God].[73]

The words may drip with ironic mockery, but the sentiment Antonio expresses is real: for him and many other Italians, from the lowborn and uneducated to the noble and learned, Dante had come to be seen as a "wonder of nature and of the human intellect," his *Divine Comedy* a preferable alternative to the word of God. Though a "mere man," Dante somehow had "seen all and written all." For Antonio and Florence's donkeymen, to meditate on *The Divine Comedy* was to reflect on the divine itself.[74]

TWO /

Bottega *to Brand*

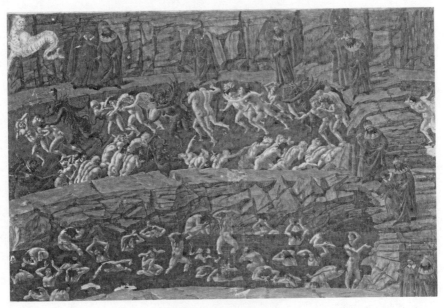

Botticelli, *Inferno* 18.
bpk Bildagentur/Art Resource, NY

Il suo famigliarissimo Dante...
The Dante he knew most intimately...

—VASARI ON MICHELANGELO'S

FAVORITE AUTHOR

round the time that an imagined Dante was
haranguing a blacksmith and garbageman in Franco
Sacchetti's stories, Florence's leading artists and
architects prepared to compete for what would be the greatest
prize in a generation. Long before the swollen Duomo would
rise up to define the Florentine skyline, the Baptistery was
the spiritual heart of the city. Dedicated to Florence's patron
saint, John the Baptist, it was where all Florentine citizens—
including Dante—received the sacrament of baptism. In 1401,
the city's powerful cloth merchant guild, the Arte di Cali-
mala, announced a competition to complete the Baptistery's
two remaining doors, the first having been designed by the
noted architect Andrea del Pisano. The massive doors were to
be made of bronze and would be the first prominent work in
Florence cast in that costly metal. The prestige of the build-
ing, combined with the deep pockets of the Calimala and the
splendor of the Baptistery's existing art, were enough to make
Florence's artists salivate.[1]

The Calimala announced that the competition was open
to "skilled masters from all the lands of Italy," and eventually
that wide field was whittled down to three finalists, who were
invited to submit models depicting the biblical scene of Abra-
ham's near sacrifice of his son Isaac: Filippo Brunelleschi,

50

his friend Donatello, and an obscure young goldsmith from the tiny Tuscan town of Pelago, Lorenzo Ghiberti.[2] Then, according to Vasari, in a heroic act of team spirit Brunelleschi and Donatello "decided that only Lorenzo's [model] was satisfactory, and they agreed that he was better qualified for the work than they. . . . So they approached the [judges] and argued persuasively that the commission should be given to Lorenzo . . ."[3]

Vasari's notional split decision was hardly how Ghiberti himself saw it:

To me was conceded the palm of victory by all the experts and by all those who had competed with me. To me the honor was conceded universally and with no exception. To all it seemed that I had at that time surpassed the others without exception, as was recognized by a great council and an investigation of learned men.[4]

Brunelleschi's biographer Antonio Manetti offered yet another perspective. After essentially accusing Ghiberti of colluding with jurors while preparing his model, Manetti wrote that the hung jury couldn't decide between Ghiberti and Brunelleschi, and so offered them the commmission jointly. But the irascible Brunelleschi would have none of it:

When Filippo and Lorenzo were summoned and informed of the decision, Lorenzo remained silent while Filippo was unwilling to consent unless he was given entire charge of the work. On that point he was unyielding. The officials made the decision thinking that certainly they would in the end agree. Filippo, like one who unknowingly has been destined for some greater tasks by God, refused to budge.[5]

Manetti's image of a larger-than-life and prodigiously self-confident Brunelleschi reveals that Vasari wasn't the only Renaissance historian prone to mythmaking. Whatever the actual case, the commission did in fact go to Ghiberti alone, and Brunelleschi proceeded to leave Florence and spend the next fifteen years in Rome with his sidekick Donatello, studying ancient forms and nursing his grudge as only a high-spirited Florentine could.

So what really happened? All three accounts contain partial truths. As Vasari and Manetti wrote, the jury very likely was divided between the equally magnificent panels submitted by Ghiberti and Brunelleschi, and it is plausible that such an important project could have been jointly assigned to the two young and inexperienced goldsmiths (Brunelleschi was twenty-four and Ghiberti twenty-three).[6] It's also difficult to argue with Ghiberti's boastful claims about the quality of his model and its effect on the jurors, as he eventually completed a work of such astounding beauty that Michelangelo would dub it the "Gates of Paradise." Yet each of the three accounts also contains distortions, if not outright lies: the competitors were hardly as virtuous as Vasari made them out to be, Ghiberti was probably not the categorically triumphant winner his self-promotional account proclaims, and Manetti's fulsome elegy of the high-minded Brunelleschi comes across as partisan. Taken together, the divergent narratives all point to one thing: the intensely communal and interactive nature of artistic life in Florence. As brutally competitive as the contest for the Baptistery doors was, it reflected the artistic ferment taking place in the city, which had become home to an astonishing number of brilliant craftsmen and creators all vying to make their names and earn their fortunes through the increasingly ambitious commissions and public works that defined a city as self-consciously aware of its grandeur as Florence.

The drama of the Baptistery doors set the stage for an even more hotly contested competition, for an even greater prize, in 1418: the commission to design the Duomo, or dome, of Florence's main cathedral, which would sit atop Santa Maria del Fiore on the city's sacred axis. No monument would better symbolize Florence's cocktail of civic pride and self-promotion than the Duomo, which aimed to be the world's largest self-supporting dome. Once again, the entrants included Brunelleschi and Ghiberti, now middle-aged and at the height of their powers. According to Vasari, as desperately as the secretive and suspicious Brunelleschi wanted the commission, he was just as keen not to reveal his design for fear that it would be stolen by a competitor. So when the committee pressed him to explain his proposal for erecting the gigantic dome, the likes of which had not appeared since the Roman Pantheon a millennium earlier, Brunelleschi replied that whoever could balance an egg on a table would be capable of producing the winning form. He allegedly proceeded to crack the end of an egg and stand the shell perfectly upright and balanced on the table. The committee members were so impressed by the artist's wit and ingenuity, Vasari wrote, that "they resolved that Filippo should be given the task of carrying out the work."[7]

In truth, no deftly cracked egg decided the fate of the most consequential architectural competition of the Renaissance, a drawn-out affair that slogged on for years, with Brunelleschi only acquiring complete control of the project after yet another bitter tussle with his archrival Ghiberti.[8] But the legend of the cracked egg reveals, once again, the deeply social, interdependent nature of Florence's creative class, as well as another quality long associated with the Florentines, a people known as *spiritosi*, spirited to the point of being prickly,

fond of verbal sparring, and able to think on their feet. Vasari wished to display Brunelleschi's *ingenium*, or raw genius, with his story of the cracked egg. Similarly, Vasari wrote, when Giotto was asked for proof of his talent by a patron, he responded by drawing a perfect circle in all its spare and unadorned simplicity.[9]

That so many of these great names knew, competed against, and told stories about one another astonishes us now. But their intense connections were no coincidence or fluke. Over the decades, their creative talent had been nurtured by the city's *botteghe*, or workshops, a system of artisanal training and apprenticeship. While other Italian cities, especially Venice, also developed their own workshop system, Florence had the most elaborate and programmatic model for mapping out the course of study and practical expectations for aspiring craftsmen.

By the late fifteenth century, Florence had more woodcarvers than butchers, suggesting that creating beautiful objects was considered as essential as eating meat. The city had more than fifty workshops for marble and stone, forty-plus master goldsmiths and silversmiths, and some thirty master painters (a group that would include Botticelli).[10] As renowned as some of these craftsmen would become, they did not think of themselves as "artists" in the modern sense of the word—that is, highly educated, theoretically minded creators with special powers. It was only after Vasari and his *Lives* that the "artist" was thought of as someone imbued with remarkable, often divinely inspired, genius. Vasari would transform humble artisans and craftsmen into exalted beings.[11]

Men like Brunelleschi learned about the structures of buildings and the elements of art through on-the-job training. They either toiled as apprentices in a master's workshop

or, in the manner of Brunelleschi and Donatello during their Roman sojourn, went out in the field and observed firsthand the way that objects were conceived and created.[12] The place where these artisans brought their discoveries to life was the *bottega*, which was at once their university and their second home, if not their first. In the collegial and convivial atmosphere of the *bottega*, craftsmen not only worked side by side but also drank together, played jokes on one another, and slept with one another's women (and men) with the same passion and resourcefulness that they put into their work. The traditions of the *bottega* went deep into the Florentine past. In his *Craftsman's Handbook* from 1390, the painter Cennino Cennini described his mammoth twelve-year-long apprenticeship, a period of enforced labor closer to indentured servitude than artistic training.

The time frame became more relaxed as the Renaissance progressed, but the reach of the *bottega* only increased. A typical noble home such as Florence's Palazzo Davanzati—the four-story mansion of a wealthy wool-trading family in the city's historic center, which has now been converted into a museum—was filled with a dazzling mixture of products from the city's *botteghe* and beyond. Unlike the daunting towers that dominated the Florentine cityscape in Dante's era, by the time the Davanzati decorated their home the emphasis was not on military protection but on a mix of functionality and aesthetic design. The pedigree and beauty of the furnishings reflected the family's high standing and social clout. The age's suppliers included the Tuscan towns of Montelupo and Deruta, centers for the manufacture of high-quality, hand-painted ceramics, items that were considered *artigianali*, artisanal, to reflect their practical use in the kitchen or dining room. The *botteghe* were responsible for other decorative works in a wealthy Floren-

tine's home, everything from the della Robbia family's colorful, tin-glazed terracotta statuary to the endless religious-themed paintings created under the direction of masters ranging from Andrea del Verrocchio (Leonardo's teacher) to Domenico Ghirlandaio (Michelangelo's *maestro*). The line between "craft" and "fine art" was blurred, as highly skilled in-between trades like the goldworker, *orefice*, customized their products with great sophistication in response to consumer demand.[13] The Renaissance workshop changed the history of art through its emphasis on versatility. We now think of Leonardo as primarily a painter, yet his apprenticeship under the sculptor Verrocchio taught him how to give volume and three-dimensional life to his canvases. Meanwhile, though Michelangelo considered himself primarily a sculptor, he apprenticed under the painter Ghirlandaio, who trained him to infuse psychological complexity and emotional texture into his marble forms, a skill that was indispensable in his Sistine Chapel frescoes.[14]

Nowhere was this collaborative spirit and its emphasis on experiential learning more evident than in a painting sometimes called "the Sistine Chapel of the early Renaissance." The Brancacci Chapel of Florence's Santa Maria del Carmine contains a cycle of frescoes, dedicated to the life of Saint Peter, that was begun in the 1420s by the painters Masolino and Masaccio. When Masolino left the project soon after it was commissioned to return to his duties as painter for the King of Hungary, the young Masaccio—who would die at the tragic, tender age of twenty-seven—completed the lion's share of the frescoes, which became so popular that Vasari described them as a kind of Florentine art school that would draw Botticelli, Ghirlandaio, Leonardo, Michelangelo, Perugino, and Raphael, among others. "In sum," wrote Vasari, "all those who wanted to study painting always went to learn something in this chapel and immerse themselves in the precepts

and rules that Masaccio established for the human figure."[15] A half-century after Masaccio died, the marvelously talented Filippino Lippi put the finishing touches on the cycle. Filippino's father, Fra' Filippo Lippi, had stood on the scaffold with Masaccio as he worked, learning the techniques that he would later pass along to his pupil, Sandro Botticelli, the painter who would in turn train Lippi's son Filippino.[16] One work of art, almost one hundred years in the making, by three major artists: with the Brancacci Chapel, the collaborative spirit of the Renaissance reached its summit (Plate 2).

The *bottega* provided more than technical training. It was also a classroom for many artists who had little to no formal schooling. Emphasizing Brunelleschi's untutored brilliance, Vasari wrote, *"non aveva lettere,"* he was unlettered—that is, he had no knowledge of Latin. Mastering this ancient language was the academic credential of the age, the equivalent of a college degree. Knowing your Cicero and Caesar was the surest way of being considered *istruito*, educated. Despite his lack in that regard, Vasari continued, Brunelleschi could "discourse so skilfully from practical experience" that he could out-argue even the learned on theoretical issues.[17] This hands-on learning enabled Brunelleschi to create transcendent adaptations of challenging scenes from the Bible in his model for the Baptistery doors and, more broadly, make major discoveries in the laws of perspective and the principles of engineering.

Vasari went on to say that Brunelleschi "devoted much energy . . . to Dante's work, which was greatly understood by him . . . and often he would place comments on Dante into his measurements and plans."[18] Brunelleschi was just one of many artists transfixed by Dante's persona and poetry, inspiring Vasari to underscore the poet's hold on Florence's creative class. Similarly, one of Dante's earliest commentators wrote of how, one day, while Dante was watching his friend Giotto

paint, he asked the artist why his figures were all so beautiful while his children were so ugly.[19] Giotto's quick reply was that he painted his figures by day but made his children by night, in the dark, when he couldn't see what he was doing. The tale is fictitious, but it conveys the painter's trademark earthy wit and deftness with words, traits typical of the rowdy *botteghe*.[20] Petrarch had warned that poetry did not belong *in tabernis*, in the taverns, but that was exactly where many of Florence's artists spent their free time, often discussing Dante and reciting his poetry *a memoria*, by heart. Artists like Brunelleschi and Giotto were far removed from the rarefied humanist culture promoted by Florence's bookish class, preferring Dante's no-nonsense personality and visceral, emotional verse. In fact, the earliest biography of Leonardo, written in 1540 by the same unknown author who first mentioned Botticelli's Dante project, the Anonymous Magliabechiano, even described what he called a "Dante competition" between Leonardo and Michelangelo, to see which of the two could best explain key passages in the *Commedia*.[21] Neither proven nor refuted to this day, the anecdote suggests Dante's omnipresence in the Florentine art world: his epic had become the stuff of everyday conversation.[22] In the words of Michelangelo, arguably the most Dantesque artist of all and an obsessive commentator on the *Commedia* his entire life, "No greater man [than Dante] was ever born."[23]

Florence's artists admired how Dante's genius had elevated him into the city's pantheon, despite his exile and its mighty challenges. He had achieved what the more ambitious among them were also seeking: immortality through art. He was not just the local boy made good; he had made great. More important, he had achieved his fame by writing not in Latin—which most of these "unlettered" artisans and craftsmen could not read—but in the Tuscan dialect, their very own language. Like them,

Dante was not above a touch of the vulgar, even inserting a fart joke (one sinner in *Inferno* makes "a trumpet out of his ass") and other salty expressions in his deeply literary *Divine Comedy.*[24] The largely uneducated artists relished having access to a work that was, quite literally, written in a language they could understand. The high-born Michelangelo, who came from noble stock and who produced a corpus of heartfelt Petrarchan verse, was an exception. The vast majority in the rough-hewn world of the *bottega* were much more at home with the raw rhythms of Dante than the refined sonorities of Petrarch.

Brunelleschi and many of his peers were also drawn to Dante because of their common love of storytelling. Unlike Petrarch and other lyric poets, Dante wove a narrative in *The Divine Comedy*, a story with a beginning, middle, and end, centering on how the forlorn pilgrim Dante wends his way out of the dark wood, through purgatory, and all the way into heaven. There were not many novels available around 1400, and while the short story genre flourished in writers like Boccaccio and Sacchetti, the age's best-known narrative was by far *The Divine Comedy.*

Artists loved their *burle*, practical jokes, which could be as elaborate as their creative works. In this spirit, Brunelleschi's biographer Antonio Manetti communicated his complicated views on perspective through a charming and entertaining fable, a practice that recalls what Dante described as *"la dottrina che s'asconde / sotto 'l velame de li versi strani"* ("the truth that is hidden / beneath the veil of my strange verses").[25] In Manetti's "Tale of the Fat Woodworker" from the 1480s, the ambitious and talented artisan Manetto (the fat woodworker of the title) is envied by many and tricked by his fellow *bottega* members—who belong to none other than Brunelleschi's workshop—into believing that he is actually a different person, one Matteo Mannini, a lazy good-for-nothing who lives

at home with his parents, making him the Renaissance version of the modern Italian *mammone*, mama's boy. The workshop members arrange for townspeople to play along and fool Manetto, and their prank is so effective that the hapless artisan actually begins to question his own identity. By the tale's end, Manetto is compelled to flee Florence for Hungary, where he eventually makes his fortune, just as the first painter of the Brancacci Chapel, Masolino, had done.

The story is a testament to the power of perspective: Manetto has difficulty deriving an internal sense of his identity and begins to see himself through the lens of others (as the made-up Matteo Mannini). This process of self-observation is similar to Brunelleschi's mathematically derived notion of one-point perspective, where the eye looks in from a fixed point to locate an object in time and space—a concept that revolutionized painting and architecture in the Renaissance. As Botticelli did in *The Map of Hell*, the tale's author Manetti also produced a series of maps on the location, shape, and size of hell in Dante's *Inferno*. Echoing his story about the fat woodworker, Manetti's drawings employed a number of different perspectives on Dante's physical universe, including the panoramic *Overview of Hell* and more detailed close-ups like the *Lair of Geryon* and *Tomb of Lucifer*.

Many artists of the 1400s would have fit into the fictional worlds of Sacchetti and Manetti. Their mischievous characters—and their obsession with Dante—were instantly recognizable in the world of the Florentine *bottega*, with its unusual mix of steely professionalism, bawdy behavior, and passionate autodidacticism.

～

"I find myself at the age of sixty-five able to make little at my craft," the tanner Mariano Filipepi wrote in his *castato* of

1458, a tax declaration required of all Florentine families.[26] Unlike Dante's and Folco Portinari's gentrified perches astride the city's sacred axis, Mariano's Ognissanti neighborhood on the north bank of the Arno was thoroughly *popolano*, working-class, filled with weavers and other manual laborers, a place far from the vast courtyards and fortress-like homes of the city's formidably powdered noblewomen. Yet Mariano was not as hard up as his *castato* would have officials believe, as financially astute Florentine families typically downplayed their holdings to minimize their tax burden. By 1464, he was prosperous enough to buy a home in the Via Nuova, in the Ognissanti neighborhood called the Unicorn, the center of his extended family's lives and careers.[27] He also owned and rented out residential units and tanning workshops. Mariano himself was a tenant of the powerful Ruccellai, the noble family who to this day retain extensive property holdings in an area now dominated by the vast Piazza Repubblica, which until the last century was a warren of modest homes stacked one upon the other. Despite Mariano's assets, the income from his work was irregular, and his tenants did not always pay. Money was a constant worry, especially with so many mouths to feed. His brimming household included his wife Smeralda, daughters Lisa and Beatrice, and sons Giovanni, Antonio, and Simone. Finally, there was the youngest, a dreamy, eccentric boy whom Mariano fathered at the advanced age of fifty-two:

sandro mjo figlolo detto dannj 13 sta allegare ede malsano.[28]
My son Sandro, age 13, is always reading and poor of health.

A bookworm was burden enough for a working-class family like the Filipepi, and with the additional worry of the boy's precarious health, Mariano felt unable to care for his youngest. So, he likely sent Sandro to live with his older son Gio-

vanni, whose nickname was Botticello because of his squat, "barrel-shape" build.[29] The practice of sending a younger sibling to live with an older one was common at the time, and probably did not faze or traumatize the displaced child, especially since Giovanni was known for his *allegria*, friendly high-spiritedness, which likely brought his naturally thoughtful younger sibling out of his studious shell. In time, Sandro would come to grace feasts and weddings (never his own) with as much flair as his stout brother. The move also brought the boy closer to the world of arts and crafts, which he loved even more than books. Mariano sent Sandro to apprentice with a goldsmith just as he was entering his teens, at which point the name Botticelli, "of the Little Barrel clan," stuck with this runt of the litter as well.[30]

An aspiring artist could not have wished for better training. Goldsmiths worked closely with painters, and some from earlier generations—including Donatello, Brunelleschi, and Ghiberti—had gone on to become legends. The unique properties of gold made it the perfect medium for aspiring artists.[31] In addition to being a precious metal that ensured its marketability among wealthy Florentines who bought and sold the bulk of the city's art, the metal could be easily melted, fused, and shaped. A single ounce could be beaten into a thin sheet of three hundred square feet.[32] Many of the era's finest draftsmen, including Germany's Albrecht Dürer, began their career as goldsmiths, as the material required attention to detail, a graceful line, and a penchant for decorative effect, all skills that the young Botticelli immediately mastered.[33] His later canvases would glow with the goldsmith's yellow and gold, giving his work its signature luminosity—especially in his map of Dante's hell.[34]

Mariano may have been an absentee father, but he charted

a wise path for his talented son. After a few years as a goldsmith, Botticelli realized that painting was his life calling, so his father placed him under the apprenticeship of a man renowned as much for his capacious lusts as for his artistic skill.[35] Fra' Filippo Lippi—so called because his aunt had sent him as an orphaned child to become a *frate*, monk—had shockingly slight inclination for the spiritual life. His superhuman talent went hand in hand with an insatiable sexual appetite. According to Vasari, "he would give anything to enjoy a woman he wanted. . . . His lust was so violent that when it took hold of him he could never concentrate on his work."[36] His patron Cosimo de' Medici allegedly went so far as to lock Lippi in his room so that he couldn't chase women, but to no avail. In Vasari's depiction, the quick-witted Lippi seized a pair of scissors, made a rope of his bedsheets, and escaped through the window "to pursue his own pleasures for days on end."[37] Cosimo likely never tried that solution again.

Lippi adored his dreamy young pupil, and one of his best-known works shows how much the apprentice painter would learn from his doting master. Lippi's *Adoration in the Forest* from 1459, the year that the teenage Botticelli entered his *bottega*, is a highly unusual treatment of the Nativity theme.[38] Many of the traditional elements from the genre are missing, including the Virgin Mary's husband, Joseph, as well as farmyard animals and the typically humble domestic touches. Instead, Mary kneels in a lush, flower-filled forest, a surprisingly natural and springlike setting for such a spiritual and wintry theme. The religious figures that do appear, including God and the Holy Spirit, seem out of place, as if they've been suddenly airdropped into the wood, and the baby Jesus looks more like the cherub of an upper-crust Florentine family than the savior of humankind. With her graceful and ideal-

ized female form, the Madonna radiates earthly, not spiritual, beauty. In what would become a trademark move for Botticelli, Lippi took a well-worn Christian theme and infused it with a pagan sensibility and love of life. Nature's glory is in full effect, as it would be in Botticelli's *Primavera*, another work featuring a dense, rich wood—recently identified as displaying over two hundred species of flowers.[39] As Ruskin would write, "No one draws such lilies or such daisies as Lippi," a skill passed on from master to pupil.[40]

Botticelli left Lippi's workshop around 1465, when he was twenty, and went on to open his own *bottega* on the Via Nuova, where he had grown up. It would be the only studio he ever owned, and it was located on the ground floor of his family's residence, near the palace of his important patrons the Vespucci.[41] The two most prominent workshops in Florence at the time belonged to Verrocchio and Antonio del Pollaiuolo, another master from whom Botticelli learned much, especially his talent for stately portraiture. Meanwhile, the influence of his teacher Lippi, who died in 1469, was everywhere. Like Lippi's workshop, Botticelli's specialized in producing Madonna-themed paintings. Art for Botticelli was very much a family affair: Lippi's son Filippino, the artist who would complete Masaccio's work on the Brancacci Chapel, was an early apprentice.[42] Like Brunelleschi, Ghiberti, and other creatives chasing after commissions and entering competitions, Botticelli's principal goal in his *bottega* was to make money while pursuing his artistic vision. The two went hand in hand. The key was to create a personal style of the highest quality that would be instantly recognizable, while also appealing to the broadest of tastes—in other words, to create a visual "brand."[43]

Botticelli quickly learned how to make work that was at once beautiful and marketable. His skills as a businessman

were of a piece with his talents as a painter. From the start of his career, the works that issued from his *bottega* found their way into Florence's homes and civic buildings, the best possible advertising spaces in an art market that was run on word-of-mouth recommendations from influential patrons.[44] The idea of creating a work of art removed from the world, destined for a museum or subject to the theoretical inquiry of art historians, would have struck Botticelli as ludicrous. The Renaissance workshop married theory and practice: it was the place where one could experiment with ideas and concepts. More important, it was *the* site where any idea had to meet the stone-cold criteria of a patron's demands. If the artist was talented and savvy enough to meet those expectations, then his creative work could generate a comfortable living. If not, poverty and obscurity were sure to result. Even a successful painter could never rest on his laurels. One had to keep chasing after commissions and closing deals.

The demand for good art in Botticelli's Florence was surging. Thanks to its flourishing banking and textile industries, the city was becoming increasingly wealthy and anxious to translate its riches into images and monuments that advertised its power and glory. Botticelli, with his start in goldsmithing followed by a prestigious apprenticeship under Fra' Filippo Lippi, was perfectly poised to leverage his facility with the brush for purses of florins. But the competition was as ferocious as the demand was great.

On June 4, 1469, just as Botticelli's *bottega* was gaining traction in the world of Florentine art, the city began celebrations for the wedding of the century. Lorenzo il Magnifico, the new ruler of Florence, was set to wed Clarice Orsini

in what would be a four-day extravaganza. In truth, and as was often the case with the Medici, the wedding was an ersatz one, as Lorenzo and Clarice had already wed by proxy six months earlier. Typically again, the fiercely proud and patriotic *fiorentini* were slow to accept the retiring, religious Clarice: an outsider from rival Rome, she was suspicious of Florence's love of worldly pleasure and celebration of artistic talent. Lorenzo's mother, the formidable Lucrezia Tornabuoni, was especially underwhelmed. Clarice had impeccable noble origins, which would enhance the Medici's social standing in Italy, and she brought with her the requisite large dowry—some 6,000 gold florins—but in a city where so much sparkled, this quiet young girl gave off merely a faint glow. "She is fair," Lucrezia wrote to her husband, but "does not compare to our Florentine girls" in either looks or manners.[45] But, Lucrezia added, "She is very modest and will soon learn our customs."[46] She went on to mention Clarice's unfortunately "narrow hips," a defect presumably offset by what she called the girl's "promising bosom."[47]

The sumptuousness of the wedding feast made up for the shortcomings of the foreign bride. Clarice spent months learning the dances she would perform, an allegory for her future performance as Florence's first lady, a role that she would play reluctantly yet gamely in her scant remaining years (she died of tuberculosis in 1488 at the age of thirty-five, having borne Lorenzo ten children). After the wedding celebration took place in San Lorenzo, the family church designed by Brunelleschi, three days of banqueting followed. Some 300 barrels of wine and 5,000 pounds of sweets were consumed.[48]

Amid the dancing and feasting in the Medici palace, it would have been easy to overlook a silent witness to the festivities. According to Vasari, Donatello's magnificent bronze

David had been commissioned by Lorenzo's grandfather Cosimo de' Medici decades earlier to stand prominently in the courtyard of the imposing family compound—though to this day there is no scholarly consensus about either the original patron, or location, of the statue.[49] But an eyewitness account confirmed the presence of Donatello's sculpture at Lorenzo and Clarice's wedding.[50] So, the *David*, one could say, was the first to greet you as you entered the Medici sanctum.

Donatello had died in 1466, three years before the wedding ceremonies, the arc of his career ending just as Botticelli's was beginning. Fittingly, his *David* stood in the hidden interior realm of Florence's most powerful family, while Brunelleschi's more celebrated work, the Duomo, graced the city's skyline for all to see. Donatello had always lived in the shadow of his mercurial friend. Though these two former goldsmiths both reached the pinnacle of Florentine art, it was always Brunelleschi who garnered the attention, both for his wins (the Duomo) and for his losses (the Baptistery doors). Hot-tempered like Brunelleschi, Donatello also had a softer side: Vasari described him as "a man of great generosity, graciousness, and courtesy, more considerate towards his friends than towards himself."[51] Though Donatello seemed content to play second fiddle to the self-absorbed Brunelleschi, he too built up a staggering body of work. He received plum commissions, such as his sculpture of Saint Mark for that most mercantile of holy places, Orsanmichele, a one-time grain market converted into a church for Florence's powerful craft and trade guilds. And his enigmatic sculpture *Zuccone*, the bald or "pumpkin-headed" prophet, would mystify audiences for centuries with its misshapen, fragile beauty and irresistible earthiness.[52] But no work of his captures the imagination like the *David* (Plate 3).

The Medici Palace was an enormous fortress-like residence,

steroidally exaggerated in its look of strength and power—
one scholar fittingly dubbed it a Renaissance McMansion.[53]
Its muscular exterior suggested the impregnability of both a
bank vault and a military bunker, which made the presence
of Donatello's *David* all the more jarring. A youth of delicacy
and disarming finesse, Donatello's sculpture was everything
that Michelangelo's later and more famous version of a per-
fectly built young athlete coming into his physical peak was
not. Nor does it have the wiry, rawboned toughness of a work
greatly inspired by it, Verrocchio's *David*. It is hard to imag-
ine Donatello's preening, sensuous David winning a fight with
anyone, let alone a giant like Goliath.

Many consider that the statue has homoerotic qualities,
reflecting the rumor that its creator, Donatello, was gay.[54] If this
is true, it made life dangerous for Donatello. Florence's noto-
rious Ufficiali della Notte, Officers of the Night, arrested per-
petrators of "sodomy," male homosexual acts. Dante's *Inferno*
reveals the challenge of being homosexual in a deeply Chris-
tian culture like that of Florence: in Circle 7, Dante punishes
the Sodomites, including his beloved teacher Brunetto Latini,
to a lifetime of running naked beneath a rain of fire, describ-
ing him as *"sbando dell'umanità,"* "banned from humanity."
But, as was so often the case in sophisticated Florence, the sur-
face facts told only part of the truth. Despite its Officers of
the Night, Florence was actually the most open-minded city
in Italy, perhaps in all of Europe, when it came to homoerotic
desire. Gay men from all corners of Italy flocked there for
what little sexual freedom there was to be had, resulting in the
term *il vizio fiorentino*, the Florentine vice, to describe homo-
sexuality.[55] Germans even used the verb *florenzen* (literally, "to
Florence") for the act of male love.[56]

Allegations of the bachelor Donatello's supposed homosex-

uality were mostly the result of some anonymous, playful texts written about the Medici household and published in 1548, and the question has never been settled one way or another.[57] Nor does it ultimately matter. What is manifestly clear and essential is that this second *David* by Donatello stands an artistic universe apart from his initial version of the figure. Decades before his bronze coup, Donatello had created a more traditionally mythological and martial *David*, a work as tame and static as its successor is breathtakingly fluid and dynamic (Plate 4).

That the Medici would choose the second, stranger, and more unsettling version of *David* as the showpiece for their family seat suggests their depth and discernment in understanding art. They were an often brutal, always calculating, and generally ruthless lot whose ambition and greed led them to crush their rivals and foment endless discord in a city that they dominated for centuries. But without their devotion to art and to the artists who made it, the careers of men like Donatello—and Botticelli after him—would have been unimaginable. Donatello may no longer have been alive in 1469 when the wedding of Lorenzo and Clarice was celebrated with such fanfare, but he was a metaphysical guest of honor in a rite bathed in the aura of his artistic vision.

Of course, life was not only about art for the Medici. In order to enter the city, the Florentine citizen of Botticelli's time would pass through a gate just beyond the first circuit of walls. The brick exterior of this entry point gave the area its name: Porta Rossa, the Red Gate. It was here that the Medici family set up its green-felt-covered *banchi*, tables, where they would set the daily exchange rate and record their financial transactions. These were the bread-and-butter operations of banking, as vital as they were hidden.

The process of establishing prices and rates of return

for their thriving business was hardly straightforward. As with Folco Portinari before them, Medici bankers faced a distinct challenge that would make the jaw of today's Wall Street financier drop to the floor: to lend money at interest was considered a sin that could land you in hell. Dante, like all Christians, had a name for this now universally accepted practice of lending money at high interest: usury. In *Inferno* 15, Dante placed the usurers under that same rain of eternal fire that chars the naked bodies of the Sodomites. Like the Sodomites, Dante reasoned, usurers commit a crime *contro natura*, against nature, by getting something from doing nothing. For Dante, homosexuality and moneylending for an excessive interest rate were of a single, sinful piece. The source of his idea on the supposedly unnatural quality of interest-generating loans was a prestigious and venerable non-Christian source: Aristotle.[58]

So, from both a religious and philosophical perspective, moneylending in Botticelli's Florence was *vietato*, forbidden. But this divinely inspired ban did not stop the Medici, who could be as brilliant and creative in finding ways to grow their florins as the artists they supported.[59] They managed to lend money for profit without ever calling it that by name, resorting, in the words of one financial historian, "to all kinds of subterfuges in order to conceal interest charges."[60] They called the interest payment a discretionary "gift," accepted untraceable secret deposits, and manipulated foreign exchange rates.[61] Their shenanigans kept the city's lawyers and notaries happy: documents were deliberately worded in obscure and ambiguous language, creating ripe conditions for expensive litigation.[62] The Medici's financial tricks and tools were more elaborate and secretive than those of Folco Portinari and his generation,

just as their profits swelled to a scale that the bankers of Dante's time could only have fantasized about.

One of the not-so-behind-the-scenes men who made sure the Medici financial machine hummed along was Tommaso Soderini. The scion of a Florentine political dynasty, Soderini would go on to become the third most powerful man in Florence, behind his nephew Lorenzo il Magnifico and his brother Giuliano.[63] But that was a distant third. Courtiers like Soderini, later described as a mafia-like "boss," understood that their job was to let Lorenzo grab the political glory while they enjoyed the favors that came along with Medici patronage.[64] In a world where banking and beauty, art and commerce, were inextricably linked, a word from someone like Soderini could make or break a painter's career.

While the Medici were transforming Florence into an economic powerhouse, Botticelli's *bottega* was rising to prominence. He worked amid a numerous family that included siblings with their spouses and children; up to twenty *bocche*, mouths (the term used on tax documents), lived in the Filipepi compound on Via Nuova. And he was surrounded by a large group of boisterous assistants and errand boys who, like him, loved nothing more than a good prank. Botticelli's assistants all lived in the studio, and he was contractually obliged to provide for their food and general upkeep.[65] He supplied his workers with drawings, which they transformed into wooden inlays, banners, tapestries, embroideries, and other decorative objects whose sales provided a steady income stream and underwrote Botticelli's more artistically ambitious projects. Early in his career, he let his unevenly talented assistants handle only the least important aspects of a commission—a meticulousness he unfortunately abandoned later on.[66]

Like his father, Botticelli played down his business success for tax purposes, declaring during the prime of his career that he worked *"quando e' vole,"* when he liked—that is, part-time and thus less subject to taxation.[67] And like his raucous older brother Giovanni, the once-sheepish Sandro was now a fun-loving miscreant notorious for his pranks. But not all the mischief in his *bottega* was harmless, and many rivals were jealous of his rising star. Some considered his joking a nuisance, and the painter was no stranger to scandal. Anonymous informants would twice accuse Botticelli of sodomy, leaving notices for the Officers of the Night in their dreaded receptacle in Santa Maria del Fiore.[68] To this day, the accusations have been neither proven nor discredited. But given Botticelli's life-long aversion to marriage—the mere mention of it could cast him into a paroxysm of despair—and an absolute dearth of any information connecting him to women, it is highly likely that he was a closeted gay man.

Botticelli's early success put him on the radar of the Medici and their circle, especially its *consigliere*, Soderini. In 1469, the Mercanzia, the body that oversaw all of Florence's guilds, commissioned a leading artist, Piero del Pollaiuolo (brother of the powerful *bottega* master Antonio del Pollaiuolo), to complete a series of seven "virtue" paintings, allegories of the important qualities of a successful merchant.[69] When Pollaiuolo was slow to complete the commission, Soderini actively lobbied in 1470 for one of the remaining paintings to be awarded to Botticelli. When Soderini spoke—especially as his words were backed by Medici force, actual or implied—Florence listened.[70]

The work that resulted from Botticelli's first major commission sent a clear message: a new age of painting was at hand. Competent but static, Pollaiuolo's elegant stylization of the allegorical figure of Charity in all her formal piety is ultimately a

rather stiff work lacking pathos or grace (Plate 5). Botticelli's figure of Fortitude has the human touch: the limbs flow gracefully into the drapery, the figure exudes a calm, poised energy that makes it seem very much alive. Botticelli took the flattened, inert pictorial universe of Pollaiuolo and gave it flesh and blood. The Mercanzia's palace stood in Piazza della Signoria, Florence's storied central square, and adjacent to Palazzo Vecchio, the city's massive town hall. *Fortitude* (Plate 6) was hung on the ground floor of the Mercanzia in the public court dedicated to Florentine commerce, a meeting place commonly visited by wealthy merchants keen on acquiring art for their mansions and palaces. Now that his work was on view in the most visible of places, the populace, poor to rich, were well aware of Botticelli's name and talents.[71] *Fortitude* became associated with the city of Florence and its mercantile prowess, thus fueling demand for Botticelli's work.[72] Fittingly, to those in the know, the painting also bore traces of another Medici passion, besides finance: the model for *Fortitude* was Lorenzo's mistress, the beautiful noblewoman Lucrezia Donati.

The installation of *Fortitude* was just the beginning of Botticelli signing his name, as it were, in Florence's public places. In 1472, the city's grandest reception room, the Sala dei Gigli, or Hall of the Lilies, Florence's floral symbol, was created in Palazzo Vecchio. Officials immediately began to ornament it with suitably lavish decorations, and plans were made for portraits of the two authors synonymous with Florence's literary supremacy, Dante and Petrarch, to cover the enormous doors leading into the Sala. The design for the Dante portrait was assigned to Botticelli.[73]

THREE /

Chiaroscuro

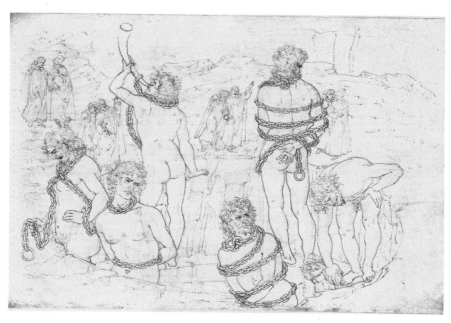

Botticelli, *Inferno 31.*
bpk Bildagentur/Art Resource, NY

Quant'è bella giovinezza che si fugge tuttavia.
How beautiful is youth, which is forever fleeting.

Botticelli's *Fortitude* put him on the radar of the Medici. By the time he designed the Dante door in the Palazzo Vecchio two years later, in 1472, he was part of the family's inner circle—where he would discover that the Medici, despite their exquisite taste, did not dispense their golden name for free. Like all bosses, sooner or later they called in their favors.

On January 29, 1475, the usual bustle of Florence's Piazza Santa Croce came to a standstill. Even the most diligent craftsmen and harried housewives would have ceased their activities as rumors began to spread of an unusual sight. The city's unofficial prince, Lorenzo il Magnifico, was organizing a massive celebration in honor of the 1474 peace accords between the Medici and the other leading families of the city, including their bitter rivals the Pazzi. After the death of Lorenzo's grandfather Cosimo, Medici opponents had formed a pact to end the family's control of Florentine politics. Through masterful diplomacy with key allies, especially the Duke of Milan and the King of Naples, Lorenzo was able to thwart the plan and preserve the peace.[1] The victory called for the kind of lavish celebration beloved by Florentines and synonymous with the Medici name. The event would indeed be so spectacular as to make Lorenzo's recent opulent wedding seem like an intimate family gathering.

Throngs began to amass in Santa Croce, home to many of the city's wool manufacturers. Just south of the Duomo and on the north bank of the Arno, the neighborhood was one of the city's least glossy and most gritty, its air redolent with the fumes and odors of its tanneries and diemakers. The hearty workers, covered in toxic chemicals and their body parts permanently stained from the inks and acids they handled, would have welcomed the break in their routine. Yet many in the gathering must also have realized the irony. Their city, steeped in republican traditions and fiercely proud of its popular will, was now deliriously celebrating the de facto dictatorship of the Medici and their fellow plutocrats.

It was ever thus in Florence. To the chagrin of the Medici's detractors (and before them, to the dismay of Dante), Florence had always been a city of, by, and for commerce, and no individual or family wielded more financial weight than the Medici and their omnipresent *banchi*, the green-felt-covered tables where they traded their florins. Lorenzo was paying for the celebration out of his own personal funds. The Florentines, increasingly at the whim of his propensity for costly spectacle and his passion for art over commerce, would pay for it in other ways.

Aesthetics and politics intermingled for Lorenzo, each dovetailing into the single category of power. In all points of this triangle, beauty was paramount, ironically enough for someone who was himself extraordinarily ugly. According to one of his contemporaries, nature may have been a nurturing *mamma*, mother, in endowing him with the mightiest of intellects. But when it came to his looks, she was more *matrigna*, evil stepmother. Born in 1449, just four years after Botticelli, Lorenzo was the favorite grandchild of the most towering of all Medici financiers, Cosimo de' Medici, the man Florentines lovingly called *Pater Patriae*, Father of the Country. From an

early age, it was clear that the gifted Lorenzo would one day succeed Cosimo and lead the family and city. Cosimo sent the adolescent Lorenzo on important diplomatic missions, tasking him with establishing political relations with the pope and religious figures in Rome whose bank accounts were the financial ballast of the Medici empire. But when Lorenzo became ruler of Florence in 1469, at the age of twenty, he had already developed a tendency, opposite to his grandfather's parsimony, to spend much more than he earned. In an inventory from the early 1470s, Lorenzo calculated that over the previous four decades the Medici had spent some 700,000 gold florins on what he deemed "essential" expenses—not only charity and taxes, but also architectural and artistic commissions.[2] Though Lorenzo found the number staggering, he still believed that the expenditure "cast a brilliant light on our estate" and that the "monies were well spent."[3] Though few would have guessed it as Lorenzo came into his prime, he represented both the summit of Medici power and the beginning of its skidding decline.

Six years earlier, in 1469, Lorenzo had similarly paved Piazza Santa Croce with sand and surrounded the yawning expanse of the square with bleachers so that an adoring Florentine public could watch him parade past, along with seventeen other knights dressed in sumptuous regalia. Of course, Lorenzo took first prize in that initial *Giostra*, Joust, a pseudo-competition that celebrated his rise to power after the death of his sickly father, Piero the Gouty.[4] As lavish as that event had been, it paled in comparison, both visually and allegorically, to what was transpiring on the morning of January 29, 1475. That was the moment, more than any other, where art and politics, rank propaganda and genuine creative brilliance, joined hands in consecrating what was in the final tally a trifle masquerading as a monument.[5]

The scores of troops marching in full livery through Piazza Santa Croce that January day were on view for the Joust of Lorenzo's playboy brother, the handsome and glamorous Giuliano. Four years Lorenzo's junior, Giuliano was marked at an early age to enjoy the leisure and worldly pleasures that Lorenzo's political responsibilities often divided him from— though Lorenzo, a notorious lothario, did find the time to bed the many women who happened to stimulate his hyperactive libido.[6] The brothers were tutored by the founder of Florence's Neoplatonic Academy, the philosopher Marsilio Ficino, the thinker responsible for fusing Plato's thought with Christian doctrine. All their lives, Lorenzo and Giuliano were surrounded by brilliant thinkers as well as artists like Botticelli and Michelangelo, both of whom were treasured members of the Medici court: Botticelli was given studio space in the Medici Palace, and the young Michelangelo was even invited to live there.

Giuliano was being fêted in Santa Croce not for his political skill or his military prowess, of which there was slight evidence, but rather for the supposedly "platonic" love that he bore a fellow noble, the breathtaking Simonetta Vespucci, daughter of Botticelli's neighbors and patrons, the wealthy Vespucci. Simonetta was Botticelli's supreme muse, the model for many of his best-known paintings and the woman considered to be the most beautiful in all of Florence. Giuliano's claim to love her from afar with lofty sentiments echoed the nobility of his social rank. He and Simonetta were living gods among the Florentine people. To see them publicly embody a sexless, spiritual love—each was either engaged or married to someone else—confirmed their soaring status.

Questions swirled in Florence about their actual relations, and the city's streets buzzed with the rumor that Simonetta

was the randy Giuliano's mistress. The scandal-mongering was later fueled by Botticelli's depiction of the two as sated, sultry lovers reclining in what looks like post-coital bliss in his *Venus and Mars* from 1485. A recently discovered letter suggests that Simonetta's husband may have even "loaned" her to Giuliano to satisfy his carnal desires, in an unusual form of payment for the crushing debts that the Vespucci family owed the Medici.[7] Whatever their connection, in Santa Croce Giuliano and Simonetta projected a "non-affair" that could not help but recall the unalloyed purity that linked the most celebrated couple in Florentine history, Dante and Beatrice.

Lorenzo and Giuliano hired Agnolo Poliziano, Politian in his anglicized form, a professor at the University of Florence and a Medici insider, to infuse the Joust with the music of poetry and the metaphysics of Neoplatonic thought. His *Verses for the Joust of Giuliano de' Medici* would become a literary classic, filled with lush descriptions of Simonetta that would eventually shape the imagery of Botticelli's *Birth of Venus*:

> You would call the foam and the sea [surrounding Simonetta/Venus] real, and real too the shell, real the blowing of the winds. You could see the goddess with eyes resplendent, and the sky and the elements laughing about her: the [Graces] treading the sand in white robes, the breeze curling their loosened and flowing hair—their faces neither identical nor different, as befits sisters.[8]

Whatever they made of this mix of erudition and flattery, few in the vast assembly in Santa Croce were likely to have questioned Giuliano's choice of love interest. Simonetta was a muse that would have made Dante's Beatrice and Petrarch's Laura proud. A devoted wife renowned for her virtue, she was

so striking that she inspired ongoing artistic outpourings in others besides Botticelli. *Il volto del Rinascimento italiano*, the face of the Italian Renaissance, Simonetta would one day be called.[9] Lorenzo il Magnifico would even write poems about her in the *Dolce Stil Novo*, Sweet New Style, the movement created by Dante and his fellow poets as he sang of his love for Beatrice. But Lorenzo was writing a different kind of "verse" that day in Santa Croce: instead of quill and ink, he was using soldiers and standards, a public poetry as evocative as any of his lyrics.

At the climax of the Joust, Giuliano entered the piazza carrying the Medici standard and mounted on a dapple-gray horse clad in armor, its housings of purple velvet embroidered with an olive branch.[10] The standard, a sumptuous cloth mounted on wood, stood an imposing fifteen feet high and seven feet wide and bore the stern figure of the warrior-goddess Athena, symbol of philosophy and military valor, carrying a spear. "*Senza pari*," the standard read: Without equal. Giuliano himself was also fully armored, with a shield slung at his breast, its surface covered by the menacing head of the Gorgon Medusa. He was playing the role of fierce warrior without actually being one. His horse was borrowed from the Duke of Urbino, a genuinely valiant soldier. The supposed joust, which typically involved highly skilled horsemen and swordsmen in an athletic competition that could be dangerous and even fatal, was the Renaissance version of pro wrestling: rigged, and full of histrionics and hijinks. It was understood that Giuliano was the victor before the so-called competition even started.

But the spectacle was much more than just bread and circus, cynical entertainment for the masses put on by a regime intent on public seduction in the name of maintaining its power. Lorenzo was a true believer in art, a skilled poet as

well as a brilliant theorist capable of holding his own in discussing ancient literature with the vastly learned Poliziano. The scene he organized in Santa Croce was as much for the eyes of history as it was for his people. A chapter in the annals of both Medici power and Florentine culture, Giuliano's Joust was a glimmering example of "Renaissance thinking," where beauty was at once an end in itself and the means of achieving a goal. To prove to the people that Giuliano and Simonetta were living gods would affirm Lorenzo's vision of Florence as the most beautiful city on earth and his Medici as the only family in the world capable of constructing a political dynasty on the shoulders of artists.

Remarkable hands were needed to craft such an alternately deceitful yet magnificent, vain yet civic-minded scene. The Medici had them in Poliziano, who rendered the event immortal with his gorgeous poetry. And they had them in the man who had painted Giuliano's standard and was now watching as his friend walked up on stage and presented it, along with his undying love, to Simonetta: the artist known to all as Little Barrel.[11]

That same year, in 1475, thanks to the support of Medici right-hand man Tommaso Soderini, the thirty-year-old Botticelli was proclaimed Master of Painting, one of Florence's highest artistic honors.[12] He was also now the unofficial family painter to the Medici, their constant companion at feasts and ceremonies, and a fully ensconced member of their entourage. Soderini was even trying to marry him off—to no avail. When he announced to Botticelli one day that it was time for him to think of settling down and taking a wife, the fatherly advice so

upset the painter that he spent an entire sleepless night desper-
ately roaming the streets of Florence.[13] True to the root of the
Italian word for bachelor (*scapolo*), and like a stubborn farm ani-
mal refusing to do his master's bidding, Botticelli would never
submit to what he considered the yoke (*capulus*) of marriage.
Soderini was forced to admit that the painter wasn't "land to
plant a vineyard on" when it came to holy matrimony.[14]

Meanwhile, Botticelli's *bottega* was thriving. The wealthiest
households in Florence vied for his work, and the commissions
kept rolling in. But nothing could compare to the boon offer
that came in soon after Giuliano's Joust. In 1475, "Sandro was
commissioned to paint a small panel, with figures a foot and a
half in length, which was placed in Santa Maria Novella. . . .
The subject is the Adoration of the Magi."[15] With these neutral
words, Vasari narrated the event that would change Botticelli's
life: his painting of *The Adoration of the Magi*. There are more
famous works by him, and more beautiful ones. But none sug-
gests so viscerally the nexus of money, power, and influence
that the Medici family had come to exercise over both Floren-
tine art and Botticelli's burgeoning career.

It was not actually the Medici who commissioned the paint-
ing, but a fellow banker, Gaspare di Zanobi del Lama. The
son of a barber whose name meant, suitably, "of the blade"
or "razor," Lama rose from humble origins to make his for-
tune as a moneylender, a dangerous occupation in the tradition
of Dante's seemingly luckless father. His success would have
been impossible without the protection of the Medici, who
controlled the flow of money in and out of Florence and its
green *banchi* more than any other family.[16] Lama repaid the
Medici in biblical fashion: he commissioned a painting that
transformed them into Magi.

It was typical of bankers to "pay forward" their spiritual sal-

vation by donating some of their profits to the beautification of Florence's churches, especially the private chapels where their families prayed on Sundays for forgiveness of their sins—while advertising their wealth to fellow Florentines.[17] In addition to decorating the chapel with traditional religious iconography, the patron often included images of himself and his circle of associates. Botticelli's *The Adoration of the Magi* (Plate 7) takes this eminently capitalist form of spiritual salvation to a new level.

To the untrained eye, the painting seems like a résumé, with typical Botticellian beauty, grace, and purity of line, of one of the more common Renaissance themes, an adaptation of a biblical passage on the birth of Christ:

> [The Magi] came into the house and saw the young child with Mary, his mother, and they fell down and worshiped him. Opening their treasures, they offered to him gifts: gold, frankincense, and myrrh.[18]

But Botticelli departs from the standard religious rhetoric. The viewer's eye is drawn to the beehive of activity and throngs of people in the bottom half of the frame. The actual subjects of worship and would-be thematic focus of the painting, the Madonna and newborn infant Jesus, are discreetly tucked into the back. It is the adoring Magi, and not the Son of God, who command the viewer's attention. The energy of the painting, its raison d'être, is more social than spiritual.

The painting is a Who's Who of mercantile Florence. The commissioning patron, Lama, is featured in prime visual real estate, left of the Virgin Mary and wearing blue, with his eyes poignantly turned to face the viewer. In the very center of the painting, Cosimo de' Medici, alias *Pater Patriae*, kneels ceremoniously at Mary's feet. Piero and Giovanni de' Medici, Cosimo's

sons, are also given starring roles as Magi mid-canvas, just below Cosimo.[19] The painting is an homage to present Medici glory as well as a paean to its future. The bottom left of the canvas features idealized portraits of the youthful, proud, and magnetic brothers Giuliano and Lorenzo (in Lorenzo's case, the good looks were pure fiction), the pair who would presumably continue the work of the Magi–Medici and bring increased wealth and splendor to their city. The painting reinforces a myth that first came to life in Benozzo Gozzoli's earlier fresco *Journey of the Magi* in the family's private chapel, a sumptuous promenade and cavalcade filled with Medici figures that charms visitors to the mansion on Via Cavour to this day.[20] The message was clear: the Medici were Renaissance Magi, givers of gifts, patrons who could pave the streets with gold.

Botticelli was no Michelangelo, composing soul-bearing sonnets wholesale in his free time, nor was he Leonardo, filling notebook upon notebook with consistently brilliant, often bizarre observations. A man of few words, Botticelli found other ways to sign his canvases. In arguably the choicest square footage of his canvas, at bottom right, directly facing the viewer at eye level, he inserted a self-portrait, wearing a yellowish cloak that recalled his training as goldsmith, and making eye contact with the viewer.

The well-groomed and well-dressed young artist, intent on building his career and affixing his visual signature throughout Florence, thus inscribed himself into a biblical scene brimming with the social energies of his commercial city, whose funds and patrons were underwriting his artistic vision. The image shows him rubbing shoulders—literally—with the good and the great, none other than the Medici, who hover around him like the sanctifying angels they would remain throughout his career. It would be difficult to find a greater example of what

one scholar called "Renaissance self-fashioning," the careful crafting of a public persona that highlights the qualities meant to be synonymous with one's name.²¹

The painting was hung at the entrance of the most important Dominican church in the city, Santa Maria Novella, with its the fabled polychrome façade by Leon Battista Alberti. It signaled both the ascent of Botticelli and the force, even the promise of eternity, of Medici wealth (though that too was another family fiction: their bank only lasted from 1397 to 1494, less than a century).²² With *The Adoration of the Magi*, Botticelli revealed himself to Florence as its most powerful family's most favored painter. He would serve brilliantly in this role for the next seventeen years, until Lorenzo il Magnifico's death in 1492. Botticelli had officially become a brand.

Dante's *Vita Nuova*, the short autobiographical mix of prose and poetry that he wrote around age thirty—the age Botticelli was when he painted *The Adoration of the Magi*—announced the birth of his poetic vocation and his love for Beatrice, both of which had transpired in the upper echelons of Florentine society. Botticelli, in similar spirit, fashioned his own artistic arrival. The painting's stated theme is the love that Christ was able to inspire in people who barely knew him, as his Nativity compels the Magi to open "their treasures [and] gifts: gold, frankincense, and myrrh" (Matthew 2:11). Yet alongside this biblical narrative, and guiding the hand that crafted the adoring Magi, Botticelli managed to depict another opening of purse and spilling out of gold: from the Medici to himself. Even the reluctant Vasari had to admit that the painting was a coup:

> The beauty of the heads that Sandro painted in this picutre defies description: they are shown in various poses, some full-face, some in profile, some in three-quarters,

some looking down, with a great variety of expressions and attitudes in the figures of young and old, and with all those imaginative details that demonstrate the artist's complete mastery of his craft. For Botticelli clearly distinguished the retinues belonging to each of the three kings, producing in the completed work a marvellous painting which today amazes every artist by its colouring, its design, and its composition.[23]

In the 1470s, Botticelli was concerned with making beautiful paintings for handsome profits. And nobody rewarded a Florentine painter as handsomely as the family that, on Lama's instructions, Botticelli had elevated into modern-day Magi. The 1470s were the painter's first golden age: he made a great deal of money both as a reliable, industrious *bottega* master and through some of his best-known works. But his success was bittersweet. While his destiny and that of the most important family in Italian art were at their most entwined, the trajectories of each moved vertiginously between sublime beauty and harrowing violence—the *chiaroscuro*, light and dark, that defined both Florence's Renaissance history and Botticelli's career.[24]

~

Medici support not only imbued Botticelli's paintings with luster and glamour, it also ensured a rise in the prices he could charge and thus gave him the freedom to pursue his artistic vision to a degree unimaginable to most of his peers. But for Botticelli that fine line between creative freedom and client demand, already blurred in *The Adoration of the Magi*, would soon be dangerously erased.

One did not get to become *primus inter pares*, first among

Florentine equals, as the Medici had, without making ene-
mies, especially among a people as notoriously competitive as
the *fiorentini*. By the time of Giuliano's Joust and Botticelli's
The Adoration of the Magi in 1475, Florence was a republic
only in name. In truth, it was a Medici principality. No less a
commentator than Machiavelli described how difficult it was
becoming to pretend otherwise:

> In the beginning, and as long as the Medici were opposed
> by families of equal power and authority to themselves,
> the citizens who might be jealous of them were able to
> oppose them openly, and had no reason to fear them
> seeing that magistrates were independent; but things
> were [now] different . . . after [1476] this [Medici] family
> had acquired so much power that those who were dis-
> contented had either to endure things patiently or resort
> to secret conspiracy if they wished to alter them.[25]

The mention of "secret conspiracy" immediately brings to
mind the Pazzi, one of Florence's most ancient families, with
a lineage that put the parvenu Medici to shame. The forebear
Pazzo de' Pazzi—literally, Crazy of the Crazies—had fought,
like Dante's ancestor Cacciaguida, in the first Holy Crusade,
returning to Florence with flints from the Holy Sepulcher at
Jerusalem. The Pazzi resembled the tough, high-minded, aris-
tocratic families celebrated by Dante in his encomium to old
Florence in *Paradiso*, where he described citizens so disdain-
ful of their looks that they wore animal skins.[26] The Pazzi
scorned all trade till 1342. Only afterward did they take up
banking and declare themselves *popolani*, on the side of the
people, so that they could hold public office. But ultimately the
Pazzi were just as deft as the Medici in linking art and money,

lucre and beauty. They spent lavishly to bolster their reputa-
tion, commissioning Filippo Brunelleschi to build the family
chapel in Santa Croce, a small gem of Renaissance architec-
ture replete with its own mini *duomo* and Luca della Robbia's
creamy white and sky-blue ceramics.

After Lorenzo il Magnifico blocked what would have been
an advantageous Pazzi marriage in 1477, the family privately
declared war. A leading member of their Roman branch, Fran-
cesco de' Pazzi, spearheaded the plan. Two nephews of Pope
Sixtus IV joined the conspiracy: Girolamo Riario, the lord of
Imola, and the teenage Cardinal Raffaele Riario. Francesco
Salvatti, Archbishop of Pisa, Florence's dreaded rival, was also
brought on board. For the Pazzi, the time had come to turn
their festering resentment of the Medici into an outright chal-
lenge. They sought the aid of a very influential friend who
was also fed up with the Medici: Pope Sixtus IV himself, who
loathed Lorenzo because he had supported the warlord Niccolò
Vitelli and other independent nobles whose dominions Sixtus
coveted.[27] When the Pazzi approached the pope with their
plan, he gave them a typically shrewd, calculating answer. As
a holy man, he said, he could in no way sanction murder. But,
he also replied, "I repeat to you . . . that I strongly desire this
change [of government in Florence] and that Lorenzo [il Mag-
nifico], who is a villain and a *farfante* [despicable rascal], does
not esteem us."[28] The conspirators were decided: to topple the
Medici dynasty, they would have to lop off its head. Lorenzo il
Magnifico and his brother Giuliano must be eliminated. Sixtus,
the conspirators reasoned, would be so elated with the result
that he would turn a blind eye to the mortal sin of murder.

Meanwhile, the Medici financial empire, which had been
carefully built up by Cosimo, was hemorrhaging cash. The
Medici were forced to close branches of their bank in Venice,

Milan, Avignon, Bruges, and London between 1469 and 1480. The rumors spread: Lorenzo was more interested in art and women—and of course power—than in banking.[29] Machiavelli blamed the declining fortunes of the family bank on Lorenzo's lack of business acumen and on the extravagant habits of Medici branch managers, who lived more like lords than the parsimonious businessman modeled by Cosimo—a view that would be seconded by no less than the father of capitalism, Adam Smith.[30] Cosimo had plowed banking profits into new investments; his progeny spent profits on maintaining their lavish lifestyle.[31] One member of the Pazzi family even refused to join the plot because he believed it was unnecessary. The Medici would soon be out of favor, he reasoned, given their poor balance sheets and distracted, erratic governing.[32] But other members of the Pazzi family were less patient. The conspirators decided that the assassination of Lorenzo and Giuliano was to take place in Brunelleschi's Duomo, symbol of the city of Florence, and during the celebration of the Eucharist, the ritual signifying the redemption of mankind by Christ's blood. In the Pazzi view, the blood of the Medici would redeem Florence. At the moment in the liturgy when Cardinal Raffaele Riario raised the Host, the butchery would begin.

The date of the planned assassination, April 26, 1478, started as a Sunday like any other. Young Cardinal Riario, a lead conspirator, showed up at the Medici Palace on the pretext of seeing their collection of ancient Roman coins. Then another of the Pazzi, Francesco, also appeared at the Medici door—but suspiciously early. It had been publicly agreed that he and other members of Florentine gilded society would arrive later that day for a banquet. Francesco is rumored to have hugged Giuliano de' Medici in the courtyard of the Via Larga mansion–fortress, presumably to congratulate him on

getting fat while recovering from a leg injury. More likely, Francesco was patting Giuliano down to see if he was armed. As Machiavelli's friend Filippo Casavecchi noted, "Where was there greater intimacy and friendship than . . . between Giuliano [de' Medici] and Francesco de' Pazzi? And you see what an evil end came of it."[33]

In the Duomo, the Pazzi plan unraveled. Giuliano was not in the church. Francesco de' Pazzi and his fellow conspirator Bernardo Bandini Baroncelli had to run and fetch him—and, as Machiavelli wrote, "it is indeed to be noted that Francesco and Bernardo were inspired by such feelings of hatred and lust for murder . . . that as they led Giuliano to the church . . . they amused him with droll and jovial stories."[34] Of course, the Medici knew that they had enemies. But they never suspected that their rivals and business associates the Pazzi, who were related to them through Lorenzo's wife, Clarice, wished them dead. As private citizens, the Medici held no official titles, and thus they had no public retinue of soldiers defending them. While they often hired bodyguards, these paid protectors did not accompany them to church. That escort would have rendered explicit what they preferred only to suggest: they were de facto rulers of the city by popular consent, not de jure ones by legal sanction. So Lorenzo and his fellow family members ambled about the public space of the Duomo freely, unsuspectingly. The service began. Giuliano finally arrived in church, where thousands of Florentines had gathered to celebrate High Mass.

When the sign for Holy Communion was given, Baroncelli pounced like a rabid dog. "Here, traitor!" he shouted, driving his blade into Giuliano's chest.[35] Giuliano fell to the ground. An equally maniacal Francesco de' Pazzi stabbed his one-time bosom friend Giuliano nineteen times. The once robust, physically arresting Medici brother, who just three years earlier had strode into Piazza Santa Croce clad in sparkling armor, was dead

in seconds. Lorenzo's attackers were neither as efficient nor as bestial. Two disgruntled priests had been hired for the job—one wonders what the Pazzi were thinking, assigning inexpert and unprepared killers to so mighty a task—and one of the would-be assassins was foolish enough to grab onto Lorenzo's shoulder before attacking him, as if to steady himself before striking. As Lorenzo turned to face his assailants, the blow glanced off his shoulder. A skilled swordsman, he defended himself with his blade as he fled to the high altar, surrounded by his supporters, and from there managed to run into the Duomo's north sacristy and bolt himself safely inside. Meanwhile, Giuliano's corpse lay in a pool of blood, trampled underfoot as a shrieking, terror-stricken public raced to the exits.

News of the butchery coursed throughout the city. The people instinctively sided with the rescued Lorenzo and the martyred Giuliano, the two brothers who had bejeweled Florence with so much beautiful art. They were the Kennedys of Renaissance Italy, graced with otherworldly charisma yet destined for tragedy in short lifetimes that were spent almost entirely before an adoring public. Giuliano's murder incited a savage wish for vengeance. A naked and wounded Francesco de' Pazzi was dragged out of bed and, along with Archbishop Salviati, summarily hanged at the Palazzo della Signoria, Florence's city hall. Nooses were looped around their necks before they were pushed out of the high windows, their corpses left to dangle stories above the ground.[36] Scores more met a similar end, as the Medici and their allies turned the city's civic center into a gallows. The message was clear: to try, and fail, to kill the Medici would result in biblical retribution. All the adult Pazzi males were eventually killed or imprisoned, and Pazzi women were forbidden to marry. The family's assets were frozen. Their children were even ordered to change their name.[37]

The ancient Romans called it *damnatio memoriae*: pummel an enemy so thoroughly and entirely as to efface them from human memory. The name Pazzi would soon rarely be uttered in the famously aspirated Tuscan accent, unless as a cautionary tale warning those who might think to challenge the Medici. In the words of the diarist Luca Landucci, the city of Florence was "bewildered with terror" in the fury of retribution that followed Giuliano's assassination.[38] The great Renaissance historian Francesco Guicciardini estimated that up to fifty people were killed, many of them hanged in the brutal manner used to execute Francesco de' Pazzi and Archbishop Salviati. "I do not believe," Guicciardini wrote, "that Florence had ever seen such a day of torment."[39] The two priests who had attempted to kill Lorenzo were hanged—and castrated. The blood that was to have been confined to the Duomo was now spilling into Florence's streets.

Medici vengeance against the Pazzi and their fellow conspirators went well beyond bodily harm. After all, the Medici were master branders, brilliant creators of propaganda and self-serving public discourse. They wished not only to obliterate the Pazzi name, but also to promote the image of Pazzi defeat and Medici victory. First, they erased and effaced: the names of the Pazzi and their coat of arms were ordered to be suppressed in perpetuity, their property was confiscated, their palace renamed, and their beloved symbol of the dolphin snuffed out from public view.[40] Then, to complement these ruthless subtractions, the Medici displayed public images that suited their cause. Models of Lorenzo were set up throughout the city. A skilled craftsman advised by Leonardo's teacher Verrocchio created three life-size wax figures in religious poses that were strategically placed in major churches: "The statue [was] dressed exactly as Lorenzo was when, bandaged and wounded at the throat [after the Pazzi attack], he stood at the windows to his house and showed himself to the people,"

Vasari wrote.[41] No models of the martyred Giuliano seem to have appeared: with their shrewd sense of public relations, the Medici chose to focus on Lorenzo's unexpected victory rather than his younger brother's brutal defeat.

Images of the Pazzi and their accomplices suffered a more bitter fate. The Medici commissioned Botticelli to paint the conspirators with nooses around their necks, a work that would be accomplished on the most ominous of settings: the walls of the Bargello, Florence's imposing fortress and prison. Beneath each figure was inscribed, like an unholy caption, a verse epitaph composed by Lorenzo. His friend Little Barrel had now etched into the façade of Florence's storied civic dungeon the mangled bodies of those who slaughtered Giuliano in the Duomo, the city's most sacred spot. A year later, in 1479, when the lone surviving conspirator Baroncelli was captured and hanged, an obscure young artist named Leonardo da Vinci, who would become one of Botticelli's chief rivals, rendered the grisly scene with journalistic precision.[42] Botticelli's death scene remained on the Bargello wall for seventeen years—until the political climate changed and it, in turn, was effaced, just as the Pazzi names had been a generation earlier. The entire city of Florence was becoming a palimpsest, written over and illustrated by victors who changed from one political generation to the next.

By painting the hanged conspirators, Botticelli had not only sold his services to his wealthy, vindictive Medici patrons for a plum commission of 40 florins. He had also made his brush complicit with their knives and nooses. Such unbridled partisanship was dangerous under any circumstances, and especially in a city as divided as fifteenth-century Florence. His portrait of the slaughtered Pazzi made him as many enemies as friends. As had happened to Dante, Florentine civil strife was about to embroil Botticelli's career—and lead him to engage with *The Divine Comedy* for the first time.

Leonardo's drawing of hanged conspirator Baroncelli.
RMN-Grant Palais/Art Resource, NY

FOUR /

The Commission

Botticelli, *Inferno 34*.
bpk Bildagentur/Art Resource, NY

Nel mezzo del cammin di nostra vita
mi ritrovai per una selva oscura.
In the middle of our life's journey
I found myself in a dark wood.
—OPENING LINES OF DANTE'S *INFERNO*

Botticelli turned thirty-five in 1480, two years after the Pazzi Conspiracy. It must have seemed like a fitting time of transition. Thirty-five was the age established by both the Bible and *The Divine Comedy* as midlife. In the book of Isaiah, the righteous King Hezekiah announces, "In the middle of my days, I shall go to hell," while Psalms declares, "the length of our days is seventy years."[1] Centuries later, Dante recapitulated those words in the opening of *Inferno,* with two lines that would change the history of literature: "In the middle of our life's journey / I found myself in a dark wood." King Hezekiah the Israelite, Dante the Florentine, and now Botticelli the Florentine—they would all go to hell and back around the time they turned thirty-five.

It was about then that the middle-aged painter began a ritual.[2] At his humming *bottega* on Via Nuova, on a large table or easel, an assistant would lay out a parchment specially prepared from untanned sheepskin. The smooth side of the paper, crafted from the fleshy interior of the animal, was face up, while the rough reverse side from the sheep's pelt lay flat against the wooden surface. The parchment measured twelve and a half inches high by eighteen and a half inches

wide. Once the assistant had finished preparing the surface, Botticelli would pick up a metal instrument called a stylus and, with its hard silver tip, trace out the main elements of his drawing, scoring the parchment's smooth fiber surface and leaving the rough side for the scribe Niccolò Mangona to fill later with lines from Dante's *Divine Comedy* in his perfectly balanced cursive script.[3] Then the text and image of each canto would be bound on facing pages to provide the most sumptuous of reading and viewing experiences.

Each one of these illustrations was done in Botticelli's hand, none by his assistants, and their unfinished state opens a window onto how they came to be made.[4] The painter began with a faint, almost translucent preliminary sketch inspired by Dante's lines and flickering with delicate energy.[5] Then, with a softer stylus dipped into an alloy of lead and tin, he fleshed out a more visible line. Once the two styluses had mapped an outline, he employed a rotation of quills and reeds to give the drawing a palpable form in yellow, brown, and black inks.[6]

This initial stage of drawing was supposed to be only the beginning of Botticelli's engagement with Dante's words. His original plan was to paint over the sketches and produce full-color renditions of each canto, in the tradition of the illuminated manuscripts of the *Commedia* that had long circulated in Italy.[7] But in the end, he added pigment to just four of his one hundred canto illustrations, and, of those, three have only a smattering of color. The lone illustration to make the complete artistic pilgrimage from sketch to drawing to painting was *The Map of Hell*.

If Botticelli was illustrating from *Inferno*, the image would be a crowded, busy rendition that conveyed the drama and emotion of the first canticle.[8] Crucially, the illustrations of

Inferno are almost devoid of the characters and personalities who have brought lasting renown to the canticle—and inspired a host of illustrators in Botticelli's wake, from William Blake's hauntingly spiritual watercolors to Gustave Doré's precisely rendered gothic illustrations. Botticelli took a different tack. The lustful Paolo and Francesco, the restless intellectual quester Ulysses, and the cannibalistic Ugolino all recede in his illustrations, swallowed up by the surrounding geographical and narrative concerns. It's not that we don't "see" those ill-fated stars of Dante's imagination, like the heart-wrenching suicide Pier delle Vigne in *Inferno* 13 or Dante's beloved mentor Brunetto Latini two cantos later in the Circle of the Sodomites. Those characters do appear, but they are minuscule and diffuse, with Pier's profile tucked discreetly inside a tree and Brunetto, his tiny face contorted with pain, almost imperceptibly tugging at the hem of Dante's cloak.[9] The only "portrait" that Botticelli's *Inferno* offers is a detailed and large-scale depiction of Satan, a seemingly odd choice given that Dante purposefully describes this character in anonymous, machine-like terms. It's as though Botticelli were anticipating Milton's version of the devil as a standout figure worthy of a close-up.

The closer Dante gets to salvation, the more the human figure surfaces in Botticelli. From the first to the last lines of his *Paradiso* illustrations, and to the exclusion of nearly all else, Botticelli's stylus traced the drama of Dante's relation to Beatrice. The two are almost always depicted inside a circle, perfectly drawn by compass, as when they appear together in *Paradiso* 9, home to the souls who most powerfully bear the mark of love.

Later, in *Paradiso* 17, Dante hears from a blessed ancestor the prophecy of his own bitter exile from Florence, which would send him wandering up and down the Italian peninsula for

Botticelli, *Paradiso 9*.
bpk Bildagentur/Art Resource, NY

the last twenty years of his life, a vagabond forever anguished over the loss of his *bello ovile*, fair sheepfold Florence:

> You will leave behind everything you love
> most dearly, and this is that arrow
> the bow of exile first lets fly.[10]

The pathos of the scene is all internal: the reader, like the character Dante, is left to ponder the awful implications of this impending expulsion. So, Botticelli illustrated the canto in a minimal key, showing only the figures of Dante and his muse Beatrice in a celestial dance meant to soften even the heartache of exile. Dante's *Paradiso* is a cast of multitudes; Botticelli's is essentially a poem of two.[11]

Botticelli, *Paradiso* 17.
bpk Bildagentur/Art Resource, NY

Botticelli's unique vision of Dante's epic—and the midlife ritual it set in motion—had been a long time in coming.

~

After Dante's death in 1321, an unusual combination of lowborn and highbrow readers, from Sacchetti's blacksmith and donkey-man to humanists including Boccaccio and Dante's own sons Pietro and Jacopo Alighieri, helped make the *Commedia* popular not just in Florence but throughout Italy. The presence of Dante's poem up and down the peninsula was fitting, for Dante had urged his fellow Italians to find a common language and the political unity that would accompany it. The poet's influence also spread well beyond Italy, with

such early promoters as Geoffrey Chaucer in England, a host of learned prelates in medieval Germany, and major authors including Christine de Pizan in France, to name only a few.[12]

But it was in Florence where Dante's star shone brightest. He had become his native city's cultural patron saint, in the tradition of an eminently Italian trope, the *poeta vate* or poet–prophet, a line that also included Dante's self-nominated nemesis, Petrarch. "One might just as well say 'Dante's Florence' as 'Florence's Dante,'" the Medici's resident philosopher Marsilio Ficino remarked.[13] In 1476, Lorenzo il Magnifico had tried—and failed—to have Dante's remains returned to the city from Ravenna, where the poet had spent the last years of his exile. The war over what Lorenzo called Dante's "most worthy bones" would rage for centuries.[14]

If the Florentines could not have Dante's corpse, they would have his image. In 1465, Lorenzo and the local government commissioned Domenico di Michelino to paint *The Divine Comedy Illuminating Florence*, which shows Dante holding his epic poem as he stands before the three realms of the afterlife, flanked on his left by the city of Florence. The message was clear: the poet had symbolically returned to the city that exiled him, a homecoming sanctioned by God Himself (Plate 8).[15] And yet Botticelli's Florence was lagging behind the rest of Italy in one embarrassing way when it came to their lost native son. The first printed edition of the *Commedia* appeared in 1472—surprisingly, not in Florence, but rather in the small Umbrian city of Foligno. This publication of Dante outside of Tuscany attested to his broad "Italian" appeal: though there was no Italian state at the time, intellectuals from Lombardy to Sicily had a strong sense of "Italian culture," thanks in large part to Dante's legacy and his pleas for unity. This lack of a hometown edition was unsettling for hypercompetitive Florence. Even rivals like Milan and Venice managed to produce

lavish volumes of the *Commedia* after the invention of the printing press by Gutenberg in 1439, which created new markets for books by famous authors like Dante, who could be thought of as a "modern classic" of that era.[16]

The time was ripe for a printed edition of Dante to appear in Florence, and in 1481 the city's government acted decisively. They chose Cristoforo Landino, one of Lorenzo il Magnifico's illustrious tutors, to edit what would be a sumptuous volume of the *Commedia*. Professor of Rhetoric and Poetry at the University of Florence, Landino was the perfect guide to Dante's complex poem for Florence's literate, urbane middle class. Though he was an accomplished Latinist and humanist in the tradition of Petrarch and Boccaccio, his decision to undertake a defense of the "vernacular" Dante shows how popular the poet was in Florence, and how dedicated Florentines were to promoting their own tongue.[17]

In his introduction, Landino emphasized Dante's bitter exile and the errors in those earlier printed "foreign" editions of the *Commedia* that had appeared in the 1470s. Landino also included a "Life of Dante" and detailed maps of hell, replete with precise measurements by Antonio Manetti, Brunelleschi's biographer and author of the witty story about the fat woodworker's confused identity.[18] The frontispiece of Landino's edition bore the title "Commentary by Cristoforo Landino the Florentine on the Comedy of Dante Alighieri, Florentine Poet."[19] Every element of this new Dante volume exuded civic pride—even the typeface. Printed in a crisp font that aimed for elegance and legibility, the humanist script distinguished itself from the more decorative gothic lettering used for religious texts and merchant accounts.[20] The typeface was called "roman" to emphasize its visual link to the great Latin works of the past, a connection that would have thrilled the imperial-minded Dante.

To complete this editorial dream team, Florence's ruling council looked for the perfect artist to illustrate the volume, which remains a marvel of scholarship to this day. The choice would come as a surprise to no one. In what must have seemed like the honor of a lifetime to the unschooled painter from the blue-collar Unicorn neighborhood, Florence's city council commissioned Botticelli to produce a series of drawings. The commission initiated his immersion in Dante. In all likelihood, he began preparing the illustrations for the Florentine *Commedia* around 1480, when plans for the volume were being finalized and just as he was entering that Dantesque midpoint of his life's journey.[21]

Botticelli's work for this official Florentine edition is well documented. But his "other" Dante project from the same time, which represents his most substantial contribution to our understanding of *The Divine Comedy*, is shrouded in mystery and surrounded by centuries of conjecture and misunderstanding. Around the time that Botticelli began to contribute drawings to the Landino volume, he was *also* commissioned, privately and by the person who was becoming his most influential patron, to produce a full set of one hundred illustrations for a deluxe edition of Dante's poem. The Florentine volume edited by Landino was meant for mass production and public consumption; the other volume was to be a single hand-lettered manuscript exclusively for private use. It is this second, privately commissioned volume that would contain the nearly complete set of illustrations of Dante by Botticelli that disappeared for centuries, only to be definitively claimed by Friedrich Lippmann in 1882. So Botticelli's single Dante project was actually a two-headed beast: one part meant for the Florentine people and the other for a Florentine plutocrat, a fitting mix in a city known in equal measures for its civic devotion and its mercantile dominance.[22]

The deluxe private volume was the first ever produced with its illustrations planned from the start.[23] The man who commissioned it, Lorenzo di Pierfrancesco de' Medici, was Lorenzo il Magnifico's first cousin, from a less powerful branch of the family. Along with his brother Giovanni, Lorenzo di Pierfrancesco had been raised by the looming paterfamilias Cosimo de' Medici, the cousins' shared grandfather. When Lorenzo di Pierfrancesco's father died, Cosimo left him and Giovanni under the guardianship of il Magnifico—a questionable decision. In 1478, during the season of the failed Pazzi coup, a cash-strapped Lorenzo il Magnifico appropriated 50,000 florins from his cousins to prevent Pope Sixtus IV and his allies from breaking the Medici bank.[24] When Lorenzo di Pierfrancesco and Giovanni came of age, they demanded that the sum be restituted, taking their powerful cousin to court. The judge supported their claim: in a rare legal defeat, il Magnifico was forced to hand over the family villa in Cafaggiolo and other properties in the Mugello as compensation.

Yet somehow Lorenzo il Magnifico and Lorenzo di Pierfrancesco managed to enjoy what was apparently an otherwise harmonious, albeit competitive relationship.[25] According to a close associate of both men, the humanist Niccolò Valori, il Magnifico "took care of [Lorenzo di Pierfrancesco] as if he were his son, providing for his care and governance by surrounding him with men of excellent learning and customs."[26] Il Magnifico gave his cousin such brilliant tutors as Amerigo Vespucci, the explorer and discoverer of the New World, America, that bears his name, and Ficino, who playfully called Lorenzo di Pierfrancesco "Laurentius minor," il Magnifico junior.[27] Like the princely il Magnifico, the learned Lorenzo di Pierfrancesco wrote poems in the Tuscan dialect (though less expertly than his cousin), and he used his wealth to amass

one of Florence's most impressive libraries.[28] For him and his fellow bibliophiles, the 1481 edition of the *Commedia* was the literary event of a lifetime. By complementing that official volume with his own private commission of a separate, even grander edition of Dante's poem, Lorenzo di Pierfrancesco may have been quietly calculating a strategy to one day claim the cultural prestige—and the political power associated with it—of his illustrious cousin.

Botticelli was now at the high point of his career, artistically and commercially.[29] But this same popularity would force him to interrupt his work on Dante. Soon after he began to illustrate the *Commedia*, in 1481, he was chosen by Lorenzo il Magnifico to paint the Sistine Chapel, as part of a select group of artists that included his rivals Perugino and Ghirlandaio. He would end up doing a perfectly fine job in executing this work for Sixtus IV in Rome from 1481 to 1482, completing three frescoes, *The Trials of Moses*, *Temptations of Christ*, and *Punishment of the Sons of Korah*, in just eleven months. As ever, he was punctual and thorough in delivering on his commissions—with the notable exception of his Dante illustrations. Oddly enough, the Roman works were the only frescoes he painted in a long and productive career, even though he showed mastery of the form.[30] But whatever glories might have arisen from Botticelli's Sistine Chapel paintings were forever eclipsed by Michelangelo's later frescoes there. Even informed art enthusiasts are unaware that there is a "Botticellian" Sistine Chapel to go alongside Michelangelo's, and Botticelli's frescoes have had their detractors: Henry Fuseli, a prominent eighteenth-century Swiss artist and illustrator of Dante, derided their "puerile ostentation."[31]

Vasari falsely believed that Botticelli's success with *The Adoration of the Magi*, that superlative piece of pro-Medici

visual propaganda, had won him the Sistine Chapel commis-
sion. While that painting from 1475 had indeed cemented
Botticelli's reputation as one of Florence's leading artists and
a Medici favorite, it was, in the fast-moving, complex world
of Florentine art and politics, already a distant memory by
1481. In truth, Lorenzo de' Medici sent Botticelli to Rome as
a goodwill gesture to the pontiff in the aftermath of the Pazzi
Conspiracy.

One of the hanged conspirators, Archibishop Salviati, had
been a close ally of Sixtus IV. Another conspirator, the pope's
nephew Girolamo Riario, managed to escape death in the
aftermath of the failed plot—for a while. He was assassinated
ten years later over a financial dispute in Forlì, when a gang
of thugs entered his palace and slashed him to death before
flinging his body into a piazza. Riario had been the last sur-
viving member of the failed Pazzi coup d'état. Many believed
that Lorenzo il Magnifico, who was certainly overjoyed by the
killing, was behind Riario's murder, though he denied any
involvement. His position after the failed coup, for practical
purposes, was one of papal appeasement and reconciliation.
The Roman Curia was the Medici Bank's most important—
that is, richest—client. By sending to Rome the artist who had
painted the effigies of the slaughtered Pazzi conspirators on
the Bargello wall, Lorenzo was seeking to heal recent wounds
and protect the family coffers. Botticelli's flowing line would
provide political balm.[32]

At the time of Botticelli's arrival in 1481, Rome was a
cultural backwater compared to Florence. Vast stretches of
undeveloped land were roamed by beggars and bandits. By
contrast, Florence was dense with wealthy and highly policed
palazzi. Rome must have seemed like a terrifying wilderness
to the Florentine painter. One can picture him methodically

working away on his frescoes for the pope, anxious to get the work done and return to his large, tight-knit family, fun-loving (and profitable) *bottega*—and nascent illustrations of Dante. The Roman paintings were for highly educated prelates and wealthy patrons who formed the papal court and had little or no connection to the Florentine families and merchants with whom Botticelli was accustomed to dealing. Separated from his Unicorn neighborhood and powerful network, Botticelli in Rome was likely a man adrift. After his Roman sojourn, he never left Florence and its environs again. He was no Brunelleschi, who had lingered for a decade and a half in the Eternal City with Donatello, poring over the ancient sites and forms that would inspire the Duomo. In the end, Botticelli was, as the expression goes, *fiorentino doc*: Florentine born and bred.

Botticelli's return to Florence in 1482, and the resumption of his work on Dante, was a homecoming. After all, Dante was the favored author of Florence's artisans and artists, the man whose verses even the donkey-men could sing. With his raw and accessible dialect poetry, Dante was, in Ruskin's words, "available to all," and Botticelli clearly felt, like so many of his peers, the irresistible pull of his poetry.[33] Back in his *bottega*, Botticelli threw himself into his Dante project with vigor, completing a series of drawings that served as the basis for engravings in the Florentine *Commedia* edited by Landino.[34] For the first time, readers might have expected to contemplate the ultimate hometown collaboration: Dante's verses set to Botticelli's images. But that's not quite how it turned out.

The much-anticipated Florentine *Commedia* was an instant success: 1,200 copies were sold on its first print run in 1481, a huge number for the time.[35] Dante had become a Renaissance bestseller. Demand was so great that publica-

tion occurred in multiple stages, and the engravings based on Botticelli's work did not appear in the initial print run of 1481. Instead, they appeared in editions of Landino's volume that were published between 1482 and 1487, most likely executed by the mediocre journeyman Bacio Baldini and only for *Inferno* 1–19. Unfortunately, the engravings were of poor quality, certainly not up to Botticelli's standards (a later commentator called them "contemptuous").[36] Then, suddenly and for unknown reasons, Botticelli's contributions to Florence's *Commedia* stopped—an abrupt break that recalled Boccaccio's aborted lectures on Dante in 1374. Botticelli became yet another leading creative to see his public project on Dante come to an unceremonious end. As popular as the Florentine *Commedia* was, its unorganized and erratic production—evidenced by the less than stellar engravings—likely caused the painter to abandon his commitment to it. His departure for Rome was also probably a factor, as it broke up the initial momentum of his work on the Landino edition, diverting his energies into other demanding projects.[37]

One of Vasari's less flattering anecdotes about Botticelli tells of a prank played by the painter on a friend, whom he had supposedly denounced as a heretic to a local priest. Taking language directly from Dante's *Inferno*, Vasari wrote that Botticelli "alleged that [his friend] believed with the Epicureans that the soul dies with the body," an allusion to *Inferno* 10 where Dante punishes heretics for this same sin of failing to believe in the soul's immortality.[38] When the accused friend appeared in court, he went on the counterattack by crying, "Isn't it [Botticelli] who is the heretic, since although he scarcely knows how to read and write he [illustrated] Dante and took his name in vain?"[39] Vasari's inflammatory yarn nailed something important: like Brunelleschi, Botticelli

non aveva lettere, was without letters, a person with no knowledge of basic scholarly subjects such as Latin. But was he truly unlearned?

The question is easy to answer. Botticelli wrote nothing about anything, let alone his intellectual interests, which makes him unlike such committed authors and obsessive self-commentators as Ghiberti, Cellini, Leonardo, Michelangelo, and Raphael.[40] But the words of others and the mountain of evidence surrounding the painter's intellectual life reveal much that Botticelli himself does not. He collaborated with many of Florence's leading minds, especially Poliziano, the poet–philosopher who advised him on grand mythological paintings including *Primavera* and *The Birth of Venus*.[41] Botticelli was no mere "student" of this brilliant mentor, as his imagery shaped the way that Poliziano wrote about Simonetta Vespucci, the muse celebrated in Giuliano de' Medici's Joust.[42] Botticelli's nineteenth-century rediscoverer, Friedrich Lippmann, affirmed the painter's robust intellect: "Either Vasari's account of his youthful idleness was false, or Botticelli must have diligently atoned for his early shortcomings, for we know him to have been deeply versed in classic literature, and a student of Dante."[43] Lippmann's view of Botticelli is now widely accepted: the consensus is that he was an impressively learned painter whose vigorous autodidacticism enabled him to tackle a poet as conceptually demanding as Dante.[44] An influential early scholar of Botticelli, Edgar Wind, put it beautifully when he described how Botticelli's *Primavera* animated the complexities of Neoplatonic thought with disarming *sprezzatura*, replacing "philosophical pedantry" with "lyrical sentiment."[45] One didn't become an intimate member of the Medici's inner circle and stalwart contributor to their humanist projects, as Botticelli did, without the requisite cultural chops. Botticelli had them in abundance.

The greatest proof of Botticelli's intellectual acumen is in the Dante illustrations themselves, especially the most celebrated—and most beautiful—of the ninety-two extant drawings: the many-hued *Map of Hell*, bathed in the glowing yellow favored by this former goldsmith's apprentice (Plate 9).[46] Florence's humanist circles had a mania for reconstructing the highly systematized world of the *Commedia*, and nobody went further in this regard than Botticelli. The realism and intricacy of his *mappa* surpasses all other renditions previous and since, including the fascinating mathematical models of Dante's hell by Brunelleschi's biographer Manetti. Botticelli's image captures the geography of Inferno from the vestibule of Limbo, through the circles of punishment and ditches of fraud, all the way to the mouth of Lucifer.[47] Most impressively of all, it contains sophisticated "instructions" for the reader by laying out the entirety of hell's itinerary in one visual swoop. Meticulously depicting Inferno in each of its stages, Botticelli represented both the experience of Dante the pilgrim as he is taking his journey and the vision of Dante the poet who depicted it.[48]

Botticelli's Dante illustrations of the 1480s were in close dialogue with his other work, including his most prominent paintings. Even a cursory glance reveals the likeness between his Beatrice and the goddesses in *Primavera* and *The Birth of Venus*.[49] The pulse of pleasure that Botticelli infused into his drawings from *Paradiso* also pervades the atmosphere of these two exuberant paintings, as both they and the Dante cycle contain their share of spinning revelry. It is impossible to say which work is influencing which. Most likely, since both paintings and the Dante drawings were created in roughly the same period, Botticelli's one vision permeated all three creations at once.

Like his Dante project, Botticelli's two paintings involved
Lorenzo di Pierfrancesco de' Medici, directly and indirectly.
A recently discovered inventory of Lorenzo di Pierfrancesco's
estate reveals that *Primavera* (Plate 10) first hung above the
lettuccio, a large nuptial bed, in his Florentine townhouse.[50]
Although its commission remains a mystery, many connect
the painting to Lorenzo di Pierfrancesco's marriage in 1482
to Semirade Appiano, the woman who had been engaged to
Giuliano de' Medici when he was cut down in his prime by
the Pazzi.[51] Perhaps the *Primavara* was a wedding present—
maybe from his cousin il Magnifico, or perhaps Lorenzo di
Pierfrancesco commissioned it himself for his wife. Whatever
the case, it is difficult to imagine a lovelier image for newly-
weds to fall asleep beneath.

The commission of *The Birth of Venus* (Plate 11) is even
more hidden—and once again circles back to Lorenzo di Pier-
francesco. Botticelli's great biographer Herbert Horne argued
that the painting was commissioned by Lorenzo di Pierfran-
cesco around 1478 for a new country house.[52] But more recent
scholarship, based on an analysis of Botticelli's style, sets the
painting's composition later, in the mid-1480s.[53] No definitive
solution has confirmed either view. Despite the uncertainty
surrouding Botticelli's two best-known works, they both came
to life around the time he was immersed in drawing from
Dante. Given these lines of confluence, it is hardly surpris-
ing that Botticelli's Beatrice often takes the form of a pagan
beauty who reminds us more of a mythic Venus than a Chris-
tian Madonna.[54]

This push and pull between Botticelli's paintings and his
Dante illustrations reached a dramatic pitch in 1483, when he
received a new commission from the prominent Pucci family.
He was asked to paint a *spalliera*, a sequence on wood pan-

els, for the old family palace in celebration of a wedding. The commission came at the height of Botticelli's popularity, when he was so flooded with work that he had to hire painters outside of his *bottega* to keep up with the demand. In this case, he enlisted the help of a painter from his rival Ghirlandaio's workshop, Bartolomeo di Giovanni. The commission called for a painting based on one of the *novelle* in Giovanni Boccaccio's *Decameron*: the tale of Nastagio degli Onesti, one of the most bizarre—and unsettling—warning tales for brides-to-be ever written.

The turn to this prestigious source was natural. In the spirit of the Dante volume of 1481 edited by Landino, Florentines were increasingly proud of their vaunted literary tradition. Boccaccio was considered a "contemporary" author: he had died only a century before, and (at least in his youthful *Decameron*) he was an exponent of the earthy, sensual worldview cherished by many Florentine humanists and so often depicted by Botticelli on his canvases. With its rich variety of one hundred individual stories, the *Decameron* offered readers a wealth of options and perspectives to apply to their daily lives—we might think of it as a deeply literary self-help manual of sorts for the age, filled with what readers perceived to be practical wisdom. It was fitting that Botticelli, immersed in his *Commedia* drawings in the early 1480s, should apply his brush to the work of Dante's most consequential early fan.

Renaissance readers were drawn to the tale of Nastagio because of its marital theme. Boccaccio's narrative has Nastagio, after his beloved rejects his proposal, venture into a Dantesque dark wood,[55] where he sees a remarkable sight: a dark knight on horseback pursues a naked woman and slaughters her, leaving his dogs to maul her corpse. Nastagio witnesses the ghostly scene repeated every Friday, and comes to learn

that the woman had spurned the knight's marriage proposal and suffers an eternity of violent revenge as a result. Somehow calculating enough to bracket the horror of this vision, the *furbo*, cunning, Nastagio senses an opportunity and decides to organize a banquet on the very spot of the massacre, inviting his family as well as that of the woman who rebuffed him. During the subsequent feast, all watch as the dark knight pursues and slaughters the defenseless woman. Astonishingly, the macabre event becomes a cautionary tale to women who dare decline a suitable marriage proposal:

> Knowing that it was no one's fault but her own that she had not already become Nastagio's wife, the young lady [Nastagio's beloved] replied to him that she consented [to his marriage proposal]. And so, acting as her own intermediary, she told her father and mother that she was happy to become Nastagio's bride, which made the two of them happy as well. The following Sunday Nastagio married her, and after celebrating their nuptials, he lived happily with her for a very long time. Nor was this the only good that came from that fearful spectacle, for indeed all the women of Ravenna were so frightened because of it that from then on they were far more willing to yield themselves to men's pleasures than they had ever been before.[56]

One must tread carefully through Boccaccio's minefield of ironies. On the surface, the passage seems to present a baldly misogynistic moral advocating violence against women to keep them in line. There are other instances of hardcore patriarchy in the *Decameron*, but they hardly tell the whole story of Boccaccio's attitude to gender. Throughout the *Decameron* he celebrates women's freedom, sexual and otherwise, and

his touching introduction dedicates the book to female readers who have little to live for other than literature. Perhaps he wrote his ugly approval of Nastagio's actions with either an upturned nose or a playful wink. Whatever the case, merchant readers in Botticelli's Florence were much less liberal-minded (and more literally inclined). They were likely to take Boccaccio's admonishment to the women of Ravenna on its face, as a warning to future brides against playing hard to get. In choosing the story of Nastagio degli Onesti, the Pucci were essentially commissioning Botticelli to paint the tale of a young woman who is punished for refusing to marry the man who desires her.[57] The warning was clear: obey your husband and bring to marriage what society—*Florentine* society—expects of a wife. Or else.

Astonishingly, Nastagio's tale was often copied on wedding gifts in Botticelli's Florence as a chilling reminder for women to respect the holy vow of matrimony.[58] It was just one of many narratives featuring violence against women— including ancient Rome's rape of the Sabine women, the Bible's young Susanna sexually betrayed by her elders, and Boccaccio's doggedly faithful Griselda who receives cruel treatment from her husband—that were painted on *cassoni*, wedding chests, to sanction patriarchal authority.[59] The story of Nastagio also recalls the principles of Dante's hell and its brutal judgments in a way that may have influenced Botticelli's rendering of it. In *Inferno*, all are subject to the rule of *contrapasso*, counter-penalty, which has sinners suffer eternal punishments directly based on their earthly transgressions: the lustful are buffeted by wild winds similar to unbridled desire, the sowers of discord carry their heads separated from their bodies, and so on.[60]

On its surface, Boccaccio's story presents us with a per-

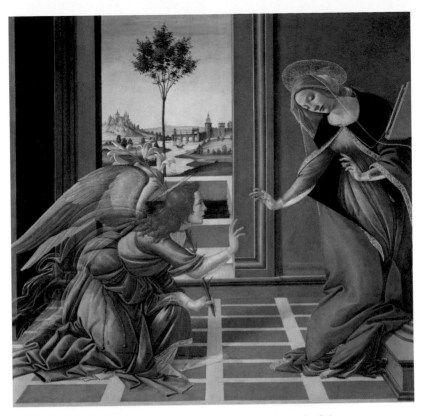

PLATE 1. Botticelli, *Cestello Annunciation* (1489).
Erich Lessing/Art Resource, NY

PLATE 2. Scenes from the life of St. Peter, Brancacci Chapel (c. 1425–27).
Scala/Art Resource, NY

PLATE 3. Donatello, *David*
(bronze; c. 1440s). *Nimatallah/Art
Resource, NY*

PLATE 4. Donatello, *David*
(marble; 1408–1409). *Alinari
Archives/Art Resource, NY*

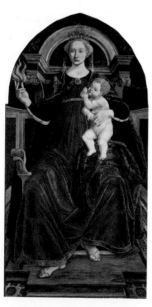

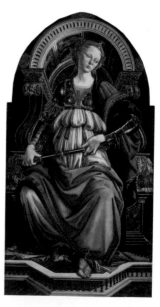

PLATE 5. Pollaiuolo, *Charity*
(1469). *Ministero per i Beni e le
Attività culturali/Art Resource, NY*

PLATE 6. Botticelli, *Fortitude*
(1470). *Ministero per i Beni e le
Attività culturali/Art Resource, NY*

PLATE 7. Botticelli, *The Adoration of the Magi* (c. 1475–76).
Ministero per i Beni e le Attività culturali/Art Resource, NY

PLATE 8. di Michelino, *The Divine Comedy Illuminating Florence* (1465).
Scala/Art Resource, NY

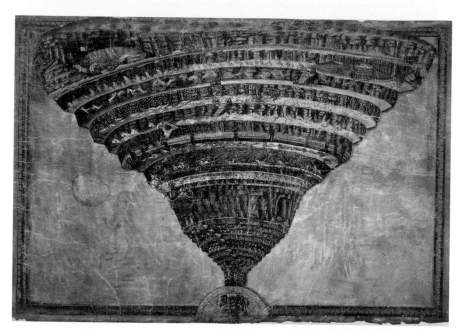

PLATE 9. Botticelli, *The Map of Hell* (c. 1495). *HIP/Art Resource, NY*

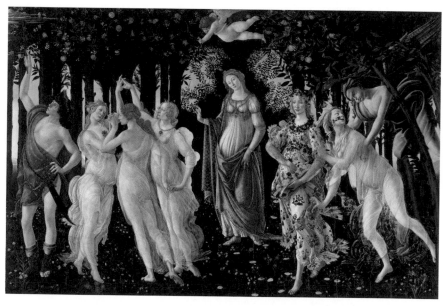

PLATE 10. Botticelli, *Primavera* (c. 1480). *Scala/Art Resource, NY*

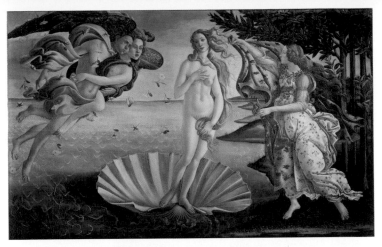

PLATE 11. Botticelli, *The Birth of Venus* (c. 1485). *Scala/Art Resource, NY*

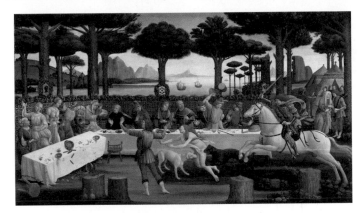

PLATE 12. Botticelli, *The Story of Nastagio degli Onesti* (panel 3; 1483).
Museo Nacional del Prado/Art Resource, NY

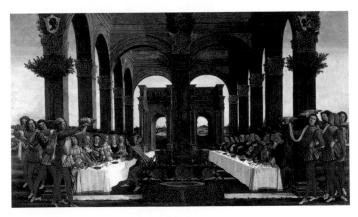

PLATE 13. Botticelli, *The Story of Nastagio degli Onesti* (panel 4; 1483).
Museo Nacional del Prado/Art Resource, NY

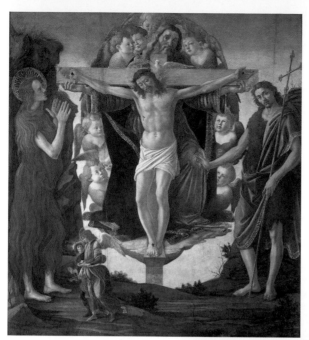

PLATE 14. Botticelli, *Holy Trinity* (1491–93). *London (Samuel Courtauld Trust) Courtauld Gallery/Bridgeman Images*

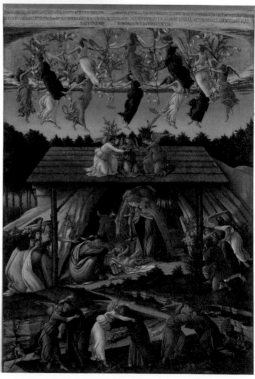

PLATE 15. Botticelli, *Mystic Nativity* (1500–1501). *National Gallery, London/Art Resource, NY*

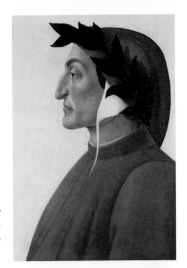

PLATE 16. Botticelli,
Portrait of Dante (c. 1495).
Wikimedia Commons

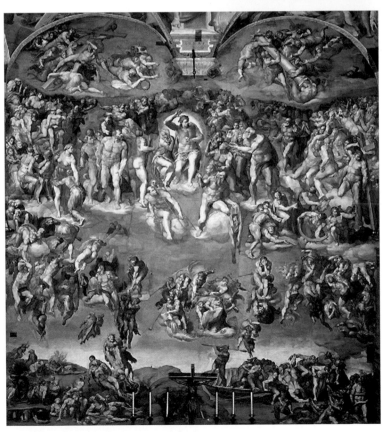

PLATE 17. Michelangelo, *The Last Judgment* (detail; 1536–41;
photo taken prior to 1980–94 restoration). *Scala/Art Resource, NY*

PLATE 18. Rossetti, *The First Anniversary of the Death of Beatrice* (1853).
HIP/Art Resource, NY

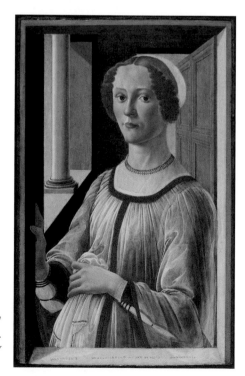

PLATE 19. Botticelli, *Portrait of a Lady
Known as Smeralda Bandinelli* (1475).
V&A Images, London/Art Resource, NY

verse and horrifying example of *contrapasso*, with a vengeful knight endlessly punishing the woman who rejected him for her alleged "sin." But, much more explicitly than Boccaccio, Botticelli seems to scorn this tidy notion of a wayward damsel kept in line by the knight's murderous lance. He underscores the cruelty of the innocent woman's fate as she faces a massively armed male consort and its ferocious animals, creating an especially unsettling panel that depicts callous guests glutting themselves as the girl is slaughtered (Plate 12).

In Botticelli's fourth and final panel (Plate 13), the social order is enforced and all are free to enjoy their feast as they celebrate the nuptials of Nastagio and his lady. The scene's monumental, pompous architecture and symmetry—the lines of the surging arches are almost absurdly phallic—expose the smug violence of a male-dominated culture. Botticelli's graphic representation of the innocent woman's suffering, in all her naked vulnerability, may very well suggest his uneasiness with Dante's comparably severe notions of just punishment and with the feasting Florentine patriarchy's comfortable acquiescence to it. After all, Walter Pater would note that Botticelli was "all sympathy," and not one to take Dante's extreme positions on sin and its punishments.[61] Botticelli's apparent distaste for Dante's categorical judgments may have led him to leave out the often gruesome details of eternal suffering that other illustrators have tended to focus on obsessively. Whatever the case, the lasting impression left by Botticelli's cycle of illustrations is much more closely aligned with the peace and pleasure of Dante's heaven than the violent episodes of moral instruction in his hell.

Dante's certainties of a Christian life after death were widely shared by his medieval contemporaries. The increasingly secular Florentine world of Botticelli and his fellow humanists

was much less enthralled by the promise of the afterlife. As the painter worked through Dante's one hundred cantos, one can only wonder about the degree to which the question of the human soul and its mortality weighed on him, for he left no written record or other testimony regarding his faith. All we have are his images. In his illustrations of Dante, the movement is from the topography, landscape, and terrain in *Inferno* to the dance between Dante and Beatrice in *Purgatorio* and *Paradiso*. It feels as though Botticelli went from trying, in a realist mania, to draw everything in hell—even Dante's cinema-like movements in *Inferno* 1—to exploring more personal and emotional realities in the last two canticles.

It is no coincidence that the only drawing in his life that Botticelli ever chose to sign was *Paradiso* 28. By then, years after his Nastagio panels and as he neared completion of his Dante cycle, Botticelli could truly claim authorship of a visual "epic" of his own and might have felt the urge to affix his name to it.

FIVE /

Late Style

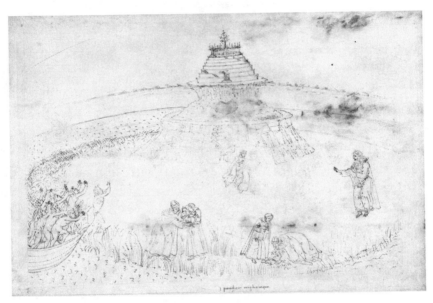

Botticelli, *Purgatorio* I.
bpk Bildagentur/Art Resource, NY

We assume that the essential health of a human life
has a great deal to do with its correspondence to its
time—the fitting together of the two. . . . But what of
artistic lateness not as harmony and resolution, but as
intransigence, difficulty and contradiction? What if
age and ill health don't produce serenity at all?

<div align="right">—EDWARD SAID</div>

B otticelli's completion of his Dante project in the mid-
1490s coincided with the end of another cycle: the
golden age of the Medici and the supremacy of their
juggernaut bank. If Botticelli had begun the Dante drawings
in the middle of life's journey, by the time he finished them
that itinerary was entering a taxing home stretch for both him
and Florence's first family.

In 1492, some of the greatest talents in Florence assembled
in the Medici villa in Careggi, brought together at the bed-
side of Lorenzo il Magnifico, who was in the last throes of a
mortal illness. His past few years had been filled with searing
headaches, itching skin, and pain in his joints so severe that he
could not pick up his beloved pen.[1] All assumed the cause was
gout, the same disease that had laid low his father, Piero—
though a recent study claims it may have been a rare hormonal
disorder, as evidenced by Lorenzo's abnormally large nose and
jaw.[2] Whatever the case, Lorenzo, like many Medici men, was
destined for an early grave.

The group at his bedside included Pico della Mirandola, a
young scholar so prodigiously—and precociously—talented

that he wrote his masterpiece, the grandiloquently titled *Oration on the Dignity of Man*, at age twenty-three. Alongside Pico stood the man rumored to be his lover, the philosopher, poet, and long-time Medici confidant Agnolo Poliziano, chronicler of Giuliano's Joust and advisor to Botticelli. Two years later, both the strapping Pico and Poliziano—a head shorter than his handsome friend and possessor of a nose so pronounced that he defended it in Latin verse[3]—would be dead, most likely poisoned in the prime of their lives (Pico at twenty-five and Poliziano at forty).[4] Violent death had become as much a Florentine trope as breathtaking art.

There was also a much less likely figure in the room that day, a stark contrast to the graceful Pico and charismatic Poliziano.[5] The lugubrious presence had hooded eyes, long beakish nostrils that put Dante's aquiline *naso* to shame, and dark skin to match his foreboding black cloak: Girolamo Savonarola, a member of the Dominican religious brotherhood long protected and financially supported by the Medici. The Mad Monk from Ferrara, as he came to be called, would soon give sermons that pushed Florence to the brink of civil war. But now his role was that of trusted member of the Medici inner circle—the very family that he would urge Florentines to overthrow.

Though he had survived the Pazzi Conspiracy, Lorenzo's last decade was a difficult one, and not just because of his physical ailments. His ill health was exacerbated by the stress of ruling an increasingly fractious city and running a faltering Medici bank. The ceaseless demands could make his more carefree early days, discussing philosophy with Poliziano and art with Botticelli over flasks of wine, and sending love lyrics to his muse Lucrezia Donati, seem like a distant memory. The fatalistic Lorenzo understood that his once-glorious life

was not meant to last. His chosen symbol was the tragicomic mask, a smiling face matched with its brooding and frowning opposite. He had learned to emulate the melancholic emblem from his teacher Ficino, who believed that life was an uncontrollable balance of good and bad, joy and pain, growth and decline. The three men who had gathered at il Magnifico's bedside each represented a different element of his multifaceted life: Pico, the humanist scholar who fed his indefatigable intellectual curiosity; Poliziano, the family philosopher who encouraged his bursting creativity and literary passions; and Savonarola, the zealot who nurtured his less-known and ever-conflicted spiritual side. Savonarola asked the dying Lorenzo to remain steadfast in his Catholic faith and, should he recover, devote himself to a life of virtue. He then recommended that Lorenzo face his imminent passing with fortitude.

Never one to be outdone, even on the brink of death, Lorenzo replied that he would embrace his mortality "with cheerfulness, if such be the will of God."[6] Soon after, on April 8, 1492, Lorenzo spent the day listening to gospels before retiring to his bed. Sometime before midnight, Florence's deeply flawed yet supremely talented prince breathed his last.

The fallout from il Magnifico's death was especially felt throughout the art world. Florence's painters and sculptors had lost their great patron and benefactor—along with the commissions that would have come from him. Botticelli had been part of Lorenzo's charmed inner circle from the beginning of his career.[7] Indeed, in Vasari's exaggerated words, had it not been for il Magnifico and "other worthy men," the aging Botticelli might have died of hunger.[8] But by the late 1480s, relations between il Magnifico and his cousin, Botticelli's leading patron Lorenzo di Pierfrancesco, had deteriorated. The "minor" Medici could no longer contain his resentment of his

more powerful, wealthier cousin. After il Magnifico's death, Lorenzo di Pierfrancesco saw his chance to become the number one man in Florence. Little did he know that he would soon face monumental resistance from one of the men standing at his cousin's deathbed.

This time of turmoil in Florentine politics was also a period of transition for Botticelli. Until 1490, he had used his workshop in a traditional way, painting the crucial parts of important commissions, especially the larger canvases that brought him fame, while his apprentices did the more artisanal tasks of preparing his materials, executing his designs, and decorating his work.[9] But as the century drew to a close, Botticelli seemed to lose interest in quality control, leaving his unevenly talented assistants with major responsibilities.[10] The works issuing from Botticelli's *bottega* in those later years are a stark reminder of how the symbiosis between a Renaissance artist and his workshop can confound our contemporary understandings of terms like *authorship* and *provenance*. It is often difficult to separate the work of the master from the hands of his disciples and apprentices.[11] As Berenson noted, even well-known masters "let their names be put to works which they had not touched at all or only slightly."[12]

Botticelli's *Holy Trinity* (1491–93) proves Berenson's point (Plate 14). The painting contains a jarring contrast of different styles and artistic levels. The putti, baby angels, surrounding the Trinity are schematically painted, giving the central section of the work a flat and workmanlike feel, and the anatomy of the scarecrow-like figure on the left is awkwardly aligned.[13] These perfunctory patches, all done by Botticelli's assistants, seem a world apart from the refined, beautifully executed but disproportionately small figures of Tobias and the archangel Raphael in the bottom left of the painting, most likely the

work of Botticelli himself. The painting was commissioned and purchased by the powerful Duke of Milan. It appears, to the naked eye, that Botticelli fobbed off a pastiche done mostly in the hand of his underlings on the unsuspecting duke.

But that was not how a Renaissance art patron would see it. By the 1490s, Botticelli was a star of the Italian art world. An emissary from the Duke of Milan touted him in a letter as the age's ranking artist, a "most excellent painter on panels and on walls. His things have a virile air and are done in the best method and perfect proportion."[14] Next in line, the agent wrote, was Botticelli's former apprentice Filippino Lippi, whose "things have a sweeter air, but I do not think that they have as much skill." Then came Perugino: "His things have an angelic and very sweet air," followed by Michelangelo's teacher, Ghirlandaio: "a good master on panel and even more so on walls. His things have a good air, and he is an expeditious man who executes a lot of work." For the age's tastemakers, Botticelli's *aria virile*, virile air, was far preferable to the *dolcezza*, sweetness, of his contemporaries.

For the Duke of Milan and his coterie, the presence of multiple hands, along with Botticelli's visual signature in the form of his miniature saints Tobias and Raphael, suggested the prominence of the artist and his *bottega*. Botticelli's workshop was in that select group that had achieved an early modern form of artistic mass production, as the highly sought-out painter struggled to meet the demand for his work. He remained a powerful brand. But the uneven *Holy Trinity* also signaled that the painter was not as thorough and committed as he had been when he broke into the Medici inner circle with his rare combination of natural skill, business savvy, and intense work ethic. By the 1490s, the young painter who had so quickly and decisively cashed in on Tommaso Soderini's sup-

port in 1470 for the commission of *Fortitude*, his first major work, had lost more than a step.

Yet, contrary to Vasari's assertions that he was running out of money, Botticelli was in sound financial shape at the time of il Magnifico's death. Two full decades of plum commissions and steady productivity were an unusually long stretch of artistic good fortune in those volatile times, and Botticelli seems to have been always a cagey negotiator of fees. He was able to save 153 florins during 1492–93, roughly equivalent to the annual income of a government official or skilled laborer—and a hefty amount of cash for someone with no dependents.[15] Crucially, this account shows that Botticelli earned his money from painting, so he was definitely not ignored or marginalized in the art world, as Vasari suggested. He was systematically saving money and carefully investing in property, even though Vasari falsely cast him as a lavish and profligate spender.[16] He was not rich, but he was certainly not poor. Other artists were paid more handsomely, especially Michelangelo and Leonardo.[17] But since one could live reasonably well on 70 florins a year with a wife and three children, a childless bachelor like Botticelli would have been more than comfortable on his earnings, which were roughly double that figure.[18]

The artist's preeminence would ebb with the death of Lorenzo il Magnifico in 1492. Pope Innocent VIII also died that year, creating a power vacuum throughout Italy and especially in Florence. Lorenzo and Innocent had been close allies: in 1487, the eldest son of the brazenly nepotistic Innocent, the dissolute Franceschetto, married Lorenzo's daughter Maddalena, and in return Lorenzo's son Giovanni was appointed cardinal at the unprecedented (and absurd) age of thirteen. The Medici would enjoy no such cozy relations with Innocent's successor, the Borgia Pope Alexander VI.

Meanwhile, a political storm was gathering across the border. The French king Charles VIII decided it was time to exploit the chaos in the Italian peninsula and press his claim to the Kingdom of Naples. In September 1494, he invaded Italy with 25,000 troops. He met scant opposition, a testament to the divisions among Italian city-states, their myopic independence rendering them incapable of banding together against a common foreign enemy. On his march to Naples, Charles invaded Florence, violating the historical alliance that il Magnifico had carefully cultivated. The French monarch's campaign provided the political opportunity of a lifetime to Lorenzo di Pierfrancesco and his brother Giovanni, who quickly set in motion their plan to seize power by joining the anti-Medici "Popular" party. By this time, Savonarola had also disavowed his lingering connection with the Medici family and was openly preaching against them and their sinful politics, though he refused to join any political party. The monk welcomed the invasion, believing it was God's way of punishing the Florentines for their many mortal sins. Meanwhile, Lorenzo di Pierfrancesco and Giovanni apparently calculated that an alliance with France and cooperation with the French invasion was a chance to cultivate their own ambitions—an act of high treason.

Charles marched into Florence on November 8, 1494—a day that would divide the life of Botticelli, and the fate of his Dante cycle, into a before and after. The hapless Piero de' Medici, utterly devoid of his father il Magnifico's charm and talent—and described by a contemporary as *"cattivo di tutti e vizi,"* guilty of all vices[19]—fled the city the next day, November 9, perhaps after having ordered the murder of the brilliant young scholar who had stood at his dying father's bedside, Pico della Mirandola, because of his support for Savonarola.[20] Four

days later, Lorenzo di Pierfrancesco and Giovanni, along with other enemies of Piero's—including suddenly rehabilitated Pazzi associates—returned to Florence under general amnesty. The Bargello walls were scrubbed of Botticelli's paintings of the hanged conspirators, erasing a gruesome reminder of Florentine civil strife and the cruel, categorical swiftness of Medici vengeance.

Lorenzo di Pierfrancesco and his cohorts sought, like il Magnifico, to become leaders by claiming to represent the will of people. But unlike il Magnifico, they refuted, at least outwardly, any visible show of power. They had the Medicean *palle*, the six balls on the family's coat of arms, removed from their houses and replaced by the people's symbol: a simple red cross on a white background. They even abandoned the Medici surname. Henceforth, Lorenzo di Pierfrancesco was to be called il Popolano, "of the People." He was positioning himself as the ultimate anti-Magnifico, in name if not in spirit.

Charles VIII quickly secured Florence with his troops, placing the city effectively under martial law. The Medici had been expelled and Charles's lieutenants and allies, including Lorenzo di Pierfrancesco, were now in charge. But then Charles, rather naïvely and precipitously, left to continue his journey south, where he was crowned King of Naples in 1495. Back in a divided Florence, Lorenzo di Pierfrancesco presided over a new city council that granted him extreme dominion. Thus, one Medici ruler replaced another in a political round of musical chairs that recalls Giuseppe Tomasi di Lampedusa's notorious dictum in *The Leopard*: "If we want things to stay as they are" (that is, for the noble class to retain its power), first and merely superficially, "things will have to change."[21]

But the new political regime installed by Charles and led

by Botticelli's patron Lorenzo di Pierfrancesco de' Medici was extremely fragile, especially without the French king's troops to maintain order. Florence, once again, descended into chaos and bitter partisan rivalries—illustrated, oddly enough, by an alleged forgery scandal from the early career of Michelangelo. According to Vasari, the young Michelangelo executed a small sleeping Cupid that so impressed Lorenzo di Pierfrancesco that he suggested Michelangelo should sell it as a pricey antique, a shameless move that casts the character of Botticelli's most important patron in an unflattering light.[22] In Vasari's account, Michelangelo took the advice. A nephew of Pope Sixtus IV, Cardinal Raffaele Riario, purchased the work on these false premises, but he quickly discovered it was a forgery and became understandably enraged. Yet, perversely enough, he was so impressed with the painting's artistic quality that he invited Michelangelo to Rome, a visit that proved fateful, for it was in Rome where Michelangelo would subsequently settle and produce the most exalted commissions of his career. The usual doubts about the truth of Vasari's story linger—but at the time it was fashionable for patrons to present recent works or even commission new ones that they would then pass off as antiquities.

Upon arriving in Rome, Michelangelo wrote a detailed letter back to Lorenzo di Pierfrancesco describing his meeting with Cardinal Riario, who would become one of the artist's patrons. Michelangelo signed the back of the letter with the instructions "Sandro di bottjcello in Firenze": in other words, once it arrived in Florence, the letter was to be hand-delivered by his friend Botticelli directly to their mutual patron. In this time of intense factionalism, any letter dispatched from Rome to Lorenzo di Pierfrancesco was likely to be intercepted by his enemies. To Michelangelo's mind, the safest intermediary was Botticelli.[23]

And it was Botticelli who may very well have played a role in strengthening the alliance between a resurgent Lorenzo di Pierfrancesco and the French king who had invaded Florence and subdued the once mighty Medici. The evidence suggests that as a gesture of goodwill meant to ingratiate himself with the French monarch, Lorenzo di Pierfrancesco may have asked—perhaps even ordered—Botticelli to complete his Dante drawings so that he could give them, in the form of a deluxe volume, to Charles VIII around the time of his invasion of Florence in 1494. Exactly when this ravishing present would have been made remains open to speculation, but it was most likely either when Charles was physically in Florence in late 1494, or soon thereafter in 1495 when he was crowned King of Naples—the volume would have made for a sublime form of congratulations.[24] The motivation for making such a gift was strong: Lorenzo di Pierfrancesco already had intimate ties with France, having served as Florence's French ambassador before the invasion, and his power base in Florence was entirely dependent on Charles's support. The connection between the two men was long-standing: when Charles was crowned King of France in 1483 at the tender age of thirteen, Florence sent Lorenzo di Pierfrancesco to console the young monarch on the death of his father and celebrate his accession to the throne.[25] The gift of a magnificent work of art featuring two of the city's most celebrated creators, Botticelli and Dante, would have been the perfect way for Lorenzo di Pierfrancesco to honor his royal protector during the power grab of his lifetime. And it would have been entirely in line with the Medici's practice of using art—especially Botticelli's—for political purposes.

If, in fact, the drawings were given to the French royal court in this manner, that would explain their relatively incomplete

and even hurried nature, especially those illustrating the lat-ter part of the *Commedia*, *Paradiso*. Botticelli had clearly been unable to execute his original plan of producing fully colored illustrations for the entire *Commedia*; the full-color *Map of Hell* was probably done at the very end of the project to pro-vide a visual key to Dante's best-known canticle.[26] The lone missing drawing, the blank leaf that was to contain the poem's final canto, *Paradiso* 33, suggests that Botticelli was indeed compelled to finish the commission by a sudden, immov-able deadline (it's not every day that France invades your city, even for the hyper-bellicose Florence of the Medici era). An order from his patron to deliver the entirety of his illustrations would have forced Botticelli, once and for all, to cease work on an on-again, off-again commission that his other numerous and demanding artistic commitments had consistently kept him away from. The command to cease and desist might even have elicited a sigh of relief: fifteen years is a long time for any-thing, especially a project whose completion was continually thwarted.

Fittingly, the final two drawings in Botticelli's Dante cycle, which were likely done around the time of Charles's invasion, were defined by erasure. In *Paradiso* 32, the painter removed all traces of his original sketch of heaven's architecture and a ring of angels, leaving only three small figures at the top of the parchment: Dante, Beatrice, and their guide, the mystic Saint Bernard of Clairvaux. The effect of the remaining, spare drawing is to elicit contemplation from the viewer while sig-naling the surpassing difficulty of rendering heaven's ineffable summit on paper. Dante himself summed up the challenge of representing the ultimate stage of his journey, which culmi-nates in one of the most dramatic—and uniquely joyous—endings in all of literature: the pilgrim comes face-to-face with

God and is given a glimpse into the mystery of creation: *"A l'alta fantasia qui mancò possa,"* "No effort of mine here could match the lofty vision."[27] The poem ends with what the reader imagines to be a scene of silent, awestruck contemplation: Dante engulfed by *"l'amor che move il sole e l'altre stelle,"* "the love that moves the sun and the other stars."[28]

The space that was meant for Botticelli's illustration of *Paradiso* 33 was left blank by the artist—and that is all we know because, shockingly, the page of this missing image has been lost.[29] Some have wondered whether Botticelli, in a kind of proto-modernist, avant-garde gesture, followed Dante verbatim and purposefully left this final leaf of *Paradiso* 33 empty to signify the surpassing majesty of the poem's final vision and its resistance to any attempt to represent it. It's doubtful that the modest, ever-practical Botticelli, an artist not given to theoretical inquiry divorced from hands-on applicability, would have conjured such an extravagant gesture. More likely, he simply ran out of time when Lorenzo di Pierfrancesco called in the work, and decided to consign his grand project with the final canto missing. A part of him must have realized how apt this possibly enforced omission was. The gradual movement of the *Paradiso* illustrations as a whole is toward minimalism and, as we see in *Paradiso* 32, cancellation. By then Botticelli had learned, as his project neared conclusion, to say more about Dante by drawing less. As with so much of the painter's life and work, we will never know his motivation for leaving that final leaf blank. It is now another of Botticelli's secrets, hidden in a mind that by the end of his Dante cycle had become, in the *Commedia's* own word, *imparadisato*: emparadised.[30]

A few years before his death, an already feeble il Magnif-ico wrote a paean to youth and sensual pleasure—"How beautiful is youth / which is forever fleeting / let us enjoy the moment / for tomorrow is uncertain." That season of unbri-dled joy must have seemed remote to a prematurely aged Lorenzo about to face his grave.

The pagan pleasure celebrated by Lorenzo would have also seemed distant to Florence as it descended into civil war after its beloved prince's death. In 1496, one year after the departure of the French troops, the heat of passion took on a very dif-ferent guise from the one depicted in Lorenzo's poetry. The city's boys and girls, dressed in angelic white gowns, stood at the head of a throng of people carrying, in the words of one eyewitness, "an amazing multitude of disgraceful statues and paintings" as well as "playing cards and dice, harps and lutes and cittrns and similar musical instruments, the works of Boccaccio."[31] The mob was led by a stooped friar swathed in a voluminous black cloak. With unusually large features and eyes bleary from lack of sleep and excessive reading, the man would never be accused of being handsome. But once he opened his mouth, few could resist his words.

Savonarola, the Mad Monk, was leading a massive Bon-fire of the Vanities, the ritual in which he and his followers cast supposedly immoral works of art, books, jewels, and decorations—many issuing from the city's famous *botteghe*—into purifying flames. Once a confidant of il Magnifico, Savonarola had come to despise the Medici and especially Lorenzo di Pierfrancesco. "I want to show you [Florentines] that your past [Medici] government was a monstrous govern-ment: it had the head of a lion, the back and rest of its hind parts were those of the dog. The lion's because the lion wants to be first," he cried in one of his *prediche*, sermons, to thou-

sands of worshipers gathered in the Duomo.[32] Florence now had a spiritual rock star, armed with a Bible and ready for warfare: cultural, political, and religious.

Frightened by Savonarola's massive popular appeal and the zealotry of his followers, Pope Alexander VI had issued a warning in early 1495 forbidding Savonarola from preaching, under pain of excommunication. But at the urgent pleading of Florence's ruling council, the Signoria, which was terrified of the civil unrest that would ensue from enforcing silence on the much-loved Savonarola, the prohibition was temporarily withdrawn. Savonarola was back at the pulpit in the Duomo by February 1495 and, a year later, the bonfires had become a common sight in the city.

There was one book that Savonarola would not burn. He peppered his speeches with one reference after another to the author who, like himself, had condemned the Florentine people for their avarice, corruption, and worldliness: Dante Alighieri.

As a Dominican, Savonarola belonged to an order celebrated by Dante in *Paradiso* for its intellectual rigor and combative skill in defending Christian doctrine. Such was Dante's respect that he called the order's founder, Saint Dominic, a "holy athlete" (*"santo atleta"*), as part of his ode to Dominican intellectual achievement, which he contrasted with the more emotional faith embodied by the "poor little man" (*"poverello"*) Saint Francis and his Franciscans.[33]

Savonarola and Dante shared more than a Dominican connection. Both loathed the materialism and love of money that had taken over their city. Dante longed for a Florence free from the dominion of the mighty florin, and his epic poem is filled with attacks on his fellow citizens' penchant for luxury and consumption—a far cry from the economically primitive

good old days of ascetic Florentines who supposedly cloaked themselves in animal hides and belts made of bone. Though Florence was much wealthier and in general enjoyed a higher standard of living in Savonarola's time than it did in Dante's, the friar had nothing good to say of his contemporary city. He denounced commerce on moral and political grounds, even though some of his Dominican predecessors had praised Florentine talent for industry and banking—understandably so, since that same wealth was underwriting the the city's prosperous Dominican order.[34]

Savonarola and Dante shared a crucial skill: they were both thinkers who could explain complex issues with brilliant flair to a broad public. Savonarola was a gifted communicator who expounded Scripture with such fervor that his eyes often filled with tears as he spoke. An observer declared that Savonarola transported his listeners to a new world where obscure religious formulas, mired in pedantic rhetoric, came to dazzling life.[35]

There was a final link between Dante and Savonarola that ensured the *Commedia* would never find its way into the bonfires. Both had a soft spot for apocalyptic thinking. They were fans of Joachim of Flora, a medieval Franciscan from Calabria who prophesied the birth of a new, spiritually pure age that would rise from the ashes of a destroyed, corrupt world. Dante reserved the lofty spiritual real estate of *Paradiso* 12 for Joachim—the canto where the leaders of the Franciscan and Dominican orders come to sing the respective praises of their founders. Dante honored Joachim with the title of *profeta*, prophet, an admiration echoed by Boccaccio in his tract *On Famous Women*. Savonarola went even further, predicting an end to the secular world, especially the Florentine version with its sensuous artwork, and a subsequent spiritual renewal based on Joachim's writings.[36]

For the Florentines who had witnessed Charles VIII's march into the city with his Swiss mercenaries, Savonarola's prediction that Florence would experience a scourge of punishment for its sins must have seemed prophetic. Remarkably, it had been Savonarola himself who met with the French king and his invading army in 1494, acting as the spokesman for Florence and convincing Charles to show the city mercy. The performance made clear to all Savonarola's political savvy and helped garner support for his anti-art message. For il Magnifico's tutor Ficino and his fellow Neoplatonists, beauty was proof of man's capacity at its best, and reflected his desire to find the divine in the earthly. This view held that beauty was by extension evidence of man's love for God. For Savonarola, beauty was instead an idolatrous distraction: it kept sinners tethered to the flesh and prevented their souls from ascending, ascetically, heavenward. So Botticelli, the artist who perhaps more prominently than any other had depicted the Neoplatonic idea of *la bellezza*, the beautiful, as a sign of heaven's love, suddenly found himself ensnared between two warring aesthetic camps—a newfound tension that changed the way he painted.

During the angry years of Savonarola's popular ascent, Lorenzo di Pierfrancesco and his brother Giovanni sought to create a new political party that could control the revolt of Savonarola's followers and prevent the return of il Magnifico's son Piero from exile. Savonarola quickly went on the counterattack. He gave a speech in which he accused Lorenzo di Pierfrancesco of wanting to become tyrant of Florence, aided by the powerful Duke of Milan, Ludovico Sforza. Savonarola so stirred up the people against Lorenzo di Pierfrancesco that in 1496 he was forced to flee abroad to Flanders for safety. Eventually, he confined himself, essentially under

self-appointed and luxurious house arrest, to his country estate in the Mugello. In the seven years up to his death in 1503, he would never again play a major role in Florentine politics. Nor would he ever commission new work from Botticelli. The fact that Lorenzo essentially disappeared from Botticelli's career after his failed coup adds weight to the thesis that he likely gave Botticelli's Dante volume to Charles VIII around 1494, for there would have been little motivation for him to make such an extraordinary gift in the years afterward as he drifted into political irrelevance.

During Lorenzo di Pierfrancesco's exile, Giovanni de' Medici became head of the Compagnacci (the Rude, Rowdy or Ugly Companions), a band of freewheeling libertarians devoted to resisting and overthrowing Savonarola, who had finally and formally been excommunicated by Pope Alexander VI in 1497. On Palm Sunday in 1498, the Florentine authorities arrested the Mad Monk in Piazza San Marco—on the "insistence of Giovanni," according to Botticelli's brother Simone Filipepi. In truth, the path to Savonarola's arrest was as byzantine in its twists and turns as Savonarola's life itself.

While debates raged in Florence among Savonarola's opponents and supporters, a Franciscan monk decided to settle the matter once and for all: by appealing directly to God. He and a follower of Savonarola planned to walk through fire together, and if one of them survived, they reasoned, then God's approval, or condemnation, of the Mad Monk and his prophecies would be manifestly clear. On the day of the Trial by Fire, the first in Florence in four hundred years, throngs led by Savonarola and his zealous followers gathered in Florence's ancient Piazza della Signoria to watch the ordeal. But nature intervened, with hail, lightning, and heavy rain. Savonarola's supporters claimed that the dousing was a miracle, proof of

their leader's blessedness. His opponents countered that it was dark magic, a sign that Savonarola was of the devil's party. A mob followed Savonarola and his Dominicans back to San Marco and murdered one of his most devoted followers, Francesco Valori.[37] Its back against the wall, Florence's divided government now saw no other option: Savonarola was arrested, in the hope of quelling the endless discord that he set in motion like a once untouchable moon over raging tides.

Six weeks later, after imprisonment and torture—during which he confessed to being a *falso profeta*, false prophet—Savonarola was led out to the Piazza della Signoria and hanged. Thousands of Florentines, many of whom had listened deliriously to his words just months earlier and burned books at his behest, cheered as his corpse blazed in an enormous bonfire.

A year and a half later, on November 2, 1499, Botticelli's brother Simone recorded a conversation with the artist :

Alessandro di Mariano Filipepi [Sandro Botticelli], my brother, one of the good painters who have lived in our city up to now, narrated in my presence at home by the fire, around the third hour of the night, how he had been discussing the case of Fra Girolamo [Savonarola] with Doffo Spini one day in his workshop. Actually, Sandro asked him for the pure truth, because he knew that the said Doffo had been one of the interrogators in the affair, always present to examine Savonarola. So [Sandro] wanted [Doffo] to recount what sins they found in Fra Girolamo by which he merited to die such an ignominious death. And so, in his turn, Doffo responded, "Sandro, should I tell you the truth? We did not find any in him, neither mortal sins nor even venial ones." Sandro asked, "Why did you cause him

to die so ignominiously?" [Doffo] replied, "It was not I, but rather Benozzo Federighi. And if this prophet [Savonarola] and his companions had not been put to death, but had been sent back to San Marco, the people would have destroyed us and cut us to pieces. The affair had gone so far that we decided that if we were to escape, they must die." And then other words were exchanged between the two of them which there is no need to record.

The author of these words, Sandro's brother Simone, was a passionate devotee of Savonarola. A successful businessman,[38] Simone regularly attended the religious rites led by Savonarola and seems to have been present at the dramatic moments of his arrest and execution.[39] In addition to being extremely devout, he was superstitious: Antonio Manetti, cartographer of Dante's *Inferno* and author of the short story about the fat woodworker, cited a letter in which Simone conjured up woodland sprites and other ghosts in human form.[40] This same credulity and naïveté apparently defined his relation to Savonarola. Simone was known to be quick to point out that all who resisted the friar eventually came to a violent end, yet he somehow overlooked the obvious contradiction of Savonarola's own grisly death.[41]

Despite his superstitious nature, Simone was also a person of learning and a bibliophile who appreciated Dante. His library contained a manuscript of Dante's canzone "Tre donne intorno al cor mi son venute" ("Three women close to my heart came to me"), which bears Simone's name, the date 1495, and the line *"dio bono fine faccj dj Luj"* ("may God bring him to a good end").[42] The brothers lived near each other in the Unicorn neighborhood where they were born and raised, and they were in constant contact. So Botticelli probably made

use of Simone's extensive library—the Dante manuscript was numbered 31 in the catalogue, suggesting a much larger collection. Given their mutual study of Dante, it is very likely that they discussed Dante together, and Savonarola as well, since Simone was preoccupied with chronicling his rise and fall and defending his actions at every turn.

Though Simone was a partisan of Savonarola, his diary seems to aim for clarity and objectivity. He records the meeting with his brother with precision (the "third hour of the night" was between 8 and 9 p.m.), and he does not make any claims about his famous sibling's thoughts or opinions. He just gives us his words. The man with whom Botticelli spoke, Doffo Spini, was a leader of Giovanni de' Medici's Compagnacci party and one of the examiners in the trial and torture of Savonarola. So Botticelli was at least on speaking terms with one of Savonarola's mortal enemies. That Spini should admit to Savonarola's intrinsic innocence ("We did not find any in him, neither mortal sins nor even venial ones") is as startling as the cold-blooded calculus with which he explains the decision to have the friar burnt at the stake ("if this prophet and his companions had not been put to death . . . the people would have destroyed us and cut us to pieces"). In Doffo's account, as reported by Simone, it was political expediency, no more and no less, that brought Savonarola, in Botticelli's own words, "to die so ignominiously."

Airing a widespread rumor with typical assertiveness, Vasari later claimed that "Botticelli was a follower of Savonarola's, and this was why he gave up painting and then fell into considerable distress as he had no other source of income."[43] Later commentators took Vasari at his word—without accounting for the fact that Vasari's staunchly pro-Medici views likely motivated his angry critique of Botticelli's supposed allegiance

to this Medici foe. In reality, Botticelli's connection to Savon-
arola, if it existed at all, was far more complicated than Vasari
reported it to be.

There is no record or conclusive evidence indicating that
Botticelli became a Piagnone, or Weeper, as the ascetic follow-
ers of Savonarola came to be called. Yet one glance at Botti-
celli's *Mystic Nativity* (Plate 15) from 1500–1501 shows that, in
the intensely spiritual air of Savonarola's Florence, something
had changed inside the painter because of the Mad Monk's
influence.[44] Tellingly, the Greek inscription atop the paint-
ing describes "the troubles of Italy," a reference to the intense
civil strife set in motion by the French invasion of Florence
in 1494, which culminated in Charles VIII's ascension to the
throne of Naples the following year.[45] The increasingly spiri-
tual Botticelli connected this political trauma to the Book of
Revelation and its talk of Christ's Second Coming, when the
devil would be vanquished and buried, as we see in the paint-
ing. The joyful iconography of earlier works like *The Birth of
Venus* and *Primavera*, with their pagan gods and goddesses
and air of rejuvenation and renewal, is nowhere to be found in
the *Mystic Nativity*.[46] Gone too is the celebratory spirit of Botti-
celli's drawings of a dancing Dante and Beatrice in the upper
reaches of heaven. Instead, we find a decidedly more Christian,
otherworldly vision that suggests spiritual apocalypse and the
afterlife of the soul: the painting situates us in that "end-of-
time" space featured in Savonarola's sermons.[47] Consistent with
Savonarola's teachings, the painter's heavenly realm has become
a much more austere, foreboding realm than it is in the Dante
drawings. A host of angels and saints have replaced Botticelli's
earlier pagan deities, and nowhere in the canvas does one see
the painted figure of an influential patron or youthful friend
or muse. The beauty is still there, but it is muted, almost with-

drawn, and the flowing grace of Botticelli's line has been transmuted into a more rigid, architectonic vision closer in spirit and design to Dante's medieval certainties and their inexorable hierarchies. As one commentator observed, in the later Botticelli "the triumph of puritanism is complete."[48]

The sober aesthetics of the *Mystic Nativity* adds plausibility to the theory that Lorenzo di Pierfrancesco gave the Botticelli volume to France's Charles VIII around the time of his 1494 invasion of Florence. The apocalyptic message and antisecularism of Savonarola is nowhere to be found in Botticelli's Dante cycle, which clearly belongs to an earlier aesthetic season, the 1480s, with their parade of paintings celebrating pagan themes and sensibilities. Indeed, a defining quality of Botticelli's *Paradiso* is the absence of the harsh spiritual air that permeates the canvases he painted in a Florence awash with the memories of Savonarola's raging bonfires. In contrast, the Dante illustrations proclaim that secular joy that Savanorola sought, literally, to incinerate.

The ideas promulgated by Savonarola and his attack on artistic vanity not only impacted Botticelli's late painting style; they altered others' perceptions of his work as well.[49] By the time of Savonarola's ascent, Botticelli had enjoyed a twenty-five-year run as one of the most successful painters in Florence. But times—and tastes—were changing.[50] He had always been primarily a domestic painter, designing his work for the private homes of wealthy clients, rather than creating the devotional paintings for churches and other sites of worship that were the bread and butter of rival *botteghe*. In Savonarola's Florence, there was less demand for the pagan, mythological works that had brought Botticelli acclaim. During the time of the Bonfires of the Vanities, desiring such an object of beauty was seen as a mortal sin. Even after Savonarola's death,

the painter was never able to reclaim his former popularity. A certain notion of graceful, secular beauty, Botticelli's trademark, had gone up in flames with the art and books burned at Savonarola's command.

By 1500, most of Botticelli's inner circle and many of the key figures of his life were either no longer alive (Lorenzo and Giuliano de' Medici, Savonarola, Poliziano, Simonetta Vespucci) or no longer in power (Lorenzo di Pierfrancesco). The painter was increasingly suffering from health problems, and his commissions were becoming scarcer. In a letter from 1502 to his mistress Isabella d'Este, the nobleman Francesco Malatesta wrote: "Another [artist], Alexandro Botechiella, has been much extolled to me, both as an excellent painter, and as a man who works willingly, and has no hindrances, as the aforesaid [Perugino and Filippino Lippi]."[51] The once-renowned painter had slipped into such obscurity that his name was misspelled, and former rivals once ranked below him were now surpassing him. Though he had labored profitably in the decades previous, around 1500 his finances took a dramatic turn for the worse, and he died in poverty—which is astonishing considering the assets he had accrued in earlier years, and that he had no dependents.[52]

The painter's story in the last years of his life is one of steady decline, with his workshop turning out occasionally inferior products under the not-always-watchful eye of Botticelli, who, according to one scholar, "spent at least as much time in managing as in painting" in his final decades."[53] He was suddenly plagued by debt, to the point that his brother Simone and nephew Benincasa di Giovanni were compelled to refuse his inheritance because it was "dreadfully onerous."[54] It is not that Botticelli stopped working. In 1505, he was in negotiations with a religious order in Montelupo, a small town outside

Florence acclaimed for its ceramics, for what would have been one of the largest panel paintings in existence by a Florentine artist. But the price was only 70 gold florins, a fraction of what Botticelli could have charged in his prime, and he was now working not for Florence's rich families but for a provincial organization.[55]

Mariano Filipepi's intuition about his *malsano*, physically compromised, son was proving prophetic. As Botticelli aged, he suffered increasingly from poor health. Perhaps, as he faced dwindling commissions and the loss of his regular patrons, he realized, as a fellow artist like Beethoven would centuries later, that "synthesis was not possible." The harmony promised in his earlier work was now only a younger man's impossible dream.[56] During this last period, in 1495, in the midst of the tumultuous Savonarola years, Botticelli is alleged to have painted Dante's portrait (Plate 16), a barely studied work that has become one of the world's most recognizable renditions of the poet—though we know precious little about its provenance and the circumstances surrounding its creation.[57] The subject's aquiline nose, firm lips, and prominent chin all suggest that Botticelli, if he did indeed paint the portrait, was familiar with portraits of Dante by predecessors including Andrea del Castagno and Domenico di Michelino.[58] Yet none of these artists had attempted anything remotely comparable in ambition and scope to Botticelli's *Commedia* cycle. The individual illustrations themselves contain many mini-portraits of Dante, some quite different from one another.[59]

In all likelihood, the portrait, which may have been done to adorn the library of a scholar, marked the end of Botticelli's direct artistic engagement with Dante as persona and poet, a fifteen-year period that rivaled in intensity and length Botticelli's other defining relationships, especially with the Medici

family.[60] For all their differences in social class and formal education, Botticelli and Dante were ultimately kindred spirits. Each spent almost two decades on a single creative project that consumed much of his mature creative life: Dante, his *Commedia*, and Botticelli, his illustrations of that same poem. They shared a common dialect, a mutual love for their native city, and an all-too-pervasive sense of the fragility of the beautiful works they were creating in times of unusual upheaval and violence. Botticelli may have begun the Dante project as a *pittore senza lettere*, an unlettered painter, but by the end he was a full-fledged *dantista*, Dante scholar.

According to Vasari, life after Dante was unkind to Botticelli: "old and disabled, he moved about on crutches . . . then, no longer able to work, infirm and decrepit, reduced to a most pitiable state, he passed away from this life."[61] In 1510, at the age of sixty-five, Botticelli was laid to rest in the Church of Ognissanti, in the same neighborhood and at the end of the same street where he had worked his entire life, save for one brief year in Rome. His grave is marked by a simple circular tombstone that reads:

Mariani Filipepi filiorum sepulcrum.
The sepulcher of Mariano Filipepi's children.

Just as in his illustration of Dante's *Paradiso* 28, the painter was identified not as an individual, but as belonging to the Filipepi family and its paterfamilias, Mariano. To the very end, the self-effacing workman known as Little Barrel kept off radar, where he would remain for centuries.[62]

~ PART 2 ~

Afterlives and Renaissances

SIX /

History's Lost and Found

Botticelli, *Purgatorio* 10.
bpk Bildagentur/Art Resource, NY

History is the one field of study that does not begin at
the beginning.

—JACOB BURCKHARDT

Giorgio Vasari was the opposite of Botticelli: a medi-
ocre painter, he was much better with the pen than
with the brush,[1] whereas the vastly more talented art-
ist Botticelli avoided the printed word, letting his paintings do
the talking. Written four decades after Botticelli died, Vasa-
ri's scant pages on the painter described an arc in freefall: first
the unwise turn to Dante, then the financial troubles of his
bottega, finally the surrender to the spiritual frenzies of Savo-
narola and the ascetic renunciation of painting. The story is
clean in its lines of cause and effect. But Vasari was never in
the business of fact. He was to the end a successful impresario
and winner of commissions, instrumental in founding Italy's
first art school, Florence's Accademia di Belle Arti in 1563,
and a favorite artist of the Medici after their return to power.
The *Lives* was meant to advance his career goals while telling
a captivating—and brilliantly written—story about the prog-
ress of Italian art. Arguably, Vasari invented *storia dell'arte*,
art history. In Italian, *storia* means both "history" and "story."
A dazzling mix of artistic analysis and rumor and innuendo,
Vasari's biography became Botticelli's obituary.

Ironically, Botticelli's Dante illustrations, especially *Inferno*
with its *Map of Hell*, embodied the skill prized above all oth-
ers by Vasari: *disegno* or drawing, which he called the *padre*
(father) of art.[2] Florentine painters' skill at *disegno* elevated

146

them above other Italian artists, Vasari argued, especially the more color-driven Venetians, whose focus on pigment and hue distracted them from the linear precision typical of Tuscan art—a claim that has been disputed by contemporary scholarship.[3] Mastering *disegno*, Vasari believed, did more than create brilliant draftsmen; it enabled artists to grasp "the animating principle of all creative processes."[4] No wonder that, years after Vasari's emphatic elevation of *disegno*, the artist Federico Zuccari, himself a noted illustrator of Dante, cleverly refracted the term into the anagram *segno di Dio* (sign of God).[5]

We can think of Botticelli as belonging to phase two in Vasari's evolutionary schema of Italian art: he was part of a transitional group of artists whom Vasari considered better than their medieval predecessors, creating work that was "well designed and free from error."[6] Yet, in Vasari's view, the work of Botticelli and his peers still lacked "any sense of liveliness" and "harmonious blending of colors."[7] In a true leap forward into a new era, Vasari wrote, an artistic god like Michelangelo "triumphed . . . over nature itself," by combining a realism, spontaneity, and energy missing in earlier generations through "the effortless intensity of his graceful style [that] defies comparison."[8]

Botticelli's relation to Michelangelo recalls Dante's to Petrarch. Though the two artists were born decades apart, Michelangelo in 1475 and Botticelli in 1445, they seem to have been good friends or at least trusted acquaintances, given that Michelangelo had asked Botticelli to hand-deliver an important letter to Lorenzo di Pierfrancesco de' Medici during his forgery scandal of 1496. But, as Vasari saw it, their art belonged to different eras entirely.

Though both were masters of *disegno*, Michelangelo's robust, muscled, flowing figures make Botticelli's seem slight and immobile in comparison. If Botticelli's Virgin Mary looks like

she is about to sashay gracefully off the canvas in the *Cestello Annunciation*, Michelangelo's Adam and Eve appear ready to come crashing out of the Garden of Eden like running backs plowing for extra yardage on the ceiling of the Sistine Chapel. Botticelli and Michelangelo did share a passion for what Vasari, speaking of Michelangelo, called *il suo famigliarissimo Dante*, "the Dante he knew most intimately." But they responded to the *Commedia* differently. Botticelli's Dante drawings, especially in *Purgatorio* and *Paradiso*, are sparse, suggestive, and refined. In contrast, Michelangelo's Dante-inspired forms brim with vigor. His *Final Judgment* (Plate 17), like Botticelli's *The Map of Hell*, is a vast spiritual chart filled with Dantesque coordinates.

At the bottom right of this apocalyptic work, where Jesus assigns each soul its place in the afterworld, the muscled boatman Charon batters the cowering sinners on the river Styx in terms directly relayed from Dante's *Inferno* 3: "The demon Charon, with his eyes like embers, / by signaling to them, has all embark; / his oar strikes anyone who stretches out."[9] But the most Dantesque moment of all occurs just below the left foot of Christ, where Saint Bartholomew displays the flayed skin of Michelangelo, hanging like an unworn cloak and recalling Dante's haunting lines from the Wood of Suicides in *Inferno* 13:

> Like other souls, we [suicides] shall seek out the flesh
> that we have left, but none of us shall wear it;
> it is not right for any man to have
> what he himself has cast aside.[10]

Michelangelo does something here that the more reticent Botticelli would have never dared: insert himself into the painting's action. Early in his career, Botticelli had discreetly tucked a branded self-portrait into the corner of his pro-Medici *The*

Adoration of the Magi. But Michelangelo goes well beyond this kind of visual signature, and stages his own post-mortem judgment. He was an accomplished author who produced a magnificent body of soulful poetry.[11] His literary melancholy found its visual analogue in his self-portrait as flayed artist, called to account for what he believed to be a lifetime of sin, perhaps related to guilt over his homosexuality.[12] Dante's verses thus became a transcript for Michelangelo's soul-searching.

It's fairly certain that Michelangelo never saw Botticelli's Dante drawings. By the late 1490s, he had moved to Rome, and there is no record of the deluxe volume commissioned by Lorenzo di Pierfrancesco circulating there until long after Michelangelo's death, when Queen Christina brought her eight drawings to Rome in 1668. Indeed, few if any of Botticelli's fellow artists were able to view his Dante drawings in the first centuries after the painter died. Some have argued that visual echoes of Botticelli's work appear in the Dante illustrations of Jan van der Straet, a sixteenth-century Flemish painter in the Medici court, also known by his Italianate alias Giovanni della Strada. It has also been alleged that Botticelli's Dante illustrations influenced the work of Zuccari, a widely traveled court painter who wrote the Vasari-like (though much less popular) *An Idea of Painting, Sculpture, and Architecture* in 1607. But these claims remain speculative.[13]

Michelangelo once said to his friend (and worshiper) Vasari, "You are a man who brings the dead back to life" and can "prolong the life of the living"—or make the living seem dead and the dead become forgotten, he might have added.[14] In the first two centuries after Botticelli's death, thanks in large part to Vasari, both the artist's reputation and his Dante project fell into the dustbin of history.

But at least the drawings still existed. Friedrich Lippmann,

the German connoisseur who rediscovered Botticelli in the nineteenth century, claimed that the lifelong *dantista* Michelangelo was also "known to have illustrated the entire poem [Dante's *Commedia*] with pen drawings made on the wide margins of a printed edition."[15] This unaccounted-for volume, Lippmann added, eventually passed into the hands of the Florentine sculptor Antonio Montauti, who died in 1740, and was lost at sea along with a parcel of the artist's other possessions. "A happier fate has guarded Botticelli's work," the German art historian concluded.[16] But this more fortunate destiny would prove bittersweet.

For one thing, the original unified set of the drawings was inexplicably broken up into two smaller units. At some unknown point, the lesser portion of the drawings became the property of a French collector who was closely connected to the royal court, Paul Pétau, a member of the Parliament of Paris for decades until his death in 1614. Pétau gave the illustrations to his son Aléxandre, who sold them, in a codex bearing his father's bookplate and dated 1632, to Queen Christina, an eccentric and freethinking woman who was one of the most important art collectors of her time.[17] After abdicating her throne in 1668, Christina moved to Rome, bringing along her share of Botticelli's project, which included *The Map of Hell* and drawings from the early cantos of *Inferno*. So, Botticelli's Dante project was privately held by powerful patrons and did not circulate. Like much of his art, which was once displayed in the most prominent places, the illustrations were receding from view.

~

After disappearing in the 1500s and 1600s, the bulk of Botticelli's whirling figures of Dante and Beatrice must

have languished on some overlooked shelf in a Parisian book-
shop belonging to Giovanni Claudio Molini. The descendant
of a long line of booksellers, Molini was born in Florence in
1724, toward the end of the Medici family's reign. Two years
after Botticelli's death in 1510, the Medici returned to power.
But they were not the Medici of before; they were much more
interested in accruing titles and riches for themselves than
they were in supporting public art. By the time the family line
petered out and the city passed into Austrian hands in 1742,
the name Medici was synonymous not with the versatile bril-
liance of prince–poets like Lorenzo il Magnifico, but rather
with the corruption and stagnation of a moribund political
dynasty on its last gilded legs.

It's not surprising that Molini decided to leave the backwa-
ter of Florence for the commercial opportunities of the cul-
tural jewel of Europe, Paris, where he began working as an
imprimeur–libraire, printer and bookseller, in 1765.[18] He pros-
pered, becoming official bookseller to the French king, Louis
XVI. Molini's close commercial ties to the French court, cou-
pled with his Tuscan background, would have been a strong
motivation for him to acquire the Dante illustrations from the
French king or whoever held the drawings at that time—
and add them to his already impressive collection of rare titles.
Regardless of how Botticelli's Dante volume came into Moli-
ni's hands, it was definitely in French exile throughout the sev-
enteenth and eighteenth centuries.

The Molini family combined scholarly acumen with entre-
preneurial energy to an exceptional degree: Giovanni Clau-
dio's brother Pietro, in London, was similarly appointed
Foreign Bookseller to the British Royal Academy by order
of King George II.[19] Meanwhile, Giovanni Claudio's shop in
Paris's Odéon district, near the intellectual heart of the city
in the Latin Quarter, specialized in precious volumes of Ital-

ian literature, from classic Renaissance works by Petrarch and Boccaccio to recent bestsellers like Cesare Beccaria's *On Crime and Punishment*, one of the first books to argue against capital punishment.[20] Molini also owned a pricey early edition of Dante's philosophical work the *Convivio*, from 1490,[21] one of his many exquisite holdings coveted by rich collectors.[22] But the scant scholarship on Molini does not even mention the Botticelli cycle. Few in Molini's eigtheenth century felt compelled to explore Botticelli's legacy, and the denunciation of the Dante project by Vasari had by then become the canonical view. Just as Queen Christina and then the Vatican had sequestered their eight illustrations in the late 1600s, Molini apparently kept his cache of the drawings carefully cosseted as well, as there is no trace of official correspondence or other inventory connected to the group before they were sold to the 10th Duke of Hamilton in 1803. Whether he knew it or not, Molini's silence at once enhanced the drawings' value and preserved their mystery.

Botticelli wasn't the only Florentine whose legacy was suffering in Molini's Paris. That era's spirit of skeptical, rational inquiry had little patience for Dante's hyper-Christian *Divine Comedy*. For many thinkers in the Age of Reason, Dante's age of faith was like a dangerous drug that had to be kept out of the libraries and away from the masses. A host of thinkers, from Immanuel Kant and David Hume to Thomas Jefferson and Denis Diderot, were openly critical of the medieval spirit, which Edward Gibbon went so far as to decry as "rubbish."[23] As one critic remarked, Botticelli's "Dante illustrations could not be admired until Dante himself again came to be so."[24]

One thinker in particular had it in for both Dante and his Middle Ages. François-Marie Arouet, alias Voltaire, can be

thought of as a father of today's public intellectual. Pundits who decry the latest scandal in the op-ed pages of the *New York Times*, analyze the current crisis on CNN, and pronounce their daily oracles on Twitter owe a special debt to this *philosophe*, man of letters, born in the seemingly remote time of 1694 yet blessed with the talent of always seeming contemporary and *au courant*. Everything about him, from his memorable quips to his extravagant habits and scandalous lifestyle—he was likely addicted to caffeine, gorging himself on coffee from morning to night,[25] and never married, spending nearly two decades in a passionate affair with a married female scientist—shouted freethinker. And few writers in history had his talent for the "viral" comment. *Si Dieu n'existait pas, il faudrait l'inventer*: If God did not exist, it would be necessary to invent him.[26] *Écrasez l'infâme*: Crush the loathsome thing (the Roman Catholic Church).[27] Phrases like those and many others became so well known that they graduated into slogans, serving as ammunition in the culture wars that Voltaire thrilled to fight. So widespread was his reputation that the entire age was named after him: *l'époque de Voltaire*.

In his widely read *Philosophical Dictionary*, Voltaire skewered Dante's highly personal and eccentric style for its lack of adherence to classical rules, calling it a *salmigondis*, hodgepodge.[28] And in a chummy letter to a ferocious Dante detractor in Italy, the Jesuit Saverio Bettinelli, Voltaire labeled Dante *fou*, crazy, and his work a *monstre*, monster.[29] As if these inflammatory remarks weren't enough, Voltaire delivered the clincher: "Nobody reads Dante anymore," he triumphantly remarked in his *Lettres philosophiques* (Philosophical Letters) from 1756.[30] Just as Botticelli had found a powerful enemy in Vasari, so had Dante encountered his nemesis in the self-appointed spokesman of the Enlightenment. Voltaire's fellow

philosophes were even more cruel: they did not attack this sup-
posedly crazy literary monster, Dante's *Commedia*. They just
ignored it.[31]

~

A few decades later, when the Enlightenment moment
receded—and when more emotion-driven movements
like the "cult of sensibility" in Britain and Sturm und Drang
in Germany arose in opposition to it—Dante's poetry began
to find less hostile readers and Botticelli's art less indifferent
eyes. Dante, in particular, experienced an astonishing revival.
He became a fixture for Pre-Romantic authors such as the Ital-
ian poet–patriot Vittorio Alfieri, who in a 1783 poem called
Dante *grande padre*, great father, a reverent move typical of a
new generation of Italian and European writers intent on har-
nessing the energies of Dante's iconoclastic vision.[32] In Ger-
many, the Schlegel brothers, August Wilhelm and Friedrich,
wrote a series of essays in the 1790s that emphasized the sym-
bolic power of Dante's *Commedia* and asserted its status as a
"Romantic" work—Friedrich Schlegel even labeled Dante "the
holy father and founder of modern poetry."[33] The name Dante
was becoming code for pure imagination and heroic resolve,
and writers were celebrating the *Commedia* for the very same
qualities that Voltaire and his peers had condemned it.[34]

The prime reason for Dante's international resurgence
was the sudden availability of his masterpiece in languages
other than Italian. The first French translation of *Inferno*, by
Antoine de Rivarol, appeared in 1783; it was followed by Ger-
man translations of the entire *Commedia* by K. L. Kanne-
giesser and A. F. K. Streckfuss two decades later. The first
English version of the whole *Commedia* appeared in 1802
by Henry Boyd, a prelude to the work that decisively res-

urrected Dante in Britain: Henry Francis Cary's *The Vision* from 1814, a brilliant rendition in Miltonic blank verse of *The Divine Comedy*, which drew the glowing praise of Samuel Taylor Coleridge and was read by Ugo Foscolo, John Keats, John Ruskin, and many fellow literati.[35] As one scholar put it, Cary's Dante, published in a handsome edition with the iconic illustrations of Gustave Doré, would come to "grace many a Victorian parlour table."[36]

Even those who disliked Dante could not help but weigh in on the once-ignored poet. William Wordsworth, a rare dissenter, called Dante's poetry "tedious" and dismissed it as a "German" metaphysical fad, the English poet's ultimate put-down.[37] Yet Wordsworth's hostile opinion actually said more about his opinion of Dante's sudden popularity than his interpretation of *The Divine Comedy*, a work whose intensely personal focus, quest for spiritual transcendence, and anatomy of the poetic process shared much with Wordsworth's own autobiographical masterpiece on the growth of the poetic mind, *The Prelude.* Politically conservative and personally tetchy, Wordsworth was lashing out not at Dante's work per se, but at a new group of radical, upstart, left-wing poets—the so-called second generation of British Romantic authors, led by Shelley, Byron, and Keats—who had adopted Dante as their model and inspiration, often while criticizing Wordsworth. The word *Dante* had become synonmous in Romantic England with a politically progressive, socially disruptive ideology that the traditionalist Wordsworth despised.

It was not only those on the literary summit who were preoccupied with Dante. Wordsworth's son-in-law Edward Quillinan was primarily a merchant and only a minor author, yet he too kept Dante close to heart as he entered his own private "dark wood," writing these words on the eve of his wife's death:

My Beloved Dora [Wordsworth's daughter] breathed
her last at one o'clock A. M.—less five minutes by the
stairclock at Rydal Mount.—*Io dico che l'anima sua
nobi[l]issima si partì nella prima ora del nono giorno del mese.*
["I say that her most noble soul departed in the first hour
of the ninth day of the month."] Dante. Vita Nuova.
Beatrice.[38]

Less than one hundred years after Voltaire had proclaimed
Dante's literary death, his work was being read widely enough
in English to articulate the thoughts of a grieving husband in
his most intimate moment.[39]

In this age of the Grand Tour, extended journeys to Italy by
wealthy Europeans who studied Italian in general and Dante
in particular were becoming fashionable.[40] For aristocratic
British boys trained in Latin, Italian was a sexy "modern" sub-
ject and welcome antidote to the dry grammatical exercises
that they associated with the dead languages of antiquity.
Even Wordsworth had turned to Dante and Italian literature
as an undergraduate at Cambridge, firing his budding poetic
imagination with this increasingly seductive form of academic
rebellion. From the drawing rooms of London to the quad-
rangles of Oxbridge, Dante's dark wood had become a place
to burnish one's bohemian credentials. Thomas Love Peacock
gleefully satirized the obsession with all things Dante in his
popular novel *Nightmare Abbey* from 1818:

I don't know how it is, but Dante never came in my way
till lately. I never had him in my collection, and, if I had
had him, I should not have read him. But I find he is
growing fashionable, and I am afraid I must read him
some wet morning.[41]

Echoing Peacock, Stendhal summed up the broader European Dante mania in 1823: *"le poète romantique par excellence c'est le Dante."*[42] Like Voltaire's punchy slogans, these quotable literary pronouncements were the equivalent of the celebrity tweet, signaling to the wider world that reading Dante was now *de rigueur.*

Botticelli's paintings inspired no such fanfare. Yet his work was also beginning to attract new interest around the time of Dante's revival. For centuries, his *Primavera* and *Birth of Venus* were sequestered by the Medici family and seen only by a hundred or so people. As Europe's wealthy tourists continued to flow into Florence and pour money into the city's museums and local economy, the government took action and seized Botticelli's two signature works, hanging them in the Uffizi Gallery in 1815. There, they began to draw attention, especially from the many British Grand Tourists in Italy, enhancing the painter's legacy—but slowly. Although the world now celebrates these two paintings for their images of feminine beauty, nineteenth-century critics still accused Botticelli of painting "ugly women" and "sad" or "peevish-looking" Madonnas.[43]

~

Born in Basel in 1818, at the height of European Dante mania, Jacob Burckhardt was the son of a Protestant clergyman and had even considered becoming a priest. But it was in Italian art, not the Christian God, where the creative adolescent found his highest calling. The patrician Burckhardts were one of their city's leading clans, and instilled in Jacob the sense of gentility and decorum that became his signature trait. The young Burckhardt was like the young Friedrich Lippmann: a product not only of wealth and privilege, but

also of a distinctly European notion of high culture and the value of tradition. Like Lippmann, Burckhardt would devote his career to disseminating and transmitting this cultural birthright—and to explaining the riches of the land he loved above all others.

At age thirty-five, that midway point in life established by Dante, Burckhardt spent two years collecting material for *The Cicerone: A Guide to Enjoying Italy's Works of Art*, one of the most influential travel books of the nineteenth century. Such was his passion for his adopted spiritual homeland that as a teenager he referred to himself with the roguish Italianate pseudonym Giacomo Burcardo.[44] Meanwhile, Burckhardt's *Cicerone* (an antiquated term for guide) established him as one of Europe's leading commentators on Italian culture. It also changed his understanding of his craft.

A historian by training and profession, Burckhardt had become increasingly disillusioned with the "grand march" notion of history articulated by Hegel: history as a monumental relay race, each successive society improving upon—as well as rejecting—the achievements of the previous one. Because Hegel's focus was on broad social and cultural trends, his sweeping view naturally privileged large political and economic forces. Burckhardt's cultural pilgrimage to Italy in researching *The Cicerone* inspired him to think otherwise. Whether he was staring at the stained glass of Milan's great cathedral (a practice, Burckhardt warned, that could damage the eyes) or marveling at Giotto's *Last Supper* ("one of the purest and most powerful works of the fourteenth century"), he came to believe that great art, just as much as great men and social forces, could make history.[45]

Burckhardt also believed that history should be taught not through abstract ideas and abstruse writings, but through the passionate personal investment of someone who has witnessed

its astonishing creations in person, felt their aura firsthand. In that sense, he was very much a latter-day Vasari: one who wrote of things he had actually seen, in some cases touched and felt. But unlike Vasari, who had no qualms about opining on works that he had *not* seen—such as Botticelli's complete set of Dante drawings—the buttoned-down Burckhardt never issued an insight without a scholarly sense of restraint and accountability.

The Cicerone appeared in 1855, the same year that the French historian Jules Michelet first used the term *Renaissance* as a broad historical category. Though Michelet was a political liberal and more progressive than the tradition-bound Burckhardt, they essentially agreed on the notion of the Renaissance as a time of unprecedented cultural rebirth. But Burckhardt went further. He systematically homed in on how the Renaissance had initiated a new phase in human history:

> In the beginning of the fifteenth century a new spirit entered the painting of the west. Though still employed in the service of the Church, its principles were henceforth developed without reference to merely ecclesiastical purposes. A work of art now gives more than the church requires; over and above religious associations, it presents a copy of the real world; the artist is absorbed in the examination and the representation of the outward appearance of things, and by degree learns to express all the various manifestations of the human form as well as of its surroundings (realism). Instead of the general types of faces, we have individuals . . .[46]

This passage from *The Cicerone* articulates the principles that have come to define our understanding of the Renaissance: a spiritual view of the world giving way to the secular,

an emphasis on individuality, and a devotion to scientific and realistic inquiry. As things turned out, Burckhardt's sojourn in Italy and study of its art would provide him with the field material that he later developed into a full-blown theory of the Renaissance.

There were political dimensions to both Michelet's and Burckhardt's understanding of that new term *Renaissance*. For Michelet, Italy's Renaissance was actually a code for the cultural rebirth of his own nation—many do not realize that the word appeared not in a study of Italy per se but rather in his monumental *Histoire de France*. When the French king Charles VIII brought his soldiers to Florence in 1494, Michelet argued, they could not help but breathe in the city's remarkable cultural air and imbibe its revolutionary ideas, which they then imported back to France. Though Michelet does not mention it, this royal envoy to Florence may very well have imported more than just concepts: Botticelli's Dante drawings were likely among Charles VIII's booty when he returned to Paris from the Italian front. The liberal yet moderate Burckhardt was deeply disillusioned by the failed European revolutions of 1848 and what he believed to be their overly leftist positions, a political sentiment that may have inspired him to argue that the birth of the Renaissance was fueled in part by the Italian model of the "state as a work of art," committed to bourgeois values and focused on the rise of the individual.[47]

Vasari's influence permeates Burckhardt's *Cicerone*. Scant pages of it are devoted to Botticelli, and the year of its publication, 1855, still found the once-acclaimed painter in the shadows among Europe's educated elite. According to Burckhardt, Botticelli "never thoroughly accomplished what he intended," echoing Vasari's notion of him as a profligate who wasted his talent and lived in "infinite disorder."[48] Burckhardt's dis-

missal is even more pointed and sustained than Vasari's: Botticelli "worked in a hurry," Burckhardt wrote in *The Cicerone*, leading him to produce work that was "rude and lifeless" and characterized by a "strangely mannered realism."[49] In a book filled with rapturous musings on many of Botticelli's fellow painters, the critical disdain is striking.

Around the time of Burckhardt's *Cicerone*, a leading art historian, Gustav Friedrich Waagen, viewed Botticelli's Dante illustrations in Scotland's Hamilton Palace, misidentifying them in 1854 as being by "various hands." He was likely in haste, as the Duke of Hamilton's collection was just one of many stops in an extended tour that led to the publication of his influential (though flawed) *Treasures of Art in Great Britain: Being an Account of the Chief Collections of Paintings, Drawings, Sculptures, Illuminated Mss., &c. &c.* The length of the title reveals how much ground the author had to cover, and how difficult it would have been for him to give the complicated Dante cycle more than just a passing consideration. Like Burckhardt's *Cicerone*, Waagen's massively ambitious, dilettantish work was filled with a combination of keen insights and gross error.

After *The Cicerone*, Burckhardt began what would be his most influential work—the book that, more than any other, continues to inform our understanding of Botticelli's Florence: *The Civilization of the Renaissance in Italy*. Published in 1860, it tackled a theme too vast to be treated systematically. But Burckhardt aimed to give readers the essence of the era rather than its facts and figures, and the writing itself brimmed with *sapore*, flavor. In the spirit of Dante, who wrote not in the dead scholarly language of Latin but rather in the living dialect of Tuscan, Burckhardt created an accessible history meant for the public.[50] "I have done everything I possibly could to lead [my students] on to acquire personal possession of the past—in

whatever shape or form," he wrote. "I never dreamt of train-
ing scholars and disciples in the narrower sense. . . . I know
perfectly well that such an aim may be criticized as fostering
amateurism, but that does not trouble me overmuch."[51] That
same amateur spirit that had inspired Burckhardt to write *The
Cicerone* would animate his study of the Renaissance.[52] No
wonder that early in his career he had remarked, "History, to
me, is always poetry for the greater part."[53]

According to some, *The Civilization of the Renaissance in
Italy* is even more important today than when it appeared one
hundred and sixty years ago, especially because of its sugges-
tion that human freedom finds its supreme expression in art,
not politics.[54] Others had likewise defined the Renaissance
by epochal changes such as the rise of the individual and the
rebirth of interest in Greco-Roman culture, but nobody until
Burckhardt had succeeded in weaving them together into a
narrative that reads as fluidly as a novel by Dickens or Balzac.

The personalities in *The Civilization of the Renaissance in
Italy* exude as much energy and force as their creative work.
And no figure is more vividly drawn or given more impor-
tance than the one who in Burckhardt's eyes seems to have
singlehandedly led Italy, mired as it had been under the yoke
of religion in the Middle Ages, charging into the Renaissance:

> [Dante] was and remained the man who first thrust
> antiquity into the foreground of national culture . . .
> the Christian cycle of history and legend was familiar,
> while the ancient was relatively unknown, was full of
> promise and interest, and must necessarily have gained
> the upper hand in the competition for public sympathy
> when there was no longer a Dante to hold the balance
> between the two.[55]

The pervasive Romantic notion of Dante as a "hero" clearly influenced Burckhardt: he celebrated Dante as a fearless character who overcame exile and all its challenges to write his mighty poem and journey to his Christian God, and who became the key figure in Italy's cultural *rinascita*, rebirth:

> ... in the whole spiritual or physical world there is hardly an important subject which the poet [Dante] has not fathomed, and on which his utterances—often only a few words—are not the most weighty of his time. For the visual arts he is of the first importance, and this for better reasons than the few references to contemporary artists— he soon became himself the source of inspiration.[56]

Dante represented what we now call, thanks to Burckhardt, the Renaissance man: he was the first in a long line of polymaths that included Agnolo Poliziano, the Medici courtier, advisor to Botticelli, and classical scholar who could read Aristotle and also paint Madonnas; Lorenzo il Magnifico, the Medici prince who could rule a state while also writing exquisite love verses; and Leon Battista Alberti, the visionary architect who could bend a coin with his bare hand and leap over a standing man. All of these successors were in debt to that first "all-sided" wonder and *uomo universale*, universal man: Dante.[57] An accomplished poet, musician, and artist in his own right before deciding to become a historian, Burckhardt had personal knowledge of what it took to be a Renaissance man.[58]

By Burckhardt's time, others among the age's leading historians were working to separate Dante the forward-thinking poet from his supposedly backward-minded Middle Ages. Michelet called the Middle Ages "bizarre and monstrous."

His close collaborator, Edgar Quinet, wrote that Dante "broke out of the tomb of the Middle Ages."[59] Burckhardt was far more measured: "For us the Middle Ages are infinitely great through the presentiment of what is coming, through their promise for the future."[60] But for others, like the Bishop of Nevers, the Renaissance was Satan's time. Perhaps so moralistic a view could be expected from a man of the church. But even in the realm of literature and art, many in the nineteenth century expressed dismay over what they believed to be the loss of religious fervor that accompanied the achievements of Dante. Victor Hugo, repulsed by the renewed fashion for Greco-Roman architecture in France, observed, "This was the decadence that we call the Renaissance. . . . It was this setting sun which we take to be a dawn."[61] Charles Dickens despised Michelangelo's Sistine Chapel, questioning how anyone with a shred of aesthetic judgment could find in it "any general idea, or one pervading thought, in harmony with the stupendous subject."[62]

For some, the values of the Middle Ages versus the Renaissance became a code for whether one believed in the life or death of God—especially for the age's most influential anti-Renaissance voice, John Ruskin. Raised in a London home that mixed a passion for Romantic poetry with deep piety, he was imbued with an enduring sense of nature as the mystical handiwork of God. From an early age, he was committed to drawing nature as it was, devoid of art-historical models and suffused instead with what he called divine harmony. He came to believe that the Renaissance had ushered in a godless, mercantile attitude that negated the spirituality of his beloved medieval period.[63] It descended like a plague ("the Renaissance frosts came . . . all [beauty] perished"),[64] and represented "a flood of folly and hypocrisy."[65] With the fervor of what one

commentator called a "modern-day Savonarola,"[66] he excoriated any artist who opted for Renaissance classicism and formalism over the more spiritual and romantic atmosphere of medieval art.[67] And he reserved even harsher judgment for those who based their work, as Botticelli did, on the imitation of great models rather than on their own instincts and intuitions.[68] Yet Ruskin would play a significant part in rehabilitating Botticelli's name, confirming Burckhardt's notion that history is indeed a field that rarely begins at the beginning.

Botticelli in Britain

Botticelli, *Purgatorio 31.*
bpk Bildagentur/Art Resource, NY

If the Botticelli goes cheap, of course, I'd like to buy it.

—DANTE GABRIEL ROSSETTI

Renaissance expression circulating in Victorian
England seemed made to order for the artist–poet
Dante Gabriel Rossetti: *Inglese italianato è un diavolo
incarnato*, an Italianate Englishman is a devil incarnate.[1] Born
in 1818, the same year as Jacob Burckhardt and when Dante's
popularity was surging, Rossetti was the son of émigré Italian
scholar and patriot Gabriele Rossetti, a distinguished profes-
sor of Italian at King's College, London.[2] From an early age,
the son shared his father's love of the mystical and Dantesque.
Though his first name was actually Gabriel, in print he put
his middle name first in honor of the *Sommo Poeta*, who rep-
resented the height of artistic creation for both father and son.[3]
As his brother William Michael wrote, Rossetti did more than
"read" Dante. He inhabited him.[4]

Well-born and high-spirited young artists of Italian descent
were a rarity in Victorian England, so Rossetti immediately
stood out in creative circles, especially because of his interest
in the occult. Physically beautiful, with long hair and a brood-
ing, Byronic aura about his lean frame, he studied painting
and poetry, all the while remaining under Dante's spell. Early
in his career, Rossetti began to collaborate with a group of
artists who shared his love for Italian Renaissance art—of a
certain vintage. Alongside painters including William Hol-
man Hunt, John Everett Millais, and his own brother Wil-
liam Michael, Rossetti longed for the decorative abundance,

rich primary colors, and precise draftsmanship of Italian art of the 1400s. They formed a society in 1848 and called it the Pre-Raphaelite Brotherhood because they believed that by the 1500s—the age of Raphael, Michelangelo, and Leonardo, which for Vasari represented the apogee of Italian art—painting had become mechanistic and mannered, lacking the verve and spirit of the previous century. In Raphael's elegance, they saw the corrupting model of an academic style. And in Botticelli, long scorned and forgotten, they found their aesthetic savior.

For the nineteenth-century Pre-Raphaelites, Botticelli's graceful yet mysterious forms embodied the moment they prized above all others, fifteenth-century, or *Quattrocento*, Italian art. The advent of international rail travel in Europe enabled many of the Pre-Raphaelites to make regular pilgrimages to Florence, where they could see, in person, masterpieces like the recently hung *Primavera* in the Uffizi. The Grand Tour, a prohibitively expensive rite reserved for the aristocracy, was giving way to modern tourism. Till then, the only artist who had based his work directly on Botticelli's Dante drawings was one of the Pre-Raphaelites: William Dyce, a Scottish painter and founding member of the Brotherhood, visited Hamilton Palace in the 1840s and modeled one of his canvases of Beatrice on Botticelli's version of Dante's muse.[5] But because of Dyce's limited reputation (and talent), his work did not have the impact of paintings by more brilliant colleagues like Rossetti, who would make the name Botticelli synonymous with timeless feminine beauty for the first time.[6]

Rossetti and the Pre-Raphaelites distilled their collective beliefs into a set of principles that Rossetti's brother William Michael defined thus:[7]

1, To have genuine ideas to express; 2, to study Nature atten-
tively, so as to know how to express them; 3, to sympathise
with what is direct and serious and heartfelt in previous art,
to the exclusion of what is conventional and self-parading
and learned by rote; and 4, and most indispensable of all, to
produce thoroughly good pictures and statues.

The manifesto's mix of idealism and pragmatism, from its call
for authenticity to its mandate of making viable art, reflected
Rossetti's own uncanny ability to live in the most unfettered
way yet still produce a vast corpus of riveting work on canvas
and in print.

In the late 1840s, in the Reading Room of the British
Museum—the same august space where Karl Marx, Virginia
Woolf, and Mahatma Gandhi, among others, would write—
Rossetti began to translate Dante's *Vita Nuova*, the poet's youth-
ful memoir of his love for Beatrice and apprenticeship in the
Sweet New Style. The book was more than gorgeous poetry
for Rossetti: it was a self-help guide that taught him how to
sublimate his passion for the virginal Elizabeth Siddal, the art-
ist's model who would eventually become his wife.[8] Rossetti's
rendering of the *Vita Nuova* remains stunningly fresh, despite
its flowery locutions and antique diction. Many still consider it
the best English version of Dante's text, since it recreates what
no other translation has since: the raw, unsettling, even hallu-
cinatory qualities of a work that combines elements as diverse
as earthly love, blinding grief, and intimations of eternal grace.

Meanwhile, the fame of the Pre-Raphaelites continued to
spread. In addition to being talented artists, they were relent-
less and shrewd self-promoters. And they understood that
there was one critic in particular whose good word would
legitimate them in the fusty world of Victorian art.

~

Looking back on his first sketch as an adolescent, the "many-sided" John Ruskin—like Vasari, he was a skilled drafts-man as well as a brilliant writer and thinker—recalled that from then on he never imitated anyone as he entered "on the course of study which enabled me afterwards to understand Pre-Raphaelitism."⁹ His magnum opus, *Modern Painters*, had appeared in 1843, five years before William Michael Rossetti's Pre-Raphaelite manifesto, when Ruskin was only in his mid-twenties. It would be frequently reprinted over the decades to come. It took a revolutionary position by arguing that the landscapes of a contemporary painter like J. M. W. Turner were superior to the works of the Old Masters. His iconoclasm pleased the Pre-Raphaelites, who relished Ruskin's language of originality and mysticism while sharing his willingness to reject the sacred canon of art history.

Despite Ruskin's highly publicized misgivings about the Renaissance, the Pre-Raphaelites did all they could to ingrati-ate themselves with him, realizing, as one scholar noted, that his support was the equivalent of a "blank check for an art-ist."¹⁰ Rossetti began to court Ruskin with a passion he usually reserved for the ever-changing women in his life. When he learned that the young critic wished to meet him, he wrote breathlessly, "McCracken [a patron of Rossetti's] of course sent my drawing to Ruskin, who the other day wrote me an incredible letter about it remaining mine respectfully (!!!) and wanting to call."¹¹ Punctuating the words like triumphant fist pumps, the three exclamation points say it all.

In 1851, Ruskin and Rossetti met for lunch at Ruskin's grand family home in Denmark Hill, a leafy London suburb.

Although they were roughly the same age, in their early thirties, the contrast could not have been more dramatic. The prim Ruskin, with his fastidious manners and well-groomed beard, looked much older than his guest, the proverbial wild child. Ruskin's lilting voice and stammer suggested a man more at home with beautiful words and pictures than the society of his fellow man—and woman. With his mix of brilliance and self-regard, he was likely to opine on anything from natural history, botany, and geology to mythology, public affairs, and of course the arts.[12] Rossetti, for his part, was just as effusive, so it must have been difficult for either party to get a word in edgewise. Not surprisingly, the luncheon was a flop, and whatever conversation might have arisen between the two was interrupted by the sad news of Rossetti's father's imminent death.

Ruskin would nonetheless go on to become the Pre-Raphaelites' patron saint, his writing providing the theory behind much of their practice.[13] Soon after his and Rossetti's ill-fated tête-à-tête, he wrote a letter to *The Times* of London openly defending the Pre-Raphaelites. And he used his considerable wealth to collect the work of its members, including Millais and the talented painter who was Rossetti's wife, Elizabeth Siddal.[14] Rossetti himself served as Ruskin's teaching assistant in the early 1850s for a course on drawing given to factory workers, an outcome of their common desire to bring art to the people. So intertwined were the fates of Ruskin and the Pre-Raphaelites that Millais actually ended up marrying Ruskin's wife, Effie, after she left him. Ruskin seemed to have treated his lovely bride as one of his prized artifacts: something to admire in the abstract but never actually touch (he was allegedly repulsed by the sight of her pubic hair).[15] The marriage was annulled on the grounds of non-consummation.[16] Ruskin remained a bachelor for the rest of his life.

In 1853, not long after his translation of the *Vita Nuova* and his meeting with Ruskin, Rossetti drew *The First Anniversary of the Death of Beatrice*, the basis for a painting of the same name (Plate 18). The Romantic atmosphere of the work, with its emphasis on Dante as the heroically suffering mourner, is offset by its historical precision and detail, reflecting Rossetti's cult of the medieval world, recreated here in lush, vibrant color.[17] The choice of scene is telling. The moment in the *Vita Nuova* when Dante draws an angel—an act that suggests Dante's potential skill as a visual artist[18]—comes amid the depth of his grief over Beatrice. Before her death, she had been a rather conventional muse in the manner of the Sweet New Style: beautiful and enchanting, yet ultimately generic and forgettable. But the real-life Beatrice Portinari's sudden death at age twenty-four from tuberculosis unsettled this neat artistic plan. Dante, person and poet, genuinely mourned. He could not get the death of his childhood infatuation out of his head. His public grief must have rankled his fellow poets. In fact, rifts were developing among the formerly bosom friends who sang of love and created a new literary school. Dante's best friend and the dedicatee of the *Vita Nuova*, Guido Cavalcanti, actually reprimanded Dante in a sonnet translated by Rossetti:

> I come to thee by daytime constantly,
> But in thy thoughts too much of baseness find:
> Greatly it grieves me for thy gentle mind,
> And for thy many virtues gone from thee.[19]

To this day, we can't say for sure why Cavalcanti was so disgusted by Dante's supposedly "abject life" and "dishonour'd soul," but the implication is clear: Dante's newfound cult of

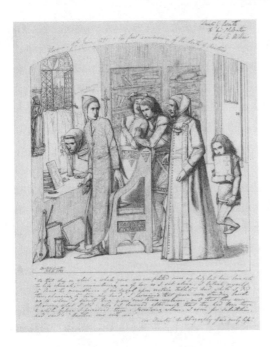

Rossetti's drawing,
*The First Anniver-
sary of the Death of
Beatrice.*
Bridgeman Images

Beatrice had no place in the principles and protocols of the Sweet New Style.[20]

The painting shows that Rossetti disagreed with Cavalcanti. The figure of Dante is sympathetic and strong, anything but the pathetic mourner. For the idealistic Rossetti, the haunted, mystical grief of Dante over his lost love was sheer poetry, the epitome of those direct, serious, and heartfelt qualities of art prized by the Pre-Raphaelites in their manifesto. To recreate Dante drawing an angel was to enter full-bore into the mystery of the *Vita Nuova*.

By the 1860s, Rossetti's hard living was taking its toll. He was prone to illness, terrifying mood swings, and chemical addictions. The accumulated maladies and destructive habits had aged him almost beyond recognition. His youthful beauty had thickened into a puffy body, his signature long hair was

shorn or gone, and his fleshy features were covered by an avuncular dark beard. Worst of all, he lost Siddal, his Beatrice, in 1862, to a drug overdose that may have been a suicide. The experience so devastated Rossetti that he buried a manuscript of his unpublished poems alongside his wife's corpse. By then, much of the early promise of Rossetti's prodigious talents was coming to naught, recalling Beatrice's words to Dante in *Purgatorio* about how rich soil will grow only weeds if it is "badly seeded."[21] Despite his precarious finances, Rossetti would have liked to amass an art collection to rival those of his higher-born and better-heeled patrons, especially his lordlike protector Ruskin. But his champagne dreams exceeded his beer budget, and he had accrued a list of disappointed creditors that was matched only by his record of jilted lovers.

Yet Rossetti always seemed to find a way to get what he desired, and now he wanted a Botticelli, whose work he had admired (and longed to collect) from as far back as 1849, the year of his *Vita Nuova* translation. In 1867, the moment finally arrived. One of Botticelli's early portraits, of the Florentine noblewoman Smeralda Bandinelli (also referred to by her married name, Brandini), was about to be auctioned at Christie's. Live auctions of Italian art were quite the thing in Victorian London, as more and more enthusiasts, many of whom had traveled to Italy, aspired to collect the nation's cultural treasures. One didn't need to have deep pockets—there were bargains to be had because of the vast supply of works coming into England from Italy and the unanswered questions that often lingered over their provenance. Doubts about authorship were baked into the price, lowering the cost of paintings that purchasers understood they were buying at great risk. Rossetti's cautious excitement fills his letter to his agent on the eve of the sale:

My dear Howell: I wish if you attend that sale tomorrow you'd let me know the result at once, by message or coming. If the Botticelli goes cheap, of course, I'd like to buy it if practicable but perhaps I'd better give up the idea. If very cheap, I would ask you to get it and [I will] pay you in a day or two.[22]

The low figure that the painting fetched the next day, as his agent Howell swooped in for the purchase, must have shocked Rossetti. For a piddling £20, a few thousand dollars today, Rossetti was able to acquire a work that now hangs in London's Victoria and Albert Museum.

Botticelli's *Portrait of a Lady Known as Smeralda Bandinelli* dates from 1475, around the time he painted *The Adoration of the Magi*. Its starkly hieratic beauty cannot but help recall the mysterious muses of the Pre-Raphaelites, especially Rossetti's late wife, Siddal. More than "prettiness," the painting exudes feminine power, and its hold is more spiritual than sexual (Plate 19). The portrait of Smeralda Bandinelli became an engine of inspiration for Rossetti, who reproduced its long slender hands, transparent gown, and direct gaze in new works.[23] His obsession with the painting even pushed him to do something at once sacrilegious and illegal. "My dear Howell," he wrote to his secretary, "I forgot to ask [your wife] Kate to tell you not to shriek when you see the Botticelli if others are here—I have been restoring the head-dress, but don't mean to tell."[24]

Restoring was a typically loaded Rossettian euphemism. According to his brother William Michael, Rossetti had "painted on the back of the head of his Botticelli, and improved it very sensibly—the previous condition of this part of the picture being obviously wrong, and I understand injured by previous cleaning."[25] Modern infrared technology shows that the

only area that Rossetti actually repainted was Smeralda's much-damaged white cap.[26] In any case, Rossetti had no formal training in art restoration and of course had no right to fiddle with Botticelli's original. But he was trying to get "inside" the painting, discover how Botticelli worked, and if necessary make adjustments that in his view corrected flaws caused by earlier handlers. For the first time since the artist's death in 1510, someone was so consumed by Botticelli's vision that he was willing to tamper with his handiwork—and risk arrest—in hopes of uncovering its mysteries.

Ever the opportunist, Rossetti's love for Botticelli's portrait did not keep him from exploiting it for profit: in 1880 he would sell the picture for £315, a tidy rise of nearly 1,500 percent from its original cost. Rossetti could not resist commenting, "I have turned dealer! . . . The idea of selling pictures you don't have to paint is certainly a very great one."[27]

Botticelli's work was not the only "resurrection" of Rossetti's from this time. In 1868, a year after purchasing the portrait, he petitioned to have Siddal's grave opened so that he could retrieve the book of poems he had buried with her in a spasm of grief. It was classic Rossetti: a wild act of unmediated passion followed by a dubious maneuver of calculated vanity. The verse would eventually be published by Ellis and White in 1882, the same bookseller that housed Botticelli's lost drawings, and the same year that Lippmann rediscovered them. Meanwhile, in the year Rossetti raided Siddal's grave, 1868, Algernon Charles Swinburne's "Notes on Designs of the Old Masters at Florence" appeared. The essay described "the faint and almost painful grace which gives a distinctive value and curious charm to all the works of Botticelli."[28] Botticelli was slowly becoming fashionable and, as William Michael Rossetti's words attest, Rossetti was a prime reason: "If [my brother Dante Gabriel] had not something to do with the vogue [of

Botticelli] which soon afterwards began to attach to that fascinating master, I am under a misapprehension."[29]

~

Situated in a small city about sixty miles from Rossetti's London, Oxford University in the Victorian age was in some ways the minor, modern equivalent of Renaissance Florence. Its extraordinary impact was out of whack with its small size: roughly half of Britain's first twenty-eight prime ministers—including the man who failed to take decisive action in the season of Lippmann's Botticelli acquisition, William Gladstone—held Oxford degrees, and its alumni included the likes of John Locke, Thomas Hobbes, and Percy Bysshe Shelley, to name only a few. Like Renaissance Florence, Victorian Oxford was a strange mix of worldly vision and navel-gazing. On the one hand, it was impossible to consider the cultural life of England, if not the world, without the contributions of its graduates. And yet, as in the highly regulated world of the Florentine *botteghe*, within Oxford's gated residential colleges the pettiest of grudges and most arcane of protocols (along with the most elaborate of pranks) persisted.

The divided spirit of Oxford in Rossetti's age was embodied by two critics who stood at opposite ends of its hierarchy: John Ruskin and Walter Pater. In 1869, just two years after Rossetti's coup in purchasing Botticelli's *Portrait of a Lady Known as Smeralda Bandinelli* for a song, Ruskin became Oxford's Slade Professor of Fine Art, one of the university's most prestigious chairs. The Slade professorship was offered only at Oxford, Cambridge, and University College, London. In 1871, Ruskin also founded an art school at Oxford, the Ruskin School of Drawing. Like Vasari, he was both an artist and an art historian, who yearned to see evaluators of art schooled in the actual

processes of creation. His reputation at Oxford preceded him, lending his pronouncements on art an oracular air.

Pater enjoyed no such pull. Born in 1839 to a modest middle-class English family, he began teaching at Oxford around the same time as Ruskin, but as a Reader, not as a chaired professor, and in the marginal subject of German philosophy. A closeted gay man who lived with his sisters, Pater would one day futilely aspire to the Slade professorship after Ruskin resigned from it. Like Ruskin, Pater was a full-blown aesthete who surrendered to the interpenetration of art and life. Both were staunch defenders of the Pre-Raphaelites. Ultimately, Pater matched Ruskin in intellectual acumen but lacked his remarkable capacity for systematic thinking, a deficit he more than made up for with what would turn out to be a new and revolutionary approach to how we look at art.

Despite the differences between the two men, personally and professionally, each would do more for Botticelli's legacy—and his Dante project—than anyone else in Britain, including Rossetti. Late in his career and soon after beginning his professorship at Oxford, Ruskin began to have a change of heart about Botticelli, most likely because of the Pre-Raphaelites. In *Ariadne Florentina*, a study of Renaissance engraving from 1873 based on a series of lectures, Ruskin took on Vasari, accusing him of failing to understand Botticelli's finances and, more broadly, the details of the painter's old age. He was especially harsh in criticizing Vasari's misreading of Botticelli's Dante project, calling it "a very foolish person's contemptuous report of a thing to him totally incomprehensible."[30] Instead, Ruskin countered, the cycle of illustrations represented "out-and-out the most important [work] in the history of the religious art of Italy."[31]

As influential as Ruskin's promotion of Botticelli was, it was not original—in fact, it came largely from Pater. On Sep-

tember 19, 1872, Ruskin had written to his secretary, "can you quickly ferret out anything about the last days of Sandro Botticelli—Vasari says decrepit & poor—I want to know what other accounts there are by Thursday next at latest [when Ruskin was set to lecture on Botticelli]—and can you find, or lend me, that paper on Sandro, which I was so pleased with, in some magazine last year, by an Oxford man [Pater]—you told me who, so must know."[32] Ruskin was referring to the series of articles that Pater had written about Botticelli and the Renaissance, which were about to be collected into a book whose influence would eclipse even Ruskin's own *Modern Painters* and come to rival Vasari's *Lives of the Artists*.

Published in 1873, Pater's *Studies in the History of the Renaissance* carries an innocuous-sounding title that masks its explosive contents. From the opening pages, it makes the critic himself the measure of all artistic meaning, while creating a new way of thinking called "aesthetic criticism":

The objects with which aesthetic criticism deals—music, poetry, artistic and accomplished forms of human life— are indeed receptacles of so many powers or forces: they possess, like the products of nature, so many virtues or qualities. What is this song or picture, this engaging personality presented in life or in a book, to ME? What effect does it really produce on me? Does it give me pleasure? and if so, what sort or degree of pleasure? How is my nature modified by its presence, and under its influence?[33]

Pater's deeply subjective understanding of art and emphasis on the pleasure of communing with visual beauty would shape the approach of connoisseurs like Bernard Berenson, who would stare at a painting for hours to establish mental

catalogues that could be used to authenticate and evaluate art for wealthy collectors. Wanting to expand the notion of the Renaissance beyond the mere revival of interest in classical antiquity, Pater spoke of the era as the "general excitement and enlightening of the human mind." He focused on Botticelli's fifteenth-century Italy because of its "special and prominent personalities, with their profound aesthetic charm."[34] By placing Botticelli alongside titans including Michelangelo and Leonardo, Pater infused the long-neglected painter with new cultural prestige.

For Pater, Botticelli was "before all things a poetical painter," capable of "blending the charm of story and sentiment, the medium of the art of poetry, with the charm of line and colour, the medium of abstract painting."[35] All those skills, Pater argued, led to a single all-consuming project: "So [Botticelli] becomes the illustrator of Dante."[36] Pater argued that the illustrations put to shame their medieval predecessors: "with their almost childish religious aim, [Giotto and his followers] had not learned to put that weight of meaning into outward things, light, colour, everyday gesture, which the poetry of the 'Divine Comedy' involves," he wrote, adding "before the fifteenth century Dante could hardly have found an illustrator."[37]

Pater's words represent the first ever sustained consideration of Botticelli's Dante drawings. Other than Vasari and the Anonymous Magliabechiano, who first mentioned Botticelli's Dante project in 1540, nobody had even commented upon the drawings in passing in the three centuries since they had been created, except for Gustav Friedrich Waagen, who in 1854 mislabeled them as being by "various hands." Pater meditated on them with all his critical might: "Botticelli's illustrations are crowded with incident, blending, with a naïve carelessness of pictorial propriety, three phases of the same scene into one

plate."[38] In some cases, Pater argued, Botticelli even surpassed Dante. A man of complicated faith who, like Jacob Burckhardt, had considered becoming a priest, Pater rejected the spiritual certainties of Dante's medieval vision and its unwavering, unforgiving judgements. He found Botticelli to be more humane and magnanimous than the poet he was illustrating:

> So just what Dante scorns as unworthy alike of heaven and hell, Botticelli accepts, that middle world in which men take no side in great conflicts . . . [Botticelli's] morality is all sympathy; and it is this sympathy, conveying into his work somewhat more than is usual of the true complexion of humanity, which makes him, visionary as he is, so forcible a realist.[39]

By accepting that "middle world" between heaven and hell, and refusing to judge the sinners whom Dante eternally condemns, Pater's Botticelli recoiled from the strict laws of punishment governing Dante's universe. What's more, for Pater, Botticelli typified "the uncertain and diffident promise which belongs to the earlier Renaissance itself."[40]

~

A decade later, in 1882, at the height of the Victorian cult of Botticelli that Ruskin and Pater had set in motion, Friedrich Lippmann stared at a large sheepskin parchment in Ellis and White booksellers, remarking that it was covered in its entirety with Sandro Botticelli's flowing line. With that flash of recognition transmitted from Lippmann's eagle eye, the rehabilitation of Botticelli entered its most dramatic—and expensive—phase. Botticelli's Dante cycle was about to mobilize the policies and purses of two of Europe's most powerful nations.

It was one thing for Lippmann to be certain he was behold-
ing a genuine Botticelli. It was another to secure the drawings
and initiate their transfer from British to German soil. The
auction block was an unpredictable, volatile space. Any collec-
tor with deep pockets could swoop in and claim their quarry
for the right price. So, Lippmann decided that he would try
to buy the entire collection of Hamilton manuscripts, Botti-
celli's Dante included—a signature tactic that had worked on
other occasions.[41] This preemptive move, he believed, would
enable him to purchase the drawings, and ensure his claim
to art-collecting immortality, before they went to auction. But
that option would cost a massive sum, around £80,000, or $7
million in today's currency, at a time when unlike the present
even wealthy collectors were not prone to offer stratospheric
amounts for a work of art, especially one of contested and mys-
terious provenance. In full understanding that the drawings
would go to the highest bidder, Ruskin, who had seen Botti-
celli's *Commedia* illustrations on a visit to Hamilton Palace in
1853, launched a campaign to raise the funds necessary to keep
the work in England.[42] But for one of the few times in his life,
the sage of Oxford would make a losing artistic bet.

Money wasn't the only issue that featured in the negotiations:
there was also patriotism and its resentful offspring, wounded
national pride. "This extraordinary treasure [Botticelli's Dante
drawings] ought not to leave England. . . . If our great English
families are obliged to sell their unique collections . . . the
nation ought to secure them."[43] So fumed Britain's Princess
Victoria in a letter to her mother, Queen Victoria, when she
learned of the possible sale of the drawings to Germany. Victo-
ria was placing love of homeland over love of husband: she was
married to Germany's Crown Prince Friedrich. Her misgiv-
ings were conveyed to the prime minister, William Gladstone,
an accomplished scholar of literature who had written beau-

tifully on Dante and other Italian icons, including Giacomo Leopardi.[44] Gladstone unexpectedly wavered: "The Botticelli Dante is I believe an affair of many thousand pounds. But it derives its value I imagine almost wholly from its being in fact a collection of [drawings] by Botticelli; a great artist without doubt; but I can conceive a question whether in this view it is altogether an appropriate purchase for a National Library." The convoluted syntax from this otherwise elegant thinker suggests his lack of clarity in this instance.

Luckily for the Kaiser and his new nation, Lippmann's thoughts were far less muddy. He was a cagey negotiator with politics on his side: after the foundation of the German Empire in 1871, Berlin was an imperial capital and expected to represent its new political force. The money was there because of the general economic upturn that followed upon Prussia's defeat of France in the War of 1870.[45] Convinced by Lippmann's arguments, the German government agreed to front the money. By fall of 1882, just a few months after Lippmann first laid eyes on the drawings, he officially concluded the sale. Botticelli's drawings were packed onto a steamer bound for Berlin. It would be more than a century, and after a harrowing set of events, before they alighted again on British soil.

~

A year after Lippmann's purchase, Ruskin claimed credit for Botticelli's rebirth in England in the 1883 edition of *Modern Painters*:

But I say with pride, which it has become my duty to express openly, that it was left to me, and to me alone, first to discern, and then to teach, so far as in this hurried century any such thing *can* be taught, the excellency and

supremacy of five great painters, despised until I spoke of them,—Turner, Tintoret, Luini, Botticelli, and Carpaccio. Despised,—nay, scarcely in any true sense of the word, known. I think, before the year 1874 [a mistake for 1872], in which I began work on the frescoes of Botticelli and Perugino in the Sistine Chapel, there will scarcely be found so much as a notice of their existence in the diary of any traveller, and there was no consciousness of their existence in the entire mind of modern Rome.[46]

The boast of having rediscovered Botticelli must have brought only cold comfort to Ruskin, considering that the Dante drawings were no longer on British but on dreaded imperial German soil. Even in defeat, Ruskin wanted to have the last word.

When Pater, normally reticent and soft-spoken, learned of the eminent art historian's presumptuous claim, he quickly demurred, writing, "A large part of my Renaissance Studies had previously appeared in Reviews or Magazines, among others that on Botticelli, which I believe to be the first notice in English of that old painter. It preceded Mr Ruskin's lectures on the same subject by I believe two years."[47]

Ruskin may not have been the cause of the Botticellian "vogue" (to use William Michael Rossetti's term), though his celebrity certainly did much to enhance it. Yet the doubts about Botticelli lingered, even among his greatest and brainiest fans. Even Pater asked, "is a painter like Botticelli—a secondary painter—a proper subject for general criticism?"[48] He was, Pater continued, "in the final tally no Michelangelo or Leonardo, whose work has become part of contemporary culture, and who have absorbed into themselves more minor artists and all such workmen as Sandro Botticelli."[49] Ruskin used similarly condescending terms, describing Botticelli as

the "greatest Florentine workman," that last word signaling Botticelli's humble roots and distance from more theoretically minded geniuses like Leonardo. Right around the time he praised Botticelli's work, Ruskin wrote to the powerful Harvard art historian and Dante scholar Charles Eliot Norton that he found Botticelli's paintings to be of a "strange hardness and gloom."[50] Ultimately, Ruskin could never fully accept either the artist or his epoch, writing in 1875, "Well, yes— Botticelli *is* affected, in the way that all men in that century necessarily were."[51]

In the autumn of 1881, a poem by Dante Gabriel Rossetti had appeared, an homage to *Primavera*, "For *Spring* by Sandro Botticelli," concluding with these words: "What mystery here is read / Of homage or of hope? But how command / Dead Springs to answer?"[52] More and more people were asking this very question.

The Eyes of Florence

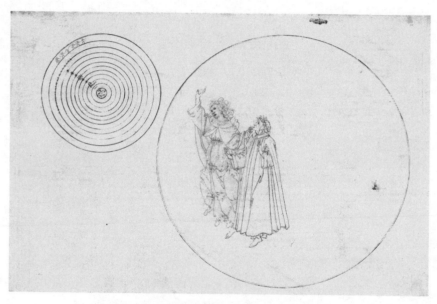

Botticelli, *Paradiso* 2.
bpk Bildagentur/Art Resource, NY

I revelled in the Botticelli Dante illustrations this
a.m., je me pâmais [I was in ecstasy].

—BERNARD BERENSON

Ever since university, Friedrich Lippmann dreamed of
building art collections for the broader public, not the
chosen few. His wish to democratize art had compelled
him to wrangle the drawings first from a wealthy but deca-
dent Scottish clan, the Hamiltons, and then from the British
Empire itself. Soon after they sailed into the port of Berlin
on November 1, 1882, Botticelli's illustrations of *The Divine
Comedy* were laid out on tables at the Kupferstichkabinett,
where teams of specialists descended on them, giving them
their first scholarly attention ever. The particulars of Botti-
celli's Dantesque lines could now be studied, catalogued, and
disseminated.

To maximize their exposure, Lippmann had the individual
illustrations removed from their binding in Botticelli's origi-
nal volume and exhibited as a series at the Kupferstichkabinett
from December 1882 to May 1883.[1] It may have been around
that time that the museum, shockingly, lost two sheets of the
priceless manuscript, containing the text for *Paradiso* 32 and
Paradiso 33. At the time, the printed canto facing each Botticelli
illustration drew little notice, and since those particular leaves
lacked images, they were likely deemed to be without value.[2]
Meanwhile, for the first time, non-royal, non-elite eyes were
able to behold Botticelli's luminous interpretation of the *Com-
media.* "The masterpieces selected from the collection were

each accompanied by pertinent explanatory text, and were kept either in sealed flat glass boxes or in solid, glass-covered frames," the Berlin *Archiv für Post und Telegraphie* reported.[3] Lippmann had succeeded in extracting the work from its rarefied perch and bringing it into living culture.

German media and cultural institutions continued to promote the Botticelli illustrations in the years to come.[4] The work came affectionately to be known in German as *der Dante*, the Dante, and, fittingly, Lippmann himself took additional decisive action on its behalf. In the Kupferstichkabinett's yearbook of 1883, he published the first extensive appraisal of the drawings, accompanied by collotype plates of selected illustrations. Four years later, in 1887, Lippmann followed up his yearbook with a scholarly blockbuster: a sumptuous book-length and actual-size facsimile of the entire cycle of the illustrations in the Kupferstichkabinett. Less than a decade later, this colossal edition—which one commentator called "not so much a 'coffee-table' as a billiard-table book"[5]—would be translated into English, which was becoming the lingua franca of the international art cognoscenti.

Though Lippmann's costly catalogue of reproductions was not widely distributed among the general public, learned societies and collectors throughout the world were able to acquire it. One no longer needed to travel to Rome or Berlin or wherever the drawings were physically housed to see them. Nor did one have to seek permission or an invitation from the work's wealthy and powerful past owners. Lippmann's college dream was now a reality. At the same time, and thanks to the business savvy of a small group of art historians in Botticelli's hometown, the study of the painter was about to become an industry.

~

In 1884, while Lippmann was introducing Botticelli's Dante cycle to new audiences all over the world, an elfin young man walked through Harvard Square. As he crossed into the Old Yard, his large eyes, fine features, and long delicate fingers formed a stark physical contrast to the nearby statue of the sturdy John Harvard, who sat in soulful contemplation, scanning the quad with the proprietary air of an academic lord.[6] The distance to the Yard from the young man's family home on 32 Nashua Street in North Station, a working-class enclave of largely Jewish immigrant families, was a mere five miles, a short carriage ride. But for this freshly matriculated student walking across a grassy expanse bordered by ivy-covered brick walls and filled with well-tailored young men carrying books and athletic gear, the journey must have felt like an expedition. For it had begun not in the Beacon Hill mansions and exclusive boarding schools familiar to most of his fellow students, but rather in the rutted streets of Butrimonys, Lithuania.

Nineteen years earlier, in 1865, the undergraduate was born Bernhard Valvrojenski. His bookish father, Albert, had planned on becoming a rabbi, but after emigrating with his family from Lithuania to Boston in 1875—when the ethnic-sounding Valvrojenski was Anglicized to Berenson—the realities of immigrant life pushed him into commerce, as it did most of the city's small Jewish community of five thousand. A daydreamer with little aptitude for the hurly-burly of business, Albert Berenson failed to give the family much material comfort in the New World, forcing his precocious son Bernhard, who eventually dropped the ethnic-sounding *h*, to go without a jacket in winter and study in an unheated room. But the

youth was so buried in his books and determined to leave the neighborhood of North Station that, as his wife, Mary, would write, "he hardly noticed the discomforts and privations he underwent."[7] Even in childhood, Bernhard's fierce intellect was matched by his equally intense drive and focus.

There was one place, both physical and symbolic, that the gifted young student yearned for above all others—a gated community in all senses of the word that was largely closed off to all but the most accomplished in his Jewish world. Gaining entry to Harvard became an obsession for Berenson, pushing him into a reading program more suited to a tenured professor than a teenager. By age fifteen, he had devoured Goethe, Milton, Dante, Heine, and the Persian poets as well as contemporary critics like Ruskin and Matthew Arnold. In a life of endless metamorphosis, the transition from Bernhard Valvrojenski, Jewish Lithuanian immigrant, to Bernhard Berenson, Harvard College class of 1887, was the most dramatic.

Berenson threw himself into the intellectual life of the campus, publishing in the *Harvard Monthly*, forming the OK literary club with fellow student and future philosopher George Santayana, and embarking on what he believed would be a career as a writer. His interest in Dante remained a constant. "Men at a given period are like the strings of an instrument," he wrote in a teenage diary entry, "and whenever they vibrate in accord with sufficient intensity they give forth a sound that is Homer, or Dante, or Shakspere [*sic*]."[8] The *Commedia* was sacred for Berenson, the intellectual equivalent of daily worship: "I get little time for reading, and that I employ in reading which I do every day, a canto of Dante, the prayers for the day, a couple of pages of Caesar, and several hundred lines of Milton."[9]

Berenson's immersion in Dante was natural. Boston was

emerging as the leading American, if not international, center for the study of Dante. Henry Wadsworth Longfellow's monumental translation of *The Divine Comedy*, in the eyes of many still the best in English (like Rossetti's *Vita Nuova*), had appeared in 1865 on the six-hundredth anniversary of the poet's birth. And in 1881, Longfellow, Norton, and the poet James Russell Lowell founded the Dante Society of America, one of the nation's first scholarly associations. Early members included such eminences as Oliver Wendell Holmes, Henry David Thoreau, and Ralph Waldo Emerson, who had translated the *Vita Nuova* in 1843. Just as Dante's work had conquered Romantic Europe a generation earlier, it now permeated America's leading cultural center.

At Harvard, Berenson buried himself in the pages of Botticelli's Victorian savior Walter Pater, whose *Studies in the History of the Renaissance* he learned "almost by heart." "Many a midnight I would come home and take it up," he wrote, "and meaning only to glance at a passage here or there, would read it cover to cover."[10] Pater taught Berenson to place absolute faith in his personal relation to a work of art. Just *looking* would become a holy rite for the budding aesthete. "We must look and look and look till we live the painting and for a fleeting moment become identified with it."[11] The task could occupy hours at a time. He would lose track of the world around him as he gazed, "trembling with nervous exhaustion" and even forgetting to eat, Mary Berenson would later note.[12]

But Berenson wanted more than cultural credentials. He wanted to combine prestige with worldly success, to be the toast of society and cut a glamorous figure—to be "the glass of fashion," as his beloved Shakespeare put it.[13] There was one faculty member who embodied Berenson's ideal: Charles Eliot Norton, whom many believed to be the most cultivated man

in America.[14] The descendant of Boston Brahmins, a cousin of Harvard's president, and a close friend of Ruskin's—he and the Victorian aesthete once made a pilgrimage to a Sienese fountain that Dante himself reputedly drank from[15]—Norton was a professor of art history at Harvard and a distinguished translator of Dante. He was such a stalwart promoter of Ruskin's medievalism that Harvard students liked to joke that when Norton died and went to heaven he would be repulsed by the pearly gates, crying, "Oh! Oh! Oh! So overdone! So garish! So Renaissance!"[16]

Berenson worshipped Norton from up close and afar, writing rapturously, "But [no man] has never made me feel so cowed, so humble, so ignorant, so dull, as Prof. Norton, by his mere presence does. . . . He is a perfect gentleman. He is in all things faultless."[17] Norton's passion for Dante inspired Berenson to write that, as a critic, Norton "surpasses any man of whom I know. How wonderful is this [when Norton said]: 'We have no man now to compare with Dante.'"[18]

In his senior year, Berenson finally mustered up the courage to write directly to Norton. "The feelings I have had in hearing you speak are like those that come to one when a dear friend speaks of the things that are nearest and dearest to both of them."[19] The clunky syntax and gushing emotion culminated in Berenson's admitting to Norton "how large a part of my consciousness you have become." There is no record of whether the snobbish, deeply anti-immigrant Norton even replied. Instead, his crushing opinion reached Berenson through a third party. "I cannot forget," Berenson would write sixty years later, "that when still an undergraduate at Harvard, Charles Eliot Norton said to [my professor] Barrett Wendell, who repeated it, 'Berenson has more ambition than ability.' Norton never changed his mind."[20]

The sting of the words, and the nagging fear that they rang true, never subsided. They became a dark source of inspiration for Berenson, pushing the young aesthete to disprove his higher-born professor, deeply a creature of the establishment. The time at Harvard gave Berenson the impression that he belonged to the world of money and success because of his talent and will. Yet it also reminded him that because of his bizarre name, immigrant origins, and outsider's religion, he would never sit among the elite as confidently and cozily as that statue of John Harvard. Or that uber-Wasp with the triple-barreled name, Charles Eliot Norton.

When Berenson was at Harvard, Isabella Stewart Gardner, wife of a wealthy industrialist, stood at the head of the city's cultural mavens. Her salons, often accompanied by music from the Boston Symphony, were one of the most coveted invitations in town. Gardner's graceful charm, artistic taste, and social standing quickly put her on Berenson's radar. After meeting her at one of Norton's lectures, Berenson managed to ingratiate himself with the heiress, likely impressing her with his quick wit and already formidable knowledge of art and literature. She began to invite him to her salons, and their early meetings included a public lecture by the British writer Edmund Gosse, who, as Mary Berenson wrote, "mentioned the sacred word 'Botticelli.'"[21]

Thanks to the influence of the Pre-Raphaelites and especially of Ruskin and Pater, the popularity of Botticelli was on the upswing in America, especially in Anglophile and Italophile Boston.[22] The publication in German of Lippmann's volume of Botticelli's Dante drawings in 1887 contributed to this rebirth, especially among Boston's Dante scholars, some of whom could read the original language. But not all of the city's *dantisti* were impressed.[23] When Norton learned that

Berenson was enthralled by Pater's essay on Botticelli, he reacted as though the undergraduate had smuggled pornography into his dorm room. Berenson, Norton wrote, should not fall under the sway of Botticelli's pagan Venus and her erotic energy, but rather strive to be a chaste "happy pilgrim" devoted to the Christian way.[24] Norton's puritanical resistance did little to suppress the new passion for Botticelli, who was suddenly of interest to America's most powerful collectors, including the Mellons, the Morgans, and, most significant of all, the Gardners.

Berenson's friendship with Isabella Stewart Gardner was anchored in a mutual love of Italy. Beyond her love for Italian art in general and Botticelli in particular, Gardner was also keenly interested in Dante. After consulting with Norton in 1886, she acquired a valuable edition of the *Commedia* that had once belonged to Ruskin: the celebrated Florentine volume edited by Landino in 1481 and containing engravings based on Botticelli's drawings.[25] As graduation approached, Berenson continued to dream of a literary career, and on March 30, 1887, he applied for a traveling fellowship that would enable him to pursue his vocation in Europe. "I am desirous," he wrote, "of devoting myself to the study of *belles lettres* towards which I have for many years felt myself strongly drawn . . . I am anxious to fit myself for the position of a critic, or a historian of literature."[26] Gardner helped fund Berenson's travel to Europe. But their friendship was never easy. Berenson had a lifelong tendency to alienate those closest to him, and Gardner could be fickle and thin-skinned. After Berenson's early time abroad, the two seldom spoke or corresponded for several years. Berenson apparently offended Gardner in some way, though we don't know how. The silence may simply have been the result of their large, conflicting personalities. No salon, it seemed, was big enough for the both of them.

In any case, the spell cast at Harvard by the Italophiles of Norton and Gardner inspired Berenson to take an unusual decision for someone of his precarious economic standing: after knocking about Europe for a while in pursuit of literary glory, including an unsuccessful attempt to study with Pater at Oxford, he resolved to move to Italy and live in Florence. Unlike the many wealthier fellow expats who had also settled in the Tuscan hills, Berenson lacked the means to fund a comfortable life abroad. But what he lacked in resources he more than made up for in other areas.

Florence was a Wild West of the art world. Despite the countless artistic treasures accumulated over the centuries, it had no laws on exporting art, which created a wide-open door for corrupt collecting. The city was so prodigal of masterpieces, and so lax about recording them, that a Titian was found in a pile of rotting linen, a Michelangelo languished at a junk dealer's, and a Leonardo was abandoned in a flea market.[27] One collector described Florence's art market as being as inexhaustible as the coal mines of England.[28] Priceless antiquities, from Etruscan vases and Greco-Roman furniture to Renaissance ceramics, could be scooped up for a few dollars.[29] A problem that all collectors faced, whether honest or underhanded, was the issue of provenance. In this pre-infrared age, it was difficult to establish whether a work was in the hand of the master himself or by his *bottega*, or if it was merely a copy or a fake. Stories abounded of collectors paying abundant sums for a supposed Leonardo or Michelangelo, only later to find that the work was bogus and their investment worthless.

Yet when the Italian government eventually passed a law limiting the export of the nation's art and antiquities, a group of Florentine dealers actually signed a letter of protest, making the astonishing claim that the legislation would halt the work of those supposedly "real artists" in the back of dealers'

rooms who were surreptitiously producing forgeries that were "a source of gain that percolates through the whole city."[30] Typically, Florentines wanted to have their artistic cake, real or fake, and eat it too.

The science of connoisseurship—the process by which an artwork came to be verified and authenticated—helped restore order to this chaotic market. The connoisseur has a long and complex history. Attempts to catalogue Italy's vast artistic treasures had included Jacob Burckhardt's *Cicerone* from half a century before Berenson's Italian sojourn, but that guidebook was by its author's own admission emphatically personal and amateurish, in the literal sense of "motivated by love," and made no pretense to objective authority. It contained many errors in attribution. Similarly, Gustav Friedrich Waagen's capacious *Treasures of Art in Great Britain*, which misidentified Botticelli's Dante illustrations as being by "various hands," was the sprawling, multivolume work of a single man quixotically attempting to catalogue an entire nation's art with only his own impressions and memory as guide. Despite their technical errors and misattributions, Burckhardt and Waagen provided an invaluable service by mapping enormous artistic terrains and, in Burckhardt's case, annotating that map with deft cultural history.[31] Building on these early attempts, a new generation of scholars brought increased rigor to the game of artistic authentication, fixing the technical errors and correcting faulty identifications.

A pioneering connoisseur was Giovanni Morelli, an Italian art historian who developed the "Morellian" technique of identifying the technical qualities and characteristics of painters through a systematic study of their minor details. His magnum opus, *Work of the Italian Painters* from 1880, became a bible to Berenson, who called Morelli the "inventor" of con-

noisseurship as a science.³² Berenson himself would be the first to synthesize Morelli's methodological exactness with Pater's intuitive aesthetic feel.³³ He also acknowledged his debt to the passionate amateurism of Burckhardt, noting that when he was a young man traveling around Italy, the Swiss historian's *Cicerone* "always went with me."³⁴

The conditions could not have been more auspicious for someone like Berenson to go beyond Burckhardtian art appreciation and leverage his skills for profit. One of his female admirers—and the small, charismatic man would have many in his lifetime—observed that he "seems to know everything about every picture that has ever been painted."³⁵ No detail was too tiny for Berenson's peregrine eye. Even something seemingly banal—as Berenson once asked cheekily, "What poet of the Renaissance indited a sonnet to his mistress's ear?"—could lead him into a breathless catalogue: "In most instances it is only a part of the ear which is characteristic. In Botticelli, for example, it is the bulb-shaped upper curve; in Perugino, the bony lobe; in the Bellini, the cavity; in Lotto, the distinct notching of the ear to the cheek; in Moroni, the *chiaroscuro*."³⁶ His minute observations extended beyond the human. Since "animals were rarely petted, and therefore rarely observed in the Renaissance," he argued, most painters tended to produce them in generic and undifferentiated forms.³⁷

Botticelli was at the center of Berenson's work. As early as 1892, his first year in Italy, Berenson wrote rapturously to his wife about gazing at *The Birth of Venus* in the Uffizi—that same work despised by Norton: "I looked at Botticelli's Venus, and never before did I enjoy it so much. . . . To bring us close to life is in one shape or another the whole business of art, and Botticelli in the Venus does bring us close to life. . . . You have

it in the toss of the drapery, in the curl of the flower, in the swing of the line."[38]

His joy in seeing the picture reminded him of "when I used to dream about it in Boston, reading Pater's description."[39] Pater, Berenson added, taught him to "love" Botticelli decades before he "understood" him.[40] Neither Pater nor Ruskin and the Pre-Raphaelites had been traditional "scholars" of Botticelli: they responded to him and his Dante project in a visceral and emotional way, with intimately personal views that could not be objectively set forth or argued.[41] It would be left to Berenson and his generation to assume the task, as one scholar noted, of "converting that opinion into knowledge."[42]

A similar thing had happened to Dante. The Romantic rediscovery of the poet was based on a questionable opinion: that Dante was a "heroic" individual. In fact, in much of the *Commedia*, Dante is trying to overcome or downplay his more individualistic tendencies. But it was precisely this surging sense of self that would captivate Dante's Romantic readers.[43] As so often is the case in literary history, it's not the "correct" interpretation that carries the day, but rather the compelling one. Similarly, Berenson and his fellow connoisseurs were now discovering qualities in Botticelli's work that would speak to the needs of the impending twentieth century, especially the Florentine painter's capacity to communicate a palpable love of earthly life in his interpretation of Dante's medieval vision.

Like Pater and Ruskin, Berenson could be ambivalent about the painter even while championing him. "Never pretty, scarcely ever charming or even attractive; rarely correct in drawing, and seldom satisfactory in colour; in types, ill-favoured; in feeling acutely intense and even dolorous—what is it then that makes Sandro Botticelli so irresistible that nowadays we may have no alternative but to worship or abhor him?" Berenson

asked, attesting to Botticelli's newfound cult.[44] Following Pater, Berenson was interested in the effect Botticelli's work had on the viewer, so he was willing to overlook the artist's supposed technical defects. As Berenson wrote, "if we are such as have an imagination of touch and of movement that it is easy to stimulate, we feel pleasure in Botticelli that few, if any, other artists can give."[45]

A clue to the Florentine painter's strange genius, Berenson concluded, lay in his Dante illustrations, which Berenson had seen in Lippmann's German volume of reproductions from 1887. Berenson later described them in terms of a "symphony [that] subordinates color to linear scheme," the handiwork of the "greatest artist of linear design that Europe ever had."[46] He spoke of Botticelli's magical "line which envelops, models, and realizes with such a vivacity and speed," adding "you quickly find yourself not looking at the form, but caressing it with your eyes, not contemplating, but living the action."[47]

Berenson was not the only one in his household to caress Botticelli's work visually. His wife, Mary Costelloe Berenson, was an accomplished scholar and connoisseur in her own regard. She moved to Italy with Berenson after leaving her first husband, an unusual and even scandalous decision at the time, and she would spend the next several decades as deeply immersed in studying the Renaissance as Berenson himself. A mutual passion for Botticelli and Dante sustained their domestic life. "Quite rainy days of reading and writing," Mary wrote in a diary entry early in their time together in Florence.[48] "Went to Uffizi. Reading Dante, Graf's Attraverso il Cinquecento, and Ruskin. Bernhard reading Dante and Vasari."[49] In a recently discovered unpublished essay from 1894, she described the "immense popularity among cultivated Anglo-Saxons of the fifteenth century artist, Sandro Botticelli."[50] Mary argued

that the craze stretched back to the Pre-Raphaelites and then Ruskin and Pater, all of them drawn to the fifteenth-century Italian painter out of "a dissatisfaction with the present that [led] them to take refuge in dreams of other ages."[51] Botticelli's work became overwhelmingly popular, she argued, because he expressed "the perplexity in [people's] own souls."[52]

The year of Mary Berenson's essay, 1894, Berenson published *The Venetian Painters of the Renaissance*, an instant success. Berenson was about to join the vanguard of the international art community. Perhaps this newfound prestige inspired him to reach out to Isabella Stewart Gardner and rekindle their long-dormant friendship, so that he could show her he had "made it." More likely, the ever-opportunistic Berenson knew that his wealthy and well-placed former friend could advance his career. His finances were precarious: he was dependent upon his unsteady income as a writer, and he and Mary needed to find more reliable means of support in order to stay in Italy and continue studying art. Gardner was now collecting Italian art in earnest and Berenson was in the perfect position to advise her. He sent his former mentor a conciliatory note lathered with flattery:

Your kindness to me at a critical moment is something I have never forgotten, & if I have let five years go by without writing to you, it has been because I have had nothing to show that could change the opinion you must have had of me when you put a stop to our correspondence. The little book [*The Venetian Painters of the Renaissance*] I now send is one for which I can count on more credit from you than from most people.[53]

From that moment on, they began to collaborate actively. That same year, Gardner purchased Botticelli's *Death of Lucretia*

with the help of Berenson, who verified its provenance and brokered the sale.

Gardner's focus on collecting Botticelli was still unusual for the time. Just two years earlier, in 1892, Botticelli's magnificent panel painting of Boccaccio's tale of Nastagio degli Onesti had actually been rejected by the Museum of Lyon, and only accepted by Madrid's Prado after it was included as part of a larger gift. Despite her prescience in anticipating the future value of Botticelli's work, Gardner could also be short on business savvy—a flaw that Berenson exploited. He was not always straightforward with the information he gave her, especially when it came to the price of a work, which at times he artificially inflated to ensure a higher commission for himself.[54]

Meanwhile, in 1896 the English translation of Lippmann's edition of Botticelli's Dante drawings appeared, nine years after its initial German publication, which only a small polyglot percentage of the anglophone world had been able to read. Finally, and for the first time ever, readers of English had access to reproductions of Botticelli's cycle of illustrations. Though the book was a deluxe volume that circulated primarily among elites, it was the first edition of the Dante cycle to reach a critical mass of art enthusiasts. Berenson reviewed it for the *Nation*— and had surprisingly little good to say of it. He criticized the drawings as being "not at all Dantesque" and even satirized them, commenting that Botticelli's attempt to represent Dante's capacious vision with line alone was "like playing Beethoven's 9th Symphony on the French horn."[55] But ultimately Berenson excused Botticelli's failures, conceding that "Dante does not lend himself to illustration." Even if he did, Berenson added, Botticelli would be the last man for the job.

The issue, reading between the lines, came down to Berenson's idea that the artistic visions of those two great Florentines were incompatible. For Berenson, Dante was all force and raw

vigor. The sweetness, grace, and surface beauty of Botticelli had no place in his medieval predecessor's ferociously doctrinal universe. Despite his reservations, if not hostility, Berenson did find some value in the illustrations, whose "pure rhapsodies of line" testified to Botticelli's artistic supremacy and made them worth a second critical look.[56]

Berenson's commissions from dealing in Botticelli and other Renaissance artists were making him rich, and his opportunites kept growing.[57] In 1898, Gardner built an institution whose suggestion of bygone beauty continues to entrance visitors to this day: Boston's Isabella Stewart Gardner Museum, the first American collection to focus exclusively on Italian Renaissance art, is housed in a grand building styled after the fifteenth-century Venetian Palazzo Barbaro. Gardner was especially keen on collecting more Botticelli, and Berenson was the obvious intermediary. Egged on relentlessly by Berenson, in 1899 Gardner paid a royal sum for the so-called *Chigi Madonna* in a bidding war. "I was for years the only critic who sustained that Botticelli's Chigi was genuine. I talked and talked about it," he wrote to her.[58] He also described the work as "the last universally accepted Botticelli on the market among his madonnas [and] it is the one of the noblest and grandest."[59] The Roman Prince Chigi first offered the painting to Gardner in 1899 for $30,000, more than a million dollars today. She demurred, but in time she changed her mind. By then the price had more than doubled. The sale was controversial in Italy, where many claimed that it was illegal, and Prince Chigi was even fined. But eventually the painting was transferred to the Gardner Museum, where it presently hangs.

Berenson was only the most prominent, and controversial, of a small group of expat scholar—dealers living and working

in Florence, all of them focused on resurrecting Italy's Renaissance treasures and all of them drawn to Botticelli. One of these connoisseurs, or "eyes" as we might call them, Herbert Horne, was born a year before Berenson, in 1864, and was a gifted artist in his own right, developing groundbreaking techniques for bookbinding and printmaking. Rigorously historical and allergic to any approach that emphasized personality over actual artistic process—which made him Berenson's opposite—Horne amassed a personal collection that would become the lovely Horne Museum on Florence's Via Benci. As a side hustle, he discreetly offered his services to the wealthy collectors who were increasingly swooping in on Florence's Renaissance art. Unlike the more avid Berenson, Horne brokered deals with his nose upturned, careful to keep what was then called "the picture trade" at arm's length.

As if in penance for all the money he was making as an art agent, Horne chose to live in an unheated garret in the future Horne Museum, devoting all the other rooms to his growing collection. The focus of Horne's painstaking research was Botticelli. When the British had agreed to transfer the Dante illustrations to Germany, Horne mourned the sale, writing, "an unrivaled monument of Italian art was allowed to leave this country [England], before any effort had been made to acquire it for the nation, and, indeed, before the directors of our museums had realized its importance."[60] Yet, he conceded, it was only when the cycle left England for Germany "that the drawings became widely known, or that Botticelli was acknowledged as their sole author."[61] Like Lippmann, Horne wanted precious art exhibited and discussed, not hoarded and bartered.

Another expat promoter of Botticelli was the mysterious Aby Warburg, whose impact on the field of art history would

outstrip Horne's and even Berenson's. The son of a wealthy Hamburg merchant, Warburg moved to Florence around the same time as Berenson and revolutionized the study of Botticelli with a new approach that dynamically situated the work of art in its cultural moment of creation. He showed how artistic form reflected the ways in which a given period thought and felt, its "mentality." As Warburg put it in his celebrated motto: "God dwells in the details."[62] In his dazzling interpretation of Botticelli's *Primavera*, which began as a doctoral dissertation, Warburg highlighted the role of literary sources, and revealed how the painter was influenced by his collaboration with Medici poet–philosopher Agnolo Poliziano. Warburg showed that Botticelli and Poliziano used classical models from Latin and Greek, both texts and images, to express previously submerged human emotions.[63] The flowing hair and draperies of Botticelli's goddesses, according to Warburg, were no mere decorative effects; they were codes of meaning that used ancient forms to express a radically new sense of reborn pagan feeling, which would become a hallmark of the Renaissance worldview.[64]

Warburg was one of the first to excavate the meanings layered beneath Botticelli's surface beauties and to show that Botticelli was not a mere "unlettered" artist, as Vasari had labeled him, but rather a sophisticated mind attuned to the Florentine rediscovery of antiquity and the intellectual energies of humanism. As a testament to Warburg's innovations, the Warburg Institute, a leading center for the study of the interaction between images, culture, and society, was founded in 1913 in Hamburg. During the years of Nazi repression in the 1930s it moved to London, where it remains today.

Of these pioneering Botticelli scholars, the one who devoted the most energy to Botticelli's Dante project was Horne.[65] In

his celebrated monograph *Alessandro Filipepi, Commonly Called Sandro Botticelli, Painter of Florence*—in the opinion of many, still the best study of Botticelli's life and career—Horne analyzed the 92 extant drawings in detail. All told, his section on the Dante illustrations takes up roughly one-fifth of a monumental work that took decades to write. Like Berenson, Horne had viewed the illustrations in the English translation of Lippmann's volume in 1896. "If we approach Botticelli's designs in the expectation of finding illustrations in our modern acceptation of the term," he wrote, "we shall have to confess with a recent critic that, 'as illustrations, these drawings will to most people prove disappointing.' "[66] That "recent critic" was Berenson. But Horne ultimately disagreed, countering that Botticelli had no interest in merely "illustrating" Dante's cantos; he was trying to communicate their essence. "These illustrations," he wrote, "were intended to form a pictorial commentary of the entire action of the 'Divina Commedia,' and viewed as such, they must appear to every student of Dante to far surpass every attempt of the kind, whether as a work of art, or as a pictorial interpretation of the poem."[67] Horne went further than even Lippmann or Pater in underscoring the stand-alone brilliance of the drawings. He proclaimed their genius.

Horne was especially rapturous about Botticelli's versions of upper Purgatory, writing that they stood out "from the rest of [his] drawings by reason of the sumptuous beauty of their design."[68] He brilliantly observed that the holy pageant honoring Beatrice must have reminded Botticelli of the great public processions of his age, which were often featured on *cassoni* or wedding chests, as Botticelli's unsettling panels on Boccaccio's tale of Nastagio had been.[69] Following Horne's cue, one wonders if perhaps that most spectacular public scene in of all Botticelli's life, Giuliano de' Medici's Joust of 1475 for the love of

the "peerless" Simonetta Vespucci, might have influenced his depiction of Beatrice and her heavenly parade. Whatever the case, Horne's verdict fully legitimized the Dante cycle in the eyes of the international art community.

Horne's *Alessandro Filipepi, Commonly Called Sandro Botticelli, Painter of Florence* was published in 1908 in a small edition of 240 copies, at the exorbitant cost of 10 guineas, or $1,200 in today's money. Difficult to follow and printed in fine blue ink on special paper, it was an unabashedly rarefied project. Yet it remains, in the words of the art historian John Pope-Hennessy, "the well from which later books on Botticelli one and all are drawn."[70] When Horne fell ill in 1916, less than a decade after his book's publication, his longtime friend and fellow Botticelli resurrector Aby Warburg rushed to see him in Florence, though Warburg was living in Germany, an enemy of Italy in World War I. Horne died later that year at the age of fifty-two, and a grief-stricken Berenson remembered him as a "living spring"—a *primavera*.[71]

NINE /
Berlin and Beyond

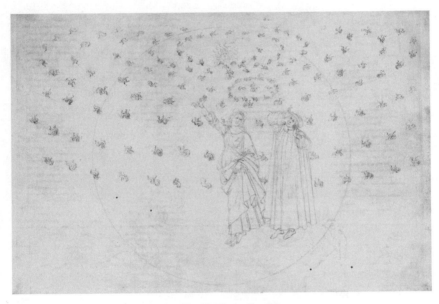

Botticelli, *Paradiso* 30.
bpk Bildagentur/Art Resource, NY

I opened the top [of the rescued crate] and drew out
an illustration . . .

—COLONEL MASON HAMMOND, WORLD WAR II
"MONUMENTS MAN"

In *A Room with a View*, published in 1909, just a few years
before Herbert Horne's death, E. M. Forster poked fun at
the holier-than-thou artistic pieties of the Reverend Cuth-
bert Eager, a snobbish aesthete modeled on a fellow Oxford
man, John Ruskin. Early in the novel, the beautiful English
ingénue Lucy Honeychurch ventures into Florence's Basilica
of Santa Croce, final resting place of the nation's great artists
and thinkers, from Michelangelo and Machiavelli to Gali-
leo and Rossini. Like many English tourists, she has come to
discover the Renaissance—but she has lost the guide for her
conventional middle-class tastes. Adrift without her Baede-
ker, the go-to tourist manual of her age that had supplanted
Burckhardt's *Cicerone*, Lucy stumbles onto a tour being led
by Reverend Eager, who is pontificating to a crowd of fellow
tourists: "Remember . . . the facts about this church of Santa
Croce; how it was built by faith in the full fervour of medi-
evalism, before any taint of the Renaissance had appeared.
Observe how Giotto in these frescoes—now, unhappily,
ruined by restoration—is untroubled by the snares of anatomy
and perspective."[1]

As if channeling Burckhardt, Michelet, and the host of his-
torians who had touted the Renaissance, a cry of dissent erupts
in cavernous Santa Croce:

208

"No," exclaimed Mr. Emerson, in much too loud a voice for church, "Remember nothing of the sort! Built by faith indeed! That simply means the workmen weren't paid properly. And as for the frescoes, I see no truth in them. Look at that fat man in blue! He must weigh as much as I do, and he is shooting into the sky like an air-balloon."[2]

The worldly, sensual Mr. Emerson has no patience for Eager's ascetic contemplation. He passes on to his son, the brooding George, the same passion for earthly pleasure and human emotion that compelled him to reject Eager's life-denying discourse. In the ongoing struggle between Renaissance secularists and defenders of medieval faith, Forster's verdict lands on the side of the Emersons and their pagan sensibilities. The phrase *a room with a view* has come to suggest how Florence embodies a site for rediscovering the power of art and, in the case of Lucy Honeychurch, awakening the soul. More broadly, Forster's novel offers a fictional coda to the historical narratives on the Renaissance from the nineteenth century.

Lucy and George's love is ignited by a stolen kiss in the Tuscan countryside outside of Florence—not far from Berenson's Villa I Tatti, soon to be the world's preeminent site for Italian Renaissance scholarship. A British aristocrat named Kenneth Clark was a frequent visitor, and traveled with Berenson in 1926 to help him on a new edition of *The Drawings of the Florentine Painters*. Clark would go on to become a leading public intellectual through bestselling books like *The Nude* (1956) and the television program *Civilisation* in the 1960s and 1970s. Fittingly, he would hold Ruskin's chair as Slade Professor of Art History at Oxford.

Clark spearheaded an army of critics and scholars who were pushing Botticelli and his Dante project into the cultural

mainstream. And yet, as one critic has perceptively argued, ultimately "the professors had little or nothing to do with the revival of Botticelli."[3] The typical academic did not "resurrect" Botticelli and his Dante illustrations, but rather added to an already existing foundation that had been created—in deeply individual ways—by Lippmann, Berenson, and Horne, and before them Ruskin, Pater, and the Pre-Raphaelites. By the time of Clark's work with Berenson, a chain of succession had been established, as teams of students and acolytes continued the groundbreaking work of those original generations of aesthetes, authors, and artists.[4]

Meanwhile, the word *Renaissance* itself had started to turn up in the most unexpected places. Far from Botticelli's Florence geographically and temporally, the Black philosopher Alain Locke wrote an essay in 1929 called "Our Little Renaissance," a call for America to reclaim Black cultural traditions, just as the Italian Renaissance had recuperated classical Greek and Roman forms.[5] Invoking the author who helped put Botticelli back on the map, Locke wrote, "I wonder what Mr. Pater would say," as he elaborated his notion that "the Negro Renaissance must be an integral phase of contemporary American art and literature."[6] In the racist atmosphere of the 1920s, Locke's view had its critics, with some accusing his Black Renaissance as being "imitative"—the same objection often raised against Botticelli and his antiquity-loving fellow artists.[7] Others questioned the connection to Africa of Black Americans, just as earlier skeptics had raised a brow over the supposed link between fifteenth-century Florence and the chronologically distant Greco-Roman world.[8] The artists themselves engaged the question, in poems like Countee Cullen's "Heritage," with its opening line, "What is Africa to me?" and Langston Hughes's "Godmother," with its plaintive

insight, "So long, / So far away / Is Africa."[9] Hughes's answer
to the challenge of remembering an Africa he never knew is
one that would have resonated in Florence's *botteghe*:

> Not even memories alive
> Save those that history books create,
> Save those that songs
> Beat back into the blood—[10]

The term *Harlem Renaissance* did not actually appear
until 1940, when Hughes wrote of New York's Black cultural
"rebirth" of the 1920s already coming to an end:

> That spring for me (and, I guess, all of us) was the end
> of the Harlem Renaissance. We were no longer in vogue,
> anyway, we Negroes. Sophisticated New Yorkers turned to
> Noel Coward. Colored actors began to go hungry, publish-
> ers politely refused new manuscripts, and patrons found
> other uses for their money. . . . The generous 1920's were
> over. And my twenties almost over.[11]

From that moment on, the tag *Harlem Renaissance* became
synonymous with artistic legends including Duke Elling-
ton, Louis Armstrong, Zora Neale Hurston, and Josephine
Baker.[12] The cultural rebirth in Harlem shares with Botticel-
li's Florence a defining element of all renaissances: the belief
that great art can create cultural unity, even confer identity.
In Botticelli's time, the Italian peninsula was a collection of
warring and fragmented city-states and regions—but the out-
pouring of astonishing works of art, especially in Florence,
now enables us to speak of a collectively "Italian" cultural
spirit that existed even when there was no political analogue.

Black Americans in 1920s Harlem, most of them descendants of slaves, overcame even greater obstacles. Their musicians, writers, and performers managed to forge a sense of cultural identity in a nation that had treated them with sustained brutality and injustice. But in both cases, the figures creating their renaissances were unaware of the label that would later frame their lives and work, when historians and critics had the time and perspective to pore over an earlier period's achievements.

~

The mix of nationalism and connoisseurship at the heart of Lippmann's purchase of Botticelli's *Commedia* cycle continued to define German cultural policy in the decades leading up to the world wars. While most German art institutions wanted native works on national themes, other museums, such as the German National Gallery, expressed a more liberal, cosmopolitan outlook—typified by Lippmann—and sought to acquire the best works regardless of their ties to the fatherland.[13] But everything changed with the ascent of Hitler.

In 1933, Hitler was appointed Chancellor and his Nazi Party established a totalitarian regime. The dictator hated cosmopolitan Berlin for its eclecticism and liberal spirit, embodied in artistic treasures that had come from all over the world. The Nazi policy of cultural isolation and protectionism was the opposite of the ideals of a "Renaissance man" like Lippmann, who had wanted to make art accessible to all regardless of nation or class. The Nazis put party sympathizers in high-ranking positions and removed many museum personnel, especially those of Jewish origin, as well as works associated with what they believed to be a decadent avant-gardism (what Hitler called "degenerate art").[14] The Nazi Party destroyed (or

secretly added to their personal collections) scores of modern artworks from Lippmann's Kupferstichkabinett, especially German Expressionist prints and drawings.[15] All told, the regime removed some 16,000 pieces of art from German collections, including 64 paintings, 26 sculptures, and 326 drawings from Berlin's National Gallery.[16]

As difficult as things were for the Kupferstichkabinett, the Botticelli drawings were far too prestigious, and far too aligned with Hitler's tastes, to suffer directly. In his youth as a painter, Hitler had produced hundreds of eerie works—often filled with steroidally large buildings dwarfing tiny stick figures. He even sold paintings and postcards for a living during his early years in his native Austria. His interests veered strongly toward the Classical with a capital and pedantic C, with a preference for the generically academic and traditional works of the Greco-Roman world and the Italian Renaissance. And he had a soft spot for Florence. Later, after the breakdown of the German alliance with Mussolini's Fascists, Hitler would spare the city's major buildings and artistic sites even as his air force bombed the rest of the Italian peninsula.[17]

At the height of his power in 1938, on a triumphant journey to Italy to meet with Mussolini and solidify their Pact of Steel, the German dictator and his coterie traveled to Florence, arriving on May 9.[18] Speakers were set up along the route to amplify the crowd's cheering embrace of Hitler as his train pulled into Santa Maria Novella Station at 2 p.m., where Mussolini awaited him. The two dictators toured the city's historic sites, including a several-hour visit to the Uffizi and a walk across Vasari's secret corridor above the Ponte Vecchio. While Mussollini was bored stiff by the sightseeing ("It would take a week to get through all this art," he muttered under his breath), Hitler was absorbed by masterpieces like Michelan-

gelo's *Doni Tondo*.[19] The visit fulfilled a dream for the Führer with artistic pretensions. Berenson declared it *"il giorno della vergogna,"* the day of shame.[20]

Given Hitler's ingrained passion for Italy's Renaissance art, there was never any danger of him calling Botticelli or his Dante project "degenerate." Eventually, however, the impending destruction of Europe would menace the Botticelli drawings. When World War II broke out on September 1, 1939, the danger to Europe's artistic patrimony was incalculable. The question of what to do with so much priceless art weighed on the minds of the Allied leaders. An American government plan led to the creation of a glamorous group called the Monuments Men, who were directly responsible for protecting Europe's cultural treasures—the first initiative of its kind in military history. The results were prodigious: after D-Day in

Deane Keller beside Botticelli's *Primavera* in the Castle of Monte-fugoni, a refuge outside of Florence where many priceless artworks were hidden during the war. *Pictures from History / Bridgeman Images*

1944, they visited up to 60 towns and 125 sites per month, rescuing countless works of art.[21] In Italy the Monuments Men included the likes of Deane Keller, an artist and professor at Yale who left his cushy post for military service when he was in his forties.[22] Like many other Monuments Men, he fought alongside soldiers half his age. His most daring feat was in Pisa's medieval Campo Santo cemetery, which lies close to the city's famous Leaning Tower. When Renaissance frescoes were severely damaged by shelling, Keller quickly moved to save them by bringing in a rescue team of soldiers and art experts. The frescoes contained images from Dante's *Divine Comedy*, including one that had also captivated Botticelli's imagination: the three-faced Satan.[23]

Meanwhile, the damage to Germany's artistic heritage was astounding. The most vulnerable site was the Nazi capital, Berlin. As the war began to turn increasingly against the Germans, Botticelli's illustrations, along with other priceless works from the Kaiser Friedrich Museum of the National Gallery, were removed from the Kupferstichkabinett and stored in one of the city's two *Flaktürme*, flak towers, massive storage silos with six-foot-thick concrete walls and heavy steel doors over all apertures. They served as bunkers for civilians, military personnel, and the city's art during bombardments. More ominously, they also functioned as platforms for anti-aircraft missiles. As Allied forces moved closer to Berlin, Hitler ordered the shipment of a trainload of art from the flak towers to a salt mine deep in the German countryside of Thuringia—a now infamous site where large amounts of Nazi gold and stolen works of art were later discovered by the U.S. Army.[24] Botticelli's Dante drawings were loaded onto that train.

After the shipment, and soon after the surrender of Berlin to the Soviet Army in May 1945, fire broke out in one of the flak towers. It was extinguished, but several days later a sec-

ond and more destructive fire raged. Three floors of the tower were ravaged, and their contents destroyed. The head of the Soviet fire brigade, Andre Belokopitov, visited the site just after the second fire was put out. After opening the heavy metal door, he watched as priceless ancient statues disintegrated right before his eyes, their marble vaporized by the combination of oxygen and extreme heat.[25] In the words of one of the Monuments Men, Colonel Mason Hammond, "Nothing remain[ed] of pictures, tapestries, porcelains, and sculptures except a deep bed of ashes, in which may be found bits of china and sculpture. . . . This loss bids fair to outrank even those of such cities as Munich, Warsaw, or Leningrad as the most serious single cultural loss of the war."[26] More than four hundred paintings and three hundred sculptures—some of the most cherished pieces of European art—were lost in the blaze, including Botticelli's *Madonna and Child with Angels Carrying Candlesticks* and his *Madonna and Child with the Infant Saint John the Baptist.*

After the defeat of Germany, Botticelli's Dante drawings were transferred from their Thuringian salt mine to a vault in Berlin that until recently had housed Hitler's Reichsbank. Cataloguing the chaotically strewn art in the former Reichsbank was akin to a complex military maneuver. One of the Monuments Men described wandering past "something like four hundred pictures lined up against the wall in a series of rows," as well as "leather-bound boxes containing the priceless etchings, engravings and woodcuts from the Berlin Print Room"—the Kupferstichkabinett, which had been the peacetime home of the Dante illustrations.[27] Mason Hammond also chronicled his arrival at the Reichsbank vault, where he discovered scattered boxes of treasure marked "Rembrandt" and "Rubens" and filled with other masterpieces, including the famous bust of Nefertiti. He surveyed the artistic chaos, then

randomly walked over to one of the boxes. "I opened the top," he wrote, "and drew out an illustration . . ."

It was from Botticelli's cycle of *The Divine Comedy.* The drawings had survived. By then they had covered hundreds of miles over hundreds of years, and a map of their itinerary would have included both likely (Florence, Rome) and unlikely destinations (Paris, Scotland, Berlin). But no journey would be as fraught as those two short train rides, first from Hitler's flak tower to the Thuringian salt mine, and then from the salt mine back to Berlin and the Reichsbank. The drawings were delicate, fixed as they were on ancient sheepskin parchment in delicate silverpoint sensitive to light. Despite their fragile state, they had now outlasted Hitler.

～

Born in Boston and educated at Harvard and Oxford, where he was a Rhodes Scholar, Mason Hammond would go on to become a professor of Latin at Harvard, where he spent his entire academic career, from 1928 to 1973. He also served as director of two of Italy's most prestigious cultural institutions, the American Academy of Rome and Berenson's Villa I Tatti in Florence, which the connoisseur bequeathed to Harvard in his will in 1959. A prolific scholar of Roman politics, Hammond was a beloved presence on campus, devoting himself to Harvard's history after his retirement and cataloguing and translating all the Latin and Greek inscriptions on its buildings, gates, and plaques. The "eyes of Florence," the professional class of connoisseurs led by scholar–agents like Berenson and Horne, could not have concocted a more suitable savior for Botticelli's Dante.

Yet the Cold War would prove to be as threatening to Bot-

ticelli's Dante illustrations as world war had been. In 1949, with the official founding of two separate German states, East and West, the original Kupferstichkabinett's collection was also divided. After the construction of the Berlin Wall in 1961, fifty-seven of Botticelli's illustrations became East German holdings, in the Kupferstichkabinett of the Staatliche Museen zu Berlin. The remaining twenty-seven became the property of West Germany, in the Kupferstichkabinett of the Staatliche Museen Preussischer Kulturbesitz in West Berlin.[28] East Berlin retained the lion's share of the drawings because it had the luck of geography on its side: the initial site of the Kupferstichkabinett happened to lie on the eastern side of the Wall.

Botticelli's splintered group now inhabited two distinct worlds and worldviews. The drawings in East Berlin were meant to symbolize the power and prestige of timeless art in a revolutionary society that, at least in theory, proclaimed itself free of the economic divisions and consumer culture of its capitalist enemies. In the spirit of Lippmann, East German politicians and their Soviet-backed sponsors argued that masterpieces by Botticelli and other internationally acclaimed artists belonged to the people: to workers, to society writ large, and not just to the moneyed classes that frequented museums and purchased art in the West. In reality, few East German workers, who were for the most part preoccupied with economic and political survival in their shortage-prone and massively surveilled regime, had the time or the will to meditate on Botticelli's Renaissance glories. And on the other side of the Wall in West Berlin, the drawings languished, rarely visited in this time of restricted movement and ideological warfare.[29] West Berlin's emphasis on future-oriented and modernist art rendered Botticelli's Dante drawings of scant interest in the intensely politicized city. Kenneth Clark summed up the dire

situation: in a Cold War Berlin divided into East and West, the illustrations were "not normally exhibited."[30]

International access to the illustrations was limited on both sides of the Wall. Western visitors were not welcome in East Berlin, and citizens of the Eastern Bloc were severely restricted in their ability to travel to West Berlin and elsewhere. International exhibitions combining the drawings were out of the question because of the strained diplomatic relations and lack of cultural exchange between East and West. For most art enthusiasts, Botticelli's Dante project was slowly fading into oblivion behind the Iron Curtain.

Meanwhile, on British and American college campuses and among art cognoscenti internationally, the illustrations were entering a scholarly golden age. Essays and articles, monographs and appreciations abounded, as Botticelli became a well-established academic subject, his name nearly synonymous with the Renaissance itself. In 1976, Berenson's protégé Kenneth Clark published *The Drawings by Sandro Botticelli for Dante's "Divine Comedy"* with a mainstream commercial publisher, Harper and Row, introducing the volume with a masterful (though not always accurate[31]) consideration of the gorgeously reproduced illustrations—made available by the three museums that held them, in Rome as well as in East and West Berlin[32]—and their complex history. His essay was the most insightful on the drawings to appear since Horne's tour de force in 1908 and, before that, Lippman's deluxe facsimile in 1887. While his predecessors Horne and Lippmann had produced pricey collector's editions of the illustrations, Clark created the world's first coffee-table version.

Only the end of the Cold War would make it possible, for the first time in their complicated history, for all of Botticelli's ninety-two extant illustrations of the *Commedia* to be brought

together and exhibited—jointly, and symbolically, curated by Germany's Kupferstichkabinett, Italy's Vatican Library, and Britain's Royal Academy in 2000. "The fortunes of Botticelli's Dante cycle encapsulate both the history of European collecting and recent German history," wrote Philip King, president of the Royal Academy.[33] The three nations that together had played the most prominent roles in the afterlife of Botticelli's Dante cycle mobilized in organizing a traveling show that passed through Berlin, Rome, and London, former sites of dispersion and division that were now celebrating Botticelli's unified vision of Dante. The series of exhibitions attracted the world's leading Botticelli scholars and led to numerous publications. The outpouring was reminiscent of the earlier "renaissance" of the drawings, when Lippmann had laid them out on tables for specialists at the Kupferstichkabinett in 1882. One hundred years later, the drawings were once again before the eyes of the public—this time on a global scale that even the committed cosmopolitan Lippmann could never have imagined.

D espite our distance from Lippmann and his original discovery, our ongoing conversations about the Renaissance owe a debt to him and his fellow art historians who resurrected Botticelli and his Dante project. Fiercely independent and often combative thinkers, Ruskin, Pater, the Pre-Raphaelites, Berenson, Horne, and Warburg were united in their wish to convey how and why the seemingly remote art of fifteenth-century Italy could matter to the present. The skeptical view is that those ancient Italian artistic practices suddenly "mattered" because they served practical and often selfish purposes.

For example, some believe that the myth of an "individualistic" Renaissance helped the committed bourgeois Burckhardt debunk the communist dream of the European revolutions of 1848, just as a rejuvenated idea of the value, cultural and financial, of Renaissance art helped Berenson become quite rich and Lippmann enhance the luster of the newly formed German state. There is an element of truth to such claims—and there is usually a fair amount of ego and ambition inspiring those who make history. But the Renaissance has meant and continues to mean more to the many worldwide captivated by its art and history. The rediscovery of Botticelli's Dante unquestionably helped fuel those meanings.

Historically, the term *Renaissance* is invoked whenever a critical mass of innovative minds come together to rethink tradition and then, through intense collaboration, produce original works that have transformative effects. In the United States alone, the word has been applied to phenomena as varied as Washington, D.C.'s monumental architecture and Silicon Valley's technological breakthroughs, as well as the cultural ferment in 1920s' Harlem, to name only a few.[34] In the case of Botticelli's Dante cycle, the nineteenth- and twentieth-century thinkers who rescued it from its Vasari-induced oblivion believed that the drawings epitomized three key qualities that were essential to their notion of the Renaissance writ large.

First, the illustrations embody what Burckhardt called Renaissance "many-sidedness." In taking on Dante's poem, the painter Botticelli showed that he was a brilliant reader of literary texts. His ability to move fluidly from one artistic medium to the next was a quintessential Renaissance trait, one that thanks to Burckhardt we now see as a driving force in the rebirth of Italian art after the Middle Ages. While few, and not even Vasari himself, doubted Botticelli's skill with the

brush, it was his talent for literary interpretation that enabled him to produce a work filled with insights into Dante's poem.

Second, Botticelli's Dante cycle offered its later interpreters visual proof of how the Renaissance period broke with the spiritual doctrine of its medieval past and moved in a more rational, science-based direction—the "early modern" world of the Florentine humanists. Especially in Pater's reading, Botticelli's illustrations translate or "carry over" Dante's vision into a Renaissance key, thus announcing the advent of a new historical age.

Third, Botticelli's modern champions saw in the drawings a world-changing "Florentine ethos." The names Dante and Botticelli were inextricably linked, as were many fabled Renaissance creators, to the city of Florence. And through this link Botticelli's cycle was also connected to the preeminent Florentine family, the Medici. That banking clan's patronage of the arts revealed a defining quality of the Renaissance for many nineteenth-century historians, including the most influential one of all, Jacob Burckhardt: the power of art to shape history. The commission of Botticelli's Dante drawings by a member of the Medici family made it the supreme embodiment of the Florentine marriage of art and politics and its accompanying belief that beauty can reshape the world. All of the rediscoverers of Botticelli's Dante cycle were, in one way or another, enthralled by the worldview of Renaissance Florence. Lippmann, Pater, and Ruskin studied and wrote about Florentine art obsessively. More dramatically, Berenson, Horne, and Warburg lived in the city so that they could dedicate themselves to firsthand encounters with its art. Each sought art history's version of Forster's figurative "room with a view."

There is an additional reason—a corollary of sorts to

the Florentine ethos—why the drawings proved so influential, one that has less to do with expanding the notion of the Renaissance and more with the momentum of celebrity. After his long period of oblivion, Botticelli would come to rival Dante in name recognition. The value of his illustrations of *The Divine Comedy* increased in lockstep with the painter's own growing fame, nurtured by both critical acclaim and popular appeal. The same Botticelli who had been accused of painting "ugly women" and "peevish-looking" Madonnas only a century before became a brand name whose images might even cause pilgrims in the Uffizi to faint. The Florentine psychiatrist Graziella Magherini, who treated more than a hundred cases of Stendhal's Syndrome between 1988 and 1998, observed that the slightest of details could incite this aesthetic overload: "Have you noticed the wind, the motion of the sea [in Botticelli's *The Birth of Venus*]? These details allow you to understand how many disturbing elements underlie this beautiful form."[35] Long before these modern tourist dramas, Berenson said it best when, skeptical of the painter's Dante cycle, he answered a rhetorical question forming in the minds of many: "What then is the value of [Botticelli's] illustrations [of Dante]? The answer is simple enough. Their value consists in their being drawings by Botticelli, not at all in their being illustrations of Dante."

In the decades since the blockbuster traveling exhibition in 2000 that united Botticelli's once-dispersed drawings, many more shows and several more affordable editions of the Dante illustrations have appeared—often accompanied by the latest discoveries of the meanings and mysteries of what can still be described as Botticelli's "secret."

Epilogue

Aura is tied to ... presence; there can be no replica of it.
—WALTER BENJAMIN

In the summer of 2017, I arrived in Florence to start a semester-long fellowship at Villa I Tatti, Harvard's Center for Italian Renaissance Studies. *Tat-ti*, as we all called it, careful to hold the Italian double *t* on our tongues for effect, stands hieratically upon a hill on the outskirts of Florence. Its manicured gardens, magnificent Renaissance library, and architectural splendor were all paid for by Bernard Berenson's connoisseurship. I had never heard of him before my visit, but now his taste and his largesse had transported my wife and me, along with our three small children, from upstate New York to the Tuscan hills. Walking through this quilt of green and gold on cloudless days, it was easy to imagine Forster's Lucy Honeychurch and George Emerson sharing their stolen kiss in surroundings that seemed borrowed from a Renaissance painting.

We found an apartment near the leafy plane trees and wide, open space of Piazza d'Azeglio, a majestic nineteenth-century square. Just around the corner stood the much more intimate, chaotic Piazza Sant'Ambrogio, home for centuries to a sprawling open-air market. A block to the south of Piazza Sant'Ambrogio lay the even more ancient Piazza dei Ciompi, so-called because of the wooden clogs (*ciompi*) worn by its artisans, who famously revolted in 1378. The walk from Piazza d'Azeglio to Piazza dei Ciompi took no more than a few minutes. But there were ghosts everywhere along the way.

In Piazza dei Ciompi was a rough-hewn apartment building with a modest *targa*, plaque, announcing *"Di Lorenzo Ghiberti delle Porte questa fu casa"*: "This was the house of Lorenzo Ghiberti of the Gates [to Paradise]"—the sculptor, Brunelleschi's great rival, who created the Old Testament scenes in gold leaf adorning the massive doors of Giotto's Baptistery. A few hundred meters away, in the Basilica of Santa Croce, loomed the loftiest spirit of all: a nineteen-foot-high statue of Dante created to mark Florence's becoming the Italian capital in 1865, the six-hundredth anniversary of the poet's birth.

Without planning to, I went on a media diet after landing in Italy. For our first days, we had no Internet at home, and throughout our stay the connection was unreliable and intermittent. But a large part of the reason was Florence itself: the past felt so alive. I sensed a different kind of "news" being transmitted, one beholden not to current events but to much deeper cultural currents, swirling through the architecture of the buildings, the art in the museums, the design of the city.

From the moment I passed through the highly monitored gates at Villa I Tatti, the churchlike quiet, combined with the cascading shelves and state-of-the-art resources, made me feel like burrowing inside the antiquated tomes of its library.

Lunches were three-course extravaganzas served by a liveried wait staff; the morning coffee break included a slab of freshly baked *schiacciata*, salty focaccia; and afternoon tea was accompanied by an array of *biscotti*, to be enjoyed either on the terrace overlooking Florence or in Berenson's plush library. The grounds of Villa I Tatti produced their own wine and olive oil. I had died and gone to scholar's heaven.

The iconic image of Berenson resplendent in his double-breasted suit, and standing proudly in the sumptuous library where we often took our meals, came to haunt me. Behind the fancy clothes and patrician air, I could sense the hardscrabble Lithuanian immigrant Bernhard Valvrojenski yearning for

Berenson at home, Villa I Tatti. *Biblioteca Berenson, I Tatti—The Harvard University Center for Italian Renaissance Studies, courtesy of the President and Fellows of Harvard College*

the respect his prodigious talents could never fully secure, his contentious spirit still smarting from the words of his revered mentor, the Brahmin Charles Eliot Norton ("Berenson has more ambition than ability"). Was he really an objective *studioso*, art historians (including some in my peer group of fellows) continued to ask, if his judgments were tied to financial gain? And vice versa: was he truly rich, the moneyed classes wondered, if he was always at the beck and call of powerful magnates whose resources dwarfed his own?

A month into my stay, I came across a set of illustrations: a costly facsimile reproduction of Friedrich Lippmann's 1896 edition of Botticelli's drawings of Dante's poem. It was the English translation of the book in which Lippmann, soon after securing the purchase of the drawings in London's Ellis and White in 1882, had definitively proven that they were by Botticelli and Botticelli alone. I sat down with the massive volume. As I studied the pages, the scales fell from my eyes. I had seen reproductions of the drawings before, and they had left me cold. They seemed pretty enough, in that signature graceful, Botticellian way. But like many—including Berenson—I didn't think at first that the drawings captured the spirit and energy of *The Divine Comedy*, that they were "not at all Dantesque." There seemed to be something decorative and "humanist"—that is, secular and pagan—about them that missed the point of Dante's vision (later I would learn that this worldly element was the point). I registered their beauty, but couldn't find in them Dante's visceral yearning for God. Berenson's jibe summed up my early reaction: Botticelli's attempt to represent Dante's vision was "like playing Beethoven's 9th Symphony on the French horn."

How wrong I was. What I had not seen before, and what I began to see that day in Villa I Tatti, was that the drawings

were a "poem" in their own regard, and that together they represented one of the most sustained and powerful interpretations—better, visions—of Dante's work ever created. But that full understanding would only come later. Much later.

After studying Lippmann's deluxe volume, I went to the Uffizi early one Saturday morning, trying to enjoy the art while struggling to keep my marauding three-year-old son from ripping a gash in one of the priceless canvases or breaking off the arm of an ancient statue. After offloading the rambunctious child—mercifully, my in-laws were visiting—I found a moment of calm in the Botticelli Room and spent time in front of the *Cestello Annunciation*. I sensed the movement of the Madonna's dance, the worldly joy emanating from her graceful figure. I *felt* the Renaissance for the first time.

Botticelli's Dante drawings had presented me with a mystery. Staring at them at I Tatti, day after day, I recalled what Hemingway wrote about F. Scott Fitzgerald in *A Moveable Feast*: "His talent was as natural as the pattern that was made by the dust on a butterfly's wings."[1] Botticelli's line had that *leggiadria*, technically "lightness" but more ineffably a quality of inexpressible, soaring joy—in the words of Italo Calvino, the kind of lightness that flies like the bird, not plummets like the feather. When I wasn't at I Tatti researching my sabbatical project, a study of the *Commedia*'s reception over the centuries, I was scouring the city to see Botticelli's paintings firsthand. I needed to do the same for his Dante.

Luckily, access to Botticelli's Dante was only a short train ride away. One morning in December toward the end of my stay, I boarded a train for Rome. My plan was to visit the Vatican Library and see the original set of drawings once held by Queen Christina of Sweden, especially the most exquisite jewel of all: the intricately drawn and fully colored *Map of*

Hell, the only complete work in the cycle. Unfortunately, my plan was little more than a daydream. I hadn't secured any of the necessary introductions and permissions to get access to what I quickly discovered was a restricted part of the Vatican Library's collection. One bemused Vatican employee fobbed me off to another, politely yet decisively refusing my request. As the understanding demurrals began to develop into annoyed *nos*, I felt my already slim chances dwindling. I decided on the nuclear option: I asked to see the director. Access to Botticelli, if it were even possible, would only come through a kind word from someone "upstairs."

To my surprise, the director appeared. But his welcoming smile was mixed with a look of incomprehension.

"You are asking to see one of our most precious holdings," he said to me, still smiling but speaking firmly. "I'm afraid it's not possible."

I summoned the most formal Italian I could muster in protest, but I could tell his mind was made up. About to be ceremoniously turned out, I made one last plea.

"*Solo quindici minuti.*" Just fifteen minutes, I begged.

"*Va bene,*" he said, startling me with his change of mind. "Okay. Fifteen minutes, just you and me, no pencil, no paper, no photos."

A few minutes later I was led into a private room of the Vatican. And there it was: Botticelli's *Map of Hell*, along with a small selection of other, more sparsely drawn illustrations from the early cantos of the poem. The director and I stood before them in silence, our gaze fully absorbed by that lone full-color image of Inferno. The first thing that struck me was how incredibly different it appeared from the many reproductions I had seen of it. What they failed to capture was Botticelli's hand. In the original *Map of Hell*, I could see

the remarkably precise, painstaking details that are glossed over in reproduction. The scoring of the parchment, the tiniest of features and gestures in the sinners, the varying hues and shades within the individual colors—it was all there in a way that a reproduction could never capture. What I saw, for the first time, was Botticelli's vision of Dante's hell: somehow all the mind-boggling intricacies and textures coalesced into a seamless whole.

The director and I continued to look on silently. He, too, a man who spent his days among precious objects and works of beauty, was transfixed. After a long while he gave me a look of complicity and we mumbled something unnecessary— "*incredibile, davvero . . .*"—before turning back to the drawing. Perhaps he had given me access because he himself wished to see it. Whatever the reason, the work now gripped us both.

The German philosopher Walter Benjamin described the "aura" of art as the inexplicable energy that emanates from the original, a sensation so palpable that it can make looking feel like a religious rite. The word comes from the Latin for gold, *aurum*, and suggests the energy or glow a work of beauty exudes, reminding us why Petrarch chose the name Laura for his source of poetic inspiration. According to Benjamin, to grasp an artwork's true aura, you must see the original, go back to the moment and time of its creation by a human hand. That quest for originals had led Jacob Burckhardt to scour the Italian peninsula for glimpses of works that would fuel his theory of the Renaissance. The eureka moment of Friedrich Lippmann's lifetime—the certainty that all the illustrations in the Dante cycle were by Botticelli alone—could only have occurred as he contemplated the painter's images in their large parchment volume.

Six centuries before Benjamin, Dante wrote that art at

its best was a *visibile parlare,* a "visible speech" that feels like heaven's own language. No words better captured the effect of looking at Botticelli's illustrations. My fifteen minutes with *The Map of Hell* were up. I thanked the director and said goodbye. Botticelli had shared his secret.

ACKNOWLEDGMENTS

In the introduction to his gorgeous Italian Folktales, Italo Calvino wrote that his book made him feel as though he had lived for years "in woodlands and enchanted castles," leading him to wonder if he could ever return to earth again.

I can relate to the feeling. No book of mine was conceived in more enchanted a space than this one. After decades of studying Italy, especially Dante and its modern culture, I felt the surprising pull of its Renaissance art. Part of the reason was atmospheric: I was spending a sabbatical in Florence with my family, and the visual splendor of the Renaissance seemed to loom around every corner and beneath each portico. Long familiar to me, the city suddenly took on a new form: *Look closely*, I could hear my mind telling me, *there's much you haven't truly registered before. . . .*

Especially Botticelli. The "secret" this book describes, as Dante himself might have written, exists on many different levels, from the literal one of Botticelli's lost illustrations of the *Commedia* to larger questions about the meaning of art,

its power to reveal our identities, and the public, even political, roles it can play. Looking back, the most beautiful thing about this secret was how it remained mysterious to me while I wrote, constantly leading to new discoveries, not just about the Renaissance but also about how art from centuries ago can shape today's cultural conversations.

I would never have been able to take this thrilling journey to the Renaissance, literal and figurative, without the help of many. My first and greatest debts are to my agent, Joy Harris, and the editor of this book, Alane Mason. I thank Joy for the gift of her ongoing belief in my work and uncommon wisdom that has guided me along every step of my writing career. And I thank Alane for her remarkable ability to understand this book seemingly better than me, the person writing it. I have done my best to meet the incredibly high intellectual and literary standards of her editing, and I am deeply grateful for the privilege of working with someone of such knowledge and insight. I thank the entire team at W. W. Norton, who have been a pleasure to work with: Mo Crist, Ingsu Liu, Rebecca Munro, Elizabeth Riley, Eve Sanoussi, Sarah Touborg, and Michelle Waters. I am also indebted to Allegra Huston for her superb copyediting that did much to strengthen the manuscript.

My knowledge of the Renaissance has been profoundly enhanced by my time as a Wallace Fellow at Villa I Tatti, the Harvard University Center for Italian Renaissance Studies, in 2017. I extend my warmest thanks to the director, Alina Payne, and to the marvelous staff at Tatti who helped make my time there so enriching and enjoyable, including Susan Bates, Ilaria Della Monica, Angela Dressen, Ingrid Greenfield, Thomas Gruber, Jocelyn Karlan, Angela Lees, Michael Rocke, and Amanda Smith. The friendship and conversation

of the fellows and visitors to Tatti, especially Brad Bouley, Nicola Courtright, and José Maria Pérez Fernández, made this extraordinary opportunity particularly memorable. My fellowship in Florence would not have been possible without the assistance of Susan Elvin Cooper, Bard College faculty grants officer. I thank her for her eagle-eyed copyediting and remarkable perspicacity in helping me not only design and articulate my research proposals, but also in guiding me to a deeper understanding of the principles and ideas that brought them to life. Generous support of my book was provided by the Bard Research Fund. I thank my colleagues in the Languages and Literature Division as well as the College's administration for their sustaining belief in my work.

At a crucial moment, I reached out to a circle of dear friends and trusted readers who responded brilliantly and generously to my request that they read my entire manuscript and offer their thoughts: Christian Dupont, Geoffrey Harpham, Scott McGill, and Kristin Phillips-Court. Other friends and colleagues kindly responded to requests I had while writing, including Ricardo Galliano Court, Nicola Gentili, and Jason Houston. With astonishing professionalism and precision, Karl Fugeslo provided an expert proofreading of the manuscript. To all, my heartfelt *grazie* for your time and expertise.

I was invited to deliver presentations on research related to *Botticelli's Secret* at several institutions, and it is a pleasure to express my gratitude to all the cherished colleagues who hosted me, including Mattia Acetoso at Boston College, Enrico Cesaretti at the University of Virginia, Francesco Ciabattoni at Georgetown University, Alison Cornish at New York University, Thomas Pfau at Duke University, and Penny Marcus and Giuseppe Mazzotta at Yale University. To Giuseppe in particular, I am indebted for much of what I know about the

Renaissance, going back to my studies with him in graduate school. What a joy it was, in 2019, to reconnect with him and hear him bring details of Florence's Renaissance history to life as we strolled through the *centro storico*.

Two more happy debts remain. Far too numerous to mention by name, students in my LIT 241 course on the Renaissance at Bard College have made teaching issues related to this book an ongoing source of pleasure and intellectual growth. I thank them for all the ways in which they challenge me to sharpen my thinking and find new answers to the questions that the Renaissance poses for each generation. Above all, it is to my wife, Helena Baillie, and our children, Isabel, James, Annabel, and Sofia, that I owe my deepest gratitude. For all the times I had been to Florence, I had never before pushed my son in a stroller past the Medici Palace on Via Cavour, taken a daughter to the carousel in Piazza della Repubblica, or snuck away from work to spend the afternoon at the Bargello with my wife after a meal at Sostanza, an ancient trattoria located on the same street where Botticelli had lived and worked. It wasn't just the city's art that I was seeing with new eyes: it was Italy itself, brought to life by the laughter and cries for gelato of my children.

TIMELINE

1265	Birth of Dante Alighieri
1274	Dante meets Beatrice
1290	Death of Beatrice, age 24
1295	(c.) Dante completes the *Vita Nuova*
1302	Dante is exiled for alleged political graft
1304	Petrarch is born
1306	(c.) Dante begins *The Divine Comedy*
1321	Completion of *The Divine Comedy*
	Death of Dante Alighieri in Ravenna
1373	Giovanni Boccaccio lectures on Dante
1374	Death of Petrarch
1397	Medici Bank opens
1400	More than 800 manuscript editions of *The Divine Comedy* in circulation
1401	Competition for the Baptistery doors (Ghiberti wins, Brunelleschi second)
1408–1409	Donatello sculpts his marble *David*
1422	Brancacci Chapel commissioned

1436	Completion of Florence's Duomo (Brunelleschi wins, Ghiberti second)
1440	(c.) Donatello sculpts his bronze *David*
1445	(c.) Birth of Alessandro di Mariano Filepepi, alias Sandro Botticelli ("Little Barrel")
1449	Birth of Lorenzo de' Medici, known as il Magnifico
1461	(c.) Botticelli enters the *bottega*, workshop, of the scandalous Fra' Lippo Lippi
1464	Death of Cosimo de' Medici, alias *Pater Patriae* ("Father of the Country")
1465	(c.) Botticelli opens his *bottega* on Via Nuova
1470	Botticelli commissioned for *Fortitude*, at the behest of Tommaso Soderini
1472	First printed edition of *The Divine Comedy*, at Foligno
1475	*Giostra,* Joust, celebrating Giuliano de' Medici's love for Simonetta Vespucci
1475–1476	(c.) Botticelli paints *The Adoration of the Magi*
1476	Death of Simonetta Vespucci, age 22
1478	Pazzi Conspiracy
	Murder of Giuliano de' Medici, age 25
	Botticelli paints effigies of hanged conspirators on Bargello wall
1480	(c.) Botticelli paints *Primavera*
1481	Landino's landmark Florentine edition of *The Divine Comedy* published
	Botticelli in Rome to paint the Sistine Chapel
	(c.) Botticelli begins to illustrate Dante for Lorenzo di Pierfrancesco de' Medici
1482	Botticelli returns to Florence from Rome
1482–1489	Engravings of *Inferno* 1–19 based on Botticelli's drawings appear in Landino's Dante volume
1485	(c.) Botticelli paints *The Birth of Venus*

1490 Botticelli accused of sodomy by Florence's Officers of the Night for the first time

1492 Death of Lorenzo il Magnifico

1494 French King Charles VIII invades Florence
Exile of il Magnifico's son Piero di Lorenzo de' Medici, alias the Unfortunate
Murder of Agnolo Poliziano and Pico della Mirandola
Medici Bank ceases operations
Rise of Girolamo Savonarola
(c.) Botticelli completes Dante illustrations for Lorenzo di Pierfrancesco de' Medici

1496–1497 Savonarola leads Bonfires of the Vanities, the public burning of art in Florence

1497 Savonarola excommunicated by Pope Alexander VI

1498 Savonarola hanged and his corpse burned

1500–1501 Botticelli paints the *Mystic Nativity*

1502 Botticelli accused of sodomy by Florence's Officers of the Night for the second time

1503 Death of Lorenzo di Pierfrancesco de' Medici
Leonardo paints *Mona Lisa*

1504 Michelangelo completes the *David*

1510 Death of Botticelli

1512 Michelangelo completes his paintings on the Sistine Chapel ceiling

1550 First edition of Giorgio Vasari's *Lives of the Artists*

1564 Death of Michelangelo

1568 Second edition of Giorgio Vasari's *Lives of the Artists*

1689 Eight of Botticelli's Dante illustrations discovered in the collection of Queen Christina of Sweden in Rome

1756 Voltaire proclaims, "Nobody reads Dante anymore"

1803 10th Duke of Hamilton purchases the bulk of Botticelli's Dante illustrations

1814 Henry Francis Cary's *The Vision*, an English translation of Dante's *The Divine Comedy*, appears

1815 Botticelli's *Primavera* and *The Birth of Venus* hung in the Uffizi Gallery

1849 Dante Gabriel Rossetti translates Dante's *Vita Nuova*

1855 French historian Jules Michelet coins the term *Renaissance*

1855 Jacob Burckhardt publishes *The Cicerone*, a guide to Italian art

1860 Jacob Burckhardt publishes *The Civilization of the Renaissance in Italy*

1861 Unification of Italy

1865 Florence named capital of Italy

Monument to Dante erected in the Basilica of Santa Croce

Bernard Berenson born as Bernhard Valvrojenski in Lithuania

1869 Edgar Quinet "invents" the idea of Mona Lisa's enigmatic smile

Dante Gabriel Rossetti purchases Botticelli's *Portrait of a Lady Known as Smeralda Bandinelli* for £20

1871 Unification of Germany

1872 John Ruskin lectures on Botticelli at Oxford University

1873 Walter Pater publishes *Studies in the History of the Renaissance*

1882 Friedrich Lippmann negotiates the purchase of Botticelli's Dante illustrations for the newly created Germany

1882–1883 Lippmann displays Botticelli's Dante drawings to public for the first time at the Kupferstichkabinett

1887 Lippmann publishes, in German, the first book on Botticelli's Dante drawings

1896 English translation of Lippmann's book on Botticelli appears

	Bernard Berenson reviews Lippmann's book on Botticelli for the *Nation*
1899	Isabella Stewart Gardner, aided by Bernard Berenson, buys Botticelli's *Chigi Madonna*
1908	Herbert Horne's *Alessandro Filipepi, Commonly Called Sandro Botticelli, Painter of Florence* published
1945	Monuments Men discover Botticelli's Dante drawings after their removal from Hitler's storage tower
1948	Dante drawings temporarily transferred to National Gallery in Washington, D.C., before their repatriation to Germany
1961	Building of the Berlin Wall
	Division of Botticelli's Dante illustrations between East Berlin and West Berlin
1976	Kenneth Clark's "coffee-table" edition of Botticelli's Dante illustrations published
1989	Fall of the Berlin Wall
	Botticelli's Dante illustrations returned to Berlin's Kupferstichkabinett
2000	All 92 extant Dante illustrations by Botticelli appear together for the first time at exhibitions in Rome, Berlin, and London
2008	Florence city council officially revokes Dante's exile with a vote of 19 for to 5 against—706 years after his exile

KEY TERMS

accidia, n.: from the medieval Latin *acedia*, "spiritual negligence"; Petrarch's term for his spiritual "sluggishness," as opposed to Dante's visceral embrace of Christian faith. More broadly, Petrarch's religious intransigence may be thought of as a prelude to modern feelings of melancholy, even existential crisis.

aria virile, n./adj.: Italian for "virile air"; the quality of Botticelli's painting, in the view of a contemporary commentator, that made his work the most desirable of all Italian artists, especially in comparison to merely "sweet" painters like his former pupil Filippino Lippi.

avere lettere, v./n.: Italian for "to know Latin"; literally, "to be literate"; term used by Vasari to describe artists like Brunelleschi (*"non aveva lettere"*) with little formal schooling—including Botticelli, whose working-class background and lack of schooling, in Vasari's view, disqualified him from being able to interpret Dante.

aura, n.: English for "distinctive atmosphere"; from the Latin *aurum*, "gold"; the concept invoked by Walter Benjamin in 1935

to describe the mystery and energy emanating from original works of art.

bello ovile*, adj./n.:* Italian for "fair sheepfold"; Dante's term for Florence in *Paradiso* 25.

bottega*, n.:* Italian for "artist's studio, workshop"; from the Latin *apotheca*, "warehouse." Often, as in Botticelli's case, attached to the artist's home, as reflected in a phrase from the Middle Ages, "*uscio e bottega*": literally, "door and shop," that is, to work where one lives.

chiaroscuro*, adj.:* English and Italian for "light and dark," associated with the dramatically lit canvases of Caravaggio; more metaphorically, Botticelli's ability to combine messages of hope and despair, beauty and decay, in a single brushstroke—and, by extension, the dizzying mix of glory and terror, truth and deception, of Florence's Renaissance history.

cicerone*, n.:* English for "tour guide"; an eighteenth-century Italian term humorously referring to the eloquence and learning of Latin culture's great "guide," Cicero (giving the Italian word the playful meaning "big Cicero"). The word appears as the key term in Jacob Burckhardt's *The Cicerone: An Art-Guide to the Painting in Italy for the Use of Travellers and Students*, an influential travel guide to Italy's artistic and cultural splendors published in 1855.

commedia*, n.:* Italian for, literally, "comedy," "intended to draw laughter"; historically, the term defined by Aristotle in his *Poetics* as that literary genre dealing with human weakness and folly, written in a low style, and ending happily (as opposed to the high style and macabre plotlines of tragedy); from the ancient Greek *komos*, a curious spectacle in which festive males danced around the image of a large phallus. The original title of Dante's epic poem was the *Comedìa*; *Divina*, "Divine," was added centuries later.

connoisseur*, n.:* English and French for "expert"; historically, a group of aesthetes in the nineteenth and twentieth centuries who

could verify the authenticity of an artwork—and make a financial killing doing so (e.g., Bernhard Valvrojenski, alias Bernard Berenson, one of Botticelli's mightiest promoters).

contrapasso, n.: Italian for "counter-penalty"; the system of sin and punishment in Dante's *Inferno*, from the biblical tradition "an eye for an eye, and a tooth for a tooth."

damnatio memoriae, n.: Latin for "condemnation of memory"; the ancient Roman practice of destroying not only the memory of someone but also everything associated with them: surviving family members, public honors, statues, etc. E.g., the practice of the Medici toward the Pazzi after the failed Conspiracy of 1478.

disegno, n.: Italian for "design," "draftsmanship," more broadly, "drawing"; the term used by the pioneering art historian—and Botticelli detractor—Giorgio Vasari to designate the supreme talent and principle of Florentine Renaissance art. In Vasari's own words: "*Disegno*—the father of our three arts, architecture, sculpture, and painting—emanates from the intellect and extrapolates from contingent elements their universal principle, like a pure form or idea of all of nature's manifestations."

farfante, n.: Italian for "despicable rascal, villain"; Pope Sixtus IV's term for Lorenzo il Magnifico on the eve of the Pazzi Conspiracy of 1478, which had papal support.

fiorentino doc, n.: Italian for "Florentine, born and bred": literally, a Florentine *di origine controllata*, of certified provenance. The designation *denominazione di origine controllata*, or DOC, is used by the Italian government to ensure the quality and authenticity of wines and food products. More metaphorically, *fiorentino doc* describes someone with a long and deep connection to Florence, like Sandro Botticelli.

Flaktürme, n.: German for "flak towers": two massive storage silos erected by Hitler in Berlin toward the end of World War II

that served as bunkers for civilians, military personnel, and the city's art during bombings. One of the towers was ravaged by fire; and one contained Botticelli's Dante drawings, which were transported to safety in a Thuringian salt mine before the fall of Berlin in May 1945.

Inglese italianato è un diavolo incarnato, phrase: Italian for "an Italianate Englishman is a devil incarnate"; coined in the sixteenth century by Roger Ascham, the phrase became a shorthand for the "proper" Englishman who goes to Italy on a Grand Tour and comes back to his native land armed with the supposedly "Italian" skills of roguish charm, cunning, and artistic sensibility. The fictional Cecil Vyse in E. M. Forster's *A Room with a View* aspires to the tag, but is too prudish and effete to embody it; the real-life Dante Gabriel Rossetti was its living incarnation.

infinito disordine, adj./n.: Italian for "infinite disorder"; Vasari's term for the effect caused by Botticelli's decision to illustrate all one hundred cantos of Dante's *Divine Comedy.*

ingegno, n.: Italian for "innate or natural brilliance," from the Latin roots *in* + *genium,* "to have genius within"; Vasari's preferred word for the native genius of uneducated artists who could think on their feet and come up with clever solutions—anecdotes that were probably fictitious (e.g., Vasari's depictions of Giotto drawing a "zero" to prove his drawing skill, Fra' Lippo Lippi climbing out of the window to unleash his lust, and Brunelleschi cracking an egg to model his Duomo). Vasari gives no example of Botticelli's *ingegno.*

Laurentius minor, n./adj.: Latin for "Lorenzo Junior"; term used by the philosopher Marsilio Ficino to describe Lorenzo di Pierfrancesco de' Medici, emphasizing both his close connection to his more powerful cousin Lorenzo il Magnifico and his inferior ("minor") status to him.

leggiadria, n.: Italian for "lightness"; more ineffably, the quality of inexpressible, dancing joy that radiates from Botticelli's painting.

malsano, adj.: Italian for "unhealthy"; term used by Mariano Filipepi to describe his youngest son, Sandro Botticelli.

Pre-Raphaelite, n./adj.: English for "before the painter Raphael"; a Victorian artistic "Brotherhood" which included Dante's translator and Botticelli's promoter Dante Gabriel Rossetti; they were critics of the mannered formalism in Raphael and other High Renaissance artists, whom they negatively compared to Botticelli's feminine beauties and pagan forms.

secretum, n.: Latin for "secret," something "hidden, not meant to be known"; from the word for "to separate, set apart," as in Petrarch's *Secretum* from 1347–53, a private confession of his spiritual crisis.

Sacro Poema, adj./n.: Italian for "Sacred Poem"; Dante's term for his *Commedia* in *Paradiso* 25.

Senza Pari, adj.: Italian for "Peerless"; Giuliano de' Medici's term for his muse, Simonetta Vespucci—and the word decorating Botticelli's standard for Giuliano and Simonetta in the Joust of 1475.

sprezzatura, n.: Italian and English for "studied nonchalance"; coined by Baldessare Castiglione in 1528 to describe the ideal Renaissance courtier and his (seeming) capacity for (seemingly) effortless excellence. The term suggests how Botticelli's light touch could hide the philosophical complexities infusing allegorical works like *Primavera* and *The Birth of Venus*.

volgare, n.: Italian for "vernacular"; from the Latin *vulgus*, "common" or "popular"; Dante's term for the Tuscan dialect in which he wrote his *Commedia*, representing a turn away from the traditional classical languages of epic poetry, especially his guide Virgil's Latin.

ydiotae in tabernis, phrase: Latin for "idiots in the tavern," Petrarch's tag for the unlearned immune to what his protégé Boccaccio described as poetry's "stable" and "eternal" principles—though many of these same "drinkers" skewered by Petrarch relished Dante's dialect poetry.

NOTES

Reference Style

Complete details are given at the first citation of a source, and in abbreviated form afterward. Full details of key sources may be found in the Select Bibliography. Unless otherwise indicated, translations are my own.

Prologue

1. For a description of Lippmann's visit to Ellis and White, see Nick Havely, *Dante's British Public: Readers and Texts, from the Fourteenth Century to the Present* (Oxford: Oxford University Press, 2014), 247–49. See also Frauke Steenbock, "The Hamilton Collection," in *Botticelli and Treasures from the Hamilton Collection*, ed. Dagmar Korbacher (London: Courtauld Gallery, 2016), 12–13; and Dagmar Korbacher, " 'I am very, very happy that we have it': Botticelli's Dante and the Hamilton Collection at the Kupferstichkabinett," in *Botticelli and Treasures from the Hamilton Collection*, ed. Korbacher, 14–24.

2. For a description of Lippmann's persona and artistic tastes, see C. D., "The Late Dr. Lippmann," *The Burlington Magazine for Connoisseurs* 4, no. 10 (January 1904): 7–8.

3. As an eminent historian proclaimed, "The Reniassance is a primal

scene of European historiography to which we seem bound to return
out of fascination or denial," and an academic ritual replete with
"Burckhardt-bashing" from his "ungrateful children" occupying their
departmental chairs. See Randolph Starn, "Renaissance Redux," *American Historical Review* 103, no. 1 (February 1998): 122–23.

4. Jules Michelet, "The Renaissance and the Discovery of the World and
Man," in *The Renaissance Debate*, ed. Denys Hay (Huntington, NY:
Robert E. Krieger, 1976), 22.

5. John Ruskin, *The Stones of Venice* (New York: Da Capo, 1960), 228.

6. A library of scholarship emphasizes the intellectual lines of connection between the Middle Ages and the Renaissance. For a general
overview of the matter and an emphatic defense of the link between
medieval and Renaissance thought, I will single out the seminal Lynn
Thorndike, "Renaissance or Prerenaissance?" *Journal of the History of
Ideas* 4 (1943): 65–74; and for a sense of the thriving European intellectual culture that informed such a major literary work of medieval
times as Dante's *Commedia*, see Giuseppe Mazzotta, *Dante's Vision
and the Circle of Knowledge* (Princeton: Princeton University Press,
1993).

7. For a study of Virgil's presence in medieval times, see Domenico
Comparetti's classic *Virgil in the Middle Ages*, trans. E. F. M. Beinecke
(Princeton: Princeton University Press, 1997).

8. See Dante, *Purgatorio* 26.113. All references to Dante's text are to *La
Commedia secondo l'antica vulgata*, ed. Giorgio Petrocchi, Edizione
Nazionale della Società Dantesca Italiana (4 vols.; Milan: Mondadori,
1966–67). I use either my own English translations or, when indicated,
Allen Mandelbaum's from Dante, *The Divine Comedy* (New York:
Everyman's Library, 1995).

9. The notion of Western's society's movement away from religion animates Marcel Gauchet's controversial and provocative *The Disenchantment of the World: A Political History of Religion*, trans. Oscar Burge
(Princeton: Princeton University Press, 1997).

10. See, for example, the work of Oswald Spengler and its praise of the
medieval period over the Renaissance and its supposedly "modern,"
"decadent" spirit in *The Decline of the West*, trans. Charles Francis
Atkinson, vol 2: *Perspectives in World History* (2 vols.; London: George
Allen, 1923), 891, 982. See also Paul Ratner, "Why Some Conservative
Thinkers Seriously Want the Return of the Middle Ages," *Big Think*,
March 5, 2017, https://bigthink.com/paul-ratner/time-to-get-medieval
-why-some-conservative-thinkers-love-the-middle-ages. For a fictional

critique of Renaissance rationalism, see the words of Leo Naphta in his quarrel with Ludovico Settembrini in Thomas Mann's *The Magic Mountain*, trans. John E. Woods (New York: Vintage International, 1995), 512–13: "In [the Middle Ages] it was thought disgraceful to send to school any lad who did not wish to become a cleric, and this scorn for the literary arts, on the part of the aristocracy and commonfolk alike, had remained the hallmark of genuine nobility; whereas the literary man, that true son of humanism and the bourgeoisie, who could read and write—which nobles, warriors, and common people could do only poorly or not at all—could do nothing else, understood absolutely nothing about the world, and remained a Latin windbag, a master of speech, who left real life to honest folk . . ."

11. See C. D., "The Late Dr. Lippmann," 7–8.

12. For a description of the 12th Duke of Hamilton and his litany of vices, see Havely, *Dante's British Public*, 247.

13. See "The Rise and Fall of Hamilton Palace," National Museums of Scotland website, https://www.nms.ac.uk/explore-our-collections/ stories/art-and-design/the-rise-and-fall-of-hamilton-palace/.

14. Less than fifty years after Lippmann's visit to Ellis and White, the palace of the Hamilton family (once described by Daniel Defoe as "great possessors") would be razed to the ground after a final fire sale. For a description of the 10th Duke of Hamilton's typical Grand Tour and collecting habits, see Steenbock, "The Hamilton Collection," 11–12. For a catalogue of his collection, see Letter XXVIII, "Duke of Hamilton's Collection," in Gustav Friedrich Waagen, *Treasures of Art in Great Britain: Being an Account of the Chief Collections of Paintings, Drawings, Sculptures, Illuminated Mss., &c. &c.* (3 vols.; London: John Murray, 1854), 3:297–301.

15. Molini's notice was subsequently pasted into the volume of illustrations and thus appears to be a certificate of purchase; see Korbacher, " 'I am very, very happy that we have it,' " 16.

16. The original Italian reads: *"o di mano di Sandro Botticelli, o di altro disegnatore di quell'ottimo tempo del disegno."* See Korbacher, " 'I am very, very happy that we have it,' " 17.

17. See *Botticelli and Treasures from the Hamilton Collection*, ed. Korbacher, 38.

18. Waagen, *Treasures of Art in Great Britain*, 3:307.

19. See Paul Colomb de Batines, *Bibliografia dantesca; ossia, Catalogo delle edizioni, traduzioni, codici manoscritti e comenti della Divina commedia e delle opere minori di Dante* (3 vols.; Prato: Aldina, 1845–46), 2:174

(no. 335); and Friedrich Lippmann, *Drawings by Sandro Botticelli for Dante's "Divina Commedia." Reduced Facsimiles After the Originals in the Royal Museum Berlin and in the Vatican Library with an Introduction and Commentary by F. Lippmann* (London: Lawrence and Bullen, 1896), 17.

20. William Clarke, *Repertorium Bibliographicum: Or, Some Account of the Most Celebrated British Libraries* (London: William Clarke, 1819), 260.

21. For Vasari's full account of Botticelli, see his *Lives of the Artists: Volume I*, trans. George Bull (London: Penguin, 1987), 224–31. This edition is based on selections from the second edition of Vasari's *Lives of the Artists*, published in 1568. For Vasari's original text, see *Vite dei più eccellenti pittori, scultori e architettori: Nelle redazioni del 1550 e 1568*, ed. Rosanna Bettarini and Paolo Barocchi (8 vols.; Florence: Sansoni, 1966–87).

22. Vasari, *Lives of the Artists*, 227. I have altered the incorrect translation of this edition, which renders *"per essere persona sofistica"* as "being a man of inquiring mind," a wording that fails to register the biting undercurrent of irony in Vasari.

23. See the discussion, and conflicting interpretations, in Richard Stapleford, "Vasari and Botticelli," *Mitteilungen des Kunsthistorischen Institutes in Florenz* 39, nos. 2/3 (1995): 397–408; and Bouk Wierda, "The True Identity of the Anonimo Magliabechiano," *Mitteilungen des Kunsthistorischen Institutes in Florenz* 53, no. 1 (2009): 157–68.

24. The original Italian reads: *"[Botticelli] dipinse e storiò un Dante in cartapecora a L[oren]zo di P[ie]ro Franc[es]co de' Medici, il che fu cosa maravigliosa tenuto."* See the discussion in Schulze Altcappenberg, "'Per essere persona sofistica,'" 21–22. See also Francesca Migliorini, "Botticelli's Illustrations for Dante's *Comedy*: Some Considerations on Form and Function," in *Sandro Botticelli (1445–1510): Artist and Entrepreneur in Renaissance Florence*, ed. Gert Jan van der Sman and Irene Mariani (Florence: Istituto Universitario Olandese di Storia dell'Arte, 2015), 157.

25. Vasari actually knew only a small portion of Botticelli's Dante project, and in indirect fashion, through a celebrated volume of the *Inferno* from the 1480s: the Florentine edition edited by Cristoforo Landino that contained 19 engravings based on Botticelli's prototypes (see Schulze Altcappenberg, "'Per essere persona sofistica,'" 21). Stapleford discusses how Vasari's personal agenda shaped his distortions of the Anonymous Magliabechiano's basic facts in "Vasari and Botticelli," 397–408.

26. See Alessandro Cecchi, *Botticelli* (Florence: Federico Motta,.2005), 62;

and Poliziano's descriptions of Botticelli's spirited exchanges and play-
ful wit in *Detti piacevoli*, ed. Tiziano Zanati (Rome: Istituto dell'Enci-
clopedia Italiana, 1983), nos. 328 and 366.

27. Of Botticelli's original drawings, the following are presumed lost:
Inferno 2–7, *Inferno* 11, and *Inferno* 14. An additional two sheets, con-
taining the text for *Paradiso* 32 and *Paradiso* 33 but no drawings, dis-
appeared in Berlin at an unknown date. Another illustration, *Paradiso*
31, was never done, as the space in the manuscript for it was left blank.
For discussion of the drawings' survival and disappearance, see Schulze
Altcappenberg, " 'Per essere persona sofistica,' " 19; and "The Jewel of
the Collection: Sandro Botticelli's Drawings for Dante's *Divine Com-
edy*," in *Botticelli and Treasures from the Hamilton Collection*, ed. Kor-
bacher, 73, 76 *n*4.

28. For an incident involving Pater and the "slippered feet" he admired, see
Richard Ellmann, *Oscar Wilde* (New York: Vintage, 1984), 84.

29. Pater was also a fan of Rossetti, comparing him to Dante for their com-
mon ability to render "sensous" and "material" something as ethereal
as the human soul. See his "Dante Gabriel Rossetti," in *Appreciations:
With an Essay on Style* (London: Macmillan, 1895), 221.

30. For Ruskin's seminal work on Botticelli, based on a series of lectures
delivered at Oxford in 1872, see his *Ariadne Florentina: Six Lectures on
Wood and Metal Engraving* (New York: Charles E. Merrill, 1892), 90.

31. Walter Pater, *Studies in the History of the Renaissance* (Oxford: Oxford
University Press, 2010), 35.

32. Lippmann, *Drawings by Sandro Botticelli for Dante's "Divina Comme-
dia,"* 1.

33. See Rachel Cohen, *Bernard Berenson: A Life in the Picture Trade* (New
Haven: Yale University Press, 2013), 156.

34. For a discussion of Mangona's errors in quoting Dante on Botticelli's
illustrations and his misordering of cantos, see Peter Dreyer, "La storia
del manoscritto," trans. Maria Beluffi, in Dante, *La Divina Commedia:
Illustrazioni Sandro Botticelli* (Paris: Diane de Stellers, 1996), 39–40.

35. A version of this sentiment was expressed by the art historian Kenneth
Clark, who spoke of Botticelli's ability to combine "the dreams of the
Middle Ages, the elaboration of scholasticism" with "a pagan sensu-
ousness and firmness of outline," in his *Florentine Painting: Fifteenth
Century* (London: Faber and Faber: 1945), 28.

36. For the translation from Lippman's German, see Havely, *Dante's Brit-
ish Public*, 247.

37. For Stendhal's words on his overwhelming encounter with Italian

art ("I had palpitations of the heart. . . . Life was drained from me. I walked with the fear of falling"), see *Rome, Naples and Florence*, trans. Richard N. Coe (Richmond, UK: John Calder, 1959, rept. 2010), 302. For a scientific perspective on the issue, see Graziella Magherini, *La sindrome di Stendhal* (Florence: Ponte alle Grazie, 1995). The Florentine psychologist Magherini coined the term "Stendhal's Syndrome" and has studied the disorienting effects of Italian art on foreign tourists for decades. See my discussion of her work in *My Two Italies* (New York: Farrar, Straus and Giroux, 2014), 183.

38. For discussion of Botticelli's presence in Proust, see Paolo Marco Fabbri, "Madame Swann e la *Vergine del Magnificat*," http://www.marcelproust .it/miscel/fabbri.htm. More broadly, see Kathryn Hughes, "Destination Venus: How Botticelli Became a Brand," *Guardian*, March 5, 2016, https://www.theguardian.com/artanddesign/2016/mar/05/destination–venus–how–botticelli–became–a–brand.

39. See Riccardo Venturi, "Into the Abyss: On Salvador Dalì's *Dream of Venus*," in *Botticelli Past and Present*, ed. Ana Debenedetti and Caroline Elam (London: University College of London Press, 2019), 266–89.

40. E. H. Gombrich, "Botticelli's Mythologies: A Study in the Neoplatonic Symbolism of His Circle," *Journal of the Warburg and Courtauld Institutes* 8 (1945): 7.

41. See Lene Østermark-Johansen, *Walter Pater and the Language of Sculpture* (London: Ashgate, 2011), 40.

42. Ana Debenedetti, Mark Evans, Ruben Rebmann, and Stefan Weppelmann, introduction to *Botticelli Reimagined*, ed. Mark Evans and Stefan Wepplemann et al. (London: V & A Publishing, 2016), 10.

43. Lippmann, *Drawings by Sandro Botticelli for Dante's "Divina Commedia,"* 16–17.

44. See Herbert Horne, *Botticelli, Painter of Florence* (Princeton: Princeton University Press, 1980), 249: "On the tablet, which the fourth angel on the left is holding, Botticelli has inscribed his name, 'sandro/dima/rian/o': not by way of signature, as it would seem, but as an expression of hope that his own spirit might ultimately find salvation among the least of the angels."

Chapter 1: The Pop Star

1. For Dante's physical characteristics, see Richard Holbrook, *Portraits of Dante from Giotto to Raffael: A Critical Study, with a Concise Iconography* (Boston: Houghton Mifflin, 1911), 16.

2. For a study of the city's founding, see Colin Hardie, "The Origin and Plan of Roman Florence," *Journal of Roman Studies* 55, nos. 1/2 (1965): 122–40, esp. 140.

3. The house would one day become one of the most opulent *palazzi* in all of Florence, after a member of the Medici family purchased and enlarged it. Jacopo Salviati, son-in-law of Lorenzo il Magnifico, bought the *palazzo* in 1456, and it remained in the Salviati family until 1768. The building has now been broken up into high-end vacation rentals.

4. For a consideration of the building materials favored by the wealthy class in medieval Florence, see Piergiorgio Malesani, Elena Pecchioni, Emma Cantisani, and Fabio Fratini, "Geolithology and Provenance of the Materials of the Historical Buildings of Florence (Italy)," *Episodes* 26, no. 3 (September 2003): 250–55.

5. See Marco Santagata, *Dante: The Story of His Life*, trans. Richard Dixon (Cambridge, MA: Belknap Press of Harvard University Press, 2016), 23. As Santagata points out, the supposedly ignoble burial of Dante's father Alighiero is an imputation from Forese Donati, a childhood friend with whom Dante exchanged insults through a literary form called the *tenzone* (duel). See Dante, *Rime*, ed. Gianfranco Contini (Turin: Einaudi, 1995), Sonnet 88, no. 2, line 8 of "Forese a Dante." While Forese's accusation cannot be taken as incontrovertible fact, Alighiero's status as an undistinguished and middling businessman seems likely.

6. For discussion of Florentine traditions of betrothal and marriage, see Santagata, *Dante*, 36–37. For broader discussions of medieval family life, see Charles de La Roncière, "Tuscan Nobles on the Eve of the Renaissance," in *History of Private Life*, vol. 2: *Revelations of the Medieval World*, ed. Georges Duby and Philippe Ariès, trans. Arthur Goldhammer (5 vols.; Cambridge, MA: Harvard University Press, 1992–98), 157–310; Barbara B. Dieffendorf, "Family Culture," *Renaissance Quarterly* 40 (1987): 661–81; and Christiane Klapisch-Zuber, *Woman, Family and Ritual in Renaissance Italy*, trans. Lynne Cochrane (Chicago: Chicago University Press, 1985).

7. The original reads: *"Ecce deus fortior me, qui veniens dominabitur michi."* Dante, *Vita nuova* (Milan: Garzanti, 1993), 2.

8. *"Heu miser, quia frequenter impeditus ero deinceps!"* Dante, *Vita nuova*, 2.

9. Santagata argues that Dante is likely embellishing here, as it was improbable for a family of modest means like his to afford private sleeping quarters. More likely, Dante wept over Beatrice while surrounded by nosy family members (*Dante*, 8).

10. See Robert Davidsohn, *Storia di Firenze* (8 vols.; Florence: Sansoni, 1956–68), 8:560; and Giovanni Boccaccio, *Esposizioni sopra la "Comedia" di Dante*, ed. Giorgio Padoan, in *Tutte le opere di Giovanni Boccaccio*, vol. 6, ed. Vittore Branca (Milan: Mondadori, 1965), 30–34.

11. See Aristotle, *Poetics*, trans. Stephen Halliwell, Loeb Classical Library (Cambridge, MA: Harvard University Press, 1995), 1451b4.

12. See Dante, *Purgatorio* 15.117.

13. See Paolo Sassetti, "Marriage, Dowry, and Remarriage in the Sassetti Household (1384–97)," trans. Isabella Chabot, in *Medieval Italy: Texts in Translation*, ed. Katherine L. Jansen, Joanna Drell, and Frances Andrews (Philadelphia: University of Pennsylvania Press, 2009), 446–50.

14. For a discussion of Dante's "fourth" child and the attendant controversies, see Santagata, *Dante*, 53.

15. Translation from Mandelbaum. The original Italian reads:

 Se mai continga che 'l poema sacro
 al quale ha posto mano e cielo e terra,
 sì che m'ha fatto per molti anni macro,
 vinca la crudeltà che fuor mi serra
 del bello ovile ov' io dormì agnello,
 nimico ai lupi che li danno guerra;
 con altra voce omai, con altro vello
 ritornerò poeta, e in sul fonte
 del mio battesmo prenderò 'l cappello.

16. There has been much historic dispute among scholars as to the potential meaning of *cappello* (crown). See the summary by Nicola Foscari (2000–13), Dartmouth Dante Project, https://dante.dartmouth.edu/search_view.php?doc=200353250070&cmd=gotoresult&arg1=2.

17. See the 1555 edition of *The Divine Comedy*, edited by Lodovico Dolce and published by the Venetian printer Gabriele Giolito de' Ferrari.

18. See Kelly DeVries and Niccolò Capponi, *Campaldino 1289: The Battle That Made Dante* (Oxford: Osprey, 2018), 6.

19. See Santagata, *Dante*, 109.

20. *Il Libro del Chiodo*, Archivio di Stato di Firenze, http://www.mondi.it/almanacco/voce/245019. For translation (which I have slightly modified) and discussion, see Ruth Levash, "The Rehabilitation of Dante Alighieri, Seven Centuries Later," Library of Congress website, https://blogs.loc.gov/law/2016/04/the-rehabilitation-of-dante-alighieri-seven-centuries-later/.

21. See *Paradiso* 25.3.

22. On the question of Dante's potentially suicidal thoughts, see Giuseppe Mazzotta, "The Life of Dante," in *The Cambridge Companion to Dante*, ed. Rachel Jacoff and Jeffrey Schnapp (Cambridge: Cambridge University Press, 2007), 9. In addition to his philosophical treatise the *Convivio* (*Banquet*, 1304–7), Dante's writing in the early years of his exile included his landmark treatise on languages, *De vulgari eloquentia* (*On Eloquence in the Vernacular*, 1302–5).

23. See *Inferno* 10.15.

24. *Inferno* 10.60.

25. *Inferno* 10.72.

26. See Vanessa Malandrin, Adanella Rossi, Leonid Dvortsin, and Francesca Galli, "The Evolving Role of Bread in the Tuscan Gastronomic Culture," in *Gastronomy and Culture*, ed. Katalin Csobán and Habil Erika Könyves (Debrecen, Hungary: University of Debrecen, 2015), 12.

27. See *Inferno* 10.48.

28. See *Inferno* 10.49–51.

29. UPI, "Florence Moves to Revoke Dante Exile," June 17, 2008, https://www.upi.com/Odd_News/2008/06/17/Florence-moves-to-revoke -Dante-exile/73391213746224/.

30. For a fascinating history of Dante's coveted corpse, see Guy Raffa, *Dante's Bones: A Poetic Afterlife* (Cambridge, MA: Harvard University Press, 2020).

31. Early commentaries on *The Divine Comedy* include Jacopo della Lana, c. 1324–28; Guido da Pisa, c. 1327–28; L'Ottimo Commento, c. 1333–38; Pietro Alighieri, c. 1340–64; and Giovanni Boccaccio, 1373–75.

32. See Simon Gilson, *Dante and Renaissance Florence* (Cambridge: Cambridge University Press, 2009), 7.

33. In truth, scholars have shown this massive group of Dante manuscripts to come from multiple scribes all working in the same Florentine scriptorium, which included and may also have been run by Francesco di ser Nardo. The false yarn about his prodigious Dantesque output was narrated by Vincenzo Borghini, a prominent sixteenth-century humanist who worked closely with Vasari in editing the revised version of his *Lives of the Artists* from 1568. See Sandro Bertelli, "Dentro l'officina di Francesco di ser Nardo da Barberino," *L'Alighieri: Rassegna dantesca* 28, no. 47 (July–December 2006), 77–90; and the website Italian Paleography, description of Manuscript Morgan MS M.289, https://italian -paleography.library.utoronto.ca/content/about_IP_302.

34. By the mid-1300s, the *Commedia* was so widely disseminated and discussed throughout Italy that there was already "no such thing as direct,

unmediated access to Dante." See Simon Gilson, "'La divinità di Dante': The Problematics of Dante's Reception from the Fourteenth to Sixteenth Centuries," *Critica del testo* 14, no. 1 (2011): 581–603, esp. 587.

35. See Justin Steinberg, *Accounting for Dante: Urban Readers and Writers in Late Medieval Italy* (Notre Dame, IN: Notre Dame University Press, 2007).

36. On the relation between the Renaissance and humanism, see James Hankins, "Renaissance Humanism and Historiography Today," in *Palgrave Advances in Renaissance Historiography*, ed. Jonathan Woolfson (London: Palgrave Macmillan, 2005), 73–96.

37. See Jacob Burckhardt, *The Civilization of the Renaissance in Italy*, trans. S. G. C. Middlemoore (London: Penguin, 1990), 136.

38. The actual literacy rate was closer to two-thirds of the male population in 1480—certainly not as high as Burckhardt surmised but still impressive for the time. See Paul Grendler's classic study *Schooling in Renaissance Italy: Literacy and Learning, 1300–1600* (Baltimore: Johns Hopkins University Press, 1991), 78.

39. Marcella Roddewig lists 827 circulating manuscripts in *Dante Alighieri: Die "Göttliche Komödie": Vergleichende Bestandsaufnahme der "Commedia"-Handschriften*. Stuttgart: Anton Hiersemann, 1984. For a discussion of the textual history of Dante's epic, see Gabriella Pomaro, "*Commedia*: Editions," trans. Robin Treasure, in *The Dante Encyclopedia*, ed. Richard Lansing (New York: Garland, 2000), 201–6. See also John Ahern, "What Did the First Copies of the *Comedy* Look Like?" in *Dante for the New Millennium*, ed. Teodolinda Barolini and H. Wayne Storey (New York: Fordham University Press, 2003), 1–15.

40. A claim was made that before Boccaccio's public lectures, and shortly after Dante's death in 1321, the Franciscan friar Accursio Bonfantini was invited by the *comune* of Florence to give regular Sunday lectures on the *Commedia* in Santa Maria del Fiore. See Lorenzo Mehus, *Historia litteraria florentina: Ab anno MCXCII usque ad annum MCDXXXIX* (Munich: Wilhelm Fink, 1968), clxxii. But Mehus does not give any source or proof. See the discussion in Ciro Perna, "La 'Lectura Dantis' come genere boccacciano," in *Boccaccio editore e interprete di Dante: Atti del Convegno internazionale di Roma 28–30 ottobre 2013*, ed. Luca Azzetta and Andrea Mazzuchi (Rome: Salerno, 2014), 437.

41. Petition from Florentine Citizens, *Libro delle Provvisioni* (1373), cited and translated in Michael Papio, *Boccaccio's Expositions on Dante's Comedy* (Toronto: Toronto University Press, 2009), 7–8. I have slightly modified the translation.

42. Though Boccaccio accepted the invitation to speak on Dante, he, as well as Petrarch, otherwise "fled from university teaching as if it were the plague" (Paul F. Grendler, *The Universities of the Italian Renaissance* [Baltimore: Johns Hopkins University Press, 2004], 207). See also Papio, *Boccaccio's Expositions on Dante's Comedy*, 14ff. For the complicated issue of how to value the Renaissance florin, see Richard Goldthwaite's magisterial *The Economy of Renaissance Florence* (Baltimore: Johns Hopkins University Press, 2009), 609–14. I am indebted to Ricardo Galliano Court for help on the purchasing power of Boccaccio's honorarium.

43. For mention of the enduring popular image of Boccaccio as a "ribald bon vivant," see Tobias Foster Gittes, review of Boccaccio's *Genealogy of the Pagan Gods: Volume 1, Books I–V*, ed. and trans. Jon Solomon, *Renaissance Quarterly* 65, no. 4 (Winter 2012): 1167.

44. For the story of "putting the devil back into hell," see the tale of Rustico and Alibech, Day 3 and Story 10 of the *Decameron*.

45. See Giovanni Boccaccio, *Genealogy of the Pagan Gods*, ed. and trans. Jon Solomon (2 vols.; Cambridge, MA: I Tatti Renaissance Library, 2017), 14.4.12; and Petrarch, *Familiarium rerum libri*, ed. Enrico Bianchi, in *Prose*, ed. G. Martelloti with P. G. Ricci, E. Carrara, and E. Bianchi (Milan and Naples: Riccardo Ricciardi, 1955), 21.15, 1008. See the discussion in Papio, *Boccaccio's Expositions on Dante's Comedy*, 9.

46. See Guyda Armstrong, "Boccaccio and Dante," in *The Cambridge Companion to Boccaccio*, ed. Guyda Armstrong, Rhiannon Daniels, and Stephen J. Milner (Cambridge: Cambridge University Press, 2015), 122.

47. Giovanni Boccaccio, "Life of Dante," in *The Early Lives of Dante*, trans. Philip Wicksteed (New York: Henry Holt, 1904), 10.

48. Boccaccio, "Life of Dante," 11.

49. See Giovanni Boccaccio's "Accessus" or introduction to his expositions on Dante's *Comedy*, in Papio, *Boccaccio's Expositions on Dante's Comedy*, 39. See also Massimiliano Corrado, "La 'Lectura Dantis,'" in *Dante: Fra il settecentocinquantenario della nascita e il settecentenario della morte* (Rome: Salerno, 2015), 665.

50. Omerita Ranalli notes that the lectures were to have been held "every day except for holidays" from October 23, 1373, to January 1374. See her "'Accessus ad auctorem' e primo canto dell'*Inferno* nella lettura fiorentina di Giovanni Boccaccio," in *Scrittori in cattedra: La forma della "lezione" dalle origini al Novecento*, ed. Floriana Calitti (Rome: Bulzoni, 2002), 9.

51. See Samuel K. Cohn Jr., "Epidemiology of the Black Death and

Successive Waves of Plague," https://www.ncbi.nlm.nih.gov/pmc/
articles/PMC2630035/.

52. See Giorgio Padoan, "Boccaccio, Giovanni," in *Enciclopedia dantesca*,
ed. Umberto Bosco (6 vols.; Rome: Istituto dell'Enciclopedia Italiana,
1970–75), 1:645–50. See also Ranalli, "'Accessus ad auctorem' e primo
canto dell'*Inferno* nella lettura fiorentina di Giovanni Boccaccio," 9–10.

53. See Corrado, "La 'Lectura Dantis,'" 1370.

54. See Ugo Foscolo, "A Parallel between Dante and Petrarch," ed.
Gianfranca Lavezzi, in vol. 2 of *Opere*, ed. Franco Gavezzeni (2 vols.;
Turin: Einaudi-Gallimard, 1994–95), 633–60.

55. Giovanni Boccaccio, *Opere latine minori*, ed. Aldo Francesco Massèra
(Bari: Laterza, 1928), 238. See also Giuseppe Velli, "Il *De vita et moribus
domini Francisci Petracchi de Florentia* del Boccaccio e la biografia del
Petrarca," *MLN: Italian Issue* 102, no. 1 (January 1987): 32–38.

56. See Francesco Petrarca, *Res seniles [Letters on Old Age]*, Libri *V–VIII*,
ed. Silvia Rizzo with Monica Berté (Florence: Le Lettere, 2009), 5.2,
30–51; and the discussion in Christopher S. Celenza, *The Intellectual
World of the Italian Renaissance: Language, Philosophy, and the Search for
Meaning* (Cambridge: Cambridge University Press, 2018), 28.

57. Petrarch's epistolary response to Boccaccio, and its accompanying cri-
tique of Dante, are in his *Familiarium rerum libri*, 21.15, 1002–14.

58. For discussion of how Petrarch's dismissal of his Tuscan poems—he
repeatedly claimed that they were *nugae*, trifles—was undercut by his
lifelong work on them, see Martin McLaughlin, "Humanism and Ital-
ian Literature," in *The Cambridge Companion to Renaissance Human-
ism*, ed. Jill Kraye (Cambridge: Cambridge University Press, 1996), 226.

59. See McLaughlin, "Humanism and Italian Literature," 228.

60. For Niccoli's opinion, see Leonardo Bruni, *Dialogi ad Petrum Paulum
Histrum* (1401), in *Prosatori latini del Quattrocento*, ed. Eugenio Garin
(Milan and Naples: Riccardo Ricciardi, 1952), 70. See also the discussion
in Patricia Lee Rubin, *Images and Identity in Fifteenth-Century Florence*
(New Haven: Yale University Press, 2007), 137, and, more broadly, her
analysis of Dante's influence on *Quattrocento* Florentine art, 137–46.

61. See, for example, Dante's points on how each day the illustrious ver-
nacular digs up "thorn bushes growing in the Italian forest," and how
always "the best language is suited to the best thinking" (*De vulgari elo-
quentia*, ed. and trans. Steven Botterill [Cambridge: Cambridge Univer-
sity Press, 1996], 43, 49). See also my discussion in *My Two Italies*, 109.

62. See Petrarch's poem "Quand'io movo i sospiri a chiamar voi," "When

I utter sighs, in calling out to you," trans. A. S. Kline, https://www
.poetryintranslation.com/PITBR/Italian/PetrarchCanzoniere001-061
.php#anchor_Toc9485190.
63. Dante, *Paradiso* 33.86.
64. See McLaughlin, "Humanism and Italian Literature," 227–28.
65. See Leonardo Bruni, "Comparison of Dante and Petrarch," in *Dante: The Critical Heritage, 1314(?)–1870*, ed. Michael Caesar (London: Routledge, 1989), 210. I have slightly modified the translation by D. Thomson and A.F. Nagel.
66. Boccaccio agreed with Dante on the point that "theology is nothing else but a poem of God's." See his *Trattatello in Laude di Dante*, ed. Pier Giorgio Ricci, in vol. 3 of *Tutte le opere di Giovanni Boccaccio* (Milan: Mondadori, 1974), 425.
67. On the "cultural schizophrenia" among Italian intellectuals caused by Petrarch's radical separation of Latin and vernacular literature, a move fueled by his struggle with Dante's legacy, see McLaughlin, "Humanism and Italian Literature," 229.
68. See Franco Sacchetti, *Tales from Sacchetti*, trans. Mary G. Steegmann (London: J. M. Dent, 1908), 84. I have modified and modernized these translations (esp. 95).
69. Sacchetti, *Tales from Sacchetti*, 85.
70. Sacchetti, *Tales from Sacchetti*, 87.
71. Sacchetti, *Tales from Sacchetti*, 87.
72. Sacchetti, *Tales from Sacchetti*, 87.
73. Sacchetti, *Tales from Sacchetti*, 95.
74. Sacchetti composed the following poem after Boccaccio's lecture series:
 Come deggio sperar che surga Dante,
 Che già chi il sappia legger non si trova,
 E Giovanni, ch'è morto, ne fe' scola?
 How dare I hope that Dante will be reborn,
 Since there's nobody around who knows how to read him,
 And Giovanni, who is dead, no longer teaches him?
 See Massimiliano Corrado, "La 'Lectura Dantis' in Dante," 668; and Franco Sacchetti, *Il libro delle rime con le lettere. La battaglia delle belle donne* (Turin: UTET, 2007), 316–21 (CLXXX) and 320 (ll. 92–93).

Chapter 2: *Bottega* to Brand

1. For a sense of the competition's importance, see Richard Krautheimer,

Lorenzo Ghiberti (Princeton: Princeton University Press, 1983), 34. And for a sense of the international cachet of Florence's textile industry, see the fictional praise heaped on it by the priest inspecting Don Quixote's library: "Give [that book] to me, friend, for I value finding it more than if I were given a cassock of rich Florentine cloth" (Miguel de Cervantes, *Don Quixote*, trans. Edith Grossman [New York: Ecco, 2003], 51).

2. See Krautheimer, *Lorenzo Ghiberti*, 39.

3. Vasari, *Lives of the Artists*, 138.

4. Lorenzo Ghiberti, *Commentarii*, in *A Documentary History of Art*, ed. Elizabeth Gilmore Holt, vol. 1: *The Middle Ages and the Renaissance* (3 vols.; New York: Doubleday, 1957–66), 157. See also Lorenzo Bartoli's introduction to Lorenzo Ghiberti, *I commentarii (Biblioteca Nazionale Centrale di Firenze, II, I, 333)*, ed. Lorenzo Bartoli (Florence: Giunti, 1998), 19–20.

5. Antonio di Tuccio Manetti, *The Life of Brunelleschi*, trans. Catherine Enggass (University Park: Pennsylvania State University Press, 1970), 50.

6. See Ross King, *Brunelleschi's Dome: How a Renaissance Genius Reinvented Architecture* (New York: Bloomsbury, 2013), 20.

7. Vasari, *Lives of the Artists*, 147.

8. For a history of the Duomo's commission and Brunelleschi's struggle for control of the project, see King, *Brunelleschi's Dome*, esp. his discussion of Brunelleschi's rivalry with Ghiberti (43–48).

9. Ingrid Rowland and Noah Charney, *The Collector of Lives: Giorgio Vasari and the Invention of Art* (New York: W. W. Norton, 2017), 111.

10. See "Patrons and Artists in Late 15th-Century Florence," National Gallery of Art website, https://www.nga.gov/features/slideshows/patrons-and-artists-in-late-15th-century-florence.html.

11. Rowland and Charney, *The Collector of Lives*, 6.

12. See Jacques Mesnil, "L'éducation des peintres florentins au XVe siècle," *Revue des idées* 14 (September 15, 1910): 195–206.

13. See Susan Mosher Stuard, *Gilding the Market: Luxury and Fashion in Fourteenth-Century Italy* (Philadelphia: University of Pennsylvania Press, 2006), 150.

14. I am indebted to Kristin Phillips-Court for this insight into Leonardo's and Michelangelo's multifaceted training.

15. Vasari, *Lives of the Artists*, 131.

16. On the relation between Masaccio's painting and Botticelli's apprenticeship under Fra' Lippo Lippi, see John T. Spike, "Botticelli and the Search for the Divine," *Botticelli and the Search for the Divine: Florentine*

Painting Between the Medici and the Bonfires of the Vanities, ed. John T. Spike and Alessandro Cecchi (Williamsburg, VA: College of William and Mary, Muscarelle Museum of Art, 2017), 20.

17. See Vasari, *Lives of the Artists,* 136.

18. For the links between Brunelleschi and Dante, see Vasari, *Lives of the Artists,* 137.

19. The story takes the form of a clever Latin pun in Benvenuto da Imola's commentary on the *Commedia* from 1376, who reports Giotto's witty reply to Dante as *"Quia pingo de die, sed fingo de nocte"* ("I paint by day, procreate by night"). The yarn is completely fabricated, part of a Vasari-like chain of seductive legend: Benvenuto borrowed it from his friend Petrarch who, following the fifth-century author Macrobius, ascribed it to the ancient painter Mallius. For a history of the fallacious but revealing quote, see Enid Falaschi, "Giotto: The Literary Legend," *Italian Studies* 27 (1972): 1; and Andrew Ladis, "The Legend of Giotto's Wit and the Arena Chapel," *Art Bulletin* 68, no. 4 (December 1986): 583 *n*13.

20. Boccaccio also included a story featuring Giotto's quick, deft wit—and homely looks: see Day 6, Story 5, a tale that shows how Giotto, when insulted because of his appearance, could, to tweak Boccaccio's concluding words, "give as good as he got" (*Decameron,* 490).

21. For a study of Michelangelo's vast knowledge of Dante (whom he reputedly "knew almost by heart"), see Peter Armour, "'A ciascun artista l'ultimo suo': Dante and Michelangelo," *Lectura Dantis,* special issue: *Visibile Parlare: Dante and the Art of the Italian Renaissance* 22/23 (Spring and Fall 1998): 141–80, esp. 141.

22. See Anne Pegoretti, "Early Reception Until 1481," in *The Cambridge Companion to Dante's "Commedia,"* ed. Zygmunt Barański and Simon Gilson (Cambridge: Cambridge University Press, 2019), 245.

23. See Paul Barolsky, "Dante and the Modern Cult of the Artist," *Arion: A Journal of Humanities and the Classics* 12, no. 2 (Fall 2004): 3.

24. See Dante, *Inferno* 21.139.

25. See Dante, *Inferno* 9.62–63.

26. See Herbert Horne, *Botticelli, Painter of Florence* (Princeton: Princeton University Press, 1980), 2.

27. For a study of Botticelli's relation to his native neighborhood, see Gert Jan van der Sman, "Botticelli's Life and Career in the District of the Unicorn," in *Sandro Botticelli (1445–1510),* ed. van der Sman and Mariani, 183–201.

28. See Horne, *Botticelli, Painter of Florence,* 3.

29. See Horne, *Botticelli, Painter of Florence,* 3.

30. A minority viewpoint on the origin of Botticelli's nickname holds that the artist got it from his proverbial gluttony, a trait playfully satirized by Lorenzo il Magnifico in his *Simposio*, a poem from c. 1473–74 on *"alcuni che troppo dati a' piaceri e troppo inordinatamente al bere s'erano profusi"* ("certain [Florentines] overly given to pleasure and inordinately fond of drink"): "Botticelli whose fame is no secret / Botticelli I say. Botticelli the greedy / who is greedier and more brazen than a fly" (see Cecchi, *Botticelli*, 26).

31. For a lovely poetic meditation on gold's malleability, actual and metaphoric, see John Donne's "A Valediction: Forbidding Mourning," in *The Collected Poems*, ed. Roy Booth (Ware, UK: Wordsworth Editions, 1994), 34:

 Our two soules therefore, which are one,

 Though I must goe, endure not yet

 A breach, but an expansion,

 Like gold to a[i]ry thinnesse beate. (21–24)

32. For a thorough discussion of the goldsmith's trade and its technical elements, see Benvenuto Cellini, *The Treatises of Benvenuto Cellini on Goldsmithing and Sculpture*, trans. C. R. Ashbee (New York: Dover, 1967).

33. See Aby Warburg, *Botticelli*, trans. Emma Cantimori (Milan: Abscondita, 2003), 93: "Sandro Botticelli has for each immobile object, clearly defined, the attentive eye of the Florentine 'painter–goldsmith'; one can see this in the loving precision with which he reproduces every single object." See also Stuard, *Gilding the Market*, 149.

34. See Liana Chaney, *Quattrocento Neoplatonism and Medici Humanism in Botticelli's Mythological Paintings* (Lanham, MD: Lanham University Press of America, 1985), 185–86. In Ruskin's words, goldsmithing helped Botticelli achieve "a glowing harmony never reached with equal perfection, and rarely attempted, in the later schools" (*Ariadne Florentina*, 178–79).

35. See Vasari on Botticelli's apprenticeship to Fra' Filippo Lippi: "Botticelli threw all his energies into his work, following and imitating his master so well that Fra' Filippo grew very fond of him and taught him to such good effect that very soon his skill was greater than anyone would have anticipated" (*Lives of the Artists,* 224).

36. Vasari, *Lives of the Artists*, 216.

37. Vasari, *Lives of the Artists*, 216.

38. See Horne, "Quelques souvenirs de Sandro Botticelli," *Revue archéologique* 39 (1901): 13.

39. On Botticelli's abundant floral imagery and references, see Mirella

Levi d'Ancona, *Botticelli's* Primavera: *A Botanical Interpretation Including Astrology, Alchemy and the Medici* (Florence: Olschki, 1983).

40. See Ruskin, *Ariadne Florentina*, 114. In *Mornings in Florence* (1875), Ruskin made a similarly rapturous comment on Lippi's protégé: "No Florentine painter, or any other, ever painted leaves as well as [those by the Memmi brothers], till you get down to Sandro Botticelli, who did them much better" (https://www.gutenberg.org/files/7227/7227-h/7227 -h.htm).

41. For a consideration of the relation between a Renaissance artist's "home" and his workplace or "studio," see Linda Bauer, "From *Bottega* to Studio," *Renaissance Studies* 22, no. 5 (November 2008): 642–49.

42. See Patrizia Zambrano on the complex and rich relation between these two artists: "The 'Dead Christ' in Cherbourg: A New Attribution to the Young Filippino Lippi," *The Burlington Magazine* 138, no. 1118 (1996): 321–24.

43. For the emergence of Botticelli's commercial imprimatur, see Caroline Campbell, "Botticelli and the *Bottega*," in *Botticelli Reimagined*, ed. Evans and Weppelmann et al., 24: "The Botticelli visual brand was intentionally compelling and clear."

44. For an important study of the Renaissance art market in all its financial complexity, see Richard Goldthwaite, *Wealth and the Demand for Art in Italy, 1300–1600* (Baltimore: Johns Hopkins University Press, 1993).

45. See Lucrezia Tornabuoni de' Medici, *Sacred Narratives*, ed. and trans. Jane Tylus (Chicago: University of Chicago Press, 2001), 31.

46. See Lucrezia Tornabuoni de' Medici, *Sacred Narratives*, 31.

47. See Lucrezia Tornabuoni de' Medici, *Sacred Narratives*, 31.

48. Christopher Hibbert, *The Rise and Fall of the House of Medici* (London: Penguin, 1974), 118.

49. The timeframe for Donatello's bronze *David* remains a matter of conjecture. For a convincing dating of the sculpture to the early 1440s, see John Pope-Hennessy, *Donatello: Sculptor* (New York: Abbeville Press, 1993), 155. For an overview of the controversies surrounding the statue's moment of creation, see Peter Weller, "A Reassessment in Historiography and Gender: Donatello's Bronze David in the Twenty-First Century," *Artibus et Historiae* 33, no. 65 (2012): 43–77.

50. See Weller, "A Reassessment in Historiography and Gender," 49.

51. Vasari, *Lives of the Artists*, 186.

52. For a thoughtful piece on Donatello's sculpture, considered to be of the Old Testament prophet Habakkuk and originally created for the bell

tower of the Florence cathedral, see Peter Schjeldahl, "Entranced by Donatello," *New Yorker*, March 2, 2015.

53. Denise A. Costanza, "The Medici McMansion?" in *The Renaissance: Revised, Expanded, Unexpurgated*, ed. D. Medina Lasansky (Pittsburgh: Periscope, 2014), 288–307.

54. The scholarly debate over whether or not Donatello's *David* contains "homoerotic" imagery is long and combative. Scholars who argue on behalf of the figure's supposedly homosexual elements include H. W. Janson, *The Sculpture of Donatello* (Princeton: Princeton University Press, 1979), 85; and Laurie Schneider, "Donatello's Bronze *David*," *Art Bulletin* 55, no. 2 (1973): 215–16. The trend among more recent critics (which I support) has been to rebut the notion of a homoerotic *David* as inconclusive and conjectural. For this view, see especially John Pope-Hennessy, "Donatello's Bronze *David*," in *Scritti di storia dell'arte in onore di Federico Zeri* (Milan: Electa, 1984), 122–27; and Robert Williams, "On the Meaning of Donatello's *David*," transcript (2007), 9, cited in Weller, "A Reassessment in Historiography and Gender," 68.

55. For a major study of same-sex love in the Renaissance, see Michael Rocke, *Forbidden Friendships: Homosexuality and Male Culture in Renaissance Florence* (New York: Oxford University Press, 1998).

56. See Rocke, *Forbidden Friendships*, 3.

57. See *Facetie, motti e burle di diversi signori e persone private*, discussed in Weller, "A Reassessment in Historiography and Gender," 50.

58. See Aristotle, *The Politics of Aristotle*, trans. Benjamin Jowett (Oxford: Clarendon Press, 1885), book 1, chapter 10, p. 19: "The most hated sort [of moneymaking], and with the greatest reason, is usury, which makes a gain out of money itself, and not from the natural use of it. For money was intended to be used in exchange, but not to increase at interest."

59. See Tim Parks, *Medici Money: Art, Banks, and Metaphysics in Fifteenth-Century Florence* (New York: Enterprise, 2005), 40.

60. Raymond De Roover, *The Rise and Decline of the Medici Bank, 1397–1494* (Philadelphia: Beard Books, 1999), 57.

61. The financial sleights of hand practiced by the Medici and their fellow Florentine bankers is the subject of Parks's superb *Medici Money*.

62. De Roover, *The Rise and Decline of the Medici Bank*, 57.

63. For background on the Soderini family in general and Tommaso in particular, see K. J. P. Lowe, *Church and Politics in Renaissance Italy:*

The Life and Career of Cardinal Francesco Soderini (1453–1524) (Cambridge: Cambridge University Press, 1993), 9–12.

64. See Roger J. Crum, review of *The Soderini and the Medici: Power and Patronage in Fifteenth-Century Florence* by Paula C. Clarke, *Renaissance Studies* 7, no. 1 (March 1993): 115–19. For a study of the symbiotic link between Medici politics and advisors like Soderini, see Paula C. Clarke, *The Soderini and the Medici: Power and Patronage in Fifteenth-Century Florence* (Oxford: Clarendon Press, 1991).

65. For discussion of Botticelli's *bottega*, see Cecchi, *Botticelli*, 59–93.

66. Alessandro Cecchi notes that Botticelli, as his career wore on, "increasingly delegated his work to his pupils and assistants, in the end allowing them to take over, which meant that a good part of the artistic production of his later years was of inferior quality" ("Botticelli and His Time," *Botticelli and the Search for the Divine*, ed. Spike and Cecchi, 42).

67. The declaration is from 1480. See Cecchi, "La bottega nella via Nuova Ognissanti: 'Sandro è dipintore, lavora in chasa quando e' vole' (1470–1510)," in *Botticelli*, 59–93.

68. These *denunce anonime*, anonymous accusations, were deposited on October 14, 1490, and November 16, 1502. See Cecchi, *Botticelli*, 64, 66.

69. For description of the Soderini–Botticelli connection, see Michelle O'Malley, "Finding Fame: Painting and the Making of Careers in Renaissance Florence," *Renaissance Studies* 24, no. 1 special issue, *Re-Thinking Renaissance Objects: Design, Function, and Meaning* (February 2010): 11–17. For the commission itself, see Alison Wright, *The Pollaiuolo Brothers* (New Haven: Yale University Press, 2005), 231–49, 561–63.

70. For Soderini's probable involvement in the commission, see O'Malley, "Finding Fame," 14.

71. For discussion of how Botticelli's pictures often were hung in prominent public locations—and how the "Visibility of these works contributed to the image Florentines had of their city"—see Michelle O'Malley, introduction to Part 1, "Botticelli in His Own Time," in *Botticelli Past and Present*, ed. Debenedetti and Elam, 7.

72. See Michelle O'Malley, "Responding to Changing Taste and Demand: Botticelli after 1490," in *Sandro Botticelli (1445–1510)*, ed. van der Sman and Mariani, 101–19.

73. On the Dante–Petrarch door design, see Nicola Rubinstein, *The Palazzo Vecchio, 1298–1532: Government, Architecture, and Imagery in the Civic Palace of the Florentine Republic* (Oxford: Clarendon Press, 1995), 61. On the close attention given by Lorenzo il Magnifico to the project,

see Melinda Hegarty, "Laurentian Patronage in the Palazzo Vecchio: The Frescoes of the Sala dei Gigli," *Art Bulletin* 75, no. 2 (1996): 264–85. Cecchi notes that before June 24, 1480, Botticelli reproduced cartoons for the figures of Dante and Petrarch that were inlaid in the door between the Sala dei Gigli and the Sala delle Udienze of Palazzo Vecchio (*Botticelli*, 47).

Chapter 3: *Chiaroscuro*

1. For a description of the tumultuous events and their successful resolution, see William Roscoe, *The Life of Lorenzo de' Medici, Called the Magnificent* (3rd. ed.; London: A. Strahan, 1797), 78–85.

2. See Lauro Martines, *Power and Imagination: City-States in the Renaissance* (Baltimore: Johns Hopkins University Press, 1988), 243. Martines remarks, "Art and power in Renaissance Italy went hand in hand" (241).

3. Martines, *Power and Imagination*, 243.

4. Lorenzo's Joust of 1469 was commemorated in the verse of Luigi Pulci, "La giostra di Lorenzo de' Medici."

5. For analysis of the blurred lines between "art" and "propaganda," especially in connection to the religious themes of most of the era's paintings, see Martines, *Power and Imagination*, 241–44.

6. For mention of Lorenzo's rapacious sexuality, see Miles J. Unger, *Magnifico: The Brilliant Life and Violent Times of Lorenzo de' Medici* (New York: Simon and Schuster, 2008), 68, 371. See also his contrast between the two "very different personalities" of Lorenzo and his brother, Giuliano (157–58).

7. See Ross Brooke Ettle, "The Venus Dilemma: Notes on Botticelli and Simonetta Cattaneo Vespucci," *Notes in the History of Art* 27, no. 4 (Summer 2008): 3–10.

8. Agnolo Poliziano, *Stanze cominciate per la giostra di Giuliano de' Medici*, ed. Vincenzo Bona (Turin: Loescher, 1954), 1.99–101. I have slightly modified the translation in Ronald Lightbown, *Sandro Botticelli* (2 vols.; Berkeley: University of California Press, 1978), 1:159–60.

9. See Barbara Renzi, ed., *A Guide to Italian Language and Culture for English-Speaking Learners of Italian: La Dolce Italia* (Cambridge: Cambridge Scholars, 2017), 319.

10. Ronald Lightbown, *Sandro Botticelli: Life and Work* (New York: Abbeville, 1989), 43.

11. Lorenzo il Magnifico described the standard thus in his inventory: "A

cloth mounted on a board dressed with gold, about 4 ells high and 2 ells wide, with a figure of Pallas on it and with a shield and a spear painted by Sandro Botticelli." Cited in Antonio Paolucci, "Botticelli and the Medici: A Privileged Relationship," in *Botticelli: From Lorenzo the Magnificent to Savonarola*, ed. Alessandro Chioetto (Turin: Skira, 2003), 73. The ell was an ancient unit of measurement equal to the typical length of a person's arm.

12. Frank Zollner, *Botticelli* (New York: Prestel, 2015), 30.

13. For the jocular exchange between Botticelli and Soderini, see Poliziano, *Detti piacevoli*, no. 200, cited in Horne, *Botticelli, Painter of Florence* 43–44, docs. 1–2; and Cecchi, *Botticelli*, 62–63. See also Ida Maier, *Ange Politien: La formation d'un poète humaniste, 1469–1480* (Geneva: Droz, 1966), 419–24.

14. Soderini's original words are *"non era terreno da porvi vigna."*

15. Vasari, *Lives of the Artists*, 226.

16. Little is known of Lama. See Horne: "Of Giovanni Lami [*sic*], I can find nothing; but I surmise that he was a merchant who had built up his own fortunes, and wished to ingratiate himself with the Medici" (*Botticelli, Painter of Florence*, 40).

17. See Mesnil on Lama's attempt to "please God through gifts to the Church" in *Botticelli* (Paris: Michel Albin, 1938), 47.

18. Matthew 2:11, "Virtual Christianity: Bibles—MIT," http://www.mit .edu/activities/csa/bibles.html.

19. For an analysis of the painting's medley of approaches to portraiture, including Botticelli's self-portrait, see John Pope-Hennessy, *The Portrait in the Renaissance* (Princeton: Princeton University Press, 1963), 30.

20. On the connection between Botticelli's and Gozzoli's Magi–Medici paintings, see Paolucci, "Botticelli and the Medici," 69.

21. See Stephen Greenblatt, *Renaissance Self Fashioning: From More to Shakespeare* (Chicago: University of Chicago Press, 2005), passim.

22. See Spike, *Botticelli and the Search for the Divine*, ed. Spike and Cecchi, 26.

23. Vasari, *Lives of the Artists*, 226–27.

24. See Paolucci, "Botticelli and the Medici," 58ff. There is no conclusive evidence that Lorenzo il Magnifico was Sandro Botticelli's direct patron, but his brother Giuliano did commission Botticelli to paint a portrait of him that now hangs in London's National Gallery.

25. Francesco Guicciardini, *The History of Italy*, trans. Sidney Alexander (Princeton: Princeton University Press, 1984), 315.

26. Teodolinda Barolini has referred to Dante's rather primitive aesthetic as his penchant for "caveman chic." See her " 'Only Historicize':

History, Material Culture (Food, Clothes, Books), and the Future of Dante Studies," *Dante Studies* 127 (2009): 37–54, esp. 46.

27. See Roscoe, *The Life of Lorenzo de' Medici*, 177.

28. See Lauro Martines, *April Blood: Florence and the Plot Against the Medici* (Oxford: Oxford University Press, 2003), 158.

29. John Najemy, *A History of Florence: 1200–1575* (New York: Wiley–Blackwell, 2006), 354.

30. See Machiavelli, *Istorie fiorentine*, ed. Plinio Carlo (2 vols.; Florence: Place, 1927), 2:218. See also the discussion in De Roover, *The Rise and Decline of the Medici Bank*, 59.

31. See De Roover, *The Rise and Decline of the Medici Bank*, 60.

32. Parks, *Medici Money*, 213.

33. Niccolò Macchiavelli, *Machiavelli and His Friends: Their Personal Correspondence*, ed. and trans. James B. Atkinson and David Sices (DeKalb: Northern Illinois University Press, 1996), 158.

34. Niccolò Macchiavelli, *Florentine Histories*, trans. W. K. Marriott (London: J. M. Dent, 1909), 321.

35. See Martines, *April Blood*, 116.

36. See Martines, *April Blood*, 125.

37. Parks, *Medici Money*, 217.

38. Najemy, *A History of Florence*, 356.

39. Guicciardini, *The History of Italy*, 357.

40. Hibbert, *The Rise and Fall of the House of Medici*, 142.

41. Vasari, *Lives of the Artists*, 240.

42. See Walter Isaacson, *Leonardo da Vinci* (New York: Simon and Schuster, 2017), 89.

Chapter 4: The Commission

1. See, respectively, Isaiah 38:10 and Psalms 90:10, "Virtual Christianity: Bibles—MIT," http://www.mit.edu/activities/csa/bibles.html.

2. The exact timing and length of Botticelli's Dante project remains the subject of ongoing debate, and the literature on the subject is vast. As recently as 1975, the reliable *Enciclopedia dantesca* noted, "the chronology of [Botticelli's] drawings of the *Commedia* remains uncertain" ("Botticelli, Sandro," 1:689). The drawings have been variously dated from c. 1480 to 1510, the year of Botticelli's death (my own view, as discussed below, is a dating from c. 1480 to c. 1495). For a thorough treatment of the subject, see Peter Dreyer in *Dantes Divina Commedia mit den Illustrationen von Sandro Botticelli: Codex Reg. Lat. 1896, Codex*

Ham. 201 (Cim. 33) (Zurich: Belser, 1986). See also Schulze Altcappenberg, "'Per essere persona sofistica.'"; and Lightbown, *Sandro Botticelli* [1978], 1:148 and 2:173.

3. Scholars generally attribute the script to Niccolò Mangona, whose work dates from 1482 to 1503. See Annarosa Garzelli, *Le immagini, gli autori, i destinatari*, vol. 1 of *Miniatura fiorentina del Rinascimento, 1440–1525: Un primo censimento*, ed. Annarosa Garzelli (2 vols.; Florence: Giunta Regionale Toscana and La Nuova Italia, 1985), 472, 518. See also Dreyer, "La storia del manoscritto," 37–40.

4. See Dreyer, "La storia del manoscritto," 35, on how the detailed representations by Botticelli of individual cantos were only possible because he had attentively read the *Commedia*. But, Dreyer adds, Botticelli did not necessarily avail himself of Landino's commentary.

5. See Barbara Watts on how the complex design of the Dante volume suggests Botticelli's innovative structuring of the illustrations and his perspicacity as a reader ("Sandro Botticelli's Drawings for Dante's *Inferno*," 195, 197).

6. Further technical analysis of Botticelli's drawing and painting techniques may be found in Diane Kunzelman, "Comparative Technical Investigations of Paintings by Sandro Botticelli," in *Sandro Botticelli (1445–1510)*, ed. van der Sman and Mariani, 27–44.

7. For a discussion of Botticelli's relation to the illuminated manuscript tradition, see Julia Schewski, "Illuminated Manuscripts of the *Divine Comedy*: Botticelli and Dante Illustrations in the 14th and 15th Centuries," in *Sandro Botticelli*, ed. Schulze Altcappenberg, 312–25.

8. For the techniques Botticelli employed in his Dante illustrations, see Schulze Altcappenberg, "'Per essere persona sofistica'"; and Doris Oltrogge, Robert Fuchs, and Oliver Hahn, "*Finito and Non finito*: Drawing and Painting Techniques in Botticelli's *Divine Comedy*," in *Sandro Botticelli*, ed. Schulze Altcappenberg, 334–35.

9. As one commentator shrewdly observed, "the element of movement in [Botticelli's] composition almost obscures the narrative" of the *Commedia* as well as its characters. See *Sandro Botticelli*, ed. Schulze Altcappenberg, 68.

10. The original Italian reads: "*Tu lascerai ogne cosa diletta / più caramente; e questo è quello strale / che l'arco de lo essilio pria saetta*" (*Paradiso* 17.55–57).

11. Pope-Hennessy describes Botticelli's genius for portraiture in terms of his ability to capture the "kernel of the personality . . . seldom in the fifteenth century was the poetic essence of the individual pinned down more faultlessly" (*The Portrait in the Renaissance*, 30).

12. See, respectively, Karla Taylor, "A Text and Its Afterlife: Dante and Chaucer," *Comparative Literature* 35, no. 1 (Winter 1983): 1–20; Ernst Behler, "Dante in Germany," in *The Dante Encyclopedia*, ed. Lansing, 262; and Werner P. Friederich, *Dante's Fame Abroad, 1350–1850: The Influence of Dante Alighieri on the Poets and Scholars of Spain, France, England, Germany, Switzerland, and the United States* (Rome: Edizioni di Storia e Letteratura, 1950), 57.

13. See Peter Keller, "The Engravings in the 1481 Edition of the *Divine Comedy*," in *Sandro Botticelli*, ed. Schulze Altcappenberg, 326.

14. See Guy P. Raffa, "On the City of Florence's Struggle to Get Back Dante's Body," *Literary Hub*, May 18, 2020, https://lithub.com/on-the -city-of-florences-struggle-to-get-back-dantes-body/.

15. See the discussion in Pegoretti, "Early Reception Until 1481," 257. According to Dreyer, Michelino's representation of Mount Purgatory would influence Botticelli's version ("La storia del manoscritto," 32).

16. For a listing of the various editions of *The Divine Comedy* published in Italy after the advent of moveable type, see Batines, *Bibliografia dantesca*, passim.

17. See Angela Dressen, "From Dante to Landino: Botticelli's *Calumny of Appeles* and Its Sources," *Mitteilungen des Kunsthistorischen Institutes in Florenz* 59, no. 3 (2017): 352.

18. For discussion of the Landino edition as part of how Florence reclaimed Dante as "civic poet" in the 1480s, see Sally Korman, "'Danthe Alighieri Poeta Florentino': Cultural Values in the 1481 *Divine Comedy*," in *Reevaluating Renaissance Art*, ed. Gabriele Neher and Rupert Shepherd (London: Ashgate, 2000), 57–69.

19. The original reads: "*Comento di Christophoro Landino Fiorentino sopra la Comedia di Danthe Alighieri Poeta Fiorentino.*"

20. See Anne Dunlop, "'El Vostro Poeta': The First Florentine Printing of Dante's *Commedia*," *Canadian Art Review* 20, nos. 1/2 (1993): 29–42.

21. Scholarly opinions are divided on when Botticelli began work for the Florentine *Commedia*. Vasari notes that after returning from Rome in 1482, Botticelli "illustrat[ed] the *Inferno*" (*Lives of the Artists*, 227), a dating supported by Dreyer, who also proposes 1482 as the starting point ("La storia del manoscritto," 30). Schulze Altcappenberg gives c. 1480, before Botticelli's trip to Rome, as the starting point ("'Per essere persona sofistica,'" 23), which I support for two reasons: first, the engravings based on Botticelli's drawings were published as early as 1482, which suggests that the process of adapting Botticelli's work likely predated the return from Rome; second, a volume as grand in scope as the

Florentine *Commedia* would have probably had an enormous amount of planning behind it, making it likely that Botticelli was tapped for his contributions before he departed for the Eternal City.

22. The relation between Botticelli's drawings for the Florentine *Commedia* and his work for Lorenzo di Pierfrancesco's deluxe volume has long divided scholars. Early pioneers like Friedrich Lippmann and Josef Strzygowski believed (correctly, in my view) that that there was only one set of drawings by Botticelli used for both projects. Others have disagreed, including the eminent Botticelli scholars Peter Dreyer and Kenneth Clark, who believed that these were two separate endeavors, with the drawings for the engravings made in the early 1480s and the illustrations for the deluxe volume made in the 1490s (see, for example, Kenneth Clark, *The Drawings by Sandro Botticelli for Dante's "Divine Comedy"* [New York: HarperCollins, 1976], 9). The prevailing scholarly view, to which I subscribe, is that affinities between the motifs and forms of the engravings and the drawings in the fully illustrated codex are too similar for there to have been two separate Dante projects started by Botticelli. A strong case for this single Dante project thesis is Schulze Altcappenberg, " 'Per essere persona sofistica,' " 23: "there can be little doubt that the illustrations on parchment commissioned by Lorenzo di Pierfrancesco de' Medici and the illustrations for the printed [Landino] edition were connected," because the engravings that appeared in the deluxe volume and those in the Landino edition are extremely similar in nature, scope, and style.

23. See Dreyer, "La storia del manoscritto," 30.

24. Lightbown, *Sandro Botticelli* [1989], 121.

25. See De Roover on how the funds taken by Lorenzo il Magnifico from Lorenzo di Perfrancesco de' Medici were reimbursed (*The Rise and Decline of the Medici Bank*, 114). On the otherwise friendly relations between the two cousins, see John Shearman, "The Collections of the Younger Branch of the Medici," *The Burlington Magazine* 117, no. 862 (January 1975): 12–13.

26. See his *Vita Laurentis Mediciis*: *"qual cura n'ebbe come di figliuolo, preponendo alla cura e governo suo uomini e di costumi e per lettere eccellentissimi."* Cited by Nicoletta Baldini in *Sandro Botticelli Pittore della "Divina Commedia,"* ed. Hein-Th. Schulze Altcappenberg (2 vols.; Rome: Scuderie Papali al Quirinale, and Milan: Skira, 2000), 1:114.

27. Marsilio Ficino, *The Letters of Marsilio Ficino*, trans. Members of the

Language Department of the London School of Economics (2nd ed.; London: Shepheard–Walwyn, 1975).

28. The holdings included manuscripts by Ptolemy, epigrams by the humanist author Michele Marullo, a portrait of Lorenzo di Pierfrancesco de' Medici by Botticelli from 1496–97, and Botticelli's mythological painting *Pallas and the Centaur.*

29. For discussion on how the decade between Botticelli's return from Rome in 1482 and the death of Lorenzo il Magnifico in 1492 marked the consolidation of Botticelli's fame and the pinnacle of his art, see Cecchi, *Botticelli*, 48.

30. See Claudio Strinati, "The Real Botticelli," in *Botticelli*, ed. Chioetto, 77.

31. See Michael Levey, "Botticelli and Nineteenth-Century England," *Journal of the Warburg and Courtauld Institutes* 23 (1960): 291–306, esp. 294.

32. For an interpretation of how Botticelli's frescoes for Pope Sixtus IV incorporate visual themes and motifs from the Pazzi Conspiracy and its attack on the Medici, see Marcello Simonetta, *The Montefeltro Conspiracy: A Renaissance Mystery Decoded* (New York: Doubleday, 2008), 189–92.

33. See Ruskin, *Ariadne Florentina*, 104: "[Botticelli] knows that the pictures he has painted in Rome cannot be understood by the people; they are exclusively for the best trained scholars in the Church. Dante, on the other hand, can only be read in manuscript; but the people could and would understand *his* lessons, if they were pictured in accessible and enduring form."

34. See Vasari, *Lives of the Artists*, 227: "When [Botticelli] had finished and unveiled the [Sistine Chapel frescoes] he had been commissioned, he immediately returned to Florence where, [to prove he was a sophisticated person], he completed and [drew] a part of Dante, illustrating the *Inferno*. He wasted a great deal of time on this, neglecting his work and thoroughly disrupting his life."

35. See Sherry Roush, "Dante as *Piagnone* Prophet: Girolamo Benivieni's 'Cantico in laude di Dante' (1506)," *Renaissance Quarterly* 55, no. 1 (Spring 2002): 49–80.

36. For the "contemptuous" comment, see Fitzroy Carrington, "Florentine Studies: The Illustrations to Landino's 'Dante,' 1481," *Art & Life* 11, no. 7 (January 1920): 372–77. As Peter Dreyer argues, the "calligraphy is datable to the 1490s and the style of the illustrations situates it between 1485 and 1507" ("La storia del manoscritto," 28).

37. For discussion of how "the material difficulties of publication" and the sojourn in Rome interrupted Botticelli's contributions to Landino's

1481 volume, see A. M. Hind, *Early Italian Engraving: A Critical Catalogue with Reproduction of All the Prints Described* (7 vols.; London: B. Quaritch, 1938–48), 1:100; and Peter Dreyer, "Botticelli's Series of Engravings 'of 1481,'" 111, 113.

38. See Vasari, *Lives of the Artists*, 229.

39. Vasari, *Lives of the Artists*, 229.

40. I disagree here with the esteemed Leonardo scholar Martin Kemp, who argues that, given the scarcity of primary evidence, "the intellectual stance of Botticelli" is very difficult to comprehend ("The Taking and Use of Evidence: With a Botticellian Case Study," *Art Journal* 44, no. 3 (1984): 212. See the discussion in van der Sman and Mariani, introduction to *Sandro Botticelli (1445–1510)*, ed. van der Sman and Mariani, 7.

41. See Cecchi, *Botticelli*, 42.

42. See Warburg, *Botticelli*, 83. Another important early scholar of Botticelli, Jacques Mesnil, argued that though Botticelli was advised by Poliziano, the execution and design of *Primavera* were all his. See Michael Hochman, "Jacques Mesnil's Botticelli," in *Botticelli Past and Present*, ed. Debenedetti and Elam, 19.

43. See Lippmann, introduction to *Drawings by Sandro Botticelli for Dante's "Divina Commedia,"* 3.

44. For a discussion of Botticelli's scholarly acumen, see Ingrid D. Rowland: "Botticelli is one of the overtly intellectual—indeed, academic—of painters. This is why, like Poussin, he has always appealed in disproportionate measure to art historians. Sometimes his learning seems to get in the way of his painting: because works like *The Birth of Venus* and the *Primavera* were meant to exclude profane viewers such as ourselves from the intimate mysteries of the Medici's closest circles, they remain deliberately, ostentatiously impenetrable, and perhaps he cannot be faulted for making them so" (*From Heaven to Arcadia: The Sacred and the Profane in the Renaissance* [New York: New York Review of Books, 2005], 77).

45. Edgar Wind, *Pagan Mysteries in the Renaissance* (New York: W. W. Norton, 1968), 126. See also the classic work by Gombrich, "Botticelli's Mythologies," 7–60.

46. For discussion of how Botticelli's *Map of Hell* relates to the reading experience of Dante's poem, see Deborah Parker, "Illuminating Botticelli's Chart of Hell," *MLN: Italian Issue* 128, no. 1 (January 2013): 84–102. See her point that Botticelli's map shows "an astonishing familiarity with [Dante's] poem" (90).

47. The age's desire to map Dante was inspired by the broader Renaissance

trend of rationalizing pictorial space and making canvases look three-dimensional, a process famously initiated by Brunelleschi's experiment with one-point perspective and then eventually codified by Leon Battista Alberti in his groundbreaking treatise *De pictura* (*On Painting*, 1435).

48. For analysis of the "spatialization of poetry" in Botticelli's illustrations, see Parker, "Illuminating Botticelli's Chart of Hell," 95–96.

49. One scholar, Alessandro Parronchi, found visual echoes of Dante's "dark wood" in the lush forest of *Primavera*—though I believe this to be a stretch. See also his description of the possible influence of Petrarch's poem "A la dolce ombra de le belle frondi" ("Into the sweet shade of the lovely leaves") on the imagery of *Primavera* (Parronchi, *Botticelli fra Dante e Petrarca* [Florence: Nardini, 1985], 68–71).

50. For discussion of the painting's probable location, see Webster Smith, "On the Original Location of the *Primavera*," *Art Bulletin* 57, no. 1 (March 1975): 31–40. See also Shearman, "The Collection of the Younger Branch of the Medici," 12–27; and Lightbown, *Sandro Botticelli* [1989], 143. For an alternate dating of *Primavera* as being done in the mid-1480s—based on stylistic analysis and in consideration of Botticelli's sojourn in Rome in 1481–82—see Horst Bredekamp, *Sandro Botticelli, La Primavera: Florenz als Garten der Venus* (Frankfurt am Main: Fischer Taschenbuch, 1988), 20–24.

51. See Lilian Zirpolo, "Botticelli's *Primavera*: A Lesson for the Bride," *Woman's Art Journal* 12, no. 2 (Autumn 1991–Winter 1992): 24–28.

52. See Horne, *Botticelli*, 50.

53. On the difficulties of dating *Primavera* and *The Birth of Venus*—and on the related question of whether Simonetta Vespucci was a model for Venus—see Ettle, "The Venus Dilemma," 3–10.

54. On the connections between Botticelli's two masterpieces, especially *Primavera*, and his Dante illustrations, see Paul Barolsky, "Botticelli's *Primavera* and the Tradition of Dante," *Konsthistorisk tidskrift* 52, no. 1 (1983): 1–6; Paul Barolsky, "Botticelli's *Primavera* as an Allegory of Its Own Creation," *Notes in the History of Art* 13.3 (Spring 1994): 14–19; and Paul Barolsky, "The Ethereal *Voluptas* of Botticelli," *Konsthistorisk tidskrift* 64, no. 2 (1995): 65–70. See also Max. C. Marmor, "From Purgatory to the *Primavera*: Some Observations on Botticelli and Dante," *Artibus et Historiae* 24, no. 48 (2003): 199–212.

55. See Lightbown, *Sandro Botticelli* [1989], 119.

56. Giovanni Boccaccio, *Decameron*, trans. Wayne Rebhorn (New York: W. W. Norton, 2013), 450–51.

57. For a reading of the story in terms of expenditure and thrift, see Christina Olsen, "Gross Expenditure: Botticelli's Nastagio Panels," *Art History* 15, no. 2 (June 1992): 146–70. On the visual similarities linking Botticelli's Dante drawings to his Nastagio panels, see 151–53.

58. See Deanna Shemek, *Ladies Errant: Wayward Women and Social Order in Early Modern Italy* (Durham, NC: Duke University Press, 1998), 174.

59. See Shemek, *Ladies Errant*, 174. As Rubin notes, Botticelli's panels expose "the naked truths, around love and marriage, duty and desire, and graphically detail how disturbing forces must inevitably submit to ordered behavior (*Images and Identity in Fifteenth-Century Florence*, 238).

60. The actual naming of the term *contrapasso* occurs in *Inferno* 28, the canto of Bertran de Born, a false counselor who divided father from son with his nefarious words, and so carries his trunk severed from his body for all eternity. See Bertran's words:

 Perch'io parti' così giunte persone,
 partito porto il mio cerebro, lasso!,
 dal suo principio ch'è in questo troncone.
 Così s'osserva in me lo contrapasso.

 Because I severed those so joined, I carry—
 alas—my brain dissevered from its source,
 which is within my trunk. And thus, in me
 one sees the law of counter-penalty. (*Inferno* 28.139–43; trans. Mandelbaum)

61. Walter Pater, "Sandro Botticelli," in *Studies in the History of the Renaissance* (Oxford: Oxford University Press, 2010), 32.

Chapter 5: Late Style

1. On Lorenzo's various ailments, see esp. Biagio Buonaccorsi, *Diario de' successi più importanti seguiti in Italia, & particolarmente in Fiorenza dall'anno 1498 in fino all'anno 1512. Con la vita del Magnifico Lorenzo de' Medici il Vecchio scritta da Niccolò Valori* (Florence: Giunti, 1568). Cited in Donatella Lippi, Philippe Charlier, and Paola Romagni, "Acromegaly in Lorenzo the Magnificent, Father of the Renaissance," *Lancet*, May 27, 2017, https://doi.org/10.1016/S0140-6736(17)31339-9.

2. See Lippi, Charlier, and Romagni, "Acromegaly in Lorenzo the Magnificent, Father of the Renaissance."

3. See Poliziano's Latin Epigram 50 in *Prose volgari inedite e poesie latine*

e greche edite e inedite, ed. Isidoro Del Lungo (Florence: G. Barberà, 1867), 137: "*Quod nasum mihi quod reflexa colla / demens objicis, esse utrumque nostrum / Assertor veniam vel ipse*" ("You mock my nose, my bent-back neck? / An idiot's jibing. I'm the first / To own their status"; trans. Nathaniel Hess, "Poliziano's Nose," Topica: A Collaborative Blog by the Classicists of Cambridge University, https://classicstopica .wixsite.com/topica/post/poliziano-s-nose).

4. The thesis that both were poisoned has been supported by modern scientific research. According to an analysis of Pico's exhumed corpse in 2018, "Mirandola's remains showed levels of arsenic levels 'almost twice the amount considered normal in the population of the Renaissance period,' and 'compatible with a form of acute arsenic exposure.'" In Poliziano's bones, "the arsenic found was 'high compared with the average levels for human bones.'" See Raychelle Burke, "Death of a Renaissance Man," https://www.chemistryworld.com/opinion/death -of-a-renaissance-man/3009052.article. Burke quotes research from Gianni Gallello, Elisabetta Cilli, Fulvio Bartoli, Massimo Andretta, Lucio Calcagnile, Agustin Pastor, Miguel de la Guardia, Patrizia Serventi, Alberto Marino, Stefano Benazzi, and Giorgio Gruppioni, "Poisoning Histories in the Italian Renaissance: The Case of Pico della Mirandola and Angelo Poliziano," *Journal of Forensic and Legal Medicine* 56 (May 2018): 83–89, doi:10.1016/j.jflm.2018.03.016.

5. See Walter Pater on the physical charm of Pico, "who even in outward form and appearance seems an image of that inward harmony and completeness, of which he is so perfect an example" ("Pico della Mirandola," in *Studies in the History of the Renaissance*, 22).

6. See Roscoe, *The Life of Lorenzo de' Medici*, 238.

7. See Michelle O'Malley, "Quality Choices in the Production of Renaissance Art," *Renaissance Studies* 28, no. 1 (February, 2014): 8.

8. See Vasari, *Lives of the Artists*, 227–28.

9. See O'Malley, "Responding to Changing Taste and Demand," 109.

10. See O'Malley, "Responding to Changing Taste and Demand," 109–10. As she observes, "There is a sense that, though Botticelli spent a good deal of time perfecting the design of these altarpieces, he had little interest in painting them" (110). O'Malley also notes that this unusual division of labor (with assistants working on large, prestigious commissions, Botticelli devoted himself to smaller and more detailed works like the *Last Commune of St. Jerome* and the *Mystic Nativity*) may have resulted from "factors that developed in the period of Savonarola's preaching and political unrest that are likely to have put the

workshop under stress. These include the relatively low prices that Botticelli agreed [to] for works of art and what seems to have been growing demand for small devotional images for the domestic sphere" (112). See the remark, in Lightbown's landmark catalogue, that more works were attributed to Botticelli's *bottega* than to the artist himself: "this . . . suggests that much of Botticelli's time after 1490 was spent at least as much in managing as in painting, as he oversaw the production and presumably the disbursement of this work" (*Sandro Botticelli* [1978], 2:117). See also Jacques Mesnil on Botticelli's *bottega* as a place where "one could find not only paintings by the master, but also replicas and copies at a reduced price, painted by pupils or qualified craftsmen as well as other objects more or less related with the field of the art of painting" ("L'éducation des peintres florentins au XVe siècle," 96–100).

11. For example, Botticelli's Nastagio panels have been attributed to both Botticelli and, at other times, dismissed as mere "hack work" from his *bottega*. See Claude Phillips, "Florentine Painting before 1500," *The Burlington Magazine for Connoisseurs* 34, no. 195 (June 1919): 208–19, esp. 216.

12. Bernard Berenson, *Rudiments of Connoisseurship: The Study and Criticism of Italian Art* (New York: Schocken, 1952), 115.

13. See Caroline Campbell, "Botticelli and the *Bottega*," 28.

14. For citation and translation of the Milanese agent's words on Botticelli, see Jonathan K. Nelson, "Botticelli's 'Virile Air': Reconsidering the Milan Memo of 1493," in *Sandro Botticelli (1445–1510)*, ed. van der Sman and Mariani, 168.

15. See Andrew C. Blume, "Botticelli's Family and Finances in the 1490's: Santa Maria Nuova and the San Marco Altarpiece," *Mitteilungen des Kunsthistorischen Institutes in Florenz* 38, no. 1 (1994): 154–65.

16. Botticelli's 1498 tax return shows that he paid the hefty sum of 155 florins to lease a farm outside Florence. This expense meant that, in addition to his regular lodging at the family compound on Via Nuova, he enjoyed access to a second home as well as the income from the farm's crops. See Blume, "Botticelli's Family and Finances in the 1490's," 154.

17. See Blume, "Botticelli's Family and Finances in the 1490's," 157, on how Leonardo deposited 600 gold florins into the same bank as Botticelli (Santa Maria Nuova) in 1490 after returning from Milan. Leonardo was able to live off the sum till 1507. Meanwhile, Michelangelo's account at the same Santa Maria Nuova held a whopping 11,000 gold florins between 1505 and 1515. His immense wealth enabled him to purchase substantial amounts of land around Florence.

18. See Blume, "Botticelli's Family and Finances in the 1490's," 157.

19. See Horne, *Botticelli, Painter of Florence*, 184.
20. For a discussion of the claim that a vengeful Piero ordered Pico's death because of his association with Savonarola, see Luke Slattery, "A Renaissance Murder Mystery," *The New Yorker*, January 22, 2015, https://www.newyorker.com/culture/culture-desk/a-renaissance-murder-mystery.
21. Giuseppe Tomasi di Lampedusa, *The Leopard*, trans. Archibald Colquhoun (New York: Pantheon, 1991), 40.
22. For the story of the forgery "sleeping Cupid," see Vasari, *Lives of the Artists*, 334.
23. For a description of the forgery scandal, see Horne, *Botticelli*, 186–88.
24. I agree with Schulze Altcappenberg that the stylistic qualities of Botticelli's illustrations lend credence to the theory that they were gifted to Charles VIII before the early 1500s: the more severe, ascetic, and Savonarola-influenced work of Botticelli in the early sixteenth century seems a world apart from the pagan and joyous aesthetics of the *Commedia* illustrations (see Dreyer, "La storia del manoscritto," 39–40).
25. See Cynthia M. Pyle, "L'entrée de Charles VIII dans Paris (1484) racontée par Baccio Ugolini à Lorenzo di Pierfrancesco de' Medici," *Bibliothèque d'Humanisme et Renaissance* 53.3 (1991): 727–34, esp. 727.
26. For a dating of *The Map of Hell* to the mid-1490s, after Botticelli had completed his illustrations of Dante's cantos, see *Sandro Botticelli*, ed. Schulze Altcappenberg, 38.
27. *Paradiso* 34.142.
28. *Paradiso* 34.145.
29. For discussion of how Botticelli's Dante "series closes with the unfinished drawing for [*Paradiso*] XXXII," see Lippmann, *Drawings by Sandro Botticelli for Dante's "Divina Commedia,"* 16.
30. See *Paradiso* 3.3, for Dante's description of Beatrice as *"quella che 'mparadisa la mia mente,"* "she who imparadises my mind."
31. Iacopo Nardi, "Istorie della città di Firenze [History of the City of Florence]," in *Selected Writings of Girolamo Savonarola: Religion and Politics, 1490–1498*, ed. Donald Beebe, Anne Borelli, and Maria Pastore Passaro (New Haven: Yale University Press, 2008), 254.
32. See Donald Weinstein, *Savonarola: The Rise and Fall of a Renaissance Prophet* (New Haven: Yale University Press, 2011), 166.
33. See Teodolinda Barolini on this "chiasmus" in *The Undivine Comedy: Detheologizing Dante* (Princeton: Princeton University Press, 1993), 216, 335–36 n11.
34. See Weinstein, *Savonarola*, 33.

35. See Weinstein, *Savonarola*, 33, 34.
36. See Weinstein, *Savonarola*, 38.
37. For a description of Savonarola's arrest and the miracle that never was, see Anthony Grafton, "Trial by Fire," *Lapham's Quarterly*, https://www .laphamsquarterly.org/politics/trial-fire.
38. On Simone Botticelli's business ties with the wealthy Spinelli family, see William Caferro and Philip Jacks, *The Spinelli of Florence: Fortunes of a Renaissance Merchant Family* (College Park: Pennsylvania State University Press, 2001), 254–56.
39. See Horne, *Botticelli, Painter of Florence*, 271.
40. See Horne, *Botticelli, Painter of Florence*, 271.
41. For analysis of Simone Botticelli's political naïveté and its relation to his understanding of Savonarola, see Horne, *Botticelli*, 271.
42. Ms. Biblioteca Nazionale, Florence, Classe VII, Codice 1152; cited in Horne, *Botticelli, Painter of Florence*, 271.
43. Vasari, *Lives of the Artists*, 227.
44. For discussion of the apocalyptic visual rhetoric and Savonarolan inflection of the painting, see Rab Hatfield, "Botticelli's *Mystic Nativity*, Savonarola and the Millennium," *Journal of the Warburg and Courtauld Institutes* 58 (1995): 88–114. For the claim that Savonarola's Christmas sermon influenced the *Mystic Nativity*, see John Pope-Hennessy, *Sandro Botticelli: The Nativity* (London: Percy Lund Humphries, 1945), 11.
45. Horne translates the inscription thus: "This picture, at the end of the year 1500, in the troubles of Italy, I, Alessandro, painted in the half-time after the time, at the time of the fulfilment of the 11th [chapter] of St. John, in the second war of the Apocalypse, in the looking of the devil for three and half years: then shall he be chained according to the twelfth [chapter], and we shall see him trodden down as in this picture." Horne describes the era of the painting as one of "spiritual fervour and [the] ecstatic power of the imagination" for Botticelli. See *Botticelli, Painter of Florence*, 295.
46. See Berenson on Botticelli's *Birth of Venus*: "the entire picture presents us with the quintessence of all that is pleasurable to our imagination of touch and of movement. How we revel in the force and freshness of the wind, in the life of the wave!" (Bernard Berenson, *The Florentine Painters of the Renaissance* [3rd ed.; New York: G. P. Putnam and Sons, 1909], 71).
47. See Hatfield on Botticelli's atypical embrace of apocalypse in this painting ("Botticelli's *Mystic Nativity*, Savonarola and the Millennium,"

100)—a far cry from Botticelli's earlier "middle world" in the Dante illustrations, as celebrated by Walter Pater. For a reading of the *Mystic Nativity* as a Dantesque work featuring a cameo by the painter in the manner of Dante as poet–protagonist of the *Commedia*, see Strinati, "The Real Botticelli," 84.

48. Clark, *Florentine Painting*, 18. Clark believed (incorrectly, in my view) that Botticelli became a "confessed follower of Savonarola after his martyrdom in 1498," adding that "we must suppose that many of [Botticelli's] drawings and profane pictures perished in the burning of the vanities which took place on Shrove Tuesday in 1497 and 1498" (18). I do agree with Clark's claim that the *Mystic Nativity* "illustrates Botticelli's state of mind in his later years," and that the effect of the Savonarolan "moment" on Botticelli's style was indeed profound (18).

49. On the affinity between Botticelli's version of heaven and Dante's, see Charles Burroughs, "The Altar and the City: Botticelli's 'Mannerism' and the Reform of Sacred Art," *Artibus et Historiae* 18, no. 36 (1997): 24.

50. Michelle O'Malley claims that in the 1490s, "Botticelli's career took a new turn and the appearance of his work altered, almost certainly in response to the religious and political crises in Florence in the last decade of the century" ("Responding to Changing Taste and Demand," 101).

51. Cited and translated by Horne, *Botticelli, Painter of Florence*, 304.

52. See Cecchi, *Botticelli*, Appendix V, 370.

53. O'Malley, "Responding to Changing Taste and Demand," 117.

54. See Cecchi, *Botticelli*, 53.

55. See Rab Hatfield, introduction to *Sandro Botticelli and Herbert Horne: New Studies*, ed. Rab Hatfield (Florence: Syracuse University in Florence, 2009), xii–xiii.

56. See Edward Said, "Thoughts on Late Style," *London Review of Books* 26, no. 5 (2004).

57. For a painter as exhaustively researched as Botticelli, there are surprisingly—even shockingly—few mentions of this widely known image of Dante. Not a single study explains the portrait's commission, dating, or defining qualities. The brilliant, exhaustive chronicler of Botticelli's life and work Herbert Horne does not even mention the portrait in his monumental *Botticelli, Painter of Florence*—an omission repeated by other major commentators including Richard Thayer Holbrook, the author of a booklength study of Dante portraiture in 1911 (Holbrook, *Portraits of Dante from Giotto to Raffael*). One respected scholar dates it, in passing, at 1495, which would neatly coincide with the end of

Botticelli's engagement with Dante (Jonathan K. Nelson, *The World of Dante*, http://www.worldofdante.org/gallery_botticelli.html). The Dante portrait is now in a private collection. Its ambiguous status, with reproductions everywhere yet its essential qualities unknown and the original sealed off from public view, points to yet another lingering secret in Botticelli's career.

58. See Holbrook, *Portraits of Dante from Giotto to Raffael*, 189–90.

59. See Holbrook, *Portraits of Dante from Giotto to Raffael*, 189.

60. For the notion that the portrait adorned a scholar's library, see Nelson, *The World of Dante*.

61. The notice is from the first edition of Vasari's *Lives of the Artists* (1550), and is cited and translated by Horne in *Botticelli, Painter of Florence*, 314. I have slightly modified the translation.

62. Botticelli's death was recorded by two registers in Florence—but in one of them, the "Libro dei Morti" ("Book of Death") kept by the magistracy in control of Florence's markets, his name was incorrectly given as "Sandro di Bartolommeo" and not "di Botticello," an error that attests to the obscurity that had come to envelop the once renowned painter. See Horne, *Botticelli, Painter of Florence*, 314.

Chapter 6: History's Lost and Found

1. Deborah Solomon described Vasari as a "solidly average" painter in "How Giorgio Vasari Invented Art History as We Know It," *New York Times*, December 1, 2017.

2. See Vasari, *Le vite de' più eccellenti pittori, scultori e architettori* (1568), chapter 15: "*Perché il disegno, padre delle tre arti nostre, architettura, scultura e pittura, procedendo dall'intelletto, cava di molte cose un giudizio universale, simile a una forma o vero idea di tutte le cose della natura ...*" ("Because design, the father of our three arts of architecture, sculpture, and painting, proceeds from the intellect and extrapolates from many things a universal judgment that is similar to the form or indeed the idea of everything in nature ..."; my translation). For a connection between *disegno* and the Dante project, see Horne: "It is impossible, perhaps, to understand the essential character of Botticelli's art, its beauties and idiosyncrasies, its limitations and defects, without an exhaustive study of these illustrations to Dante; for like every great Florentine painter, Botticelli was before all things preoccupied with *design*; and in these illustrations is exemplified the whole range of his art as a draughtsman" (*Botticelli, Painter of Florence*, 252; my emphasis).

3. Arguing against Vasari, David Rosand describes how for Venetian artists like Titian drawing was secondary or ancillary to painting because they tended to build paintings up from colors directly applied to the canvas without a preparatory cartoon; see his discussion of the *disegno–colorito* controversy in *Painting in Cinquecento Venice: Titian, Veronese, Tintoretto* (New Haven: Yale University Press, 1982), 15–26.

4. Vasari, *Lives of the Artists*, 25.

5. See the notice for the exhibit "Disegno: Drawing in Europe, 1520–1600," at the J. Paul Getty Museum, https://www.getty.edu/art/exhibitions/disegno/.

6. Vasari, *Lives of the Artists*, 251.

7. Vasari, *Lives of the Artists*, 251.

8. Vasari, *Lives of the Artists*, 253–54.

9. The original Italian reads: "*Caron dimonio, con occhi di bragia / loro accennando, tutte le raccoglie; / batte col remo qualunque s'adagia*" (*Inferno* 3.109–11; trans. Mandelbaum).

10. See *Inferno* 13.103–105, trans. Mandelbaum: "*Come l'altre verrem per nostre spoglie, / ma non però ch'alcuna sen rivesta, / ché non è giusto aver ciò ch'om si toglie.*" Michelangelo likely gleaned his doctrine of sinners divided from their mortal bodies on Judgment Day from Dante's *Inferno* 13: the Wood of Suicides that includes the heartbreaking Pier delle Vigne, who "*ingiusto fece me contra me giusto*" ("become unjust against my own just self," *Inferno* 13.72; trans. Mandelbaum).

11. See James M. Saslow, *The Poetry of Michelangelo: An Annotated Translation* (New Haven: Yale University Press, 1991).

12. See especially Michelangelo's haunting late sonnet, "Giunto è già 'l corso della mia vita" ("The voyage of my life at last has reached"):

 The voyage of my life at last has reached
 Across a stormy sea in a fragile boat,
 The common port all must pass through, to give
 An accounting for every evil and pious deed. (1–4)

 The poem contains Dantesque imagery: the *fragil barca* of line 2 recalls Dante's *navicella* ("little bark") in *Purgatorio* 1.2. Michelangelo sent the final version of the poem in a letter to Vasari in 1554. See Saslow, *The Poetry of Michelangelo*, 476 (poem 285).

13. I share the skepticism of Liana De Girolami Cheney in *Giorgio Vasari's Teachers: Sacred and Profane Art* (New York: Peter Lang, 2007), who argues persuasively on the differences—not similiarities—between the Dante illustrations by Botticelli and his successors Stradano and Zuccari (37–38). Lippmann describes Botticelli's influence on "Zucchero"

[*sic*] as "obvious," but also notes that this later artist was "unequal to the task" of reproducing Dante illustrations with any of Botticelli's genius (*Drawings by Sandro Botticelli for Dante's "Divina Commedia,"* 23–24).

14. Vasari, *Lives of the Artists*, 395.

15. Lippmann, *Drawings by Sandro Botticelli for Dante's "Divina Commedia,"* 24.

16. Lippmann, *Drawings by Sandro Botticelli for Dante's "Divina Commedia,"* 24.

17. See Francis Haskell, "'Christina Queen of Sweden' and Some Related Documents," *The Burlington Magazine* 108, no. 763 (October 1966): 494–99. The date of the sale was likely 1650, and included other valuable items such as a thirteenth-century manuscript of Ovid's *Metamorphoses*. See Catalogue of Illuminated Manuscripts, British Library, http://www.bl.uk/catalogues/illuminatedmanuscripts/record.asp?MSID=3891&CollID=8&NStart=2742. Upon Christina's death in 1689, these eight drawings (executed on seven sheets of vellum, with *The Map of Hell* and drawing of *Inferno* 1 on opposite sides of the same parchment) passed into the hands of her heir Cardinal Decio Azzolini, who died less than two months after her. These Botticelli illustrations then became the property of Decio's nephew Pompeo Azzolini, who sold them to Cardinal Ottoboni, who became Pope Alexander VIII in October 1689 and gifted the codex to the Vatican Library. See Jean Irigoin, review of *Les manuscrits de la Reine de Suède au Vatican*, in *Revue des études grecques* (1965): 723–24. It was only two hundred years later, in 1887—a year after Friedrich Lippman published his study proving that the drawings from MS Hamilton 201 were all done by Botticelli—that the Polish–Austrian art historian Josef Strzygowski was able to establish that Queen Christina's drawings had also been part of Botticelli's original set. For a convincing chronology of these illustrations and their journey from Paris to Rome, see Schulze Altcappenberg, "'Per essere persona sofistica,'" 21. Strzygowski eventually published facsimiles of the Vatican drawings as a supplement to Lippmann's landmark edition of the illustrations: *Die acht Handzeichnungen des Sandro Botticelli zu Dantes Göttlicher Komödie im Vatikan: Ein Supplement zu dem Codex im königlichen Kupferstichkabinett zu Berlin*, bound as supplement to Friedrich Lippmann, ed., *Zeichnungen von Sandro Botticelli zu Dante's Göttlicher Komödie nach den Originalen im kgl Kupferstichkabinett zu Berlin* (Berlin: Grote, 1887). See the discussion in Horne, *Botticelli, Painter of Florence*, 190.

18. See Luigi Greco, "Un libraire italien à Paris: Gian Claudio Molini,

1724–1816," *Mélanges de la blbliotheque de la Sorbonne* 10 (1990): 103–21. See also Luigi Greco, "Un libraire italien à Paris à la veille de la Révolution," *Mélanges de l'école française de Rome: Italie et Méditerranée* 102, no. 2 (1990): 261–80.

19. Royal Academy Council Minutes I, March 9, 1769. Royal Academy website, https://www.royalacademy.org.uk/art-artists/name/peter -molini.

20. See Greco, "Un libraire italien à Paris," 106.

21. See Greco, "Un libraire italien à Paris," 114.

22. See Greco, "Un libraire italien à Paris," 107.

23. Edward Gibbon, *The History of the Decline and Fall of the Roman Empire*, vol. 6, ch. 37, para. 619, https://www.gutenberg.org/files/25717/25717 -h/25717-h.htm.

24. Frank Kermode, *Forms of Attention: Botticelli and Hamlet* (Chicago: University of Chicago Press, 1985), 3.

25. On Voltaire's legendary obsession with coffee, see "Parisian Medical Chit-Chat," trans. from the *Journal de médecine de Paris* by T. C. M., *The Cincinnati Lancet-Clinic* 30 (January 7, 1893): 16; and Stephen G. Tallentyre, *The Life of Voltaire* (New York: G.P. Putnam's Sons, 1903), 1:229.

26. See Voltaire, "Epître à l'auteur du livre des *Trois imposteurs*," in *Oeuvres complètes de Voltaire,* ed. Louis Moland (52 vols.; Paris: Garnier Frères, 1877–85), 10:402.

27. Voltaire first used the term in a letter to Jean le Rond d'Alembert, an editor of the celebrated *Encyclopédie*, on July 23, 1760. See the discussion in *The Biographical Dictionary of the Society for the Diffusion of Useful Knowledge*, vol. 1, part 1 (2 vols.; London: Ogman, Brown, Green, and Longmans, 1842), 812.

28. Voltaire, *Oeuvres complètes*, ed. Moland, 18:313.

29. Voltaire, *Correspondence* (Geneva: Institut et Musée Voltaire, 1968–77), D8663.

30. For discusion of this remark from Voltaire's *Lettres philosophiques* (*Philosophical Letters*), see my *Romantic Europe and the Ghost of Italy* (New Haven: Yale University Press, 2008), 104.

31. For an understanding of why Dante's *Commedia* was eclipsed during the Enlightenment, see my "From the Dark Wood to the Garden: Dante Studies in the Age of Voltaire," *SVEC: Studies on Voltaire and the Eighteenth Century* 6 (2002): 349–70. See also *Dante*, ed. Caesar, 46–47.

32. See Vittorio Alfieri, Sonnet 53 of *Rime*, ed. Francesco Maggini (1954), in *Opere* (40 vols.; Asti: Casa Alfieri, 1951–89).

33. See Daniel DiMassa, "'Wir Haben Keine Mythologie eine Mythologie': Dante's *Commedia* and the Poetics of Early German Romanticism," Ph.D. dissertation, University of Pennsylvania, 2014, 5.

34. See Fabio Camilletti, "Later Reception from 1481 to the Present," in *The Cambridge Companion to Dante's "Commedia,"* ed. Zygmunt Barański and Simon Gilson, 137.

35. Walter Savage Landor, an influential man of letters and intimate of Wordsworth and Coleridge, summed up the feelings of many nineteenth-century readers in England: "It is wonderful how [Cary] could have turned the rhymes of Dante into unrhymed verse with any harmony: he has done it." See H. M. Beatty, "A Century of Cary's Dante," *Studies: An Irish Quarterly Review* 3, no. 9 (March 1914): 567–82, esp. 571.

36. See Alison Milbank, review of Edoardo Crisafulli, *The Vision of Dante: Cary's Translation of "The Divine Comedy,"* in *Modern Language Review* 100, no. 3 (2005): 838.

37. See my *Romantic Europe and the Ghost of Italy*, 142.

38. Journal, Wordsworth Library. Courtesy of Dove Cottage, Wordsworth Trust.

39. I discuss Quillinan's diary entry and its broader implications in my *Romantic Europe and the Ghost of Italy*, 141.

40. See Jeremy Black, *The British and the Grand Tour* (London: Routledge, 2011).

41. Thomas Love Peacock, *Nightmare Abbey* (London: T. Hookham, 1818), 69.

42. Stendhal, *Racine et Shakespeare*, ed. Leon Delbos (Oxford: Clarendon Press, 1907), 25.

43. Kermode, *Forms of Attention*, 5.

44. See Peter Burke, introduction to Burckhardt, *The Civilization of the Renaissance in Italy*, 2.

45. For Burckhardt's description of Giotto's work, see *The Cicerone: An Art-Guide to the Painting in Italy for the Use of Travellers and Students*, trans. A. H. Clough (London: T. Werner Laurie, 1879; rept. New York: Garland, 1979), 26. For a discussion of Burckhardt's lifelong passion for art, including his love of drawing, see Felix Gilbert, "Jacob Burckhardt's Student Years: The Road to Cultural History," *Journal of the History of Ideas* 47, no. 2 (April–June 1986): 259. See also Lionel Gossman, "Jacob Burckhardt as Art Historian," *Oxford Art Journal* 11, no. 1 (1988): 25–32.

46. Burckhardt, *The Cicerone*, 57.

47. I owe this insight to Ricardo Galliano Court, "Secular Squalor: The

Strange History of the Willful Destruction of the Renaissance Heart of Florence and the Building of a Pseudo-Renaissance Monument," unpublished ms.

48. Burckhardt, *The Cicerone*, 63.
49. Burckhardt, *The Cicerone*, 63.
50. See Lionel Gossman, *Basel in the Age of Burckhardt* (Chicago: University of Chicago Press, 2007), 284.
51. Jacob Burckhardt to Friedrich Nietzsche, February 1872, in Burckhardt, *Letters of Jacob Burckhardt*, ed. and trans. Alexander Dru (London: Routledge and Kegan Paul, 1955), 175.
52. Burckhardt predicted that Nietzsche's essay "On the Uses and Disadvantages of History for Life," published in his *Untimely Meditations*, would have an enormous impact because it exposed a "tragic incongruity right before our eyes: the antagonism between historical knowledge and the capacity to do or to be." Burckhardt, *The Letters of Jacob Burckhardt*, 176.
53. Burckhardt, letter of June 14, 1842, *Letters of Jacob Burckhardt*, 75.
54. The claim is the Renaissance historian David Norbrook's, cited in Weintraub, "Jacob Burckhardt," 279, and Gossman, *Basel in the Age of Burckhardt*, 283.
55. Burckhardt, *The Civilization of the Renaissance in Italy*, 137.
56. Burckhardt, *The Civilization of the Renaissance in Italy*, 101–2.
57. See Burckhardt, *The Civilization of the Renaissance in Italy*, 101. For a study of Dante's capacious intellectual and creative abilities, described as "encyclopedic" in nature, see also Mazzotta, *Dante's Vision and the Circle of Knowledge*, passim.
58. See Gossmann, "Burckhardt as Art Historian," 26.
59. See J. B. Bullen, *The Myth of the Renaissance in Nineteenth-Century Writing* (Oxford: Clarendon Press, 1994), 168.
60. From Burckhardt's manuscript of his "Lectures on Medieval History," cited and translated in Gilbert, "Burckhardt's Student Years," 271.
61. See Bullen, *The Myth of the Renaissance in Nineteenth-Century Writing*, 74.
62. Charles Dickens, *Pictures of Italy and Notes from America for General Circulation* (Philadelphia: J. B. Lippincott, 1885), 144.
63. On Ruskin's "tendency to assimilate aesthetic and religious values," see David Carrier, introduction to John Ruskin, Walter Pater, and Adrian Stokes, *England and Its Aesthetes: Biography and Taste*, commentary by David Carrier (Amsterdam: G + B Arts International, 1997), 9.
64. See discussion in Kenneth Daley, *The Rescue of Romanticism: Walter Pater and John Ruskin* (Athens, OH: Ohio University Press, 2001), 54, 56.

65. Bullen, *The Myth of the Renaissance in Nineteenth-Century Writing*, 146.
66. Richard Teitlebaum, "John Ruskin and the Italian Renaissance," *English Studies in Africa* 19, no. 1 (1976): 1.
67. See Peter Quennell, *John Ruskin: The Portrait of a Prophet* (London: Collins, 1949), 255.
68. See Derrick Leon, *Ruskin, the Great Victorian* (London: Routledge and Kegan Paul, 1949), 172.

Chapter 7: Boticelli in Britain

1. The quote "*Inglese italianato . . .*" comes from Roger Ascham's pedagogical tract *The Schoolmaster* (1563); see also E. M. Forster, *A Room with a View* (London: Penguin, 2000), 91.
2. For a description of Rossetti's father, see F. G. Stephens, *Dante Gabriel Rossetti* (London: Seeley, 1905), 6–7.
3. See Gay Daly, *Pre-Raphaelites in Love* (New York: Ticknor and Fields, 1989), 36.
4. See Daly, *Pre-Raphaelites in Love*, 37.
5. See Anne Isba, *Gladstone and Dante: Victorian Statesman, Medieval Poet* (London: Royal Historical Society, 2006), 79.
6. In "Dante's 'Afterlife' in William Dyce's Paintings" (M.A. thesis, Arizona State University, 2013), Kristopher Tiffany does not mention Botticelli's Dante drawings as having had a significant effect either on Dyce's overall aesthetic program or on the artistic culture of his day.
7. William Michael Rossetti, ed., *Dante Gabriel Rossetti: His Family-Letters, with a Memoir* (2 vols.; London: Ellis and Elvey, 1895), 1:135. See the discussion—and criticism—of William Michael Rossetti's definition of Pre-Raphaelite principles in David Latham, "Haunted Texts: The Invention of Pre-Raphaelite Studies," in *Haunted Texts: Studies in Pre-Raphaelitism in Honour of William E. Fredeman*, ed. David Latham (Toronto: University of Toronto Press, 2003), 12.
8. See Daly, *Pre-Raphaelites in Love*, 37.
9. The remark is from 1884. See John Ruskin, *Modern Painters*, vol. 2: *Of the Imaginative and Theoretic Faculties* (4th ed.; 6 vols.; London: George Allen, 1903), 248; and Tim Barringer, *Reading the Pre-Raphaelites* (New Haven: Yale University Press, 1998), 56.
10. Daly, *Pre-Raphaelites in Love*, 51.
11. Dante Gabriel Rossetti to Ford Madox Brown, April 14, 1854; cited in Daly, *Pre-Raphaelites in Love*, 52.

12. See Kenneth Clark, *Ruskin Today* (Harmondsworth, UK: Penguin 1964), xiii.

13. See Barringer, *Reading the Pre-Raphaelites*, 55.

14. Ravaged by ill health and plagued by fits of jealousy over Rossetti's adulteries, Siddal died of an overdose of laudanum in 1861. The question of whether it was suicide remains an open one.

15. Ruskin's sexuality has been the subject of a great deal of speculation. See Effie's letter to her parents:

> He alleged various reasons, hatred of children, religious motives, a desire to preserve my beauty, and finally this last year he told me his true reason . . . that he had imagined women were quite different to what he saw I was, and that the reason he did not make me his Wife was because he was disgusted with my person the first evening 10th April [1848].

Ruskin put it thus to his lawyer during the annulment proceedings:

> It may be thought strange that I could abstain from a woman who to most people was so attractive. But though her face was beautiful, her person was not formed to excite passion. On the contrary, there were certain circumstances in her person which completely checked it.

16. For a review of the complicated, bitter relations between Ruskin and his wife, and the long-standing obsession with Ruskin's sexuality, see Karl Litzenberg, "Controversy over Ruskin: Review Article," *Journal of English and Germanic Philology* 50, no. 4 (1951): 529–31.

17. See the discussion in Barringer, *Reading the Pre-Raphaelites*, 23.

18. For discussion of how Dante may have been reasonably skilled at drawing, see Santagata, *Dante*, 77–79.

19. All citations from the poetry of Dante Gabriel Rossetti are taken from the Rossetti Forum at http://www.rossettiarchive.org.

20. For a discussion of Cavalcanti's mysterious sonnet and the divergent scholarly opinions it has yielded, see Santagata, *Dante*, 101.

21. *Purgatorio* 30.119.

22. From the Rossetti Collection at the University of Texas at Austin, Harry Ransom Humanities Research Center; photocopy of a letter in C. B. McMillan, "A Catalogue of the Letters of Dante Gabriel Rossetti" (Ph.D. dissertation, University of Texas at Austin, 1975), letter 59, p. 25. See the discussion in Gail S. Weinberg, "D. G. Rossetti's Ownership of Botticelli's 'Smeralda Brandini,'" *The Burlington Magazine* 146, no. 1210 (January 2004): 24.

23. See "Portrait of a Lady Known as Smeralda Bandinelli," Victoria and

Albert Museum website, https://www.vam.ac.uk/articles/portrait-of-a
-lady-known-as-smeralda-bandinelli.

24. From the Rossetti Collection at the University of Texas at Austin,
Harry Ransom Humanities Research Center; photocopy of a letter in
McMillan, "A Catalogue of the letters of Dante Gabriel Rossetti," letter
59, p. 25. See the discussion in Weinberg, "D. G. Rossetti's Ownership
of Botticelli's 'Smeralda Brandini,'" 24.

25. Rossetti, *Rossetti Papers*, 228.

26. Nicola Costaras and Clare Richardson, "Botticelli's Portrait of a Lady
Known as Smeralda Bandinelli: A Technical Study," in *Botticelli Past
and Present*, ed. Debenedetti and Elam, 45.

27. "Portrait of a Lady Known as Smeralda Bandinelli," Victoria and
Albert Museum website, https://www.vam.ac.uk/articles/portrait-of-a
-lady-known-as-smeralda-bandinelli.

28. Algernon Charles Swinburne, "Notes on Designs of the Old Masters
at Florence," in *Essays and Studies* (London: Chatto and Windus, 1875),
327. For a broader consideration of Botticelli's resurgence around this
time, see Levey, "Botticelli and Nineteenth-Century England," 291–306.

29. William Michael Rossetti, *Dante Gabriel Rossetti*, 1:264.

30. Ruskin, *Ariadne Florentina*, 118.

31. Ruskin, *Ariadne Florentina*, 118.

32. The manuscript of Ruskin's letter is in the Pierpont Morgan Library,
New York, MA 2274 (24), gift of Decoursey Fales, 1963; cited in Gail
S. Weinberg, "Ruskin, Pater, and the Rediscovery of Botticelli," *The
Burlington Magazine* 129, no. 1006 (January 1987): 26.

33. Pater, preface to *Studies in the History of the Renaissance*, 3.

34. Pater, *Studies in the History of the Renaissance*, 6.

35. Pater, *Studies in the History of the Renaissance*, 30.

36. Pater, *Studies in the History of the Renaissance*, 30.

37. Pater, *Studies in the History of the Renaissance*, 30.

38. Pater, *Studies in the History of the Renaissance*, 30.

39. Pater, *Studies in the History of the Renaissance*, 30.

40. Pater, *Studies in the History of the Renaissance*, 30.

41. For discussion of how Lippmann's knowledge of the market and
acquaintances with collectors and dealers enabled him to purchase
important collections in bulk, see C. D., "The Late Dr. Lippmann," 7.

42. See Korbacher, "'I am very, very happy that we have it,'" 19.

43. Cited in Havely, *Dante's British Public*, 251.

44. See William Ewert Gladstone, "Works and Life of Leopardi," *Quar-
terly Review* 86 (1850): 295–336; and Isba, *Gladstone and Dante*, passim.

45. See Reinhald Grosshans, *Gemäldegalerie Berlin* (Munich: Prestel, 1998), 7.

46. John Ruskin, *Modern Painters*, in *The Works of John Ruskin*, ed. E. T. Cook and Alexander Wedderburn (39 vols.; London: George Allen, 1903–12), 4:355–66. See the discussion in Jeremy Melius, "Art History and the Invention of Botticelli," Ph.D. dissertation, University of California, Berkeley, 2010, 51.

47. Walter Pater, *The Letters of Walter Pater*, ed. Lawrence Evans (Oxford: Oxford University Press, 1970), Letter 66, 41.

48. Pater, *Studies in the History of the Renaissance*, 35.

49. Pater, *Studies in the History of the Renaissance*, 35.

50. John Ruskin, *The Letters of John Ruskin, 1870–1889*, vol. 37 of *The Works of John Ruskin*, ed. Cook and Wedderburn, 10–11.

51. Ruskin, "The Third Morning: Before the Soldan," *Mornings in Florence*.

52. The poem appeared in Rossetti's *Ballads and Sonnets* (2 vols.; London: Ellis and White, 1881).

Chapter 8: The Eyes of Florence

The epigraph, from an unpublished letter from Bernard Berenson to his wife, Mary Costelloe Berenson, on January 4, 1894, is courtesy of Michael M. Gorman, whom I thank for his assistance with some of the archival material cited in this chapter. For links to the diaries of Mary Berenson, 1891–93 and 1899–1902, see Gorman's The Bernard and Mary Berenson Digital Archive, https://www.mmgorman.it/berenson/.

1. See Korbacher, " 'I am very, very happy that we have it,' " 21.

2. The illustration for *Paradiso* 32 appeared on the page facing the one printed with the text of *Paradiso* 32, and Botticelli left no drawing of *Paradiso* 33—which, had it been done, would have been executed on the reverse side of the leaf containing *Paradise* 32.

3. See *Archiv für Post und Telegraphie* 15 (August 1884): 450; cited in Korbacher, " 'I am very, very happy that we have it,' " 23.

4. See Korbacher, " 'I am very, very happy that we have it,' " 23.

5. Clark, *The Drawings by Sandro Botticelli for Dante's "Divine Comedy,"* 7.

6. For a description of Berenson's physical appearance, see Ernest Samuels, *Bernard Berenson: The Making of a Connoisseur* (Cambridge, MA: Harvard University Press, 1979), 6.

7. From Mary Berenson's unpublished "Life of Berenson," cited in Cohen, *Bernard Berenson*, 26.

8. Bernard Berenson, notebook entry, 1887.

9. Bernard Berenson to Senda Berenson, June 21, 1888.

10. Bernard Berenson to Isabella Stewart Gardner, July 4, 1888, in *The Letters of Bernard Berenson and Isabella Stewart Gardner, 1887–1924: With Correspondence by Mary Berenson*, ed. Rollin Van N. Hadley (Boston: Northeastern University Press, 1987), 24.

11. Bernard Berenson, preface to *The Italian Painters of the Renaissance* (London: Phaidon, 1952), xiii.

12. From Mary Berenson's unpublished "Life of Berenson," cited in Cohen, *Bernard Berenson*, 86.

13. See Ophelia's use of the term in Shakespeare, *Hamlet*, act 3, scene 1, line 167, The Folger Shakespeare, https://shakespeare.folger.edu/shakespeares-works/hamlet/act-3-scene-1/.

14. See Linda C. Dowling, *Charles Eliot Norton: The Art of Reform in Nineteenth-Century America* (Durham, NC: Duke University Press, 2007).

15. See John Ruskin, *Praeterita*, iii (para. 86); cited in Clark, *Ruskin Today*, 81: "Fonte Branda I last saw with Charles Norton, under the same arches where Dante saw it. We drank of it together, and walked together that evening on the hills above, where the fireflies among the scented thickets shone fitfully in the still undarkened air. *How* they shone!"

16. Mary Berenson, diary entry, November 26, 1903; cited in Samuels, *Bernard Berenson*, 413.

17. Bernard Berenson, notebook entry, 1886.

18. Bernard Berenson, notebook entry, 1886.

19. See Cohen, *Bernard Berenson*, 46.

20. Bernard Berenson, *Sketch for a Self-Portrait*, 52; cited in Cohen, *Bernard Berenson*, 56.

21. See Cohen, *Bernard Berenson*, 57.

22. See Lillian R. Miller, "Celebrating Botticelli: The Taste for the Italian Renaissance in the United States, 1870–1920," in *The Italian Presence in American Art*, ed. Irma B. Jaffe (New York: Fordham University Press, 1989), 2.

23. See Miller, "Celebrating Botticelli," 3.

24. Miller, "Celebrating Botticelli," 5.

25. The flyleaf bore the inscription "J. Ruskin. Parted with for want of room Brantwood 3rd April 1880." See the Isabella Stewart Gardner Museum website, https://www.gardnermuseum.org/experience/collection/17672.

26. See Hanna Kiel, introduction to Bernard Berenson, *Looking at Pictures with Bernard Berenson* (New York: Harry N. Abrams, 1974), 21.

27. See Van Wyck Brooks, *The Dreams of Arcadia* (New York: Dutton,

1958), 80 *n*4; and Bernard Roeck, *Florence 1900: The Quest for Arcadia*, trans. Stewart Spenser (New Haven: Yale University Press, 2009), 152.

28. Roeck, *Florence 1900*, 151.

29. Roeck, *Florence 1900*, 151.

30. See M. H. Speigelman, "Art Forgeries and Counterfeits," *Magazine of Art* (1903–04): 80; cited in Aviva Briefel, *The Deceivers: Art Forgery and Identity in the Nineteenth Century* (Ithaca, NY: Cornell University Press, 2006), 8.

31. See P. G. Konody, preface to Burckhardt, *The Cicerone*, vii–viii.

32. Berenson, *Rudiments of Connoisseurship*, vi.

33. See Tostmann, "Berenson," 106.

34. Berenson, *Rudiments of Connoisseurship*, vi. This amateur spirit distilled in Horne's introduction to his magum opus on Botticelli: "This book has been written at leisure, during a period of many years, and with no other thought than to satisfy the curiosity of its writer" (*Botticelli, Painter of Florence*, xxi).

35. The quote is from Mary Berenson's mother, who said of the then young aesthete: "You are sure to hear of him someday"; see Samuels, *Bernard Berenson*, 108.

36. Berenson, *Rudiments of Connoisseurship*, 130.

37. Berenson, *Rudiments of Connoisseurship*, 141.

38. Bernard Berenson to Mary Costelloe, January 1892, in *The Selected Letters of Bernard Berenson*, ed. A. K. McComb (Boston: Houghton Mifflin, 1964), 13.

39. Bernard Berenson to Mary Costelloe, January 1892, *The Selected Letters of Bernard Berenson*, 12–13.

40. Bernard Berenson, *The Passionate Sightseer: From the Diaries, 1947–1956* (New York: Simon and Schuster, 1960), 15.

41. Berenson's words are a reminder of what Frank Kermode astutely pointed out as a defining characteristic of Botticelli's rediscovery—and of rediscovery in general. Such rehabilitations do not generally proceed because of new facts or knowledge about a painter or poet, but rather because of a general change in taste regarding that figure that may be set in motion by incomplete knowledge or even erroneous information—or at the very least, by lots of strong opinions. See Kermode, *Forms of Attention*, 30.

42. See Kermode, *Forms of Attention*, 30.

43. See Thomas Carlyle, *On Heroes, Hero-Worship, and the Heroic in History* (1841), https://www.gutenberg.org/files/1091/1091-h/1091-h.htm: "It must have been a great solacement to Dante, and was, as we can

see, a proud thought for him at times, that he, here in exile, could do this work; that no Florence, nor no man or men, could hinder him from doing it, or even much help him in doing it. He knew too, partly, that it was great; the greatest a man could do. 'If thou follow thy star, *Se tu segui tua stella,*'—so could the Hero, in his forsaken-ness, in his extreme need, still say to himself: 'Follow thou thy star, thou shalt not fail of a glorious haven!'"

44. Bernard Berenson, *The Florentine Painters of the Renaissance*, 67.
45. Bernard Berenson, *The Florentine Painters of the Renaissance*, 67.
46. Bernard Berenson, *The Florentine Painters of the Renaissance*, 69.
47. Bernard Berenson, *The Drawings of the Florentine Painters* (Chicago: University of Chicago Press, 1970), 93.
48. Bernard Berenson, diary entry, November 17–18, 1893.
49. Bernard Berenson, diary entry, November 17–18, 1893.
50. See Jonathan K. Nelson, "An Unpublished Essay by Mary Berenson, 'Botticelli and his Critics' (1894–95)," *19: Interdisciplinary Studies in the Long Nineteenth Century* 28 (2019), https://doi.org/10.16995/ntn.837. See Nelson's note 1 for more information on the essay's discovery and transcription.
51. Nelson, "An Unpublished Essay by Mary Berenson."
52. Nelson, "An Unpublished Essay by Mary Berenson."
53. Cited in James A. Fasanelli, "A Letter from Berenson's Early Years," *The Burlington Magazine* 108, no. 755 (1966): 85.
54. See Cohen, *Bernard Berenson,* 125.
55. Bernard Berenson, "Botticelli's Illustrations to the *Divina Commedia*," *Nation* 63 (November 12, 1896): 363–64; reprinted in *One Hundred Years of the Nation: A Centennial Anthology*, ed. Henry M. Christman (New York: Macmillan, 1965), 91–95.
56. Berenson, "Botticelli's Illustrations to the *Divina Commedia*."
57. See Berenson's words on his recently won riches in a letter to his sister Senda: "Do not be anxious about money, for I shall be happy to help you out. And in this connection relying on your good sense and judg-ment I want to tell you about my affairs. In the year that is just ending I have earned no less than $10,000. This will take your breath away, but it's true" (December 26, 1896; cited in Samuels, *Bernard Berenson*, 275).
58. Bernard Berenson to Isabella Stewart Gardner, May 23, 1899, in *The Letters of Bernard Berenson and Isabella Stewart Gardner*, 174.
59. Bernard Berenson to Isabella Stewart Gardner, June 12, 1899, in *The Letters of Bernard Berenson and Isabella Stewart Gardner*, 180.
60. Horne, *Botticelli, Painter of Florence*, 190.

61. Horne, *Botticelli, Painter of Florence*, 190.

62. See Kermode, *Forms of Attention*, 21.

63. See Claudia Wedepohl, "Why Botticelli? Aby Warburg's Search for a New Approach to *Quattrocento* Italian Art," in *Botticelli Past and Present*, ed. Debenedetti and Elam, 184.

64. See Kenneth Clark's words on the "humanist" worldview: "What was the humanist style? A compound of naturalism, perspective and the antique, we may say, used, not for their own sakes, but as the means of expressing a new sense of human values. The fifteenth century did not, like later classicists, treat antique art as a model of perfection, but as a quarry wherein could be found the rhythms and the forms in which to represent the conflict of human emotions" (introduction to *Florentine Painting*, 4).

65. Another key member of the Florentine "Botticelli circle" was the reclusive Jacques Mesnil, a Belgian journalist and activist turned art historian. Committed to social justice, Mesnil was interested in the artist as "worker," and how the artwork affected the actual lives of those associated with its creation. His research focused on how Botticelli ran his *bottega* and negotiated the contracts that led to his commissions. See Michel Hochmann, "Jacques Mesnil's Botticelli," in Debenedetti and Elam, *Botticelli Past and Present*, 225–26.

66. Horne, *Botticelli, Painter of Florence*, 250.

67. Horne, *Botticelli, Painter of Florence*, 250–51.

68. Horne, *Botticelli, Painter of Florence*, 238.

69. Horne, *Botticelli, Painter of Florence*, 238.

70. John Pope-Hennessy, introduction to Horne, *Botticelli, Painter of Florence*, ix.

71. See Berenson, *Letters*, 80; and Ian Fletcher, *Rediscovering Herbert Horne: Poet, Architect, Typographer, and Art Historian* (Greensboro: Department of English, University of North Carolina ELT Press, 1990), 122.

Chapter 9: Berlin and Beyond

1. Forster, *A Room with a View*, 22. For the inspiration for Cuthbert Eager's view, see John Ruskin on Giotto's frescoes of Santa Croce from "The First Morning: Santa Croce," *Mornings in Florence*: "You have here, developed Gothic, with Giotto in his consummate strength, and nothing lost, in form, of the complete design. [With the frescoes'] restoration . . . there is no saying how much you have lost."

2. Forster, *A Room with a View*, 22.

3. Kermode, *Forms of Attention,* 17.

4. For an earlier—and moving—passing of the scholarly baton among Botticelli's first rediscoverers, see Horne's dedication of his biography of Botticelli to "W. H. P."—Walter Horatio Pater, "to whom," Horne wrote, "I owe my initiation in these [Renaissance] studies" (Horne, *Botticelli, Painter of Florence*, v).

5. Alain Locke, *The Critical Temper of Alain Locke*, ed. Jeffrey Stewart (New York: Garland, 1983), 22. See the discussion in Ernest Julius Mitchell II, "'Black Renaissance': A Brief History of the Concept," *Amerikastudien/American Studies* 55, no. 4 (2010): 641–65, esp. 644.

6. Locke, *Critical Temper*, 22.

7. See the ugly words of Lothrop Stoddard, a Harvard-trained eugenicist, in the ominously titled *The Rising Tide of Color* (1920), cited and discussed in Mitchell, "Black Renaissance," 643.

8. See Mitchell, "Black Renaissance," 646.

9. See Countee Cullen, *My Soul's High Song: The Collected Writings of Countee Cullen, Voice of the Harlem Renaissance*, ed. Gerald L. Early (New York: Doubleday, 1991), 104; and Langston Hughes, *The Collected Poems of Langston Hughes*, ed. Arnold Rampersad and David Roessel (New York: Knopf, 1995), 129. See also the discussion in Edward Marx, "Forgotten Jungle Songs: Primitivist Strategies of the Harlem Renaissance," *Langston Hughes Review* 14, nos. 1/2 (Spring/Fall 1996): 79–93, esp. 88, 90.

10. Hughes, *Collected Poems*, 129.

11. Langston Hughes, *The Big Sea* (New York: Knopf, 1940), 344. See also Mitchell, "Black Renaissance," 649.

12. For a brilliant fictional reconstruction of the Harlem Renaissance, see Ralph Ellison's classic from 1952, *Invisible Man* (2nd ed.; New York: Vintage, 1995), passim.

13. Marion Deshmukh, "Recovering Culture: The Berlin National Gallery and the U.S. Occupation, 1945–1949," *Central European History* 27, no. 4 (1994): 413.

14. Deshmukh, "Recovering Culture," 414–15.

15. For a fictionalized account of the Nazis' systematic plundering of Jewish household goods and related practices of financial extortion, see W. G. Sebald, *Austerlitz*, trans. Anthea Bell (New York: Modern Library, 2011), 180.

16. Deshmukh, "Recovering Culture," 415.

17. Not all of Florence would emerge unscathed. See R. W. B. Lewis's

description of how the Nazis vengefully—and, from a military stand-
point, unnecessarily—destroyed five out of the six bridges spanning
the Arno. Only the most celebrated one of all, the Ponte Vecchio, was
spared. See *The City of Florence: Historical Vista and Personal Sightings*
(New York: Farrar, Straus and Giroux, 1995), 50–51.

18. See Cohen, *Bernard Berenson,* 229.

19. Ranuccio Bianchi Bandinelli, *Diario di un borghese e altri scritti* (Milan:
Mondadori, 1965), 125.

20. See Cohen, *Bernard Berenson*, 227.

21. See Craig Hugh Smyth, *Repatriation of Art from the Collecting Point in
Munich After World War II* (Montclair, NJ: Abner Schram, 1988), 21.

22. For a description of Keller and the other Monuments Men, see Robert
M. Edsel, *Saving Italy: The Race to Rescue a Nation's Treasures from the
Nazis* (New York: W. W. Norton, 2014), passim.

23. Keller died in 1992. In 2000, an urn containing his ashes was interred
in Pisa's Campo Santo. For a biographical sketch of Keller and his leg-
acy, see Theresa Sullivan Barger, "In New Haven, an Exhibition on a
Yale Professor Who Helped Rescue Art During World War II," *New
York Times*, March 6, 2015.

24. See Mason Hammond, "Remembrance of Things Past: The Protec-
tion and Preservation of Monuments, Works of Art, Libraries, and
Archives during and after World War II," in *Proceedings of the Massa-
chusetts Historical Society* 92 (1980): 93.

25. Ivan Lindsay, *The History of Loot and Stolen Art: From Antiquity until
the Present Day* (London: Unicorn Press, 2014), 505.

26. Hammond, "The War and Art Treasures in Germany, *College Art
Journal* 5, no. 3 (1946): 213.

27. Thomas Carr Howe, *Salt Mines and Castles: The Discovery and Restitu-
tion of Looted European Art* (Indianapolis: Bobbs–Merrill, 1946), 49–50.

28. See Clark, *The Drawings by Sandro Botticelli for Dante's "Divine
Comedy,"* 7.

29. See Emily Pugh, *Architecture, Politics, and Identity in Divided Berlin*
(Pittsburgh: University of Pittsburgh Press, 2014), 86.

30. Clark, *The Drawings by Sandro Botticelli for Dante's "Divine Comedy,"*
7. The sitatuation was not much better in Rome's Vatican Library, the
third site where the drawings were held and where, as Clark writes,
they were "not easily accessible" (7).

31. See Clark, *The Drawings by Sandro Botticelli for Dante's "Divine Com-
edy."* This otherwise brilliant study contains what I believe are errors in
dating (for example, he argues that the painter finished the drawings

close to his death in 1510, and not c. 1494–95 as I and others propose; see my discussion above, Chapter 4, *n*22).

32. The three institutions were the Vatican Library in Rome; the Staatliche Museen Preussischer Kulturbesitz, Kupferstichkabinett, in West Berlin; and the Staatliche Museen zu Berlin, DDR, Kupferstichkabinett und Sammlung der Zeichnungen, in East Berlin. See Clark, *The Drawings by Sandro Botticelli for Dante's "Divine Comedy,"* 6.

33. Korbacher, "'I am very, very happy that we have it,'" 22. Meanwhile, a new building for Lippmann's Kupferstichkabinett was created in Berlin's Kulturforum, a complex of the nation's elite cultural institutions and its new artistic symbol, replacing Museum Island and its legacy of schism.

34. See Eric Weiner, "Renaissance Florence Was a Better Model for Innovation than Silicon Valley Is," *Harvard Business Review*, January 25, 2016.

35. See Graziella Magherini's interview with Maria Barnas, *Metropolis M* 4 (2008), http://metropolism.com/magazine/2008-no4/confrontaties/English; and my discussion in *My Two Italies*, 185.

Epilogue

1. Ernest Hemingway, *A Moveable Feast* (New York: Simon and Schuster, 1996), 147.

SELECT BIBLIOGRAPHY

Alighieri, Dante. *La Commedia secondo l'antica vulgata*. Ed. Giorgio Petrocchi. Edizione Nazionale della Società Dantesca Italiana. 4 vols. Milan: Mondadori, 1966–67. English translation, Dante, *The Divine Comedy*, trans. Allen Mandelbaum. New York: Everyman's Library, 1995.
———. *De vulgari eloquentia*. Ed. and trans. Steven Botterill. Cambridge: Cambridge University Press, 1996.
———. *Rime*. Ed. Gianfranco Contini. Turin: Einaudi, 1995.
———. *Vita nuova*. Milan: Garzanti, 1993. English translation, *Vita Nuova*. Trans. Dante Gabriel Rossetti. London: Ellis and Elvey, 1899.
Aristotle. *Poetics*. Trans. Stephen Halliwell. Loeb Classical Library. Cambridge, MA: Harvard University Press, 1995.
———. *The Politics of Aristotle*. Trans. Benjamin Jowett. Oxford: Clarendon Press, 1885.
Armstrong, Guyda. "Boccaccio and Dante." In *The Cambridge Companion to Boccaccio*. Ed. Guyda Armstrong, Rhiannon Daniels, and Stephen J. Milner. Cambridge: Cambridge University Press, 2015. 121–38.
Armour, Peter. "'A ciascun artista l'ultimo suo': Dante and Michelangelo." *Lectura Dantis*. Special issue: *Visibile Parlare*: Dante and the Art of the Italian Renaissance. 22/23 (Spring and Fall 1998): 141–80.
Barolini, Teodolinda. *The Undivine Comedy: Detheologizing Dante*. Princeton: Princeton University Press, 1993.

————. "'Only Historicize': History, Material Culture (Food, Clothes, Books), and the Future of Dante Studies." *Dante Studies* 127 (2009): 37–54.

Barolsky, Paul. "Botticelli's *Primavera* and the Tradition of Dante." *Konsthistorisk tidskrift* 52, no. 1 (1983): 1–6.

————. "Botticelli's *Primavera* as an Allegory of Its Own Creation." *Notes in the History of Art* 13, no. 3 (Spring 1994): 14–19.

————. "Dante and the Modern Cult of the Artist." *Arion: A Journal of Humanities and the Classics* 12, no. 2 (Fall 2004): 1–15.

————. "The Ethereal *Voluptas* of Botticelli." *Konsthistorisk tidskrift* 64, no. 2 (1995): 65–70.

Barricelli, Jean-Pierre. "Dante in the Arts: A Survey." *Dante Studies* 114 (1996): 79–93.

Barringer, Tim. *Reading the Pre-Raphaelites*. New Haven: Yale University Press, 1998.

Batines, Paul Colomb de. *Bibliografia dantesca; ossia, Catalogo delle edizioni, traduzioni, codici manoscritti e comenti della Divina commedia e delle opere minori di Dante*. 3 vols. Prato: Aldina, 1845–46.

Bauer, Linda. "From *Bottega* to Studio." *Renaissance Studies* 22, no. 5 (November 2008): 642–49.

Baxandall, Michael. *Painting and Experience in Fifteenth-Century Italy: A Primer in the Social History of Pictorial Style*. Oxford: Oxford University Press, 1988.

Beatty, H. M. "A Century of Cary's Dante." *Studies: An Irish Quarterly Review* 3, no. 9 (March 1914): 567–82.

Berenson, Bernard. *The Drawings of the Florentine Painters*. Chicago: University of Chicago Press, 1970.

————. *The Florentine Painters of the Renaissance*. 3rd ed. New York: G. P. Putnam and Sons, 1909.

————. "Botticelli's Illustrations to the *Divina Commedia*." *Nation* 63 (November 12, 1896): 363–64.

————. *The Italian Painters of the Renaissance*. London: Phaidon, 1952.

————. *Looking at Pictures with Bernard Berenson*. New York: Schocken, 1952.

————. *Rudiments of Connoisseurship: The Study and Criticism of Italian Art*. New York: Schocken, 1952.

————. *The Selected Letters of Bernard Berenson*. Ed. A. K. McComb. Boston: Houghton Mifflin, 1964.

————, and Isabella Stewart Gardner. *The Letters of Bernard Berenson and Isabella Stewart Gardner, 1887–1924: With Correspondence by Mary Berenson*. Ed. Rollin Van N. Hadley. Boston: Northeastern University Press, 1987.

Black, Jeremy. *The British and the Grand Tour*. London: Routledge, 2011.

Blume, Andrew C. "Botticelli's Family and Finances in the 1490's: Santa Maria Nuova and the San Marco Altarpiece." *Mitteilungen des Kunsthistorischen Institutes in Florenz* 38.1 (1994): 154–64.

Boccaccio, Giovanni. *Decameron.* Ed. Vittore Branca. Turin: Einaudi, 1992. English translation, *Decameron,* trans. Wayne Rebhorn. New York: W. W. Norton, 2013.

————. *Esposizioni sopra la "Comedia" di Dante.* Ed. Giorgio Padoan. In *Tutte le opere di Giovanni Boccaccio,* vol. 6. Milan: Mondadori, 1965.

————. *Genealogy of the Pagan Gods.* Ed. and trans. Jon Solomon. 2 vols. Cambridge, MA: I Tatti Renaissance Library, 2017.

————. *Trattatello in Laude di Dante.* Ed. Pier Giorgio Ricci. In *Tutte le opere di Giovanni Boccaccio,* vol. 3. Milan: Mondadori, 1974. English translation, "Life of Dante." In James Robinson Smith, *The Earliest Lives of Dante,* trans. Philip Wicksteed. London: Alexander Moring, 1904. 1–111.

Bredekamp, Horst. *Sandro Botticelli, La Primavera: Florenz als Garten der Venus.* Frankfurt am Main: Fischer Taschenbuch, 1988.

Briefel, Aviva. *The Deceivers: Art Forgery and Identity in the Nineteenth Century.* Ithaca, NY: Cornell University Press, 2006.

Brooks, Van Wyck. *The Dreams of Arcadia.* New York: Dutton, 1958.

Bullen, J. B. *The Myth of the Renaissance in Nineteenth-Century Writing.* Oxford: Clarendon Press, 1994.

Buonaccorsi, Biagio. *Diario de' successi più importanti seguiti in Italia, & particolarmente in Fiorenza dall'anno 1498 in fino all'anno 1512. Con la vita del Magnifico Lorenzo de' Medici il Vecchio scritta da Niccolò Valori.* Florence: Giunti, 1568.

Burckhardt, Jacob. *The Cicerone: An Art-Guide to the Painting in Italy for the Use of Travellers and Students.* Trans. A. H. Clough. London: T. Werner Laurie, 1879. Rept. New York: Garland, 1979.

————. *The Civilization of the Renaissance in Italy.* Trans. S. G. C. Middlemoore. London: Penguin, 1990.

————. *Letters of Jacob Burckhardt.* Ed. and trans. Alexander Dru. London: Routledge and Kegan Paul, 1955.

Burroughs, Charles. "The Altar and the City: Botticelli's 'Mannerism' and the Reform of Sacred Art." *Artibus et Historiae* 18, no. 36 (1997): 9–40.

Caesar, Michael, ed. *Dante: The Critical Heritage, 1314(?)–1870.* London: Routledge, 1989.

Caferro, William, and Philip Jacks. *The Spinelli of Florence: Fortunes of a Renaissance Merchant Family.* College Park: Pennsylvania State University Press, 2001.

Campbell, Caroline. "Botticelli and the *Bottega*." In *Botticelli Reimagined.*

Ed. Mark Evans and Stefan Wepplemann, with Ana Debenedetti, Ruben Rebmann, Mary McMahon, Gabriel Montua. London: V & A Publishing, 2016. 24–29.

Carrington, Fitzroy. "Florentine Studies: The Illustrations to Landino's 'Dante,' 1481." *Art & Life* 11, no. 7 (January, 1920): 372–77.

Cecchi, Alessandro. *Botticelli*. Milan: Federico Motta Editore, 2005.

Celenza, Christopher S. *The Intellectual World of the Italian Renaissance: Language, Philosophy, and the Search for Meaning.* Cambridge: Cambridge University Press, 2018.

Cellini, Benvenuto. *The Treatises of Benvenuto Cellini on Goldsmithing and Sculpture.* Trans. C. R. Ashbee. New York: Dover, 1967.

Chaney, Liana. *Quattrocento Neoplatonism and Medici Humanism in Botticelli's Mythological Paintings.* Lanham, MD: University Press of America, 1985.

Clark, Kenneth. *The Drawings by Sandro Botticelli for Dante's "Divine Comedy."* New York: HarperCollins, 1976.

———. *Florentine Painting: Fifteenth Century.* London: Faber and Faber, 1945.

———. *Ruskin Today.* Harmondsworth: Penguin, 1964.

Clarke, Paula C. *The Soderini and the Medici: Power and Patronage in Fifteenth-Century Florence.* Oxford: Clarendon Press, 1991.

Clarke, William. *Repertorium Bibliographicum; Or, Some Account of the Most Celebrated British Libraries.* London: William Clarke, 1819.

Cohen, Rachel. *Bernard Berenson: A Life in the Picture Trade.* New Haven: Yale University Press, 2013.

Comparetti, Domenico. *Vergil in the Middle Ages.* Trans. E. F. M. Beinecke. Princeton: Princeton University Press, 1997.

Costanza, Denise. "The Medici McMansion?" In *The Renaissance: Revised, Expanded, Unexpurgated.* Ed. D. Medina Lasansky. Pittsburgh: Periscope, 2014. 288–307.

Costaras, Nicola, and Clare Richardson. "Botticelli's Portrait of a Lady Known as Smeralda Bandinelli: A Technical Study." In *Botticelli Past and Present.* Ed. Ana Debenedetti and Caroline Elam. London: University College London Press, 2019. 36–52.

Cullen, Countee. *My Soul's High Song: The Collected Writings of Countee Cullen, Voice of the Harlem Renaissance.* Ed. Gerald L. Early. New York: Doubleday, 1991.

D., C. "The Late Dr. Lippmann." *The Burlington Magazine for Connoisseurs* 4, no. 10 (January, 1904): 7–8.

Daly, Gay. *Pre-Raphaelites in Love.* New York: Ticknor and Fields, 1989.

Davidsohn, Robert. *Storia di Firenze.* 8 vols. Florence: Sansoni, 1956–68.

De Roover, Raymond. *The Rise and Decline of the Medici Bank, 1397–1494.* Philadelphia: Beard Books, 1999.

Deshmukh, Marion. "Recovering Culture: The Berlin National Gallery and the U.S. Occupation, 1945–1949." *Central European History* 27, no. 4 (1994): 411–39.

DeVries, Kelly, and Niccolò Capponi. *Campaldino 1289: The Battle That Made Dante.* Oxford: Osprey, 2018.

Dickens, Charles. *Pictures from Italy and American Notes for General Circulation.* Philadelphia: J. B. Lippincott, 1885.

Dieffendorf, Barbara B. "Family Culture." *Renaissance Quarterly* 40 (1987): 661–81.

Domenichi, Lodovico. *Facetie, motti e burle di diversi signori e persone private.* Venice: Andrea Muschio, 1571.

Dowling, Linda C. *Charles Eliot Norton: The Art of Reform in Nineteenth-Century America.* Durham, NC: Duke University Press, 2007.

Dressen, Angela. "From Dante to Landino: Botticelli's *Calumny of Apelles* and Its Sources." *Mitteilungen des Kunsthistorischen Institutes in Florenz* 59, no. 3 (2017): 324–39.

Dreyer, Peter. *Dantes Divina Commedia mit den Illustrationen von Sandro Botticelli: Codex Reg. Lat. 1896, Codex Ham. 201 (Cim. 33).* Zurich: Belser, 1986.

———. "Botticelli's Series of Engravings 'of 1481.'" *Print Quarterly* 2 (June 1984): 111–15.

———. "La storia del manoscritto." Trans. Marzia Beluffi. In Dante, *La Divina Commedia: Illustrazioni Sandro Botticelli.* Paris: Diane de Stellers, 1996. 27–40.

Dunlop, Anne. "'El Vostro Poeta': The First Florentine Printing of Dante's *Commedia.*" *Canadian Art Review* 20, nos. 1/2 (1993): 29–42.

Edsel, Robert M. *Saving Italy: The Race to Rescue a Nation's Treasures from the Nazis.* New York: W. W. Norton, 2014.

Ettle, Ross Brooke. "The Venus Dilemma: Notes on Botticelli and Simonetta Cattaneo Vespucci." *Notes in the History of Art* 27, no. 4 (Summer 2008): 3–10.

Ettlinger, Helen, and L. D. Ettlinger. *Botticelli.* London: Thames and Hudson, 1976.

Evans, Mark, and Stefan Wepplemann, with Ana Debenedetti, Ruben Rebmann, Mary McMahon, and Gabriel Montua, eds. *Botticelli Reimagined.* London: V & A Publishing, 2016.

Falaschi, E. "Giotto: The Literary Legend." *Italian Studies* 27 (1972): 1–27.

Fasanelli, James A. "A Letter from Berenson's Early Years." *The Burlington Magazine* 108, no. 755 (1966): 85.

Ficino, Marsilio. *The Letters of Marsilio Ficino.* Trans. Members of the Language Department of the London School of Economics. 2nd ed. London: Shepheard–Walwyn, 1975.

Forster, E. M. *A Room with a View.* London: Penguin, 2000.

Foscolo, Ugo. *Dei sepolcri.* Vol. 1 of *Opere.* Ed. Franco Gavazzeni. 2 vols. Turin: Einaudi–Gallimard, 1994–95. 21–38.

————. "A Parallel between Dante and Petrarch." Vol. 2 of *Opere.* Ed. Franco Gavazzeni. 2 vols. Turin: Einaudi–Gallimard, 1994–95. 633–60.

Friederich, Werner P. *Dante's Fame Abroad, 1350–1850: The Influence of Dante Alighieri on the Poets and Scholars of Spain, France, England, Germany, Switzerland, and the United States.* Rome: Edizioni di Storia e Letteratura, 1950.

Garin, Eugenio. *Prosatori latini del Quattrocento.* Milan and Naples: Riccardo Ricciardi, 1952.

Garzelli, Annarosa. *Le immagini, gli autori, i destinatari.* Vol. 1 of *Miniatura fiorentina del Rinascimento, 1440–1525: Un primo censimento.* Ed. Annarosa Garzelli. 2 vols. Florence: Giunta, 1985.

Gauchet, Marcel. *The Disenchantment of the World: A Political History of Religion.* Trans. Oscar Burge. Princeton: Princeton University Press, 1997.

Ghiberti, Lorenzo. *Commentarii.* In *A Documentary History of Art,* vol. 1, *The Middle Ages and the Renaissance.* Ed. Elizabeth Gilmore Holt. 3 vols. New York: Doubleday, 1957. 151–67.

Gilbert, Felix. "Jacob Burckhardt's Student Years: The Road to Cultural History." *Journal of the History of Ideas* 47, no. 2 (April–June 1986): 249–74.

Gilson, Simon. *Dante and Renaissance Florence.* Cambridge: Cambridge University Press, 2009.

————. " 'La divinità di Dante': The Problematics of Dante's Reception from the Fourteenth to Sixteenth Centuries." *Critica del testo* 14, no. 1 (2011): 581–603.

Goldthwaite, Richard. *The Economy of Renaissance Florence.* Baltimore: Johns Hopkins University Press, 2009.

————. *Wealth and the Demand for Art in Italy, 1300–1600.* Baltimore: Johns Hopkins University Press, 1993.

Gombrich, E. H. "Botticelli's Mythologies: A Study in the Neoplatonic Symbolism of His Circle." *Journal of the Warburg and Courtauld Institutes* 8 (1945): 7–60.

Gossman, Lionel. *Basel in the Age of Burckhardt.* Chicago: University of Chicago Press, 2007.

————. "Jacob Burckhardt as Art Historian." *Oxford Art Journal* 11, no. 1 (1988): 25–32.

Goody, Jack. *Renaissances: The One of the Many.* Cambridge: Cambridge University Press, 2010.

Greco, Luigi. "Un libraire italien à Paris: Gian Claudio Molini, 1724–1816." *Mélanges de la bibliotheque de la Sorbonne* 10 (1990): 103–21.

———. "Un libraire italien à Paris à la veille de la Révolution." *Mélanges de l'école française de Rome: Italie et Méditerranée* 102, no. 2 (1990): 261–80.

Greenblatt, Stephen. *Renaissance Self-Fashioning: From More to Shakespeare.* Chicago: University of Chicago Press, 2005.

Grendler, Paul F. *Schooling in Renaissance Italy: Literacy and Learning, 1300–1600.* Baltimore: Johns Hopkins University Press, 1991.

———. *The Universities of the Italian Renaissance.* Baltimore: Johns Hopkins University Press, 2002.

Grosshans, Reinhald. *Gemäldegalerie Berlin.* Munich: Prestel, 1998.

Guicciardini, Francesco. *The History of Italy.* Trans. Sidney Alexander. Princeton: Princeton University Press, 1984.

Hammond, Mason. "The War and Art Treasures in Germany." *College Art Journal* 5.3 (1946): 205–18.

———. "Remembrance of Things Past: The Protection and Preservation of Monuments, Works of Art, Libraries, and Archives during and after World War II." *Proceedings of the Massachusetts Historical Society* 92 (1980): 84–99.

Hankins, James. "Renaissance Humanism and Historiography Today." In *Palgrave Advances in Renaissance Historiography.* Ed. Jonathan Woolfson. London: Palgrave Macmillan, 2005. 73–96.

Hatfield, Rab. "Botticelli's *Mystic Nativity*, Savonarola and the Millennium." *Journal of the Warburg and Courtauld Institutes* 58 (1995): 88–114.

———. Introduction. *Sandro Botticelli and Herbert Horne: New Studies.* Ed. Rab Hatfield. Florence: Syracuse University in Florence, 2009. Xii–xiii.

Havely, Nick. *Dante's British Public: Readers and Texts, from the Fourteenth Century to the Present.* Oxford: Oxford University Press, 2014.

Hegarty, Melinda. "Laurentian Patronage in the Palazzo Vecchio: The Frescoes of the Sala dei Gigli." *Art Bulletin* 75, no. 2 (1996): 264–85.

Hibbert, Christopher. *The Rise and Fall of the House of Medici.* London: Penguin, 1974.

Hochmann, Michel. "Jacques Mesnil's Botticelli." In *Botticelli Past and Present.* Ed. Ana Debenedetti and Caroline Elam. London: University College London Press, 2019. 216–31.

Holbrook, Richard. *Portraits of Dante from Giotto to Raffael: A Critical Study, with a Concise Iconography.* Boston: Houghton Mifflin, 1911.

Horne, Herbert. *Alessandro Filipepi, Commonly Called Sandro Botticelli,*

Painter of Florence. London: George Bell and Sons, 1908. Reprinted as *Botticelli, Painter of Florence.* Princeton: Princeton University Press, 1980.

———. "Quelques souvenirs de Sandro Botticelli." *Revue archéologique* 39 (1901): 12–20.

Howe, Thomas Carr. *Salt Mines and Castles: The Discovery and Restitution of Looted European Art.* Indianapolis: Bobbs–Merrill, 1946.

Hughes, Langston. *The Big Sea.* New York: Knopf, 1940.

———. *The Collected Poems of Langston Hughes.* Ed. Arnold Rampersad and David Roessel. New York: Knopf, 1995.

Isaacson, Walter. *Leonardo da Vinci.* New York: Simon and Schuster, 2017.

Janson, H. W. *The Sculpture of Donatello.* Princeton: Princeton University Press, 1979.

Keller, Peter. "The Engravings in the 1481 Edition of the *Divine Comedy.*" In *Sandro Botticelli: The Drawings for the "Divine Comedy."* Ed. Hein-Th. Schulze Altcappenberg. London: Royal Academy of Arts, 2000. 326–33.

Kelly, Joan. "Did Women Have a Renaissance?" In *Women, History, and Theory: The Essays of Joan Kelly.* Chicago: University of Chicago Press, 1984. 19–50.

Kermode, Frank. *Forms of Attention: Botticelli and Hamlet.* Chicago: University of Chicago Press, 1985.

King, Ross. *Brunelleschi's Dome: How a Renaissance Genius Reinvented Architecture.* New York: Bloomsbury, 2013.

Klapisch-Zuber, Christiane. *Woman, Family, and Ritual in Renaissance Italy.* Trans. Lynne Cochrane. Chicago: Chicago University Press, 1985.

Korbacher, Dagmar. "'I am very, very happy that we have it': Botticelli's Dante and the Hamilton Collection at the Kupferstichkabinett." In *Botticelli and Treasures from the Hamilton Collection.* Ed. Dagmar Korbacher. London: Courtauld Gallery, 2016. 14–24.

Korman, Sally. "'Danthe Alighieri Poeta Florentino': Cultural Values in the 1481 *Divine Comedy.*" In *Reevaluating Renaissance Art.* Ed. Gabriele Neher and Rupert Shepherd. London: Ashgate, 2000. 57–69.

Krautheimer, Richard. *Lorenzo Ghiberti.* Princeton: Princeton University Press, 1983.

Kunzelman, Diane. "Comparative Technical Investigations of Paintings by Sandro Botticelli." In *Sandro Botticelli (1445–1510): Artist and Entrepreneur in Renaissance Florence.* Ed. Gert Jan van der Sman and Irene Mariani. Florence: Istituto Universitario Olandese di Storia dell'Arte, 2015. 27–46.

Ladis, Andrew. "The Legend of Giotto's Wit and the Arena Chapel." *Art Bulletin* 68, no. 4 (December 1986): 581–96.

Lansing, Richard, ed. *The Dante Encyclopedia.* New York: Garland, 2000.

La Roncière, Charles de. "Tuscan Nobles on the Eve of the Renaissance." In *History of Private Life*, vol. 2, *Revelations of the Medieval World*. Ed. Georges Duby and Philippe Ariès. Trans. Arthur Goldhammer. 5 vols. Cambridge, MA: Harvard University Press, 1992–98. 157–310.

Latham, David, ed. *Haunted Texts: Studies in Pre-Raphaelitism in Honour of William E. Fredeman*. Toronto: University of Toronto Press, 2003.

Levey, Michael. "Botticelli and Nineteenth-Century England." *Journal of the Warburg and Courtauld Institutes* 23 (1960): 291–306.

Lewis, R. W. B. *The City of Florence: Historical Vista and Personal Sightings*. New York: Farrar, Straus and Giroux, 1995.

Lightbown, Ronald. *Sandro Botticelli*. 2 vols. Berkeley: University of California Press, 1978.

———. *Sandro Botticelli: Life and Work*. New York: Abbeville, 1989.

Lindsay, Ivan. *The History of Loot and Stolen Art: From Antiquity until the Present Day*. London: Unicorn Press, 2014.

Lippmann, Friedrich. *Drawings by Sandro Botticelli for Dante's "Divina Commedia." Reduced Facsimiles After the Originals in the Royal Museum Berlin and in the Vatican Library with an Introduction and Commentary by F. Lippmann*. London: Lawrence and Bullen, 1896.

Locke, Alain. *The Critical Temper of Alain Locke*. Ed. Jeffrey Stewart. New York: Garland, 1983.

Lowe, K. J. P. *Church and Politics in Renaissance Italy: The Life and Career of Cardinal Francesco Soderini (1453–1524)*. Cambridge: Cambridge University Press, 1993.

Luzzi, Joseph. "From the Dark Wood to the Garden: Dante Studies in the Age of Voltaire." *SVEC: Studies on Voltaire and the Eighteenth Century* (2002:6): 349–70.

———. *Romantic Europe and the Ghost of Italy*. New Haven: Yale University Press, 2008.

Machiavelli, Niccolò. *Florentine Histories*. Trans. W. K. Marriott. London: Dent, 1909.

———. *Machiavelli and His Friends: Their Personal Correspondence*. Ed. and trans. James B. Atkinson and David Sices. DeKalb: Northern Illinois University Press, 1996.

Magherini, Graziella. *La sindrome di Stendhal*. Florence: Ponte alle Grazie, 1995.

Marx, Edward. "Forgotten Jungle Songs: Primitivist Strategies of the Harlem Renaissance." *Langston Hughes Review* 14, nos. 1/2 (Spring/Fall 1996): 79–93.

Maier, Ida. *Ange Politien: La formation d'un poète humaniste, 1469–1480*. Geneva: Droz, 1966.

Malandrin, Vanessa, Adanella Rossi, Leonid Dvortsin, and Francesca Galli. "The Evolving Role of Bread in the Tuscan Gastronomic Culture." In *Gastronomy and Culture*. Ed. Katalin Csobán and Habil Erika Könyves. Debrecen, Hungary: University of Debrecen, 2015. 10–23.

Malesani, Piergiorgio, Elena Pecchioni, Emma Cantisani, and Fabio Fratini. "Geolithology and Provenance of the Materials of the Historical Buildings of Florence (Italy)." *Episodes* 26, no. 3 (September 2003): 250–55.

Manetti, Antonio. *The Life of Brunelleschi*. Trans. Catherine Enggass. University Park: Pennsylvania State University, 1970.

Marmor, Max C. "From Purgatory to the *Primavera*, Some Observations on Botticelli and Dante." *Artibus et Historiae* 24, no. 48 (2003): 199–212.

Martines, Lauro. *April Blood: Florence and the Plot Against the Medici*. Oxford: Oxford University Press, 2003.

Mazzotta, Giuseppe. *Dante's Vision and the Circle of Knowledge*. Princeton: Princeton University Press, 1993.

————. "The Life of Dante." In *The Cambridge Companion to Dante*. Ed. Rachel Jacoff and Jeffrey Schnapp. Cambridge: Cambridge University Press, 2007. 1–13.

McLaughlin, Martin. "Humanism and Italian Literature." In *The Cambridge Companion to Renaissance Humanism*. Ed. Jill Kraye. Cambridge: Cambridge University Press, 1996. 234–45.

McMillan, C. B. "A Catalogue of the Letters of Dante Gabriel Rossetti." Ph.D. dissertation, University of Texas at Austin, 1975.

Medici, Lucrezia Tornabuoni de. *Sacred Narratives*. Ed. and trans. Jane Tylus. Chicago: University of Chicago Press, 2001.

Mehus, Lorenzo. *Historia litteraria florentina: Ab anno MCXCII usque ad annum MCDXXXIX*. Munich: Wilhelm Fink, 1968.

Melius, Jeremy. "Art History and the Invention of Botticelli." Ph.D. dissertation, University of California, Berkeley, 2010.

Mesnil, Jacques. *Botticelli*. Paris: Michel Albin, 1938.

————. "L'éducation des peintres florentins au XVe siècle." *Revue des idées* 14 (September 15, 1910): 195–206.

Michelet, Jules. "The Renaissance and the Discovery of the World and Man." In *The Renaissance Debate*. Ed. Denys Hay. New York: Holt, Rinehart and Winston, 1965. 22–28.

Migliorini, Francesca. "Botticelli's Illustrations for Dante's *Comedy*: Some Considerations on Form and Function." In *Sandro Botticelli (1445–1510): Artist and Entrepreneur in Renaissance Florence*. Ed. Gert Jan van der Sman and Irene Mariani. Florence: Istituto Universitario Olandese di Storia dell'Arte, 2015. 157–66.

Miller, Lillian R. "Celebrating Botticelli: The Taste for the Italian Renaissance in the United States, 1870–1920." In *The Italian Presence in American Art*. Ed. Irma B. Jaffe. New York: Fordham University Press, 1989. 1–22.

Mitchell II, Ernest Julius. "'Black Renaissance': A Brief History of the Concept." *Amerikastudien/American Studies* 55.4 (2010): 641–65.

Najemy, John. *A History of Florence: 1200–1575*. New York: Wiley–Blackwell, 2006.

Nardi, Jacopo. "*Istorie della città di Firenze* [*History of the City of Florence*]." In *Selected Writings of Girolamo Savonarola: Religion and Politics, 1490–1498*. Ed. Donald Beebe, Anne Borelli, and Maria Pastore Passaro. New Haven: Yale University Press, 2008. 253–55.

Nelson, Jonathan K. "Botticelli's 'Virile Air': Reconsidering the Milan Memo of 1493." In *Sandro Botticelli (1445–1510): Artist and Entrepreneur in Renaissance Florence*. Ed. Gert Jan van der Sman and Irene Mariani. Florence: Istituto Universitario Olandese di Storia dell'Arte, 2015. 166–81.

―――. "An Unpublished Essay by Mary Berenson, 'Botticelli and his Critics' (1894–95)." *19: Interdisciplinary Studies in the Long Nineteenth Century* 28 (2019). https://doi.org/10.16995/ntn.837.

Olsen, Christina. "Gross Expenditure: Botticelli's Nastagio Panels." *Art History* 15, no. 2 (June 1992): 146–70.

Oltrogge, Doris, Robert Fuchs, and Oliver Hahn. "Finito and Non finito: Drawing and Painting Techniques in Botticelli's *Divine Comedy*." In *Sandro Botticelli: The Drawings for the "Divine Comedy*." Ed. Hein-Th. Schulze Altcappenberg. London: Royal Academy of Arts, 2000. 334–41.

O'Malley, Michelle. "Finding Fame: Painting and the Making of Careers in Renaissance Florence." *Renaissance Studies* 24, no. 1: special issue, *Re-Thinking Renaissance Objects: Design, Function, and Meaning* (February 2010): 11–17.

―――. "Quality Choices in the Production of Renaissance Art: Botticelli and Demand." *Renaissance Studies* 28, no. 1 (February 2014): 4–32.

―――. "Responding to Changing Taste and Demand: Botticelli after 1490." In *Sandro Botticelli (1445–1510): Artist and Entrepreneur in Renaissance Florence*. Ed. Gert Jan van der Sman and Irene Mariani. Florence: Istituto Universitario Olandese di Storia dell'Arte, 2015. 101–19.

Østermark-Johansen, L. *Walter Pater and the Language of Sculpture*. London: Ashgate, 2011.

Padoan, Giorgio. "Boccaccio, Giovanni." In *Enciclopedia dantesca*. Ed. Umberto Bosco. 6 vols. Rome: Istituto dell'Enciclopedia Italiana, 1970–75. 1:645–50.

Paolucci, Antonio. "Botticelli and the Medici." In *Botticelli: From Lorenzo the Magnificent to Savonarola*. Ed. Alessandro Chioetto. Turin: Skira, 2003.

Papio, Michael. *Boccaccio's Expositions on Dante's* Comedy. Toronto: Toronto University Press, 2009.

Parks, Tim. *Medici Money: Art, Banks, and Metaphysics in Fifteenth-Century Florence.* New York: Enterprise, 2005.

Parker, Deborah. "Illuminating Botticelli's Chart of Hell." *MLN: Italian Issue* 128, no. 1 (January 2013): 84–102.

Parronchi, Alessandro. *Botticelli fra Dante e Petrarca.* Florence: Nardini, 1985.

Pater, Walter. "Dante Gabriel Rossetti." *Appreciations: With an Essay on Style.* London: Macmillan, 1895. 213–27.

———. *The Letters of Walter Pater.* Ed. Lawrence Evans. Oxford: Oxford University Press, 1970.

———. *Studies in the History of the Renaissance.* Oxford: Oxford University Press, 2010.

Pegoretti, Anne. "Early Reception until 1481." *The Cambridge Companion to Dante's "Commedia."* Ed. Zygmunt Barański and Simon Gilson. Cambridge: Cambridge University Press, 2019. 245–58.

Perna, Ciro. "La 'Lectura Dantis' come genere boccacciano." In *Boccaccio editore e interprete di Dante: Atti del Convegno internazionale di Roma 28–30 ottobre 2013.* Ed. Luca Azzetta and Andrea Mazzuchi. Rome: Salerno, 2014. 437–50.

Petrocchi, Giorgio. *La vita di Dante.* 5th ed. Bari: Laterza, 2008.

Petrarca, Francesco. *Familiarium rerum libri [Familiar Letters].* Ed. Enrico Bianchi. In *Prose.* Ed. G. Martelloti with P. G. Ricci, E. Carrara, and E. Bianchi. Milan and Naples: Riccardo Ricciardi, 1955. 810–1025.

———. *Res seniles [Letters on Old Age], Libri V–VIII.* Ed. Silvia Rizzo, with Monica Berté. Florence: Le Lettere, 2009.

Phillips, Claude. "Florentine Painting before 1500." *The Burlington Magazine for Connoisseurs* 34, no. 195 (June 1919): 208–19.

Poliziano, Agnolo. *Detti piacevoli.* Ed. Tiziano Zanato. Rome: Istituto dell'Enciclopedia Italiana Treccani, 1983.

———. *Stanze cominciate per la giostra di Giuliano de' Medici.* Ed. Vincenzo Bona. Turin: Loescher, 1954.

Pope-Hennessy, John. *Donatello: Sculptor.* New York: Abbeville Press, 1993.

———. "Donatello's Bronze *David.*" In *Scritti di storia dell'arte in onore di Federico Zeri.* Milan: Electa, 1984. 122–27.

———. *The Portrait in the Renaissance.* Princeton: Princeton University Press, 1963.

———. *Sandro Botticelli: The Nativity.* London: Percy Lund Humphries, 1945.

Pugh, Emily. *Architecture, Politics, and Identity in Divided Berlin.* Pittsburgh: University of Pittsburgh Press, 2014.

Pyle, Cynthia M. "L'entrée de Charles VIII dans Paris (1484) racontée par Baccio Ugolini à Lorenzo di Pierfrancesco de' Medici." *Bibliothèque d'Humanisme et Renaissance* 53, no. 3 (1991): 727–34.

Quennell, Peter. *John Ruskin: The Portrait of a Prophet.* London: Collins, 1949.

Raffa, Guy. *Dante's Bones: A Poetic Afterlife.* Cambridge, MA: Harvard University Press, 2020.

Ranalli, Omerita. "'Accessus ad auctorem' e primo canto dell'*Inferno* nella lettura fiorentina di Giovanni Boccaccio." In *Scrittori in cattedra: La forma della "lezione" dalle origini al Novecento.* Rome: Bulzoni, 2002. 9–20.

Rocke, Michael. *Forbidden Friendships: Homosexuality and Male Culture in Renaissance Florence.* New York: Oxford University Press, 1998.

Roddewig, Marcella. *Dante Alighieri: Die "Göttliche Komödie": Vergleichende Bestandsaufnahme der "Commedia"-Handischhriften.* Stuttgart: Anton Hiersemann, 1984.

Roeck, Bernard. *Florence 1900: The Quest for Arcadia.* Trans. Stewart Spenser. New Haven: Yale University Press, 2009.

Roscoe, William. *The Life of Lorenzo de' Medici, Called the Magnificent.* 3rd ed. London: A. Strahan, 1797.

Rossetti, William Michael, ed. *Dante Gabriel Rossetti: His Family-Letters, with a Memoir.* 2 vols. London: Ellis and Elvey, 1895.

Roush, Sherry. "Dante as *Piagnone* Prophet: Girolamo Benivieni's 'Cantico in laude di Dante' (1506)." *Renaissance Quarterly* 55, no. 1 (Spring 2002): 49–80.

Rowland, Ingrid D. *From Heaven to Arcadia: The Sacred and the Profane in the Renaissance.* New York: New York Review of Books, 2005.

———, and Noah Charney. *The Collector of Lives: Giorgio Vasari and the Invention of Art.* New York: W. W. Norton, 2017.

Rubin, Patricia Lee. *Images and Identity in Fifteenth-Century Florence.* New Haven: Yale University Press, 2007.

Rubinstein, Nicola. *The Palazzo Vecchio, 1298–1532: Government, Architecture, and Imagery in the Civic Palace of the Florentine Republic.* Oxford: Clarendon Press, 1995.

Ruskin, John. *Ariadne Florentina: Six Lectures on Wood and Metal Engraving.* New York: Charles E. Merrill, 1892.

———. *Modern Painters* [Vol. 1]. Vol. 4 of *The Works of John Ruskin.* Ed. E. T. Cook and Alexander Wedderburn. 39 vols. London: George Allen, 1903–12.

———. *The Stones of Venice.* New York: Da Capo, 1960.

———, Walter Pater, and Adrian Stokes. *England and Its Aesthetes: Biography and Taste.* Commentary by David Carrier. Amsterdam: G + B Arts International, 1997.

Sacchetti, Franco. *Tales from Sacchetti*. Trans. Mary G. Steegmann. London: J. M. Dent, 1908.

Said, Edward. "Thoughts on Late Style." *London Review of Books* 26, no. 15 (August 2004). https://www.lrb.co.uk/the-paper/v26/n15/edward-said/thoughts-on-late-style.

Santagata, Marco. *Dante: The Story of His Life*. Trans. Richard E. Dixon. Cambridge, MA: Belknap Press of Harvard University Press, 2016.

Saslow, James M. *The Poetry of Michelangelo: An Annotated Translation*. New Haven: Yale University Press, 1991.

Sassetti, Paolo. "Marriage, Dowry, and Remarriage in the Sassetti Household (1384–97)." Trans. Isabella Chabot. In *Medieval Italy: Texts in Translation*. Ed. Katherine L. Jansen, Joanna Drell, and Frances Andrews. Philadelphia: University of Pennsylvania Press, 2009. 446–50.

Schneider, Laurie. "Donatello's Bronze *David*." *Art Bulletin* 55, no. 2 (1973): 215–16.

Schulze Altcappenberg, Hein-Th. "'Per essere persona sofistica': Botticelli's Drawings for the *Divine Comedy*." In *Sandro Botticelli: The Drawings for the "Divine Comedy*." Ed. Hein-Th. Schulze Altcappenberg. London: Royal Academy of Arts, 2000. 13–35.

———, ed. *Sandro Botticelli Pittore della "Divina Commedia*." 2 vols. Rome: Scuderie Papali al Quirinale and Milan: Skira, 2000.

Shearman, John. "The Collections of the Younger Branch of the Medici." *The Burlington Magazine* 117, no. 862 (January 1975): 12–13.

Shemek, Deanna. *Ladies Errant: Wayward Women and Social Order in Early Modern Italy*. Durham, NC: Duke University Press, 1998.

Simonetta, Marcello. *The Montefeltro Conspiracy: A Renaissance Mystery Decoded*. New York: Doubleday, 2008.

Sman, Gert Jan van der. "Botticelli's Life and Career in the District of the Unicorn." In *Sandro Botticelli (1445–1510): Artist and Entrepreneur in Renaissance Florence*. Ed. Gert Jan van der Sman and Irene Mariani. Florence: Istituto Universitario Olandese di Storia dell'Arte, 2015. 183–201.

Smith, Webster. "On the Original Location of the *Primavera*." *Art Bulletin* 57, no. 1 (March 1975): 31–40.

Spengler, Oswald. *The Decline of the West*. Trans. Charles Francis Atkinson. 2 vols. London: George Allen, 1923.

Spike, John T., and Alessandro Cecchi, eds. *Botticelli and the Search for the Divine: Florentine Painting Between the Medici and the Bonfires of the Vanities*. Williamsburg, VA: College of William and Mary, Muscarelle Museum of Art, 2017.

Stapleford, Richard. "Vasari and Botticelli." *Mitteilungen des Kunsthistorischen Institutes in Florenz* 39, nos. 2/3 (1995): 397–408.

Steenbock, Frauke. "The Hamilton Collection." In *Botticelli and Treasures from the Hamilton Collection*. Ed. Dagmar Korbacher. London: Courtauld Gallery, 2016. 10–13.

Steinberg, Justin. *Accounting for Dante: Urban Readers and Writers in Late Medieval Italy*. Notre Dame, IN: Notre Dame University Press, 2007.

Stendhal. *Rome, Naples and Florence*. Trans. Richard N. Coe. Richmond, UK: John Calder, 1959, rept. 2010.

Stephens, F. G. *Dante Gabriel Rossetti*. London: Seeley, 1905.

Stuard, Susan Mosher. *Gilding the Market: Luxury and Fashion in Fourteenth-Century Italy*. Philadelphia: University of Pennsylvania Press, 2006.

Swinburne, Algernon Charles. "Notes on Designs of the Old Masters at Florence." In *Essays and Studies*. London: Chatto and Windus, 1875. 314–57.

Taylor, Karla. "A Text and Its Afterlife: Dante and Chaucer." *Comparative Literature* 35, no. 1 (Winter 1983): 1–20.

Teitlebaum, Richard. "John Ruskin and the Italian Renaissance." *English Studies in Africa* 19, no. 1 (1976): 1–17.

Tiffany, Kristopher. "Dante's 'Afterlife' in William Dyce's Paintings." M.A. thesis, Arizona State University, 2013.

Thorndike, Lynn. "Renaissance or Prerenaissance?" *Journal of the History of Ideas* 4 (1943): 65–74.

Tostmann, Oliver. "Berenson: The American Discovery of Sandro Botticelli." In *Botticelli Reimagined*. Ed. Mark Evans and Stefan Wepplemann, with Ana Debenedetti, Ruben Rebmann, Mary McMahon, Gabriel Montua. London: V & A Publishing, 2016. 106–9.

Vasari, Giorgio. *Lives of the Artists: Volume I*. Trans. George Bull. London: Penguin, 1987.

———. *Vite dei più eccellenti pittori, scultori e architettori: Nelle redazioni del 1550 e 1568*. Ed. Rosanna Bettarini and Paolo Barocchi. 8 vols. Florence: Sansoni, 1966–87.

Venturi, Riccardo. "Into the Abyss: On Salvador Dalí's *Dream of Venus*." In *Botticelli Past and Present*. Ed. Ana Debenedetti and Caroline Elam. London: University College London Press, 2019. 266–89.

Waagen, Friedrich. *Treasures of Art in Great Britain: Being an Account of the Chief Collections of Paintings, Drawings, Sculptures, Illuminated Mss., &c. &c.* 3 vols. London: John Murray, 1854.

Warburg, Aby. *Botticelli*. Trans. Emma Cantimori. Milan: Abscondita, 2003.

Watts, Barbara. "Sandro Botticelli's Drawings for Dante's *Inferno*: Narrative

Structure, Topography, and Manuscript Design." *Artibus et Historiae* 16, no. 32 (1995): 163–201.

Wedepohl, Claudia. "Why Botticelli? Aby Warburg's Search for a New Approach to *Quattrocento* Italian Art." In *Botticelli Past and Present*. Ed. Ana Debenedetti and Caroline Elam. London: University College London Press, 2019. 183–202.

Weinstein, Donald. *Savonarola: The Rise and Fall of a Renaissance Prophet.* New Haven: Yale University Press, 2011.

Weinberg, Gail S. "D. G. Rossetti's Ownership of Botticelli's 'Smeralda Brandini.'" *The Burlington Magazine* 146, no. 1210 (January 2004): 20–26.

Weintraub, Karl Joachim. "Jacob Burckhardt: The Historian Among the Philologists." *American Scholar* 57, no. 2 (Spring 1988): 273–82.

Weller, Peter. "A Reassessment in Historiography and Gender: Donatello's Bronze *David* in the Twenty-First Century." *Artibus et Historiae* 33, no. 65 (2012): 43–77.

Wind, Edgar. *Pagan Mysteries in the Renaissance.* New York: W. W. Norton, 1968.

Wright, Alison. *The Pollaiuolo Brothers.* New Haven: Yale University Press, 2005.

Zambrano, Patrizia. "The 'Dead Christ' in Cherbourg: A New Attribution to the Young Filippino Lippi." *The Burlington Magazine* 138, no. 1118 (1996): 321–24.

Zirpolo, Lilian. "Botticelli's *Primavera*: A Lesson for the Bride." *Woman's Art Journal* 12, no. 2 (Autumn 1991–Winter 1992): 24–28.

Zollner, Frank. *Botticelli.* New York: Prestel, 2015.

INDEX

Note: Page numbers in italics indicate figures.